CEZANNE LETTERS

WRITTEN BY JOHN REWALD

The History of Impressionism
Post-Impressionism: From Van Gogh to Gauguin
Maillol
Studies in Impressionism
Camille Pissarro
Cézanne, the Steins, and their Circle
Edgar Degas
Georges Seurat
Paul Cézanne, A Biography
Paul Gauguin
Seurat, A Biography

EDITED BY JOHN REWALD

Paul Cézanne, Letters
Camille Pissarro: Letters to his Son Lucien
Paul Gauguin: Letters to A. Vollard and A. Fontainas
The Woodcuts of Aristide Maillol: A Complete Catalog
Renoir Drawings
Paul Cézanne Sketchbook
Edouard Manet Pastels
The Watercolors of Paul Cézanne

1. Cézanne on his way to his 'Motif'
Photograph, 1873

PAUL

CEZANNE

LETTERS

EDITED BY

JOHN REWALD

With 52 Illustrations

DA CAPO PRESS • NEW YORK

TRANSLATED FROM THE FRENCH BY
MARGUERITE KAY

First Edition 1941
Second Edition 1944
Third Edition 1946
Fourth Edition 1976
(Revised and enlarged)

Library of Congress Cataloging in Publication Data

Cézanne, Paul, 1839–1906.
 [Correspondence. English]
 Paul Cézanne, letters / edited by John Rewald; [translated from
the French].–1st Da Capo Press ed.
 p. cm.
 "An unabridged republication of the edition published in New
York in 1976 with minor textual emendations and the addition of
52 illustrations from the 1941 edition"–T.p. verso.
 Includes index.
 ISBN 0-306-80630-4
 1. Cézanne, Paul, 1839–1906–Correspondence. 2. Painters–France–
Correspondence. 3. Zola, Emile, 1840–1902–Correspondence. 4.
Novelists, French–19th century–Correspondence. 5. Critics–
France–Correspondence. I. Rewald, John, 1912- . II. Title.
ND553.C33A3 1995
759.4–dc20
[B] 94-48007
 CIP

First Da Capo Press edition 1995

This Da Capo Press paperback edition of *Paul Cézanne, Letters*
is an unabridged republication of the edition first published in
New York in 1976 with minor textual emendations and the
addition of 52 illustrations from the 1941 edition. It is reprinted
by arrangement with Sabine Rewald.

Published by Da Capo Press, Inc.
A Subsidiary of Plenum Publishing Corporation
233 Spring Street, New York, N.Y. 10013

Manufactured in the United States of America

PREFACE

Cézanne's letters were published for the first time in Paris more than 35 years ago, and in Oxford, in an English translation, in 1941. The editor undertook the work with considerable hesitation having to admit that Cézanne would probably not have given his permission. A reticent man, trying to protect his daily life against any intrusion from outside, he held very definite views about the need to separate, as far as possible, the private individual and the creative artist. He wrote for instance in his later years to the young Joachim Gasquet: "I thought one could do good painting without attracting attention to one's private life.—Certainly an artist wishes to raise himself intellectually as much as possible, but the man must remain obscure."

In fact Cézanne, the man, remained in obscurity for too long; only when the world became conscious of the immense contribution which he had made to modern art, was the protective barrier, which he had tried to erect, broken down. The human being and the artist have entered history, surrounded by a web of legends which often falsify his words and thoughts and thus make him appear both colourful and petty. Cézanne himself, towards the end of his life, experienced the first wave of the flood of anecdotes soon to inundate him; he was an excellent target for gossip, especially as, in spite of occasional outbreaks of temper, he was completely helpless in the face of calumny. Convinced that, if only he could make the

world understand his art, all these silly stories would be silenced, he never bothered to contradict them, shunning his fellow-humans in order to continue his work undisturbed and indefatigably.

Now that this work has long since received due recognition, it seems justified to let the artist talk himself, to allow his own thoughts, even if somewhat awkwardly expressed, to disprove the distortions and falsifications. This is the intention underlying the publication of Cézanne's letters, based on the conviction that his correspondence will help to understand him better as a human being and to confirm the reverence with which his work is rightly regarded.

The letters mirror many contradictory trends of Cézanne's far from even temperament. Light-hearted and carefree in his youth, he later becomes suspicious and withdrawn. His expressions vary between tenderness, even humility, and arrogance; his self-reliance sometimes changes to bitterness and disappointment; his forgiveness and politeness can rapidly turn into rudeness; only towards a few old friends of his youth and some younger acquaintances he constantly shows himself warm-hearted and gentle; just as he always remains truly affectionate when writing to his son.

Cézanne's deepest grief was probably not that he felt himself misunderstood, firmly convinced as he was of slowly approaching his goal, but rather that the artistic realisation of his sensations proved to be so immensely difficult, for ever unsatisfactory to himself. For a long time Zola seems to have been the only one who understood this anxiety of his friend, equipped by fate with such exceptional gifts and so little inner peace. During an un-

6

interrupted period of more than thirty years Zola possessed Cézanne's full confidence and proved himself a friend capable of considerable sacrifices. This explains the fact that the letters to Zola represent nearly one-third of the whole correspondence. They are a worthy monument to Zola's unselfish friendship for Cézanne. Zola and some of the others to whom Cézanne wrote in those rare moments when he put his paintbrush aside, were the 'moral supports' of the lonely artist. To them he showed his true self, full of contradictions, but never banal; uncertain, but always convinced of the unchallengeable importance of Art; unpretentious and passionate, though sometimes confused and tortured.

This new edition not only presents to the English public a completely revised translation, but contains many more letters and documents than the first English edition of 1941. It has over 230 letters, 30 more than the first edition; in addition a number of extracts have been replaced by the complete documents. Among the letters discovered during the last 32 years, the most important group is the correspondence with Joachim Gasquet, once thought to be irretrievably lost. Several of the newly-added documents have so far never been published in English at all. A list of all publications in which letters by Cézanne were published for the first time is to be found on p. 11.

Even so, it was not possible to recover all of Cézanne's letters; many must be considered as lost for ever. Not a single letter to the friend of his youth, Baptiste Baille, for instance, has been found; the letters to other companions of his youth in Aix, like Antonin Valabrègue, Gustave Boyer and Joseph Villevieille are also lost, so are Cézanne's letters to Renoir and Guillaumin, as well as most of his

letters to Monet; only Camille Pissarro carefully preserved his friend's letters. In many cases, among them those of Marius Roux, Paul Alexis, Justin Gabet and Antoine Guillemet, only a single letter was discovered, although it is likely that Cézanne exchanged many more with them. Three letters to Achille Emperaire came to light a few years ago, but most of those addressed to this friend have also disappeared.

Cézanne's parents, his sister and his wife do not seem to have kept his letters and his son began to preserve them only during the last four months of his father's life. Cézanne himself has apparently thrown away all letters addressed to him, so that only a few have come to light again by mere chance; they are included for the sake of completeness. The one exception are Zola's long letters written at the time of their youth, which Cézanne preserved until his death; they are included in the edition of Zola's correspondence. In order to fill the gap caused by the loss of the letters addressed to Zola between 1858 and 1862, extracts from Zola's letters to Cézanne and to Baille are quoted here. For similar reasons the reader will find extracts from two articles which Gasquet published and sent to Cézanne. They have never been published in English before.

In order to make this volume as complete as possible, all letters and drafts known to me have been included; most of the drafts were found on the back of drawings or in sketchbooks.

The letters have been divided into three groups, corresponding to three clearly distinguishable periods in Cézanne's life. Each of these groups is preceeded by a short biographical text.

Almost all letters have been translated from the original. The translator met with considerable problems, because Cézanne's style often reads awkwardly; in a few cases even his meaning is not clear: Cézanne did not really like writing; he expressed with his brush what he wanted to say. Obviously the translator had to attempt, as far as possible, to render these peculiarities into English.

The letters from Cézanne's youth often contain more or less interesting rhymed passages. These, never meant seriously, have been left in the original French, but relegated to an Appendix, except where a verbatim rendering seemed necessary in the context.

It remains here to thank all those who have made it possible to bring together these often widely dispersed documents. First of all, I want to name the artist's late son, who gave permission for the publication of his father's letters and helped me in every way. Zola's children, the late Madame Denise Le Blond-Zola, and Dr. Jacques-Emile Zola, readily gave permission to copy the letters addressed to their father.

Cézanne's niece, Mlle Paule Conil, the late painter Charles Camoin and the writer Louis Aurenche put the letters addressed to them at my disposal and the same applies to the late Maurice Denis, Louis Le Bail, Emile Solari and Ambroise Vollard. Pissarro's children, Madame J. Delaistre, daughter of the painter Antoine Guillemet and Mr. Claude Roger-Marx brought the letters addressed to their fathers to my knowledge. The late Countess Ludolf, née Fabbri, and the late Madame Lutzviller, née Gabet, gave permission to publish the letters written to their brothers; Mr. A. Chardeau and the late Mr. Raimbault sent me the letters addressed to their fathers-in-law,

Gustave Caillebotte and Joseph Huot. Mr. Adrien Chappuis gave permission to copy the drafts of the letters to Octave Mirbeau and Marius Roux; the late Pierre Loeb I have to thank for the draft of the letter to the artist's parents and the late Madame Zak for the letter to a collector in Pontoise.

The Homehouse Trustees of the Courtauld Institute of Art in London allowed me to see the letters to Emile Bernard. Mr. P. B. Barth brought Cézanne's last letter to my knowledge; I am grateful to Mr. Geigi-Hagenbach for the letter to Paul Alexis and to the late painter Jules Joëts for the correspondence with Victor Chocquet (since checked against the originals and corrected where necessary), while the late Marcel Provence entrusted me with the letters to Numa Coste as well as the letter to Marthe Conil and the former Chief Curator of Paintings of the Louvre, Mr. Réné Huyghe, made it possible for me to get to know a letter to Théodore Duret and another to Ambroise Vollard.

I am grateful for the generous help given by Mr. Alfred H. Barr Jr., Gerstle Mack, Léo Marchutz and Fritz Novotny as well as by the late Marcel Arnaud, Edouard Aude, Gaston Bernheim-Jeune, George Besson, Félix Fénéon, Paul Gachet, Maurice Le Blond, Lucas Lichtenhan, Lucien and Ludovic Rodo Pissarro. For additional letters discovered after 1937, I am greatly obliged to Mr. Albert Chatelet, Jean Dauberville, Count Doria, Bruno Durand and Victor Nicollas as well as, once more, Mr. Adrien Chappuis.

JOHN REWALD

Letters by Cézanne and some letters addressed to him

appeared for the first time in the following publications:

E. Bernard: Souvenirs sur Paul Cézanne et lettres inédites, *Mercure de France*, 1 and 15 October 1907.

E. Zola: Correspondance; Lettres de Jeunesse, Paris, 1970. New edition: Correspondance 1858–71, with commentaries and footnotes by M. Le Blond, Paris, 1928.

A. Vollard: Cézanne, Paris, 1914.

Duret, Werth, Jourdain, Mirbeau: Cézanne, Paris, 1914.

G. Coquiot: Paul Cézanne, Paris, 1919.

J. Gasquet: Paul Cézanne, Paris, 1921.

G. Rivière: Le Maître Paul Cézanne, Paris, 1923.

G. Geffroy: Claude Monet, sa vie, son œuvre, Paris, 1924.

M. Provence: Cézanne chrétien, *Revue des Lettres*, December 1924.

L. Larguier: Le Dimanche avec Paul Cézanne, Paris, 1925.

J. Royère: Louis Leydet, *L'Amour de l'Art*, November 1925.

M. Provence: Cézanne et ses amis—Numa Coste, *Mercure de France*, 1 March 1926.

M. O. Maus: Trente années de lutte pour l'art, 1884–1914, Brussels, 1926.

D. Le Blond-Zola: Emile Zola, raconté par sa fille, Paris, 1931.

A. Germain: In memoriam E. P. Fabbri, Florence, 1934.

J. Joëts: Les impressionnistes et Chocquet, *L'Amour de l'Art*, April 1935.

G. Mack: Paul Cézanne, New York, 1935.

J. Rewald: Cézanne et Zola, Paris, 1936; 2nd enlarged edition: Cézanne, sa vie, son œuvre, son amitié pour Zola, Paris, 1939.

Catalogue of the Cézanne Exhibition, Musée de l'Orangerie, Paris, 1936 (2nd edition).

L. Venturi: Cézanne—son art, son œuvre, Paris, 1936.

J. Rewald and L. Marschutz: Cézanne et la Provence. *Le Point* (special edition), August 1936.

A. H. Barr Jr.: Cézanne d'après les lettres de Marion à Morstatt, *Gazette des Beaux-Arts*, January 1937.

M. Raimbault: Une lettre de Cézanne à Joseph Huot, *Provincia*, Bulletin de la Société de Statistique et d'Archéologie de Marseille, Fasc. 2, 1937.

P. Cézanne: Correspondance, recueillie, annotée et préfacée par J. Rewald, Paris, 1937.

L. Venturi: Les Archives de l'Impressionnisme, Paris, 1939.

V. Nicollas: Achille Emperaire, Aix-en-Provence, 1953.

J. de Beucken: Un portrait de Cézanne, Paris, 1955.

P. Gachet: Lettres impressionnistes au Dr. Gachet et à Murer, Paris, 1957.

M. Denis: Journal (1884–1904), Paris, 1957.

Künstler-Autographen von 1850–1950, Katalog Nr. 89, Gutekunst und Klipstein, Berne, 14 May 1958.

J. Rewald: Cézanne, Geffroy et Gasquet—suivi de Souvenirs sur Cézanne de L. Aurenche et de lettres inédites, Paris, 1959.

J. Rewald: Une lettre inédite de Paul Cézanne in *Festschrift D. H. Kahnweiler*, Verlag Gerd Hatje, Stuttgart, 1966.

A. Chappuis: Album de Paul Cézanne, Paris, 1966.

A few letters, which could not be copied from the originals, were taken from these publications.

CONTENTS

EARLY LETTERS
1858–70

Paul Cézanne was born at Aix-en-Provence on the 19th January, 1839, the son of a rich banker. In 1852 he entered the Collège Bourbon at Aix, where he at once became friendly with Emile Zola, who was a year younger than Cézanne and, although Parisian by birth, was educated at Aix. A sincere friendship united the two boys until, in 1858, Zola had to go to Paris with his mother, the young penniless widow of an Italian engineer. He continued his studies in Paris, always visiting Aix for the holidays. After his departure a lively correspondence was maintained between him and Cézanne, as well as with Baptiste Baille (1841–1918) who was the third of the 'inséparables', and later became a Professor at the Ecole Polytechnique.

To Emile Zola

Aix, 9 April, 1858

Good morning my dear Zola![a][1]

I have just seen Baille, this evening I am going to his country house (I'm talking about the older Baille) and so I am writing to you.[2]

Since you left Aix, my dear fellow, dark sorrow has oppressed me; I am not lying, believe me. I no longer recognize myself, I am heavy, stupid and slow. By the way, Baille told me that in a fortnight he would have the pleasure of causing a sheet of paper to reach the hands of your most eminent Greatness in which he will express his sorrows and griefs at being far away from you. Really I should love to see you and I think that I, we, shall see you, I and Baille (of course) during the holidays, and then we shall carry out, we shall complete those projects that we have planned, but in the meantime, I bemoan your absence.[3]

Do you remember the pine-tree which, planted on the bank of the Arc,[b] bowed its shaggy head above the steep

[a] Here follows a short doggerel. Raised numerals refer to the appendix where the complete French text of all poems included in the letters is given. Words or numbers in italics in the headings of letters are added by the editor.

[b] The Arc is a little river which runs through a wide valley near Aix where the three friends liked to bathe. Later, Cézanne often painted the view of this valley with the railway viaduct in the background, dominated by Mt. Ste.-Victoire.

slope extending at its feet? This pine, which protected our bodies with its foliage from the blaze of the sun, ah! may the gods preserve it from the fatal stroke of the wood-cutter's axe.

We think that you will come to Aix for the holidays and that then, *nom d'un chien*, then long live joy! We have planned hunts as monstrous and enormous as our fishing trips. Soon, my dear, we shall start to hunt fish again, if the weather holds; it is magnificent today, for I am finishing my letter on the 13th.[4-5]

<div align="right">

Paul Cézanne
Salve, carissime Zola

</div>

PS.—When you write, tell me if it is fine up there. Shall write again very soon. In future I shall not be so lazy.

Nota 1.—Bernabo, Leon with bambou (?) and Alexandre are, so I am told, at the collège, the Lycée (I don't know what kind of a trap that is) Ste. Barbe in Paris. As for the other two individuals aforesaid I shall make inquiries and give you the address in one of my next letters. (This one is riddled with nonsense.) If you should see the Bernabos, remember me to them.

Nota 2.—I received your letter in which were the affectionate doggerels that we had the honour of singing with the bass Boyer[a] and the light tenor Baille.

[a] Gustave Boyer, boyhood friend of Cézanne and Zola; Cézanne painted several portraits of him. He later became a notary in the neighbouring town of Eyguières.

To Emile Zola

<div align="right">Aix, 3 May, 1858</div>

Drawing of a rebus.[6]

(*The solution reads: One should love women.*)

Are you well? I am very busy, *morbleu*, very busy. This will explain the absence of the poem you asked me for. I am, you can be sure, most penitent not to be able to reply with a verve, a warmth, a spirit equal to yours. I love the principal's savage face! (The one in your letter, I mean, there must be no mix-up). By the way, if you guess my fabulous rebus, just for fun, write to me what I intended to say. Do one for me, *si tempus habes.*

I gave Baille your letter. I also gave Marguery[a] his.— Marguery is as dull as ever.

And now the atmosphere is suddenly cooler. Goodbye to swimming.[7]

I am sitting opposite Boyer at this moment in my room on the second floor. I am writing in his presence and I order him to add a few words to this letter in his own hand:[8]

Added in Boyer's handwriting:

I warn you that when on your return you come to visit Cézanne, you will find on the wallpaper of his room a large collection of maxims taken from Horace, Victor Hugo, etc.

<div align="right">*Boyer, Gustav*</div>

My dear, I am studying for the matric. Ah! If I had

[a] Louis-Pascal-Antoine Marguery (1941–81), boyhood friend of Cézanne and Zola, wrote novels and vaudevilles, of which neither Zola nor Cézanne thought very highly. He later became a solicitor at Aix.

matric, if you had matric, if Baille had matric, if we all had matric. Baille at least will get it, but I: sunk, submerged, done for, petrified, extinguished, annihilated, that is what I shall be.[a]

My dear, today is the 5th of May and it is raining hard. The sluice-gates of heaven are half open.[9]

Water two feet high runs through the streets. God, irritated by the crimes of the human species, has no doubt decided to wash away their numerous iniquities by this fresh deluge. For two days this horrible weather has lasted. My thermometer is 5 degrees above zero and my barometer indicates heavy rain, tempest, hurricane for today and all the rest of the quarter. All the inhabitants of the town are plunged in deepest gloom. Consternation can be read on every face. Everyone has drawn features, haggard eyes, a frightened expression and presses his arms against his body as if afraid of being bumped in a crowd. Everyone goes about reciting prayers; at the corner of every street, in spite of the beating rain, groups of young maidens are to be seen who, no longer thinking of their crinolines, cry themselves hoarse hurling litanies to the heavens. The town re-echoes to their indescribable uproar. I am quite deafened by it. I hear nothing but *ora pro nobis* resounding on all sides. I myself have let the impudent doggerels and the atrocious hallelujahs be followed by some pious *pater noster* or even *mea culpa, mea culpa ter, quater, quinter mea culpa*, thinking, by an auspicious return, to make the very august trio who reign above, forget all our past iniquities.

[a] These presentiments of Cézanne's were not entirely without justification. He did fail his first examination and only passed a few months later. Baille, however, passed and began to study natural science at Marseille.

But I notice that a change, for evermore sincere, has just calmed the anger of the Gods. The clouds are disappearing. The luminous rainbow shines in the celestial vault. Adieu, adieu.

<div align="right">P. Cézanne</div>

To Emile Zola

<div align="right">Aix, 29 . . . 1858.</div>

My dear,

It was not only pleasure that your letter gave me; receiving it brought me a higher sense of well-being. A certain inner sadness fills me, and, dear God, I only dream of the woman I told you about. I don't know who she is, I see her passing sometimes in the street when going to my monotonous college. I am so smitten that I heave sighs, but sighs that do not betray themselves outwardly, they are mental or spiritual sighs.

That poetic piece you sent me has given me great pleasure, I loved to see that you remembered the pine-tree which shades the river-banks of Palette.[a] How I should like, cursed fate that separates us, how I should like to see you coming. If I did not restrain myself I should hurl long strings of litanies of 'Good God', 'God's brothel'; 'damned whores' etc. to heaven; but what's the use of getting in a rage? That won't get me anywhere, so I resign myself.—Yes, as you say in another piece no less poetic (though I prefer your piece about swimming) you

[a] Palette is a little village on the banks of the Arc near the main road from Nice.

are happy, yes *you* are happy, but I, miserable wretch, I am withering in silence, my love (for it is love that I feel) cannot find an outlet. A certain ennui accompanies me everywhere, and only for a moment do I forget my sorrow: when I have had a drop to drink. But then I have always loved wine, and now I love it even more. I have got drunk; I shall get drunk still more, unless by some unexpected luck, hey ho, I should succeed, *nom d'un Dieu!* But no, I despair, I despair, and so I shall grow a tougher hide.

My friend, I am unfolding before your eyes a picture[a] representing:

Cicero
striking down Cataline
after having discovered the conspiracy
of that dishonourable citizen.[10]

But this should be enough to reveal to you the incomparable beauties of this admirable water-colour.

The weather is improving but I am not too sure whether it will go on. What is sure is that I am burning to go :[11]

As a daring diver
Ploughing through the liquid waters
of the Arc
And in this limpid stream
Catch the fish chance offers me.
Amen! Amen! These verses are stupid
They are not in good taste
But they are stupid
And worth nothing.
Good-bye, Zola, Good-bye.

a The following poem was illustrated by a water-colour.

I see that after my brush, my pen can say nothing good and today I should attempt in vain:[12]

> To sing to you of some forest nymph
> My voice is not sweet enough
> And the beauties of the countryside
> Whistle at those lines in my song
> That are not humble enough.

I am going to stop at last, for I am doing nothing but heap stupidity on absurdity.[13]

<div align="right">P. Cézanne</div>

ZOLA[a] TO CEZANNE

<div align="right">Paris, 14 June, 1858.</div>

My dear Cézanne,

. . . I have already plunged my body into the waters of the Seine . . . But there one finds no age-old pine tree, no fresh spring where one can cool the divine bottle, there is no Cézanne with his great imagination, his lively and piquant conversation. So, A fig for the Seine! I cried to myself, and long live the *gourre de Palette* and our heavenly parties on the banks nearby.

Paris is big, full of amusements, of monuments, of charming women; Aix is small, monotonous, petty, full of women . . . (The good God forbid that I should slander the women of Aix). And, in spite of all that, I prefer Aix to Paris.

[a] Zola, born in April 1858, was at that time in the sixth form of the Lycée St.-Louis in Paris; he was already dreaming of a career as a writer and poet.

Is it because of the trees swaying in the breeze, because of the wild gorges, the rocks piled on top of each other like Pelion on Ossa, is it the picturesque landscape of Provence which draws me there? I do not know; yet my poet's dreams tell me that a rough rock is worth more than a freshly white-washed house, the murmur of the waters more than that of a big town, virgin nature more than nature starched and tormented. Is it rather because of the friends I have left behind down there in the land of the Arc, who call me back to the country of bouillabaisse[a] and aioli? That is certainly it . . .

. . . Really I'm enormously serious today. You must forgive me these platitudinous reflections; but, you see, if one begins to examine the world from close by, one realises that it is badly put together and one can't help philosophising a little. To the devil with reason and long live joy! What has happened to your conquest? Have you talked to her?

Ah! you rascal, you would be quite capable of it. Young man, you are going to lose yourself, you are going to commit follies, but I shall soon arrive to put a stop to that. I do not want my Cézanne to be debased.

Do you swim? Go on the binge? Do you paint? Do you play your cornet? Do you write poetry? All together, what do you do? And your finals? Do they roll on? You will sink all the masters. Ah! to the devil, we shall enjoy ourselves well, I have enormous ideas. It is something gigantic, you will see . . .

If you have time, send me a few nice poems.

[a] Two national Provençal dishes; bouillabaisse is the famous fish soup and aioli a dish of dried cod, potatoes, carrots and artichokes with a sauce of olive oil and garlic.

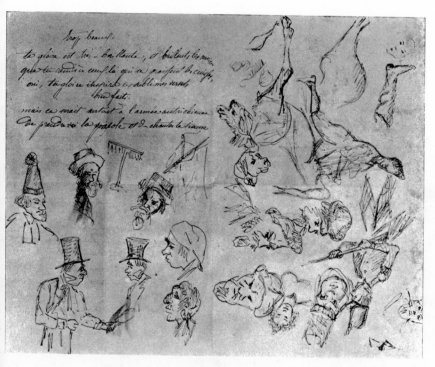

2. Drawing from the Letter to Zola, July 1858

That diverts my mind and at the same time gives me pleasure. As far as I am concerned, I have been dead to poetry for some time ...

See you soon,

Your devoted friend.

To Emile Zola

Aix, 9th July, 1858

Carissime Zola, Salve
Accepi tuam litteram, in qua mihi dicebas
te cupere ut tibi rimas mitterem ad bout-rimas[a]
faciendas, gaude; ecce enim pulcherrimas rimas.
Lege, igitur, lege et miraberis!

révolte	Zola	métaphore	brun
récolte	voilà	phosphore	rhum
vert	bachique	boeuf	aveugle
découvert	chique	veuf	beugle

chimie	uni	borne
infamie	bruni	corne

The above-mentioned rhymes you have the freedom, *primo* to put them into the plural, if your most serene Majesty shall judge it expedient; *secundo*, you can put them in any order you please; but *tertio*, I demand of you alexandrines, and finally *quarto*, I want—no, I do not want—I beg you to put everything into verse, even Zola.

[a] Bouts-rimés are poems with fixed end-rhymes, of which the friends often sent whole lists to each other.

Here are some little verses of mine which I find admirable, because they are by me—and the very good reason is that I am the author.[14]

> Zola the swimmer
> Strikes fearlessly
> Through the limpid water.
> His sensitive arms
> Are spread joyously
> In the soft fluid.

It is very misty today. Listen, I have just made up a couplet—here it is:[15]

> Let us celebrate the sweetness
> Of the divine bottle,
> Its incomparable goodness
> Warms my heart.

This must be sung to the tune: *"D'une mère chérie célébrons la douceur,"* etc.

My dear, I do really believe that you are sweating when you tell me in your letter[16]

> That your brow bathed in sweat
> Was enveloped by the learned vapour
> Which exhales as far as me horrible geometry.
> Do not believe that vilification
> If I qualify
> So does Geometry!
> In studying it I feel my whole body
> Dissolving in water under my only too impotent efforts.

My dear, when you have sent me your bout-rimé[17] I shall set about hunting for other rhymes both richer and

more distorted; I am preparing, I am elaborating—I am distilling them in my cerebral retort. They will be new rhymes—heum—rhymes such as one seldom sees, *morbleu*, in a word, accomplished rhymes.

My dear, having started this letter on the 9th July, it is right, at least, to finish it today, the 14th, but alas, in my arid mind, I do not find the least little idea, and yet, with you, how many subjects would I have to discuss, hunting, fishing, swimming, what a variety of subjects there, and love (*Infandum*, let us not broach that corrupting subject):[18]

> Our soul still pure,
> Walking with a timid step,
> Has not yet struck
> The edge of the precipice
> Where so often one stumbles
> In this corrupt age.
> I have not yet raised
> To my innocent lips
> The bowl of voluptuousness
> From which souls in love
> Drink to satiety.

Here's a mystical tirade, hum, you know it seems to me that I see you reading these soporofic verses, I see you (although it is rather a long way), shaking your head and saying: "It doesn't exactly roar with him, the poetry . . ."

Letter finished on the 15th in the evening.[19]

SONG IN YOUR HONOUR!

> Here I sing as if we were together surrendering
> To all the joys of human life.

27

It is as it were an elegy,
It is vaporous, you will see.
In the evening seated on the side of the mountain,
My eyes straying over the distant countryside
I murmured to myself,
When, great Gods, will a companion appear
To deliver me from the misery of all the pain
That overwhelms me today?
Yes! she will seem to me
Dainty, pretty, like a shepherdess,
Sweet charm, a fresh round chin,
Rounded arms, shapely legs
With a trim crinoline,
And a shape divine,
And lips of carmine.
Digue, dinguedi, dindigue, dindin
Oh! oh! the pretty chin.

I am going to stop at last, for I see that I am not really in the mood, alas![20]

Alas oh Muses! Weep, for your foster-child
Cannot even make up a short song.
Oh matric, terrible exam!
Examiners, oh horrible faces!
Were I to pass, oh joy indescribable.
Great Gods, I really don't know what I should do. Goodbye, my dear Zola, I keep rambling.

 Paul Cézanne

I have conceived the idea of a drama in 5 acts, which we shall entitle, (you and I): 'Henry VIII of England'. We will do it together in the holidays.

To Emile Zola

<p align="right">Aix, 26th July, 1858</p>

Meine liebe (sic) Freund,[a]

It is Cézanne who writes, but it is Baille who dictates. Muses! descend from Helicon into our veins to celebrate my baccalaureatical triumph. (It is Baille who speaks, it will not be my turn until next week).

In Baille's handwriting:

This bizarre originality is quite in keeping with our characters. —We are going to give you a pile of riddles to guess, but Fate has decided differently. I came to see the poetic, fantastic, jovial, erotic, antique, physical, geometrical friend of ours; he had already written on the 26th July, 1858, and was waiting for an inspiration.—I gave him one. I wrote the address in German; he was going to write at my dictation and pour out in profusion, together with the figures of his rhetoric, the flowers of my geometry (permit me this transposition—else you might have thought that we were going to send you triangles and other similar things). But, my dear, the love that lost Troy still causes much harm; I have grave suspicions, believing that he is in love. (He does not want to admit it).

My dear, it is Baille who, in a bold hand (oh, vain spirit), has just traced these perfidious lines, his mind never conceives of any others. You know him well enough, you know his folly even before he submitted to the terrible examination, how could he not be foolish now? What burlesque and misshapen ideas are being hatched in his malignantly mocking mind. You know, Baille is *bachelier ès-sciences* and on the 14th of next month

[a] Written in German.

he is sitting for his *bachelier ès-lettres*. As for me, I sit on
the 4th August; may the all-powerful Gods preserve me
from breaking my nose in my fall, which is, alas, to come.
I swot, great Gods, I break my head over this abomin-
able work.[21]

> I tremble when I see all the geography
> History, latin, greek and geometry
> Conspiring against me: I see them, menacing,
> These examiners with the piercing stare
> Which brings confusion to my very soul.
> My fear each moment is horribly doubled
> And I say to myself: Lord, all these enemies
> United here shamelessly to bring about my certain
> downfall
> Disperse thou them, confound the entire pack.
> To be sure this prayer is not too charitable—
> But forgive me, have pity, oh Lord
> I am a pious servant at your altar. . . .

What a ludicrous digression! What do you say to it?
Isn't it totally misshapen? Ah! If I had the time you would
have to swallow many another. By the way, a little later I
shall send you your *bouts-rimés*. Send up a prayer to the
Almighty (*Altissimo*) that the Faculty may decorate me
with the much-coveted title.

Added in Baille's handwriting:

*My turn to continue. I am not going to make you gulp down
verses. I have scarcely anything more to say to you, except that we
are all waiting for you: Cézanne and me, me and Cézanne. We are
swotting while we wait. Come then: only I shall not go hunting
with you: let that only be understood; I shall not hunt, but I shall*

accompany you.—After all! We shall still be able to have some good outings: I shall carry the bottle, I; although that is the heaviest! This letter has already bored you: it is made for that: I don't mean, it was with that intention that we made it.

Give our respects to your mother (I say our for good reason: the Trinity is but a single person).

We clasp your hand. This letter is from two originals.

<div align="right">

Bacézanlle

</div>

You see in this letter the work of two originals.

My dear, when you come, I shall let my beard and moustache grow: I await you *ad hoc*. By the way, have you a beard and moustache? Goodbye, my dear, I don't understand how I can be so stupid . . .

Zola spent the holidays with his friends in Aix. On the 12th November, 1858, Cézanne was at last made bachelier ès-lettres with the classification "assez bien". A letter of November 14th in which he announced this event to Zola seems to be lost.

To Emile Zola

<div align="center">

Aix, Wednesday, 17 November, 1858.

</div>

Work, my dear, *nam labor improbus omnia vincit.*[a]

Excuse, friend, excuse me. Yes, I am guilty. However, for all sins, forgiveness. Our letters must have crossed, tell me when you next write—there is no need to put yourself out for that—if you did not receive a letter dated from my chamber, rhyming with the 14th November?

I am waiting for the end of the month so that, when

[a] "Because hard work overcomes everything."

you send me another letter, you can give me the title for a *longissime* poem that I want to make up and about which I wrote to you in my letter of November 14th, which you can see, if you get it; if not, I can hardly explain its non-arrival, but, as nothing is impossible, I hasten to write to you. I passed my matriculation, but you must know that from this same letter of the 14th, always providing that it reached you.[22]

I wrote to Baille to give him the news, and to announce irrevocably and finally that I have passed matric. Heigh-ho![23-24]

P. Cézanne

After having passed his examination Cézanne was forced by his father to follow the course in law at Aix University, where he was registered that year.

To Emile Zola

Aix, 7 December, 1858.

My dear,

You did not tell me that your illness was serious, very serious.—You should have informed me; Monsieur Leclerc told me instead, but since you are well again, greetings!

After having wavered for some time—for I must confess that this *pitot*[a] was not at all to my liking at first—I finally decided to treat him as pitilessly as possible. And so I am setting to work, but faith, I do not know my mythology; however, I shall see to it that I get to know the exploits of master Hercules and shall convert them

[a] A term used in Provence for a young urchin.

into heroic deeds of the *pitot* as far as this can be done. I must tell you that my work—if it is worthy of the name of work rather than mess—will for a long time be elaborated, digested, perfected by me, for I have little time to devote to the adventurous recital of the Herculean *pitot*.[25]

Alas I have chosen the tortuous path of Law.
—I have chosen, that's not the word, I was forced
 to choose!
Law, horrible Law of twisted circumlocutions.
Will render my life miserable for three years.
Muses of Helicon, of Pindus, of Parnassus,
Come, I beg you, to soften my disgrace.
Have pity on me, on an unhappy mortal,
Torn against his will away from your altar . . .

Did you not say on hearing, no on reading, these insipid verses that the muse of poetry has withdrawn from me for ever? Alas, this is what the accursed law has done.[26]

Find out about the entrance exam for the *Académie*, because I persist in the intention which we had formed to compete at any price[a]—provided it doesn't cost anything, of course.[27]

Hercules one day slept deeply
In a wood, for the freshness was good,
For really, had he not been in a charming grove,
And if he had exposed himself to the glare
Of the sun darting its hot rays,
Perhaps he would have had a terrible headache;
Well he was sleeping very deeply. A young dryad
Passing quite close to him . . .

[a] Apparently Cézanne intended to take part in the entrance examination to the Académie des Beaux-Arts in Paris.

But I see I was about to say something stupid, so I hold my peace. Permit me to finish this letter, as stupidly finished as begun.

I wish you a thousand and one good things, joys, pleasures; goodbye, my dear, greetings to monsieur Aubert, to your parents; goodbye, I salute you.

Your friend,

Paul Cézanne

PS. I have just received your letter, it gave me great pleasure; but I beg of you in future to use thinner paper, for you bled my purse in a manner that did it much harm. Ye gods, those monsters of postal administrators made me pay eight sous. I should have had enough to send you two more letters. Therefore do use a bit thinner paper.

Goodbye, my dear.

Poem By Cezanne

Written on the back of an undated drawing, now in the Museum in Basle.[28]

Zola to Baille

Paris, 14th January, 1859

(*Extract*)

... Cézanne, who is not as lazy as you (perhaps I should say: not as busy), has written me quite a long letter.[a] Never have I seen him so much a poet, never have I seen him so much in love, so much that, far from turning

[a] This letter is apparently lost.

him away from this platonic love, I have encouraged him to persist. He has told me that at Christmas you tried to bring him back to be realistic in love. Once I shared this opinion, but now I believe that this is a plan unworthy of our youth, unworthy of the friendship we feel for him. I have answered him at length,[a] advised him to love always and tried to convince him with reasons which I cannot here explain to you. Should you have turned apostle of realism, should the advice which you gave to Cézanne not be dictated by your friendship towards him, should you too be despairing of love, I strongly suggest to you that, as soon as possible, you should read my answer to Cézanne; and I hope that, if you do, this will rejuvenate your heart, which is drowned in algebra and mechanics. I shall even copy here for you some of the lines which I intend presently to send to Cézanne.[a] They are addressed to him, but concern you just as much. Here are these lines:

"In one of your last letters I find the following sentence: 'Love as described by Michelet,[b] pure, noble love, may well exist, but it is very rare, admit it.' Not as rare as you may believe, and this is a point which I forgot to discuss in my last letter to you.[c] There was a time when I said the same, when I made fun of people who talked about purity and fidelity. This was not even so very long ago. But I have thought things over and I believe I have discovered that our century is not as materialistic as it pretends to be. We behave like young college dropouts who quarrel among themselves to find out who has com-

[a] These letters are apparently lost.
[b] This refers to Michelet's book *L'Amour*, published in 1858.
[c] This letter also seems to have been lost.

mitted the greatest misdeed; we boast about our conquests with as much egoism as possible and blacken ourselves to see who can go one better. We pretend to turn up our noses at anything sacred; but if we thus play with the altar vessels, straining to prove to everybody how worthless we are, we do this, I believe, rather from self-love than from innate depravity. The young ones especially have this pride and because love, if I dare say so, is one of the most beautiful qualities of youth, they rush to confess that they do not love, that they rummage in the filth of vice. You have gone through that phase and you must know it. He who at school would admit to a platonic love—that is to say, to something sacred and poetical—wouldn't he be treated as mad? . . ."

To Emile Zola

Aix, 17th January, 1859

The letter begins with a drawing 'La Mort règne en ces lieux.' A dialogue in verse follows.[29-30]

. . . But I note, dear friend, that for fifteen days
Our correspondence has slackened its course.
Is it, by chance, that boredom devours you,
Or has some bad cold taken hold of your brain
And confined you, in spite of yourself, to your bed? And
 your cough,
Does it worry you? Alas it's not pleasant
But yet better than many another ill.
Perhaps it is love that slowly devours your heart?
Yes? No? By faith, I don't know
But if it was love, I should say that is good.

For love, I strongly suspect, has killed no man;
Perhaps, by chance, it gives us at times
Some little torment, some little sorrow,
But if it comes today, it is gone tomorrow . . .

Now, it's several days since I wrote what you find above.
I said to myself, just like that, I don't know of anything
good to tell him, so I must wait a little before sending
him my letter, but there it is, I am in trouble, seeing that
in no way do I receive news from you. Upon my word,
sacrebleu, I have invented hypotheses, even the most imbe-
cile, regarding this keeping of silence. Perhaps, I thought,
he is occupied with some *immensissime* work, perhaps he is
lucubrating some vast poem, perhaps he is preparing
some really unsolvable riddles for me, perhaps he has
even become the editor of some feeble newspaper; but
all these suppositions do not tell me in reality *quod agis,
quod bibis, quod cantas, quomodo te ipsum portas*, etc.; I could
bore you much longer, and you could, in your wrath,
exclaim with Cicero: *Quosque* (sic!) *tandem, Cézasine,
abuteris patientia nostra?* To which I should reply that in
order not to be bored you must write to me as soon as
possible, unless there is a serious hindrance. *Salut omnibus
parentibus tuis, salut tibi quoque, salve, salve.*

<div align="right">Paulus Cézasinus</div>

To Emile Zola

<div align="right">*Aix*, 20 June, 1859</div>

My dear,
Yes, my dear, it is really true what I said in my previous
letter. I tried to deceive myself, by the dime of the pope

and the cardinals, I have had a passionate love for a certain Justine who is really 'very fine',[a] but as I have not the honour to be 'of a great beautiful'[a] (sic!), she always turned her head away from me. When I cast my peepers towards her, she dropped her eyes and blushed. Now I thought I noticed that when we were in the same street, she made as it were a half-turn and dodged away without looking back. *Quanto à della donna* I am not happy, and yet I must say that I risk meeting her three or four times a day. And better still, my dear: one fine day a young man accosted me, he is a first-year student like myself, it is in fact Seymard, whom you know. "My dear," he said, taking my hand, then hanging himself on my arm and continuing to walk towards the rue d'Italie: "I am"—he continued—"about to show you a sweet little thing whom I love and who loves me." I confess that instantly a cloud seemed to pass before my eyes, I had, as it were, a presentiment that I didn't have a chance, and I was not mistaken, for, midday having just struck, Justine emerged from the salon where she works, and upon my word, the moment I caught sight of her in the distance, Seymard gave me a sign: "There she is," he said. At this point I saw nothing more, my head was spinning, but, Seymard dragging me along with him, I brushed against the little one's frock. ...

Nearly every day since then I have seen her and often Seymard was following in her tracks . . . Ah! what dreams I have built up, and the most foolish ones at that, but you see, it's like this: I said to myself, if she didn't detest me we would go to Paris together, there I would make myself into an artist, we should be together. I said to myself, like that, we should be happy. I dreamt of pictures, a

[a] Written in English.

38

studio on the fourth floor, you with me, then how we should have laughed! I didn't ask to be rich, you know what I'm like, me, with a few hundred francs I thought we could live contentedly, but by God, that was a great dream, that one, and now I who am so lazy, I am content only when I have had something to drink; I can scarcely go on, I am an inert body, good for nothing.

My word, old man, your cigars are excellent; I am smoking one while writing to you; they have the taste of caramel and barley sugar. Ah! but look, look, here she is, she, how she glides, she sways, yes, it is my little one, how she laughs at me, she floats on the clouds of the smoke, see, see; she rises, she falls, she frolicks, twirls round, but she is laughing at me. Oh, Justine, tell me at least that you do not hate me; she laughs. Cruel one, you enjoy making me suffer. Justine, listen to me, but she is fading away, she climbs, climbs, always climbs until at last she vanishes. The cigar falls from my mouth, and thereupon I fall asleep. For a moment I thought I was going mad, but thanks to your cigar, my mind is reasserting itself, another ten days and I shall think of her no longer, or else I shall see her only on the horizon of the past as a shadow of which I dreamed.

Oh dear! with what infinite joy would I clasp your hand. You see, your mamma told me that you would be coming to Aix towards the end of July. You know, if I had been a good high-jumper, I should have hit the ceiling, I jumped so high. Because really, for one instant I did think I was going mad, it was night, it was evening, and I thought I was going mad, but it was nothing, you understand. Only I had drunk too much and so before my eyes I saw spirits swaying round the tip of my nose,

dancing, laughing, jumping about, enough to smash everything.

Goodbye, dear boy, goodbye,

P. Cézanne

On the back of the last sheet there is a drawing of a group of bathers.

To Emile Zola

Aix, beginning of July, 1859

My dear Zola,[31]
You will say perhaps: Oh! my poor Cézanne
What female demon has upset your brain?
You whom of old I used to see
Walking with a firm step
Doing nothing good, saying nothing bad?
. .
Have you never seen in hours of reverie
Graceful forms, as it were, in a mist,
Nebulous beauties whose ardent charms,
Dreamt of at night, are unseen by day?
. .
My dreams disappearing reality comes
Which finds me groaning, my heart heavy within,
And I see before my eyes a phantom arise,
Horrible, monstrous, it's the LAW as it's called.

I think I did more than dream; I fell asleep, and I must have frozen you with my platitudes, but I dreamt that I held her in my arms, my Lorette, my Grisette, my darling, my saucy imp, that I patted her buttocks, and other things besides . . .[32]

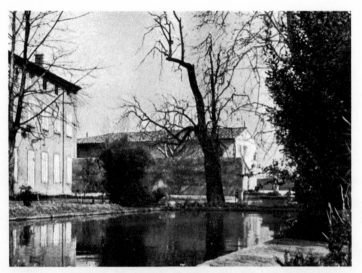

3. The 'Jas de Bouffan', with the large Fountain
Photograph

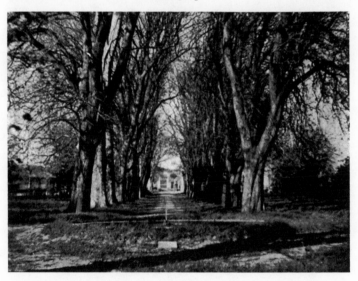

4. The Chestnut Tree Avenue in the 'Jas de Bouffan'
Photograph

Baille told me that the students, your fellow-workers, stupidly enough, God knows, looked as if they wanted to criticize your '*pièce à l'Impératrice*'. That raised my bile, and although it is rather late I am still hurling this harangue at them, the terms of which are all too feeble to characterize these boasting, abortive, literary penguins, these asthmatic mockers of your honest rhymes. If it seems right to you, pass my compliments to them, and add that, if they have anything to say, I am here awaiting them all, as many as there may be, ready to punch the first who comes within reach of my fist.

This morning, 9th July, at 8 o'clock in the morning.

I saw Monsieur Leclerc who told me that the youngest daughter M., formerly the prettiest, was cankered from head to foot and about to breathe her last on the hospital stretcher. Her mother, who has also squinted too much with her behind, moans over her latest blunders, and finally the elder of the two girls, that is the one who was formerly the ugliest and is even more so now, having carried on too much, now carries a bandage.

Your friend, who drinks vermouth to your health, Paul Cézanne. Goodbye to all your relations and also to Houchard.

To Emile Zola

Aix, towards the end of September, 1859

Baille[33] does not write to you, dear Zola, for he fears
That his mind will cause you a sudden confusion.
So fearing that you will not understand him,
He gives me free reign to write to you today.

41

So I sit in his room and it is at his desk
That I write these verses sprung from my brain.
None will claim them, I think, they are really too dull.
However, below, I shall show you some verses
That we were at great pains to compose in your honour:
'Le suif' is the name of this ode
Which scorns the code of poetic art.[34]

Here follow two sheets of sketches. The following passage is in Baille's handwriting:

"Come quickly, come quickly, dear boy.

Cézanne has had the cheek to go to . . . [illegible word]. He intends spending eight days there. He left this letter on my table and I am sending it to you.—Come quickly, come quickly, the excursions are fantastic: you can't even begin to imagine them. Goodbye, à bientot.—Write to us about your result[a], your departure, your arrival."

Baille

To Emile Zola

Aix, 30th November, 1859

I

My dear,[35]

If I am late
In giving you in rhyme
The final result

[a] This certainly refers to the Baccalaureat for which Zola had entered in 1859; he passed the written examination, but failed his aurals in German, History and Literature. During his holiday in Aix, Zola prepared once more to sit at Marseille, where, however, he even failed the written test.

Of my ferocious examination,
Which caused me great worry,

it is because (I am not in the mood) my exam was post-poned from Friday to Monday the 28th; however, I've passed.[36-7]

II

'La Provence' will soon in its columns bring
Feeble Marguery's insipid tale.
At this fresh disaster, Provence, you tremble
And the chill of death has frozen your blood.[38]

III

Here follows a long rhymed dialogue between J. B. Gaut, the editor of the weekly 'Le Memorial d'Aix' and the spirits who inspire him. It concerns a novel by Marguery, mutual friend of Cézanne and Zola, about to be published in the rival paper 'La Provence'. There is a lot of talk about the bad taste of this kind of literature, while at the same time Gaut is characterized as extremely self-satisfied and arrogant. Cézanne puts into Gaut's mouth a number of composite words made up from Latin, Greek and French roots, which he explains at the end in a descriptive 'dictionary' of Gaut's language.

My dear, I have now bored you sufficiently, permit me to bring to an end this stupid epistle, carissime Zola, salve. Greetings to your relations, to everyone, from your friend

P. Cézanne

I shall write to you when anything new occurs. Up to now the normal and habitual calm continues to enclose with its sulky wings our dull city.

Ludovico is still a writer full of fire, impetus and imagination.

Good-bye, my dear, good-bye.

To Emile Zola

Dear friend,[39-40]

CHARADE[41]

Mon premier fin matois à la mine trompeuse
Destructeur redouté de la classe rongeuse,
Plein de ruse, a toujours sur les meilleurs fricots
Avec force impudeur, prélevé des impôts.
Mon second au collège avec de la saucisse
De nos ventres à jeun faisait tout le délice.
Mon troisième est donné dans l'indigestion
Et pour bien digérer. L'anglaise nation
Après un bon souper, chaque soir s'en régale;
Mon entier est nommé vertu théologale.
(Solution: chat-riz-thé—Charité.)

Your friend who wishes you *bonnam valitudinem*.

Paul Cézanne

My dear, I have not been able, nor has Baille, to guess your riddle—which really is one; in your next letter tell me the word.

With regard to my charade I don't think I shall have such trouble. Greetings to your family.

P. Cézanne

EXTRACTS FROM EMILE ZOLA'S LETTERS
1859-60

Cézanne's letters to Zola from the end of 1859 to 1862 seem to be lost, but the following extracts from Zola's letters to Cézanne and Baille help to fill the gap.

Zola to Baille

<p align="right">Paris, 29 December, 1859</p>

... You will see Cézanne one of these days. I only wish that together you could for a moment forget the time which is sometimes so slow in passing. . . . you have firmly promised me to come to Paris next year and I count on you. I could see you at least twice a week and that would divert me a little. If that devil of a Cézanne could come we might take a small room for two and lead a Bohemian life. So we would at least spend our youth in the right way, while now we go sour, one like the other. Tell him (Cézanne) that I shall answer him one of these days . . .

Zola to Cezanne

<p align="right">Paris, 30 December, 1859.</p>

My dear friend,

I would like to answer your letter but I don't know what to tell you. I have four blank pages in front of me and not the slightest bit of news to report. Never mind, I am pushing my pen and I tell you beforehand that I shall not be responsible for the platitudes and orthographic mistakes it may commit. What are you doing, you two? I, being bored here, sometimes believe that you may be amusing yourselves down there. But when I think about it seriously, I believe that things are the same everywhere and that in these days gaiety is very rare. Then I feel sorry for you, just as sorry as I feel for myself and I ask heaven for a gentle dove, I mean an *amour*. You can't imagine

<p align="center">45</p>

what has been going through my head for some time. To
you who won't laugh at me, to you I shall confide it.
You certainly know that Michelet in *L'Amour* does not
begin his book until after the marriage, only talking about
the married couple, but not about the lovers. Very well
then, I, the nonentity, intend to depict blossoming love
and treat it up to marriage. You can't imagine the diffi-
culties of such an undertaking: three hundred pages to
fill with hardly any plot—a kind of poem for which I have
to invent everything and where everything is directed
towards one single goal: love! And what's more, as I
tell you, I have never loved, except in a dream, and have
never been loved, not even in a dream! Never mind, as I
feel myself capable of a great love, I shall ask my heart, I
shall create for myself some beautiful ideal and then
perhaps I shall accomplish my project. In any case if I
write this book, I shall not begin before the days are fine.
Should it seem to me worthy of publication, I shall tell
you, who could perhaps write it better than I, if you
wrote at all, you, whose heart is younger and more loving
than mine ...

Forgive me if my thoughts are somewhat confused.
We shall not talk politics; you never read the papers as I
allow myself to do, and you would not understand what
I want to tell you. I will only tell you that the Pope is
rather uneasy at the moment and suggest that you some-
times read *Le Siècle* because these are very strange times.
What can I add in order to end this letter happily? Shall I
encourage you to storm the barricades?[a] Or shall I talk
about painting and drawing? Damned barricades,

[a] This probably refers to the law examination, which Cézanne was
about to take.

46

damned painting! The one has to stand the test of the canons, the other is crushed by the paternal veto. When you charge the wall, your diffidence shouts at you: "You won't get very much further!" When you take up your brushes: "My son, my son," says your father, "think of the future. One dies with genius, and one eats with money." Ah! unfortunately, my poor Cézanne, life is a billiard ball which does not always roll where the hand would like to push it ...

As you have translated Virgil's Second Eclogue, why not send it to me? Thank God, I am not a young girl and I shall not be shocked ...

ZOLA TO CEZANNE

Paris, 5 January, 1860

My dear Cézanne;

I have received your letter ... You ask me to tell you about my mistresses: my loves exist only in my dreams. My follies are, to light my stove in the morning, to smoke my pipe and to think about what I have done and what I shall do. You see that they are not very costly and that I shall not harm my health thereby. I haven't seen Ville-vieille[a] yet; I shall pass on to him your commission for the passe-partout at the first opportunity ...

You say you have read my story in the paper. I am very much afraid that it hasn't been any better understood than the other one, '*Mon Follet*' ...

[a] Joseph-François Villevieille (1829–1915), a painter from Aix and pupil of Granet, used to advise Cézanne, who was ten years younger, and allowed him to work in his studio.

47

You probably know that I am anything but a favourite of the goddess Fortuna; it has been worrying me for some time that I, a big fellow of twenty, am still a burden to my family. I have, therefore, decided to take steps in order to earn the bread I eat. I intend, within a fortnight at most, to enter the Harbour Administration.[a] As you know me and understand how much I love my freedom, you can well imagine that I have to force myself to take this decision. But I would think it rather mean, were I not to do this. I shall still have a lot of time myself and shall be able to dedicate myself to work which pleases me. Anyway, I am far from abandoning writing—one abandons one's dreams with difficulty . . .

But I shall always be the same, I shall always be the rambling poet, the Zola who is your friend . . .

ZOLA TO CEZANNE

Paris, 9 February, 1860

My dear friend,

For several days I have been sad, very sad and I am writing to you in order to divert myself.

I am very downhearted . . . I think of the future, which is so dark, so dark that I shrink from it, full of horror. No money, no professional training, nothing but despondency. No-one on whom I could lean, no woman, no friend here at my side. Everywhere, nothing but indif-

[a] Zola could not stand office work and left this job again in May.

ference and contempt. That is all that offers itself to my glance when I look around, and that is why I am so downhearted ... Yet, I am sometimes in a good mood, when I think of you and Baille. I consider myself lucky to have found among the multitude, two hearts which understand mine. Whatever our position in life may be, I tell myself that our feelings for each other will remain the same and that comforts me. I see myself surrounded by such unimportant and prosaic beings that it makes me happy to know you, who is not of our century, who would invent love if it were not such an old invention ... I somehow glory in the fact that I understand you and esteem you according to your value. Let us, therefore, leave the malicious and the envious. As the majority of people are stupid, we shall not have the scoffers on our side. But what does that matter as long as you like to press my hand, as much as I do yours ...

ZOLA TO BAILLE

Paris, 20 February, 1860

... When the three of us met at the beginning of our lives and—urged by an unknown force—seized each other by the hand and swore never to separate, not one of us enquired about the wealth and possessions of his new friends. What we were looking for was the value of heart and mind and most of all that future which our youth dangled so attractively in front of our eyes ...

I am expecting Cézanne and hope as soon as he arrives to recover something of my former gaiety.[a] ...

ZOLA TO CEZANNE

Paris, 3 March, 1860

My dear Paul,

I don't know why, but I have a strong foreboding about your trip, at least with regard to the date of your more or less imminent arrival. To have you with me, to chat with you as of old—a pipe between our teeth and a glass of wine in our hands—seems to me so wonderful and at the same time so unlikely that there are moments when I ask whether I am not deceiving myself and whether this lovely dream can really come true ... I don't know from which side the storm will break, but I have the feeling that a thunderstorm is hovering above my head.

For two years you have battled in order to reach the point where you are now. It seems to me that after so many attempts victory cannot be gained without further struggles. There is, for instance, this fellow Gibert[b] who tries to find out your intentions and advises you to stay in Aix; as a teacher he obviously does not like to lose a pupil. On the other hand, your father talks about making

[a] At this time Cézanne intended to abandon his law studies, to go to Paris and become a painter. His father objected strongly to this plan, which, however, did not prevent the young artist from telling Zola that he would arrive in Paris at the beginning of April, 1860.

[b] Gibert was teaching at the Ecole Municipale de Dessin in Aix. Cézanne attended evening courses there and made drawings after plaster casts and live—but only male—models.

enquiries and consulting, of all people, this same Gibert. Their conference, which bodes ill for you, would inevitably result in delaying your journey until August. All this makes me tremble and I fear the arrival of a letter from you notifying me with many lamentations of a change in the date of your journey.[a] I have become so used to looking at the last week in March as the definite end of my boredom, that it would be most painful to find myself still alone at that time, because the stock of patience which I have laid in will last only until then . . .

You pose a strange question. Obviously, you can work here as well as anywhere else, if you are seriously determined. Moreover, Paris offers you an advantage which you could find nowhere else: the museums, where from 11 o'clock in the morning until 4 in the afternoon, you can study the old masters. You could organise your time in the following way: from 6 in the morning until 11 o'clock you could paint from a living model in an art school studio, then take your lunch and from 12 until 4 in the afternoon you could copy a masterwork which attracts you, either in the Louvre or in the Luxembourg Museum.[b] That would mean nine working hours; I believe that this is sufficient and that with such a programme you can't fail to make progress. You see, the whole evening would remain free and we could use it as we like without doing harm to our studies. And on

[a] This is in fact what happened. Gibert advised Cézanne's father against sending him to Paris. It was decided that he should continue his law studies and go to Paris only during the academic summer vacation.

[b] At that time, the works of living artists were exhibited in the Luxembourg Museum (which no longer exists), until, circa 10 years after the death of the artist, they were sent to the Louvre or to provincial museums.

Sundays we could make excursions and go somewhere into the environs of Paris; there are charming places and if you feel like it, you can sketch the trees under which we have had our breakfast on to a piece of canvas. I dream every day about the most wonderful things which I want to undertake when you are here . . . We are no longer children and have to think of the future. Let us work, work: that is the only way to reach our goal.

As to the money question, it is, of course, true that 125 francs a month will not allow you much luxury. I will give you an idea of what you will have to spend: a room for 20 francs a month, lunch 18 sous and supper 22 sous, which makes 2 francs a day or 60 francs a month; with the 20 francs for your room, that comes to 80 francs a month. Then you have to pay for the art school; 'Suisse'[a] one of the cheapest, costs, I believe, 10 francs. In addition I count with 10 francs for canvas, brushes and paints; together that comes to 100 francs. There remain 25 francs for laundry, light, the thousand little expenses which occur, tobacco and similar minor amusements. As you see, you can just about manage, and I can assure you that I do not exaggerate, rather put everything too low. But that will be a good education for you, because you will learn the value of money, and at the same time find out that a resourceful man can always extricate himself. So as not to discourage you. I repeat

[a] The so-called 'Académie Suisse' was a private institution run by a former model named Suisse, at the Quai des Orfèvres, near Notre Dame. For a small fee, artists could sketch from the nude there; their work was neither supervised nor corrected, which enabled them to develop freely. It was by no means frequented only by beginners; older painters, among them Manet, used to go to Suisse from time to time in order to sketch the models.

that you will be able to manage.—I advise you to submit this budget to your father; perhaps the sad frugality of these figures will induce him to open his purse a little more widely.—On the other hand, you can make a little money on the side here! the studies made in the art schools, and especially copies made in the Louvre,[a] are quite saleable. Even if you make only one per month, this would pleasantly augment the money available for minor amusements. It means simply that you have to find a dealer, which is only a question of looking for one.— Come here without worrying. As soon as food and drink are secured, one can devote oneself to the arts without danger . . . In any case, I count on you to notify me the day before your departure, of the date and hour of your arrival. I shall then meet you at the station and immediately conduct you in my learned company to lunch.—Before then I shall certainly write again.—Baille has written to me. Should you see him before your departure, please ask him to promise that he will join us in September . . .

ZOLA TO BAILLE

Paris, 17 March, 1860

. . . If, weary of my loneliness, I call the muse of poetry, that gentle comforter, she no longer answers . . . She has deserted me for some time, but whenever I compose rhymes without her assistance, I later tear them up in

[a] Cézanne did not apply for a student's permit to visit the Louvre free until 1868, perhaps because he didn't work under an acknowledged teacher. In his application, he named a certain Chesneau as his teacher; he received the permit on 13th February, 1868.

disgust ... Even though the last months with their confusion and disappointments have done me harm, they have not succeeded in choking all poetry within me. I feel that poetry still throbs within me and that only some auspicious event is needed for its wings to unfold again. I am expecting much from Cézanne's arrival ...

Recently, I have received a letter from Cézanne in which he tells me that his little sister is ill, and he hardly counts on arriving in Paris before the first days of next month. You will, therefore, still see him during the Easter holidays. Have a drink together then for the last time, smoke your pipes and swear to him that you will join us next September. Then we shall form a Pleiad of however few and pale stars, which will shine forth thanks to our close relationship. As our old man[a] says: "There will never be any dreams or any philosophy comparable with ours!" ...

I expect a letter from you towards the beginning of April, i.e. a letter written during your holidays at Aix. I shall not write to you before that, that is at the same time as Cézanne arrives here. This, by the way, is now very near. Give me, therefore, soon news about Aix and its inhabitants.

ZOLA TO CEZANNE

Paris, 25 March, 1860.

My dear friend,

We often talk poetry in our letters, but the words sculpture and painting occur rarely, not to say never.

a The 'old man' was Cézanne.

That is a grave omission, almost a crime; I shall try to make up for it today.

[There follow extensive reflections about a Paris fountain by Jean Goujon and a painting by the sentimental artist Ary Scheffer, which so much impressed Zola in his youthful exuberance that it led him to a sharp attack against Realism without, however, mentioning by name Courbet, its, at that time, highly controversial representative.]

... What do you mean by this word 'realism'? You boast that you paint only subjects which are devoid of poetry! But everything has its own poetry, the dung heap as well as the flower. Is that because you claim to imitate nature slavishly? But, as you carp so much at poetry, that is to say that nature is prosaic. And therefore you have lied. It is for you that I say this, monsieur, my friend, monsieur the great future painter. It is to tell you that Art is one, that spirituality and realism are nothing but words, that poetry is something magnificent, and that outside poetry there is no salvation.

I had a dream the other day. I had written a beautiful book, a magnificent book for which you had done beautiful, magnificent illustrations. Our two names shone together in gold letters on the title page and, in this brotherhood of genius, went inseparably on to posterity. Unfortunately, this is as yet only a dream.

Moral and conclusion of these four pages: you must satisfy your father by carrying on with your law studies as seriously as possible. But you must also work at your drawings, steadfast and determined—*unguibus et rostro*[a]— in order to become a Jean Goujon, an Ary Sheffer, not a realist, so that you can illustrate a certain book which struts around in my head ...[b]

[a] With tooth and claw.

[b] Cézanne never illustrated a book by Zola or any other writer.

As to the excuses you make, either for the engravings you sent me or for the tedium which your letters are supposed to cause me, I venture to say that this is in the worst possible taste. You don't believe yourself what you allege, and that comforts me. I complain only about one thing, that is that your letters are not longer and more detailed. I always await them impatiently; they fill me with pleasure for a whole day. And you know that; therefore, please, no more excuses. I would rather do without smoking and drinking than give up my correspondence with you.

Then you write that you are very sad: I reply that I am very sad, very sad. It is the wind of the century which passes over our heads: we cannot hold anyone responsible for that, not even ourselves. It's the fault of the times in which we live. Then you add that, even if I have understood you, you do not understand yourself. I don't know what you mean by the expression 'understand'. As far as I am concerned I see things thus: I have discovered in you a great goodness of heart and great imagination, the two cardinal virtues before which I bow my head. And that is enough; From that moment on, I have understood you, I have judged you. Whatever your weaknesses, whatever your errors, you will always remain the same for me . . . What do your apparent contradictions matter to me! I have judged you a good man and a poet, and I shall always repeat: "I have understood you." But away with sadness! Let us end with an outburst of laughter. In August[a] we shall drink, we shall smoke, we shall sing . . .

[a] This can only mean that Cézanne's departure had been definitely postponed. Originally Zola had expected him in Paris at the beginning of April. Zola makes no mention of this in his letter

Paris, 16 April, 1860.

... My new existence is rather monotonous. At 9 o'clock I go to the office and until 4 o'clock I enter customs declarations, copy letters etc. Or better still: I read my paper, yawn, walk up and down in my room, etc. In fact, it is rather depressing. But as soon as I have finished, I shake myself like a drenched bird, I light and puff at my pipe, I breathe, I live. I roll over in my head long poems, long dramas, long novels; I await the summer to give free reign to my spirit. Vertudieu, I want to publish a volume of poetry, and dedicate it to you ...[a]

I have received your letter. You are right not to complain too much about your fate, because in spite of everything, with two passions in your heart, one for woman and one for beauty, it would be quite wrong to despair, as you say yourself....

You sent me some verses which breathe a sombre sadness. The quick flight of life, the short span of youth with death somewhere on the horizon: all this would make one tremble if one thought of it for a few minutes. But is it not an even more sombre picture if, in the hurried passing of existence, youth, the springtime of life, is entirely missing and at twenty, having experienced no

probably because Cézanne was very downcast about it, especially as Zola did not intend to stay in Paris during August, but to spend his summer holiday, as before, in Aix.

[a] Zola never published a volume of poetry, but his first novel 'La Confession de Claude' a romantic-realistic representation of young love, published in 1865, is written in the first person, in the form of a report to his two companions. It is dedicated: "To my friends, P. Cézanne and J.-B. Baille." A year later, Zola dedicated his first essays about art to Cézanne. (See p. 105.)

happiness, one sees age approaching with long strides unable to enliven the rough winter days with memories of a beautiful summer? —That is the fate which is awaiting me.

You also tell me that sometimes you do not have the courage to write to me. Don't be egoistic: your joys belong to me as well as your sorrows. When you are gay, make me gay; when you are sad, darken my sky without fear; sometimes a tear is sweeter than a smile. Simply note down your thoughts for me from one day to the other; as soon as a new sentiment is born in your soul, write it down. And when four pages have been filled, send them to me.

Another phrase in your letter has also touched me painfully. It is this: "Painting, which I love, although I don't succeed etc." You! not succeeding? I believe that you deceive yourself. And I have already told you: there are two men inside the artist, the poet and the craftsman. One is born a poet, one becomes a craftsman, and you, who has the spark, who possesses what cannot be acquired, you complain when, in order to succeed, you have to train only your fingers to become a craftsman. I shall not leave this subject without adding two words. Last time I warned you against realism; today I want to show you another danger: commercial art. The realists still make art—after their fashion—, they work conscientiously. But the commercials, those who paint in the morning for their bread in the evening, they crawl along miserably. I say this not without reason: you work at X's studio, you copy his pictures, perhaps you admire him.[a] I am very much afraid of this path which you take,

a It is not known who this painter was.

even more so because he, whom you perhaps try to imitate, has great qualities, but makes poor use of them, which does not prevent his pictures from appearing better than they really are. It's pretty, it's fresh, it's well brushed-on; but that is entirely a question of technique and you would be wrong to stop there. Art is much more sublime, it is not satisfied with the folds of a fabric, with the rosy skin of a young woman. Look at Rembrandt; through a ray of light all his people, even the most ugly, become poetic. Also, I repeat, X. is a good master to teach you your craft but I doubt whether you could learn anything else from his pictures. As you are well off, you doubtless dream of making art and not commerce . . . Beware, therefore, of an exaggerated admiration for your compatriot; put your dreams, those lovely golden dreams, on to your canvas, and try to transfer the ideal love which you carry inside you.[a] Most of all—and this is the pitfall—do not admire a picture because it has been painted quickly; in one word, do not admire and do not imitate a commercial artist. I shall come back to this question later. Perhaps I offend very much against some of your ideas. Tell me quite frankly rather than nursing against me a secret rancour, which, for this reason, is growing every day.

[a] As far as we know them, Cézanne's early works represented mostly romantic scenes and landscapes, among them copies of sentimental pictures in the museum at Aix or after engravings of works by Lancret, Proud'hon etc. Cézanne's interest in nature awakened a few years later, as his letters show.

Paris, 26 April, 1860
7 o'clock in the morning

My dear old fellow,

I shall never stop repeating to you: don't think that I have become a pedant. Every time I am about to give you advice, I hesitate, I ask myself whether it is really my job, whether you won't get tired of hearing me shout: do this, do that. I fear that you will become angry with me, that my thoughts are in conflict with yours and that, therefore, our friendship might suffer. What shall I tell you? I am probably silly to have such bad thoughts; but I am so much afraid of the lightest cloud between us. Tell me, tell me constantly that you accept my ideas as those of a friend; that you do not become angry with me if they are in discord with your way of seeing; that I am for you just the same, the gay companion, the dreamer, the friend who so happily stretches out on the grass next to you, pipe in his mouth, glass in his hand.—Friendship alone dictates my words; I see better together with you, meddling a little in your affairs; I talk, I fill in gaps in my letters, I build castles in Spain. But by God, don't think that I want to lay down a way of conduct for you; take from my words only what suits you, what you find good, and laugh about the rest without even taking the trouble to argue with me.

And now, I have more courage to touch on the subject of painting.

When I, who can only just distinguish black from white, look at a painting, I can, of course, not allow myself to form a judgment about the brushwork. All I can say is

whether I like the subject, whether the whole makes me dream of something beautiful and great. In a word, I talk about Art, about the thought which has been dominant in the work without concerning myself with technique. And it seems to me that this is as well, because nothing appears to me more pitiful than the exclamations of so-called connoisseurs who, having got hold of some technical terms in the studios, spout them with the self-assurance of parrots. You, on the other hand, you know well how difficult it is to put paint on to canvas so that it matches your imagination—I quite understand that you, in front of a picture, are most concerned with the technique, that you enthuse about this or that brush-stroke, about a colour that has been attained etc. etc. That is perfectly natural; the idea, the spark, you have inside you; you seek the form, which you don't have; and you admire it in good faith wherever you find it. But beware; this form is not everything and, whatever your excuse, you must put the idea above it. In other words: a painting must not consist simply of crushed colours put on to a canvas; you must not constantly be concerned with the question, by what technical means an effect has been achieved, which colours were used; instead you must look at the whole, ask yourself whether the work is really what it should be, whether the artist really is an artist. In the eyes of the common man there is so little difference between a daub and a masterpiece. In both cases, it's white, red, etc., brush-strokes, a canvas, a frame. The difference lies in that nameless something revealed only through ideas and taste . . .

P.S. I have just received your letter.—It raises a sweet hope in me. Your father is becoming human; be firm without

being disrespectful. Remember that it is your future that is being decided and that your happiness depends on it.— What you tell me about painting becomes unnecessary the moment you yourself recognise X's faults. I shall answer you soon.

ZOLA TO BAILLE

Paris, 2 May, 1860

... Cézanne talks about you [*in his letter*], he admits his fault[a] and assures me that he is going to change his character. Since he himself has introduced the subject, I intend to tell him what I think about his attitude. I wouldn't have started but I believe that now it is unnecessary to wait until August[b] before attempting a rapprochement between you ...

ZOLA TO CEZANNE

Paris, 5 May, 1860.

... In your two letters you talk about Baille. For a long time I myself have wanted to talk to you about the good

[a] Baille, who continued to study in Marseille, had complained of a very cool reception when he visited Cézanne in the Jas de Bouffan, a property near Aix, bought by Cézanne's father in 1859. From later letters of Zola, it also becomes clear that Baille began at that time to make derogatory remarks about artists who chase after glory without taking any notice of the practical problems of life. Baille's relations with both his friends deteriorated much sooner than those between Cézanne and Zola.

[b] At which time Zola intended to visit Aix.

fellow.—It's true, that he is not the same as us, that his skull is not from the same mould. But he has some qualities which we do not possess and also quite a number of faults. I don't want to try here to paint his character for you, to tell you where he sins, where he wins. I would call him neither a wise man nor a fool, because that is relative and depends on the point of view from which one regards life. What difference does it make to us, his friends? Is it not enough that we have judged him a good fellow, well above the crowd, or at least more capable of understanding our hearts and our spirit. . . . I believe I have noticed that the tie which united you with Baille had weakened, that a link of the chain was about to snap. And, trembling, I ask you to think of our joyous parties, of the oath we have taken, glass in hand, to walk arms linked the same path throughout our lives, to remember that Baille is my friend, as well as yours, and that, if his character is not entirely sympathetic, he is nevertheless devoted to us, a loving friend and that after all he understands me, he understands you, is worthy of our confidence, of your friendship. If you have to reproach him for something, tell me and I shall try to defend him; or even better, tell him yourself what you dislike in him. Nothing is to be feared as much as things unspoken among friends.

You remember our swimming parties . . .; then the great day on the banks of the river, when the sun went down in glory; that landscape which perhaps we did not admire at the time, but which in memory appears to us so calm and smiling. I believe it was Dante who said that nothing is more painful than a happy memory in days of misfortune. Painful, certainly, but also full of

a bitter voluptuousness; one laughs and cries at the same time. How unfortunate we are! At twenty we already regret the past; ... we spoil our lives as if for fun; we always want to see the past revived or implore the future with loud cries, never knowing how to enjoy the present.—As I told you in my last letter, sometimes a memory, like a streak of lightning, flashes across my thoughts: something which you once said; one of our excursions; a mountain, a path, a bush, and I long for it and despair—unhappy and mad.

In both your letters you give me something like a far hope of reunion. "When I have finished my law studies", you tell me, "perhaps I shall then be free to do what seems to me good, perhaps I can then rejoin you." May God grant that this is not only the joy of a moment, that your father's eyes will be opened to your true interests! Perhaps in his eyes I am a frivolous, mad, or even down-right bad friend, because I support you in your dream, your love of the ideal. Perhaps, if he could read my letters, he would judge me severely; but even if I should lose his respect, I would still tell him frankly to his face as I tell you: "I have thought for a long time about the future, the happiness of your son, and believe, for a thousand reasons which would take too long to explain, that you should let him go where his inclinations draw him."

It needs therefore some little effort, old boy, some persistence. Que diable, have we completely lost all courage? After the night will follow the dawn; let's try, therefore, to survive this night as best we may, so that, when day breaks, you can say: "Father, I have slept long enough, I feel strong and courageous. Take pity! do not

lock me up in an office; give me my wings, I suffocate, be generous, father."

. . . I count on coming to shake you by the hand as last year [*in Aix*]. True, I would prefer you to come to me, for a host of reasons; but as I still doubt your father's good intentions, I am about to pack my cases.

ZOLA TO BAILLE

Paris, 14 May, *1860*
Harbour administration, 3 o'clock in the
afternoon

. . . As I have already told you, I wrote to Cézanne about the coldness with which he received you. I cannot do better than to copy here exactly the few words of his reply to me on the subject; here they are:

"You seem to be afraid, according to your last letter, that our friendship with Baille is weakening. Oh no! because, morbleu, he is a decent fellow; but you know quite well that my character being what it is, I don't always fully realise what I am doing, and so if I've been in the wrong towards him, let him forgive me; but otherwise you know that we get on very well together, but I agree with what you say to me, because you are right. And so we remain great friends."

You see, my dear Baille, I was right, that this was nothing but a light cloud which would vanish with the first puff of wind; I told you that our poor old boy doesn't know what he is doing, as he himself admits pleasantly enough, and that we, when he grieves us, must not hold his heart responsible, but only the bad demon

which clouds his thoughts. His is a soul of gold, I repeat; a friend who understands us, just as mad as us, just as dreamy. I am not of the opinion that he should know about the letters exchanged between us about your peace move; he must even believe that I have acted without your knowledge, he must, in a word, not know that you have complained about him, that you were for a moment at odds. As to your attitude towards him until August, the time when our pleasant gatherings will begin again, it should be like this, at least that's my opinion: you should regularly write him some letters, without complaining too much if, as he probably will, he delays his answers. Your letters should, as in the past, be affectionate, certainly without any allusion, without any hint, which could bring back your little rumpus; in a word, it should be as if nothing had happened between you. He is a convalescent whom we must nurse; if we do not want a relapse let us avoid anything imprudent. You understand what makes me speak like this, the fear of seeing our friendly triumvirate break up. Also, excuse my pedantic tone, my exaggerated fears, my perhaps unnecessary precautions; I am putting the friendship which I feel for you both above everything else . . .

In August, I want to show you the number of letters from Cézanne and make you blush when comparing them with yours . . .

ZOLA TO BAILLE

Paris, 2 June, 1860

. . . Good old Cézanne asks in each of his letters to be remembered to you. He asks me for your address so as

to write to you very often. I am astonished that he doesn't know it, and it proves, not only that he has not been writing to you, but that you have been just as silent as he. However, as this request shows his good intentions, I shall satisfy it. And so the little rumpus has become a legend.

. . . In the meantime, grow yourself some pleasure, as Cézanne says: drink, laugh, smoke and all will be for the best in the best of all possible worlds . . .

ZOLA TO CEZANNE

Paris, 13 June, 1860

My dear Paul,

The other day, on a beautiful morning, I lost my way in the fields far from Paris, three or four miles away . . . Having walked around for two long hours I developed a great appetite. I looked up; everywhere trees, corn, hedges etc. I found myself in an area completely unknown to me. Finally, beyond an old oak tree, I caught sight of a church tower; a tower indicates a village; a village, an inn. I marched towards the welcome church and soon found myself installed before a frugal meal in an indifferent café. In this café—and that is what I wanted to come to, everything else is only an introduction—I had already noticed on entering some paintings which greatly impressed me. They were big panels such as you want to do at home,[a] painted on canvas, representing village

a Ever since Cézanne's father had acquired the Jas de Bouffan, the painter had intended to decorate the big Salon, at that time unused, with murals. To begin with, he painted a romantic riverscape at dusk,

fêtes; but a chic, a brush-stroke so assured, so perfect an understanding of the effect of distance, that I was amazed. Never have I seen anything like it in a café, not even in Paris. I was told that it was a twenty-three year old artist who had done these little masterpieces. Really, when you come to Paris, we must go together to Vitry—that is the name of the happy village—and I am certain that you will admire them as much as I did . . .

I see Chaillan[a] very often. Yesterday we spent the evening together; this afternoon I shall join him in the Louvre. He told me that he had written to you, the day before yesterday, I think, so that I don't have to talk about his work here. Combes is also here, as he will have told you as well. The other artists whom I see are young Truphème, Villevieille, Chautard; Emperaire, however, I have not yet met.[b] . . . Before starting the magnificent picture which I have mentioned to you already,[c] we wait

with a small angler in the foreground; then a copy after Lancret and four high, narrow representations of the seasons, which he ironically signed with the name of Ingres. Later he placed in the place of honour a picture of his father reading a newspaper.

[a] Jean-Baptiste-Mathieu Chaillan, a painter of little talent, whom Cézanne met at the Ecole de Dessin at Aix in 1858.

[b] Chaillan, Combes, Truphème, Villevieille, Chautard and Emperaire were friends from Aix; nearly all of them had attended, together with Cézanne, the evening courses in drawing from the nude at the art school in Aix, conducted by the painter Gibert, already mentioned (see p. 50). Cézanne took part in these courses from 1858–62. He, as well as Zola, did not have a high opinion of the artistic abilities of these friends, with the exception of Emperaire. Jean-Baptiste-Mathieu Chaillan was during this time especially closely connected with Cézanne and Zola. Joseph Chautard, an intimate friend of Villevieille, later corrected Cézanne's work in Paris (see letter, p. 97).

[c] Chaillan intended to paint a great portrait of Zola, representing him as Amphyon, dressed in a toga, with a lyre in his hand, his eyes lifted up to heaven.

until I move into the room which I have just rented. On the seventh floor, old boy; the highest habitation in the quartier; an enormous terrace, a view over the whole of Paris; a charming little room which I shall furnish in the latest fashion, divan, piano, hammock, masses of pipes, a Turkish narghileh etc. Then a birdcage, a little fountain, a veritable fairyland. I'll tell you more about my garret when all these embellishments have been added. On the 8th July we move in. Baille, who probably comes to Paris in September, will no doubt enjoy sharing my retreat; alas, that I cannot say the same about you. Chaillan should tell you all about the felicities which young daubers encounter here . . .

You no longer speak to me about Law. What do you do with it? Are you still at loggerheads? This poor Law, which can't help it, how you probably rail at it! I have noticed that we always need either a grief or a love, otherwise life is incomplete. Anyhow, the idea of love calls forth to a certain extent the idea of hatred, and vice versa. You love pretty women, so you hate ugly ones; you hate the town, so you love the fields. Obviously one shouldn't push this too far . . . Truly wise would be the man who knows only love and in whose soul hatred has no place. But as it is, we are not perfect—thank God, that would really be too boring—and as you are similar to all others, your love belongs to painting and your hate to law . . .

You say that you sometimes re-read my old letters. It is a pleasure to which I often treat myself. I have kept all yours. They are the souvenirs of my youth . . .

Tell me a bit about the processions. They are a kind of holy coquetterie; under the pretext of adoring God in

one's most beautiful attire, one allows oneself to be adored. How many billet-doux a church must have seen slipping into little hands!... Tell me, tell me about everything: I am greedy for news. You, who never looks around for yourself, look around a bit for me, then tell me all you have seen. A last question: Your beard, how do you wear it?...

ZOLA TO CEZANNE

Paris, 25 June, 1860

My dear old man,

In your last letter you seem to me discouraged; you speak of nothing less than of throwing your brushes at the ceiling. You sigh about the solitude that surrounds you; you are bored. Isn't that the illness of all of us, this terrible boredom, isn't it the plague of our century? And isn't the discouragement one of the results of this spleen which chokes us? As you say, if I were near you I should try to console you, to encourage you. I would say to you that we are no longer children, that the future claims us and that it is cowardly to shrink from the task which one has set oneself; that the great wisdom is to accept life as it is; to embellish it with dreams, but to remain well aware that they are only dreams. God protect me from being your bad genie and landing you in disaster by praising art and dreams. But I can't believe that; there could not be a devil hiding behind our friendship to drag both of us into the abyss. So, recover your courage, seize your brushes again, let your imagination roam like a vagabond. I have faith in you; more, if I push you towards evil,

may this evil rebound on my own head. Above all, courage, think hard before taking this path about the thorns you might encounter. Be a man, leave the dream alone for the moment and act . . .

Now, let me talk a bit about myself . . . If I show pride and contempt towards the mob, I have none towards you, my friends; I know my weaknesses and as to qualities, I find in myself only that of love towards you. Like the shipwrecked sailor who clings to a plank floating in the water, I cling to you, my old Paul. You understand me, your character was in sympathy with mine, I had found a friend and thanked heaven for that. Several times I was afraid of losing you; now this seems to me impossible. We know each other too well ever to separate . . .

Yesterday, I spent the day with Chaillan. As you say, he is a fellow with a certain fund of poetry; only he hasn't been properly guided . . . What he has so far done is very similar to the terrible votive pictures which hang in the Madeleine Church in Aix . . . He works unguibus et rostro and desires with all his heart to have you as a companion.

I still intend to visit you soon. I need to talk to you. Letters are all very well, but one does not say all one would like to say. I am tired of Paris; I go out very seldom and, if it were possible, would settle near you. My future is still the same; very dark and so overcast by clouds that my eyes search in vain. I really don't know where I'm going: May God guide me: Write often to me, that comforts me.

I know how much you hate the crowd; therefore, talk only about yourself; and most of all, never be afraid of boring me. Courage. See you soon . . .

Paris, July, 1860.

My dear Paul,

Allow me to explain myself for the last time, frankly and clearly; everything seems to me to go so badly in our affairs that I am in a desperate state of worry about it. Is painting for you only a whim, which you happened to grab by the hair one day when you were bored? Is it only something to pass the time, a subject of conversation, a pretext not to work at law? If that's so, then I understand your behaviour: you are right not to push things to the extreme and not to create new family troubles for yourself. But if painting is your vocation—and that is how I have always seen it—, if you feel capable of doing well after hard work, then you become for me an enigma, a sphinx, someone who is I don't know how impossible and mysterious. One of two things: either you do not want to, and then you achieve your aim admirably; or you do want to, and then I don't understand anything any more. Sometimes your letters fill me with great hope, sometimes they rob me of that and more; such as your last, where you seem to me almost to be saying goodbye to your dreams, which you could so easily turn into reality. In this letter, there is this phrase which I have tried in vain to understand: "I am going to speak to say nothing, for my conduct contradicts my words." I have built up all sorts of hypotheses about the meaning of these words, but none has satisfied me. What then is your attitude? That of a lazy fellow no doubt; but what is surprising about that? You are being forced to do work which repels you. You want to ask your father to let you go to

72

Paris in order to become an artist; I do not see any contradiction between this demand and your actions; you neglect the law, you go to the museum, painting is the only work which you accept; that is, I think, an admirable unity between your wishes and your actions. Shall I tell you?—but don't be angry—you lack character; you have a horror of exertion, whatever it may be, in thought as well as in action; your great principle is to let the water run and to leave things to time and to chance. I do not say that you are completely wrong; everyone sees things in his own way or at least believes he does. Only you have already followed this course in love; you were waiting, you said, for the right time and circumstances; you know better than I, neither one nor the other have arrived. The water still runs and the swimmer is one day surprised to find nothing but hot sand.

... You are a bit negligent—let me say this without making you angry—and my letters no doubt are lying about and your parents read them. I do not believe that I am giving you bad advice; I believe I speak as a friend and according to reason, but perhaps everyone does not see things as I do and if what I have suggested above is true, I am probably not very well thought of by your family. For them, I am no doubt the *liaison dangereuse*, the stone thrown on to your path to trip you up. All this afflicts me deeply, but, as I have told you already, I have seen myself so often misjudged that one more wrong judgment added to the others would not surprise me. Remain my friend, that is all I desire.

Another passage of your letter grieved me. Sometimes, so you tell me, you throw your brushes at the ceiling when your results do not come up to your ideas. Why

this discouragement, this impatience? I could understand that after years of study, after thousands of useless attempts. Recognising your nullity, your inability to do well, you would then act wisely if you trampled your palette, your canvas and your brushes underfoot. But as, up to now, you have only had the wish to work, as you have not yet tackled the task seriously and regularly, you have no right to judge yourself incapable. So have courage; what you have done up to now is nothing. Have courage and remember that in order to arrive at your goal, you need years of study and perseverence. Am I not in the same position as you; is the form not just as rebellious under my fingers? We have the idea; so let us march freely and bravely on our path and may God guide us . . .

You ask me for details of my daily life. I have left the docks; have I done right, have I done wrong? A relative question, according to one's temperament. I can only say one thing: I could no longer remain there, and walked out. What I intend to do now I will tell you later, once I have put my plans into practice. For the moment, here is my life: we have started the picture of Amphyon in my little room on the seventh floor, a paradise adorned with a terrace from which we can see all of Paris, a quiet refuge full of sunshine. Chaillan comes at about 1.pm. Pajot, a young fellow I mentioned to you, follows soon; we light our pipes so well that after a while we can't see for more than four feet. I don't talk about the noise, these gentlemen dance and sing and by God I join them . . . but tumult is only good at the right time, to sing always, to laugh always is tiring. I do not work enough and I am angry with myself. If you come to Paris, we shall try

to organise our day so as to slog hard, without however neglecting pipe, glass and song.

Amphyon, under the brush of Chaillan, assumes the expression of a bad-tempered ape. Everything considered, I despair more than ever of this fellow as an artist . . .

Just now, a letter from Baille. I don't understand anything any more; here is a sentence which I read in this epistle: "It is almost certain that Cézanne will come to Paris: what joy!" Does that come from you, have you really recently given him this hope when he was in Aix? Or has he dreamt, has he taken for granted what is only your dream? I repeat, I don't understand anything. Please tell me frankly in your next letter how things are. For three months, according to respective letters, I have been telling myself: he comes, he doesn't come. Good God! let us try not to behave like weathervanes . . . My trip is still fixed for the 15th September[a] . . . When do you have your exam? Have you passed? Will you pass? . . .

ZOLA TO BAILLE

Paris, 25 July, 1860

. . . Paul, whose character is so good, so open, whose soul is so affectionate, so gently poetic . . .

[a] Zola's journey to Aix had been postponed from August to the middle of September; in the end it did not take place at all, probably because of lack of money.

Paris, 1st August, 1860

My dear Paul,

Rereading your letters of last year, I hit upon a little poem of Hercules between vice and virtue . . .[a] You are more poetically talented than I . . . A poet has many means to express himself: pen, brush, chisel, musical instrument. You have chosen the brush and you have done right, because everyone must follow his bent . . . But allow me to mourn the writer who dies in you . . . Instead of the great poet who is walking out on me give me at least a great painter, otherwise I would be angry with you. You, who guided my tentative steps on Parnassus and then suddenly left me, make me forget a budding Lamartine over a future Raphael . . .

I received your letter this morning . . . I agree with you that the artist should not reshape his work . . . I am entirely of your opinion: work conscientiously, do the best you can, give a little touch with the file to adjust the parts better, to form an acceptable whole, then abandon your work to its good or bad fortune, having carefully put at the bottom the date of origin . . . Like you, I speak for the artist in general: poet, painter, sculptor, musician . . .

With regard to our great problem, I can only repeat myself and give advice already given. Until both advocates have pleaded, the case remains always at the same point; discussion is the flaming torch of everything. How then, if you remain silent, will you make progress and come to a conclusion? That is physically impossible.

[a] This seems to have been lost.

And don't forget that he who shouts loudest, is not necessarily right. Speak gently and reasonably, but in the name of the horns, the tail, the navel and the hoofs of the devil, speak, do finally speak!!!...

ZOLA TO BAILLE

Postscript to an undated letter, probably beginning of September, 1860.

A charming expression which I find in one of Cézanne's letters: "I am a babe suckled by the Illusions".

ZOLA TO BAILLE

Paris, 21 September, 1860

... Tell my dear old Cézanne that I am sad and unable to answer his last letter ... It is almost useless for him to write to me until the question of his journey has been decided ...

ZOLA TO CEZANNE AND BAILLE

Paris, 2 October, 1860

... I remember a deep remark of Cézanne's. Whenever he had some money he usually hastened to spend it before going to bed. When I questioned him about this extravagance: "The devil!" he said, "If I died tonight, would you want my parents to inherit from me?" ...

You assure me that Cézanne will come here to Paris in March [*1861*].—I address this remark to Baille and not to Paul, as I have promised myself not to discuss this question with him any more.—If only what you say would be true; I go through long days of boredom . . .

ZOLA TO CEZANNE AND BAILLE

Paris, 24 October, 1860.

. . . This morning I have received a letter from Paul. What about Baille? What serious occupation has prevented him for a fortnight from writing a few lines to me? . . .

As it is Cézanne who has written to me, it is him I must answer. The description of your model has amused me very much. Chaillan maintains that the models here are just about fit to drink without being of the freshest. One draws them during the day and caresses them during the night (the word caress is a bit feeble). So much for posing during the day, so much for posing at night; it is said, by the way, that they are very accommodating, especially during the hours of the night. As to the fig-leaf, that is unknown in the studios . . . Come and you'll see.

ZOLA TO CEZANNE

Paris, 5 February, 1861

. . . The easiest for me is simply to answer your letter. Alas, no! I no longer roam the countryside, I no longer

lose my way among the rocks of Le Tholonet[a] and worst of all, I no longer rush, a bottle in my game-bag, to Baille's country seat, this memorable cottage of vinous memory; other times, other customs, as says the wisdom of the nations. I have become so sedentary that the smallest walk fatigues me ... My great pleasures now are the pipe and my dreams, feet in the hearth and eyes fixed on the fire. Thus I pass my days, almost without boredom, never writing, sometimes reading a few pages of Montaigne. To be frank, I want to change my life and to shake myself a little in order to get rid of this dust of laziness which makes me rust ... Another sad result of the life I lead is that I have become terribly gluttonous. "You were that before", you tell me; I agree, but not quite so damnably. Drink, food, everything, fills me with longing and I take the same pleasure in devouring a good morsel as in possessing a woman ...

Now then you, I hear, go painting in the middle of winter, sitting on the frozen ground without taking any notice of the cold.[b] This news has delighted me; I am delighted, not because it gives me pleasure to see you risking a severe cold and, more or less, chilblains, but because I deduce from such perseverence your love of the arts and the passion which you put into your work.

[a] The small village of Le Tholonet, a few kilometres east of Aix and near the foot of the Mount St. Victoire, had frequently been the goal of the excursions of Zola, Cézanne and Baille. Close to the village are the rocks where Zola's father François had constructed a reservoir, which provided water for the town of Aix. Zola himself has described the village, under the name of Artaud, in his novel 'La Faute de l'abbé Mouret' and Cézanne often returned there in later years to paint, especially about 1900.

[b] None of these early winter landscapes by Cézanne has been preserved.

Ah! my dear fellow, how remote I am from following you . . .

ZOLA TO BAILLE

Paris, 22 April, 1861

My dear friend,

I thank you for your letter; it makes me despair, but is useful and necessary. The sad impression which it made on me has in some way been diminished by the vague knowledge I had of the suspicion which hovered over me. I felt like an adversary, almost an enemy, in Paul's family; our different ways of looking at life and understanding it, revealed to me implicitly how little sympathy M. Cézanne has for me. What shall I tell you? All you tell me I knew already, but didn't dare to admit it to myself. Certainly I did not believe that it would be possible to accuse me to this extent of infamy and to see in my brotherly friendship nothing but hateful calculation. To be frank, I must admit that an accusation coming from such a source surprises me rather than making me sad . . .

As Paul's friend I want, if not to be loved, at least to be respected by his family; if someone indifferent, whom I have come across by chance and whom shall never see again, would listen complacently to calumnies about me and believe them, I would let it go without even trying to convince him. But in this case it is not like that; wishing, in spite of everything, to remain Paul's brother, I find myself forced to have frequent contacts with his

father, I am obliged sometimes to appear before the eyes of a man who despises me, and to whom I cannot return contempt for contempt; on the other hand, I do not want at any price to cause trouble in that family; as long as M. Cézanne, believing me to be a vile schemer, sees that his son associates with me, he will feel exasperated with his son. I do not want this to happen; I cannot remain silent. If Paul is not prepared to open his father's eyes, then I must think of doing it myself...

There is yet another detail which I believe I detect and which you hide from me, no doubt out of affection. You include both of us in this reprobation by Cézanne's family; and something, I don't know what, tells me that I am the more gravely accused of us two, perhaps even the only one. If that is so—and I don't believe that I am mistaken—I thank you for having shouldered half of this heavy burden and for having tried thus to lighten the sad impression of your letter. There are a thousand details, a thousand reasonings which have lead me to this thought; first my small means, then my more or less openly admitted state as a writer, my stay in Paris etc...

The problem appears to me this: M. Cézanne has seen the plans which he had formed frustrated by his son. The future banker has turned out to be a painter who, feeling eagle wings growing on his back, wants to leave the nest. Completely surprised by this transformation and this desire for liberty, M. Cézanne, unable to believe that anyone could prefer painting to banking and the air of the open sky to his dusty office,—M. Cézanne has taken it into his head to discover the key to this enigma. He takes care not to admit that this was so because God

wanted it so, because God, having made him a banker, had made his son a painter. But, having thought deeply, he finally understood that this was all my fault; that it was I who had made Paul into what he is today, that it was I who lured away from the bank his most cherished hope...

Fortunately it is likely that Paul has kept my letters; reading them one could easily see what my advice was and whether I have ever pushed him in the wrong direction. On the contrary, I have repeatedly made clear to him the drawbacks of his trip to Paris and advised him to treat his father with consideration...

I wanted to have him near me, but when expressing this wish, I have never advised him to rebel ... Without intending to, I have stimulated his love for the arts, and I have certainly done nothing except develop seeds which already existed, an effect which any other outside cause could have produced as well. If I ask myself, the answer is that I am not guilty of anything. My attitude has always been sincere and blameless. I have loved Paul like a brother, always dreaming of his happiness, without egoism, without self-interest. Rekindling his courage when I saw that he was weakening, always talking to him of all things beautiful, just and good, always trying to lift up his spirit and, above all, to make a man of him ... It is true that I have never talked about money in these letters; that I have never drawn his attention to this or that business enterprise where one could gain vast amounts. It is true that my letters spoke simply of my friendship, my dreams and I don't know how many noble feelings, coins which have no value anywhere in the commercial world. That is no doubt the reason why I am a schemer in the eyes of M. Cézanne.

I am making fun of it, yet I have no wish to. However that may be, here is my plan. Having first agreed with Paul, I want to see M. Cézanne alone and have a frank discussion with him. Don't be afraid, I shall be restrained and moderate in my language ... in front of our friend's father I shall behave as I ought to ...

I am telling you all this without really knowing what I shall do. I am expecting Cézanne and I want to see him before making any decision. Sooner or later his father will be forced to respect me again; if he ignores the past, the future will convince him ...

I interrupt myself, shouting: I have seen Paul!, I have seen Paul! do you understand? do you? Do you understand the melody of these three words? He came this morning, Sunday, and several times called my name from the staircase. I was half asleep; I opened my door, trembling with joy, and we embraced furiously. Then he reassured me about his father's antipathy towards me; he maintained that over-zealous, no doubt, you had exaggerated a little. Then he told me that his father wanted to see me, I shall visit him today or tomorrow. Then we lunched together, smoked a lot of pipes in a lot of public gardens, then I left him. As long as his father is here, we can only see each other now and then, but in a month we count on living together ...

Write when you can. As far as I'm concerned, we shall shake your hand in a fortnight, Cézanne and I.

Towards the end of April 1861, Cézanne's father finally consented to his son's journey. Cézanne went to Paris to join Zola and to devote himself entirely to painting.

ZOLA TO BAILLE

Paris, 1 May, 1861

... Last Sunday I went with Paul to the art exhibition ...[a]
I see Paul very often. He works a lot, which sometimes
keeps us apart; but I do not complain about this kind of
reluctance to see me. We have not yet had any parties, or
rather those in which we have indulged are not worth the
honour of the pen. Tomorrow, Sunday, we intend to go
to Neuilly to pass the day on the banks of the Seine, bathe,
drink, smoke etc. But now, the weather darkens, the
wind blows, it becomes cold. Goodbye, our fine day; I
don't know what we shall do, Paul wants to paint my
portrait.

TO JOSEPH HUOT[b]

Paris, 4th June, 1861

Dear Huot,

Oh, my good Joseph, so I am forgetting you *morbleu!*
and our friends and *le bastidon*[c] and your brother and the
good wine of Provence; you know it is detestable, what
you get here. I do not want to write an elegy in these few
lines, yet, I must confess, my heart is not very gay. I
fritter away my petty existence to right and to left.

[a] This was the 'Salon' which took place every two years and is
mentioned by Cézanne himself in the following letter to Huot.

[b] J. Huot (1840–98), boyhood friend of Cézanne. Together they
attended the evening courses at the Art School in Aix. Huot studied
at the Ecole des Beaux-Arts in Paris in 1864 and, from 1887 onwards,
was chief architect in Marseille. See Cézanne's letter to Zola, 14th
September 1878.

[c] Where Huot's friends and brothers used to meet.

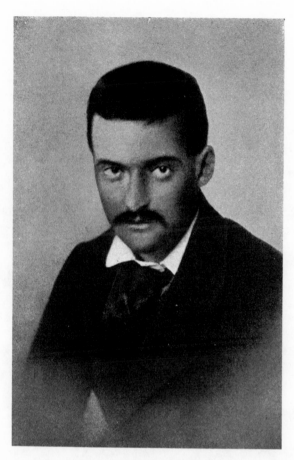

5. Paul Cézanne, 1861
Photograph

Suisse[a] keeps me busy from six o'clock in the morning until eleven. I have some sort of a meal for 15 sous; it is not a lot; but what can you expect? I am not dying of hunger, anyway.

I thought that when I left Aix I should leave behind the boredom that pursues me. I have only changed place and the boredom has followed me. I have left my parents, my friends, some of my habits, that's all. Yet I admit that I roam about aimlessly nearly all day. I have seen, naive thing to say, the Louvre and the Luxembourg and Versailles. You know them, the pot-boilers [*tartines*] which these admirable monuments enclose, it is stunning, shocking, knocks you over. Do not think that I am becoming Parisian. . . .

I have also seen the Salon. For a young heart, for a child borne for art, who says what he thinks, I believe that is what is really best, because all tastes, all styles meet there and clash there. I could give you some beautiful descriptions and send you to sleep. Be grateful to me for sparing you.[42]

I saw by Yvon a brilliant battle;
Pils in his drawing of a moving scene
Traces the memory in his stirring picture
And the portraits of those who lead us on a leash;
Large, small, medium, short, beautiful or of a worse kind.
Here there is a river; there the sun burns,
The rising of Phoebus, the setting of the moon,
Sparkling daylight, gloomy twilight.

[a] Cézanne therefore had followed Zola's advice and attended this art school, where he soon became friendly with Guillaumin, Pissarro, Oller and others. He does not seem to have moved in with Zola.

(Here I am at the end of my rhymes, so I should do well to be silent for it would be a bold enterprise on my part to want to give you an idea, even the most meagre, of the style of this exhibition.) There are also some magnificent Meissoniers. I have seen nearly everything and I intend to go back again. It is worth my while.

As my regrets would be superfluous, I shall not tell you how sorry I am not to have you with me to see all this together, but, the devil, that's how it is.

Monsieur Villevieille, where I work every day, sends you a thousand good wishes, also friend Bourck whom I see from time to time. Chaillan sends you his most cordial greetings. Greetings to Solari,[a] to Félicien, to Rambert, to Lelé, to Fortis. *Mille bombes à tous.* I should never finish if I wanted to name them all; tell me, if you can, the result of the drawing of lots[b] for all these friends.

A thousand respects from me to your parents; to you, courage, good vermouth, not too much boredom and *au revoir.*

Good-bye, dear Huot, your friend,

Paul Cézanne

PS.—You have greetings from Combes, with whom I have just had supper. Villevieille has just made the sketch for a picture gigantic in size, 14 feet high, figures of two metres and more.

The great G. Doré has a magnificent picture at the

[a] The sculptor, Philippe Solari, of Aix (1840–1906) was a boyhood friend of Cézanne and Zola. He made an important bust of the young Zola and later two busts of Cézanne in his old age.

[b] This refers to the drawing of lots for military service, which was common in France.

Salon. Good-bye again, my dear; hoping to empty a heavenly bottle.

P. Cézanne
Rue d'Enfer 39

ZOLA TO BAILLE

Paris, 10 June, 1861

... I see Cézanne rarely. Alas! it is no longer as it was at Aix, when we were eighteen, free and without worry about the future. Now the demands of our lives, our different work, keep us apart. In the morning Paul goes to Suisse, I remain in my room to write. At 11 o'clock we lunch, each by himself. Sometimes, at midday, I go to him and he works on my portrait. Then, for the rest of the day he goes to Villevieille to draw; he has his supper, goes early to bed and I do not see him any more. Is that what I had hoped for? Paul is still the excellent, odd fellow whom I knew at school. To prove that he has lost nothing of his originality, I only have to tell you that hardly had he arrived here, when he talked about returning to Aix; to have battled for three years for this voyage and then not to care a straw! With such a character, faced with changes of behaviour so little forseeable and so little reasonable, I admit that I remain speechless and pack up my logic. To prove something to Cézanne would be like trying to persuade the towers of Notre-Dame to dance a quadrille. He would perhaps say yes, but not budge an inch. And note that age has increased his stubbornness without providing him with anything

reasonable to be stubborn about. He is made of one single piece, obstinate and hard in the hand; nothing can bend him, nothing can wring a concession from him. He doesn't even want to discuss his thoughts; he has a horror of discussion, first, because to talk is tiring, and then because he would have to change his view if his opponent were right. So he has been thrown into life with definite ideas, unwilling to change them except when following his own judgment; otherwise, he remains the best fellow in the world, always agreeing, a result of his horror of discussions, but nevertheless following his own little head. When his lips say yes, most of the time his judgment says no. If accidentally he utters a different opinion, and you dispute it, he flares up, not willing to think about it, shouts at you that you don't understand a thing about the problem and jumps on to another subject. How can one discuss—what do I say?—how can one even talk to a fellow of such temper, where you don't gain a finger of ground and are simply left high and dry, observing a very strange character. I had hoped that age would have wrought some changes in him. But I find him much as I left him. My plan of action is therefore quite simple: never to stand in the way of his whims; to give him at most only indirect advice; to rely on his good nature to maintain our friendship, never to force his hand to shake mine; in one word, to efface myself completely, to receive him always gaily, to seek him out without bothering him and to leave it to his pleasure how much or how little intimacy he wishes between us. What I am saying astonishes you perhaps, it is however logical. Paul is for me still a fellow with a good heart, a friend who understands and appreciates me. Only, as everyone has

his own nature, I must wisely conform to his moods if I do not want his friendship to fly away. In order to preserve yours, I would perhaps use reasoning; with him, that would mean losing everything. Don't think that there is a cloud between us; we are still closely united and what I have just been saying has little enough to do with the fortuitous circumstances which separate us more than I would like ...

ZOLA TO BAILLE

Paris, 18 July, 1861

... For some time I have seen Cézanne rather infrequently. He works at Villevieille, goes to Marcoussis[a] etc. Yet nothing is broken between us. I still think of taking a job soon. What is certain is that I shall have one by the time you come ...

I count very much on you. It seems to me that your arrival here will bring about for me greater moral and physical well-being ...

ZOLA TO BAILLE

Paris, beginning of August, 1861

... If anyone puts a general question to me: "What do you think of this man?" I try to dodge politely so as not

[a] A small village, south of Paris, near Monthléry.

to answer. And, in fact, how can one judge a being who is neither pure matter like a picture, nor abstract like an action? What conclusion can one draw from this mixture of good and bad which makes up the human existence? ... That is what I told myself when I thought of my last letter in which I told you about Cézanne. I tried to judge him and in spite of my good faith, I regretted having come to a conclusion which, after all, is not entirely true. Hardly had Paul arrived from Marcoussis, when he came to see me, more affectionate than ever; since then we have been passing six hours together every day; our place of reunion is his little room; there, he paints my portrait; during this time I read or we chat together, then, when work has gone well above our ears, we usually go to smoke a pipe in the Luxembourg. Our conversations range over everything, particularly about painting; our memories also occupy a large place; as to the future, we touch it with one word in passing, either to express a wish for our complete reunion, or to put to ourselves the terrible problem of success. Sometimes, Cézanne delivers a lecture about economy and at the end forces me to go and have a bottle of beer with him. At other times he chants for hours a couplet with stupid words and stupid music; in the end I declare haughtily that I prefer a speech about economy. We are seldom disturbed; some intruders come from time to time and push in; Paul begins to paint furiously; I pose like an Egyptian sphinx and the intruder, thrown completely off balance by so much work, sits down for a minute, doesn't dare to move and goes again with a quiet good-bye, closing the door very gently. I would like to give you still more details. Cézanne has frequent fits of discouragement; in spite of his slightly

affected contempt of fame, I see that he would like to arrive. If things go badly he speaks of nothing less than to return to Aix and become an apprentice in a business firm. I then have to give long talks to prove to him the silliness of such a return; he agrees easily and goes back to work. Yet this thought gnaws at him; twice already he was on the point of departure; I fear that he may escape me from one moment to the other. If you write to him, do talk of our next reunion in the most glowing colours; that is the only means of holding him. We have not yet made any excursions, money holds us back; he is not rich and I even less. However, one of these days we hope to take wing and go to dream somewhere. To sum up, I can tell you that, in spite of its monotony, the life we are leading is not boring; work stops us from yawning; then some memories which we exchange gild everything with a ray of sunlight; do come and we shall be even less bored.

I restart this letter to confirm what I have said above by something which happened yesterday, Sunday. I went to see Paul, who told me in cold blood that he was about to pack his suitcase and depart the next day. In the meantime, we went to a café. I didn't make a speech; I was so surprised and so convinced that my logic would prove useless that I didn't dare to raise the slightest objection. Yet, I was looking for a ruse to keep him; in the end I thought I had found one and asked him to do my portrait. He accepted the idea with joy and this time there was no more question of going back. This damned portrait, which, according to my plan should keep him in Paris, very nearly made him leave yesterday. Having re-started twice, always dissatisfied with himself, Paul

wanted to finish it, and asked me to sit for him for the last time yesterday morning. So I went to him yesterday; entering I saw the open trunk, the half empty drawers; Paul, with a dark face, pushed things around and shoved them without any order into the trunk. Then he said quietly to me: "I leave tomorrow."—"And my portrait?" I said.—"Your portrait," he answered, "I have just crushed it. I wanted to work at it again this morning, and as it became worse and worse, I have annihilated it; and I am going." I still refrained from any remark. We went for lunch together and I only left him in the evening. During the day, he gradually became more reasonable and in the end, when he left me, promised to stay. But this is only bad patchwork; if he doesn't leave this week, he'll leave next week; you can expect to see him go from one minute to the other. I even believe that he is right. Paul may have the genius of a great painter, he'll never have the genius to become one. The slightest obstacle makes him despair. I repeat, he should leave if he wants to avoid a lot of sorrow . . .

In spite of his excellent nature and his rich natural gifts, Paul cannot bear any criticism, however gentle it may be. I leave him to his dreams, putting my hope in heaven . . .

I would certainly go to the south if only Paul wouldn't leave before September, but he will never wait until then. This would mean yet another fortnight of separation. When you see Paul, reproach him severely . . .

P.S. Definitely, Paul remains in Paris until September; but is that his final decision? Still, I hope that he will not change it again.

Back in Aix in Autumn 1861, very disillusioned by his first stay

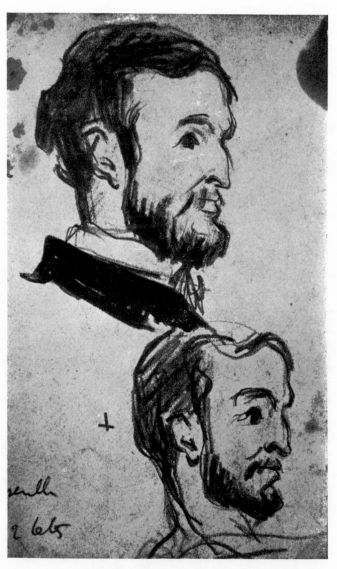

6. Portrait of a Friend, presumably A. F. Marion
Drawing about 1861

in Paris, Cézanne entered his father's bank, where, however, he made only a short stay, during which he covered the margins of the big ledger with drawings and verses such as: 'Cézanne the banker witnesses with trepidation the birth of a future painter behind his counter.' The correspondence between the two friends took some time to start again. Cézanne broke the silence by a letter to which Zola replied on the 20th January, 1862. None of the letters written to Zola by Cézanne during 1862 has been preserved.

ZOLA TO CEZANNE

Paris, 20 January, 1862

My dear Paul,

It is a long time since I wrote to you, I don't quite know why. Paris has done our friendship no good; perhaps it needs, to live merrily, the sun of Provence? No doubt it is an unhappy misunderstanding which has brought a coolness into our relations; some ill-judged incident or mischievous word received too willingly. I don't know and I don't want to know. Stirring up filth, one soils one's hands. Never mind, I still consider you my friend; by which I mean that you believe me incapable of mean action and that you think as highly of me as in the past. Should it be otherwise, it would be good if you could explain and tell me frankly what you reproach me for. But it is not a letter full of explanations which I want to write. I only want to answer your letter as your friend, and talk to you a bit, as if your voyage to Paris had never taken place.

You advise me to work and you do that with so much

insistence that one would think work repelled me. I want to persuade you of this: that my fervent desire, my thought every day is to find a job; that nothing but the impossibility of finding one, keeps me nailed down in my room; ...

Baille has not misled you when he told you that I would definitely soon join the house of Hachette as an employee.[a] I am waiting for a letter to tell me that there is a vacancy ...

I see Baille regularly every Sunday and Wednesday. We do not laugh very often; it is wolfishly cold and the pleasures of Paris, if there are any, are crazily expensive. We are reduced to talks about the past and the future, because the present is so cold and so poor. Perhaps the summer will bring back some gaiety; if you come in March,[b] as you promise, if I have my job, if fate smiles on us, then we can perhaps live a bit in the present without regretting too much, without desiring too much. But these are many ifs; only one of them has to fail and everything tumbles down.

However, don't think I am completely stupified. I am quite ill, but not yet dead. The spirit is awake and does wonders. I even believe that I am growing through my suffering ...

And you, what are you doing? How have you arranged

[a] In February, 1862 Zola did in fact enter this publishing firm, which still exists today and where he was employed in the advertising department. At the end of 1865, his novel *La Confession de Claude* was published and he was accused by the Paris police of indecency. His office was searched, which created a great uproar among the employees, and, although declared not guilty by the Tribunal, Zola left the *Maison Hachette* soon afterwards to become editor of the paper, *l'Evénement*.

[b] In fact Cézanne did not return to Paris until November.

your life? Do we have to say goodbye to our dreams, and will stupidity come and thwart our plans . . .

ZOLA TO CEZANNE AND BAILLE

Paris, 18 September, 1862

My friends,

The sun shines and I am shut in [*at Hachette*] . . . What are you doing? And why this silence? . . . I expect a letter; will you let me wait long? I am also still waiting for the copy from Paul.

Yesterday, a bird coming from the south passed over my head and I shouted: "Bird, my little friend, have you not seen down there on the road an errant picture?"— "I have seen nothing," answered the bird, "but the dust of the road. Go, be sad, they forget you." He lied, didn't he?

ZOLA TO CEZANNE

Paris, 29 September, 1862

My dear friend,

My faith has returned; I believe and hope. I have set to work with a will; every evening I shut myself into my room and write or read until midnight. The best result is that I have recovered part of my gaiety . . .

I shall pile manuscript upon manuscript in my writing desk, then, one day, I shall let them loose on the papers. I have already written three short stories of about thirty

pages[a] since Baille's departure; . . . give the good news to Baille, and tell him that your return will help to heal the wounds of the past—because honestly the past played a great part in my despair; it nearly annulled the future—now I have got completely over all that.

If there is a hope which has probably contributed to chasing away my depression, it is that of soon being able to shake your hand. I know that that is not yet absolutely certain, but you allow me to hope, that is already a great deal. I approve completely of your idea of coming to Paris to work and then retiring to Provence. I believe that this is a way to escape from the influence of the schools and to develop some originality, if one has any. Therefore, if you come to Paris, so much the better for you and for us. We shall arrange our life, passing two evenings a week together and working on all others. The hours during which we see each other won't be lost; nothing gives me as much courage as to talk for a while to a friend. So, I am expecting you.

Cézanne did in fact return to Paris in the late Autumn of 1862. This is the last of the letters still preserved from the time of their youth, addressed by Zola to Cézanne and to Baille. From the following years we have a number of letters to mutual friends from Aix, like Antony Valabrègue, Marius Roux, Numa Coste and Philippe Solari, in which Zola occasionally mentions Cézanne. These letters are to be found in Zola's 'Oeuvres Complètes', published by his son-in-law, Maurice Le Blond, Paris, 1928 (see the Volume: 'Correspondence, 1858–1871'). Zola's letters to Cézanne and Baille included above are taken from this edition. Zola's later letters to Cézanne seem to have been lost, except for the letters of 20 May, 1883 and 4 July, 1885.

[a] Zola wrote at that time a number of short stories which were published in 1865 under the title *Contes à Ninon*. This was his first publication, followed soon by the novel *La Confession de Claude*, which he dedicated to Cézanne and Baille.

To Numa Coste[a]

Paris, 5 January, 1863.

My dear,

This letter which I address to you is meant for you and Mr. Villevieille at the same time. And first of all, I could have written to you a long time ago, because it is already two months since I left Aix.

Shall I talk to you about the fine weather? no. Only, the sun, until now hidden by clouds, has to-day just put its head through the garret window, and wanting to end this last day gloriously, throws us in departing a few pale rays.

I hope that this letter will find you all in good health. Courage and let us try to be together again in a little while.

As in the past (for it is right that I should tell you what I am doing), I go to Suisse in the morning from eight until one o'clock and in the evening from seven to ten. I work calmly and eat and sleep that way too.

I go fairly often to see Mr. Chautard who has the kindness to correct my studies. The day after Christmas, I had supper with them and tasted the *vin cuit* that you sent them, oh monsieur Villevieille, and your little girls, Fanny and Thérèse, are they well, at least I hope so, and all of you too? My respects, I beg you, to Mme. Villevieille, to your father, to your sister, to you also. By the way, is the picture, of which I saw you doing the sketches, going well? I spoke to Mr. Chautard about it, he praised

[a] Numa Coste (1843–1907) historian, journalist and painter, was a boyhood friend of Cézanne and Zola; he remained in permanent contact with Zola, but in later years lost touch with Cézanne.

the idea of it and said that you should be able to make something good of it.

Oh Coste, young Coste, do you go on annoying the *reverendissime* Coste the elder? Are you still painting, and the academic soirées at the school, how are they going, tell me who is the poor wretch who poses for you like an X, or holds his belly? Have you still got the two ugly apes from last year?[a]

It is now nearly a month since Lombard came back to Paris. I learned, not without sorrow, that he attends the Signol studio. This worthy gentleman makes them learn a certain hackneyed style which leads to doing just what he does himself; that's all very well, but not admirable. To think that a young intelligent man had to come to Paris to lose himself. However, the novice Lombard has made great progress.

I also love Félicien, Truphémus's[b] fellow student.

The dear boy sees everything through the eyes of his *illustrissime* friend and only judges after his friend's colours. According to him, Truphème dethrones Delacroix, he alone can produce colour, and also thanks to a certain letter, he goes to the Beaux-Arts. Don't think that I envy him.

I have this moment received a letter from my father announcing his impending arrival for the 13th of this month; tell M. Villevieille to give him any commission he likes and that, as for M. Lambert (my address for the moment being Impasse Saint-Dominique d'Enfer) he should write some instructions, or have them written,

[a] Cézanne, Coste and other friends attended from 1858–62 evening classes at the Ecole des Beaux Arts in Aix.

[b] The painter Auguste Truphème (1836–98), had a grant from the town of Aix to enable him to study painting.

about the object, the place where it is to be bought and the best way of sending it; I am at his service. Meanwhile I yearn for:[43]

The days when we went to the fields of the Torse[a]
To eat a good lunch, and palette in hand
Traced on our canvas the landscape around ...

I hope that this present letter which I did not finish at once will find you all in the best of health; my respects to your parents, bonjour to our friends; I shake your hand, your friend and colleague in painting,

Paul Cézanne

Go and see young Penot and say *bonjour* to him from me.

To Numa Coste

Paris, 27 February, 1864

My dear,

You must excuse the paper on which I am answering you; I have nothing else at the moment ... What can I say about your unhappy lot, it is a great calamity which has befallen you and I understand how annoying it must be to you.[b] You tell me that Jules too has had bad luck and that he is going to anticipate the call-up.

[a] A small river on the outskirts of Aix in the direction of the village Le Tholonet.
[b] Numa Coste had just drawn an unlucky number in the conscription lottery and so had to do seven years' military service. Cézanne, who had been passed fit for military service in Paris (the letter in which he tells this to his parents is lost), avoided service by paying a substitute to take his place, which was then customary among well-to-do families. As the only son of a widow, Zola did not have to serve at all.

A supposition (Baille was with me yesterday evening when I received your letter): if by chance you intend anticipating your call-up and you could come to Paris to enlist in a corps here, he might (Baille, I mean) be able to put in a good word for you with the lieutenant of your company because, so he tells me, he knew a great number who came from the same training school as he did, and also from St.-Cyr. What I am telling you is only in case the idea should occur to you to return here, where, even as a recruit, you would have more facilities of all sorts, both as regards leave and easier duties, so that you could devote yourself to painting. It is up to you to decide and to see whether the whole thing appeals to you, and still I fully realise that this is not at all gay for you.—If you can see them, remember me to good old Jules, who can't be very happy, and to Penot, who really should give me news of his family and of his father.

As for me, old man, my hair and beard are longer than my talent.[a] Still, no discouragement from painting, one can easily make one's little way, even as a soldier. I see here some who come to attend the anatomy courses at the *Ecole des Bozards* (where, as you must know, there has been a very great change and the Institute has been swept out).[b] Lombard is drawing, painting and pirouetting more

[a] Two months later Zola wrote to Antony Valabrègue, a mutual friend from Aix, "Cézanne has had his beard shaved off and has sacrificed the tufts on the altar of the victorious Venus."

[b] This refers to an imperial decree of 11th November, 1863 which greatly limited the power of the Institut de France over the Académie des Beaux Arts and abolished the Institute's prerogative to nominate the Professors of the Academy. These measures, though liberal in intention, deeply hurt the 83-years-old Ingres, although, as before, all teachers appointed to the Academy continued to be selected from the members of the Institute.

than ever, I have not yet been able to go and see his drawings, with which he tells me that he is satisfied. For two months I have not been able to touch my [*illegible word*] after Delacroix.[a]

I shall, however, touch it up again before leaving for Aix, which will not be before the middle of July, I believe, unless my father recalls me. In two months, that is to say in May, there will be an exhibition of painting like the one last year, if you were here we could look it over together.[b] Well, may everything turn out for the best. Give my affectionate respects to your parents and believe me, your devoted friend.

<div align="right">Paul Cézanne</div>

I shall soon see Villevieille, he will have greetings from you to me.

[a] This probably refers to his copy of the "Barque du Dante", (Venturi no. 125).

[b] Reference to the Salon (which, in accordance with the imperial decree mentioned above, from then on took place every year instead of every second year), and the Salon des Refusés. In 1863 an exhibition, concurrent with the official Salon, had been arranged of all those paintings refused by the Jury. In spite of the scandal which this had provoked, the Salon des Refusés was repeated in the following year. Although the Jury showed itself much less strict in 1864, some rooms next to the Salon were used to exhibit those paintings which, in the official wording, had been considered as "too weak to take part in the competition for prizes and awards".

To Camille Pissarro[a]

Paris, 15 March, 1865

Monsieur Pissarro,

Forgive me for not coming to see you, but I am leaving this evening for St. Germain and shall only come back on Saturday with Oller[b] to take his pictures to the Salon, for he has painted, so he writes, a biblical battle-scene, I think, and the big picture which you know. The big one is very beautiful, the other I have not yet seen.

I should have liked to know whether, in spite of the misfortune that befell you, you have done your canvass for the Salon.—If sometimes you should wish to see me, I go every morning to Suisse and am at home in the evenings, but give me a rendezvous that suits you and I shall come and shake your hand when I return from Oller's. On Saturday we are going to the barrack of the Champs-Elysées to bring our canvases, which will make the Institute blush with rage and despair.[c] I hope that you will have done some fine landscapes, and shake you warmly by the hand.

Paul Cézanne

[a] Camille Pissarro (1830–1903), whom Cézanne had met through the painter Armand Guillaumin at the *Atelier Suisse*, was of all the Impressionists the one with whom Cézanne became most friendly and whom he looked upon as his master. Cézanne introduced him also to Zola and from 1866 onwards Pissarro often came to Zola's literary soirées.

[b] Francisco Oller, born in Porto-Rico, pupil of Courbet and Couture, was a friend of Pissarro. Cézanne had met Oller also at *Suisse*. In 1866 Oller lived in Paris in the same house as Cézanne: 22, rue Beautreillis. Cézanne's letters to Oller in 1895 show that their friendship later deteriorated.

[c] Pissarro's two landscapes, one of them painted on the banks of the Marne, were accepted by the jury; in the Catalogue Pissarro described himself as a pupil of Corot. One of Oller's pictures was also accepted, while Cézanne's paintings were refused.

To Heinrich Morstatt[a]

Aix, 23 December, 1865

Postscript to a letter written by Antoine Fortuné Marion[b] to Heinrich Morstatt, inviting him to come to Aix-en-Provence for Christmas.

The undersigned begs you to accept Fortuné's invitation, you will cause our accoustic nerves to vibrate to the noble tones of Richard Wagner. I beg you to do this . . . please accept my sincere compliments and crown our wish by acceding to it. I am signing, also for Fortuné,

Your old

Paul Cézanne

To M. de Nieuwerkerke
Superintendent of the Beaux-Arts

Paris, 19th April, 1866

Sir,

Recently I had the honour to write to you about the two pictures that the jury has just turned down.[c]

[a] The German musician Heinrich Morstatt (1844–1925), spent his business apprenticeship from 1864–67 in Marseille, where he became friendly with A. F. Marion, a student of the natural sciences, who introduced him to Cézanne. Morstatt later became director of a music school in Stuttgart.

[b] Marion (1846–1900) was a boyhood friend of Cézanne and Zola. Later he became Professor of Zoology at the University of Marseille and Director of the Natural History Museum there. He also painted and was greatly influenced by Cézanne, for whom he repeatedly sat as a model.

[c] This letter has apparently been lost.

As you have not yet answered me, I feel I must remain firm about the motives which led me to apply to you. Moreover, as you have certainly received my letter, there is no need for me to repeat the arguments that I thought necessary to submit to you. I content myself with saying again that I cannot accept the unauthorized judgment of colleagues to whom I myself have not given the task of appraising me.[a]

I am therefore writing to you to insist on my petition. I wish to appeal to the public and to be exhibited at all costs. My wish appears to me not at all exorbitant and, if you were to interrogate all the painters who find themselves in my position, they would all reply that they disown the Jury and that they wish to participate in one way or another in an exhibition which would perforce be open to all serious workers.[b]

Therefore let the *Salon des Refusés* be re-established. Even were I to be there alone, I should still ardently wish that people should at least know that I no more want to be mixed up with those gentlemen of the Jury than they seem to want to be mixed up with me.

I trust, Monsieur, that you will not continue to keep silent. It seems to me that every decent letter deserves a reply.[c]

[a] Only those artists who had already received awards in the Salon were entitled to vote in the election for the Jury. As Cézanne had not yet been accepted for the Salon, he had, of course, no vote.

[b] Apart from Cézanne, this time Manet and Renoir had also been refused. Of the future Impressionists, Degas, Monet, Morisot, Pissarro and Sisley had been accepted.

[c] On the margin of this letter the draft for the answer reads: "What he asks is impossible, it has been recognised how little suitable the exhibition of the 'refusés' was for the dignity of art and it will not be repeated."

Please accept, I beg you, the assurance of my most distinguished sentiments.

Paul Cézanne

2, rue Beautreillis

In spite of this impetuous request, no exhibition of the 'Refusés' took place in 1866. Zola who, a few weeks before, had been appointed literary editor of the Paris daily 'L'Evénement' had asked the director, without waiting for his answer to Cézanne's letter, to entrust him with the Review of the Salon. On the same day on which Cézanne wrote his second letter to M. de Nieuwerkerke (above), Zola announced in 'L'Evénement' that, in order to relieve his heart, he would attack the jury sharply, telling them the unvarnished truth. He did in fact, from the end of April to the middle of May, publish a number of articles in which he attacked the jury, made fun of the professors of the Académie des Beaux Arts and especially praised Manet, whose pictures had been refused. His unconventional views roused a storm of indignation and Zola was asked to stop his reviews, which he had planned as a series of 16–18 articles. After the first few, he published a 'Farewell' notice and decided to put the whole series together in a brochure with the following dedication to Cézanne in the form of a letter:

EMILE ZOLA: TO MY FRIEND PAUL CEZANNE

Paris, 20 May, 1866

It gives me an immense pleasure, my friend, to be able to talk to you alone. You can't imagine how much I have suffered during this battle which I have just had with the crowd, with unknown people; I felt myself so little understood, I sensed such a hatred around me, that despair often made the pen fall out of my hand. Today I can allow myself the great pleasure of one of our intimate talks which we have had for ten years. It is for you alone

that I write these few pages, I know that you will read them with your heart and that, tomorrow, you will love me with even greater affection.

Imagine that we are alone, in some out-of-the-way corner, remote from all battles and that we talk as old friends who know each other's hearts and understand each other with a glance.

For ten years we have talked art and literature. We have lived together—do you remember?—and often daylight has taken us by surprise, while we were still talking, leafing through the past, questioning the present, trying to find the truth and to create for ourselves an infallible and perfect religious faith. We have turned over terrible mountains of ideas, we have examined and rejected all systems and, after this hard labour, have come to the conclusion that, outside an active and individual life, there is nothing but lies and stupidity.

Happy are those who have memories. In my life, I see you like the pale young man about whom Musset talks. You represent the whole of my youth; I find you involved with all of my pleasures, with all of my sufferings. Our brotherly spirits have developed side by side. Today, at the beginning of our careers, we have faith in ourselves, because we have penetrated our hearts and skins.

We have lived in our own shade, isolated, not very sociable, enjoying each others' thoughts. In the midst of the complaisant and superficial crowd we felt lost. We looked for personality in everything; in every work, painting or poem, we looked for a personal note. We maintained that the masters, the geniuses, were creators who, every one of them, had created a world out of many pieces and we rejected the followers, the impotent ones,

whose metier it is here and there to steal a few scraps of originality.

Do you realise that we were revolutionary without knowing it? I have now been able to say aloud what for ten years we have been saying quietly to each other. The noise of the battle has penetrated to you,—hasn't it?—and you have noticed the good reception given to our cherished thoughts. Oh! these poor boys who lived so healthily in the heart of Provence under the bright sun, hatching out such folly and such bad faith!

For—you probably didn't know this—I am a man of bad faith. The public has already ordered several dozen straitjackets for me, to take me to the madhouse at Charenton. I praise only my relatives and my friends, I am an idiot and a crook, looking for scandal.

That is pitiable, my friend, and very sad. Will history always be the same? Does one always have to howl with the mob or be silent? Do you remember our long conversations? We agreed that even the smallest new truth could not see the light of day without exciting fury and jeers. And now it is my turn to be whistled and shouted at . . .

There they are, the torn up pages of a study which I have not been able to complete . . .

It's an excellent story, my friend. For nothing in the world would I destroy them [*his reviews of the Salon*]; by themselves they are not worth much, but they were, so to speak, the touchstone by which I tested the public. Now we know how unpopular our cherished ideas are.

Yet it pleases me to spread them out here a second time. I have faith in them, I know that in a few years the whole

world will say that I am right. I am not afraid that one day they will be thrown into my face.

<div style="text-align: right">Emile Zola</div>

Cézanne spent the summer of 1866 in Bennecourt, a village on the right bank of the Seine, opposite Bonnières, about ten kilometres from Nantes in the direction of Rouen. It seems likely that one of his new Paris acquaintances, the painter Antoine Guillemet (1841–1918), a friend of Pissarro and Courbet and a pupil of Corot and Daubigny, had drawn Cézanne's attention to this place, especially as Daubigny often used to paint there.

Zola visited Cézanne repeatedly in Bennecourt during the summer. On June 14th he wrote to Numa Coste: "I go away to the country to join Paul. Baille is coming with me and we shall be away from Paris for a week ... As was to be expected, Paul has been refused by the Salon jury, so has Solari and all the others whom you know. They have gone back to work and are convinced that they have ten years in front of them before they can count on being accepted."

On July 26th, almost four weeks after Cézanne's letter of 30th June 1866, Zola wrote again to Coste: "Three days ago I was still with Cézanne and Valabrègue in Bennecourt. Both are still there and will return only at the beginning of next month. The place is a veritable artists' colony. We have dragged Baille and Chaillan there and later we shall take you there as well."

In two early short stories, 'La Rivière' and 'Une Farce, ou Bohème en Villégiature', Zola has described the atmosphere of these happy get-togethers:

"In the evenings, after supper, the whole company stretches out on two bundles of straw which generous Mother Gigoux has spread out on the ground in the courtyard of the inn. To the disgust of the peasants, who find it impossible to get to sleep, wild theoretical discussions are held well up to midnight. People smoke their pipes and look at the moon. On the slightest difference of opinion, they call each other idiots and cretins ... the famous celebrities of the moment are being run down ... everybody becomes intoxicated by the hope of soon overthrowing everything which exists in order to produce a new art, whose prophets they expect to be. These young people on their

bundles of straw in the stillness of the night, are conquering the world."

Although introduced under different names, Cézanne, Chaillan, Solari and his mistress, Valabrègue, Guillemet, and also Zola himself and his future wife, are easily recognisable. What especially contributed to the liveliness of the discussions, was the fact that the writers and poets took the side of romanticism, while the painters defended realism. Zola intended, on the basis of these discussions, to produce a book about 'the work of art face to face with its critics', a work which, however, he never wrote. About Cézanne's work in Bennecourt, Zola reported to Coste: "He develops more and more in the original direction which his nature prescribes for him. I have great hopes for him . . . at the moment he is engaged in painting works, great works, on canvases 4 to 5 metres wide."

To Emile Zola

Bennecourt, 30 June, 1866

My dear Emile,

I received the two letters you sent me in which were the sixty francs, for which I thank you very much because I am more unhappy than ever when I haven't a sou. So nothing amusing happens of which you do not speak at length in your last letter. Impossible to get rid of the *patron.*ᵃ I don't know for certain which day I shall be leaving, but it will be Monday or Tuesday.ᵇ I have done

ᵃ This was 'Père Dumont' who, together with his wife, née Rouvel (in Zola's short story called 'Mother Gigoux'), ran the small shop and the only inn at Bennecourt.

ᵇ Cézanne, however, must have postponed his departure because, in the middle of July, Zola still visited him in Bennecourt and then wrote to Numa Coste: "Soon, either in August or at the end of September, he will go to Aix, but stay there no more than two months." In fact, Cézanne stayed in Aix right up to the end of the year and Guillemet visited him there.

little work, the fête at Gloton[a] was last Sunday the 24th, and the brother-in-law of the *patron* came, a whole heap of idiots.—Dumont will leave with me.

The picture is not going too badly, but a whole day passes very slowly; I ought to buy a box of water-colours to work during the time I do nothing to my picture. I am going to change all the figures in my pictures; I have already given Delphin[b] a different posture—like a hair— he is like that, I think it is better. [*Here follows a drawing of a man stoking a fire.*] I am also going to alter the two others. I have added a bit of still life to the side of the stool, a basket with a blue cloth and some green and black bottles.[c] If I could work at it a little longer it would go fairly quickly, but with scarcely two hours a day, it dries too rapidly, it is very annoying.

Really these people should pose for one in the studio. I have begun a portrait out-of-doors of old father Rouvel,[d] which is not turning out too badly, but it must still be worked over, particularly the background and the clothes, on a canvas of 40, a little longer than one of 25.

Tuesday night and last night I went fishing, with Delphin, in the holes, I caught more than twenty at

[a] A small place, only a few hundred metres from Bennecourt. Zola repeatedly returned to Bennecourt and Gloton during the next few years.

[b] This was Delphin Levasseur, one of the sons of the village smith, who also let rooms to summer visitors and where Zola occasionally stayed. As the 14-year-old Delphin had to help his father in the smithy, he could not spare more than two hours modelling for Cézanne.

[c] It is not possible from the indications given by Cézanne to identify the picture in question. Probably it was lost or destroyed.

[d] The 70-year-old father of Mme. Dumont, the wife of the landlord.

7. Letter to Zola, 30th June, 1866

least in a single hole.[a] I took six, one after the other, and once I got three at one go, one in the right and two in the left; they were rather beautiful. It's easier, all this, than painting, but it doesn't lead far.

My dear, *à bientôt*; and my respects to Gabrielle,[b] as well as to you.

Paul Cézanne

On my behalf, thank Baille, who is saving me from the need for money.

Food here is getting too meagre and trichinous, in the end they will give me something to eat only when I beg for it.

And my greetings to your mother whom I was forgetting, *mille pipes*.

TO EMILE ZOLA

Aix, circa 19 October, 1866

My dear Emile,

For some days it has been raining in a determined way. Guillemet[c] arrived on Saturday evening, he has spent

[a] These were no doubt freshwater crabs, which in small running streams are fished at night with the help of lanterns, when, blinded by the light, they can often be caught with bare hands. In the neighbourhood of Aix they are also caught in this way.

[b] Gabrielle-Eléonore-Alexandrine Meley who in 1870 was to become Madame Zola. The novelist met her about 1863–64 at the house of Cézanne who, together with Marius Roux, Philippe Solari and Paul Alexis, acted as witness at their marriage.

[c] Guillemet, who had already visited Cézanne in Bennecourt, tried during his stay at Aix to obtain a higher monthly allowance for Cézanne from his father. He remained on friendly terms with Cézanne and especially with Zola.

some days with me and yesterday—Tuesday—he went to a small place, good enough, which costs him 50 francs a month, linen included. In spite of the driving rain the countryside is magnificent and we have done a bit of sketching. When the weather clears up he will start work seriously. For my part, idleness overwhelms me, for the last four or five days I have done nothing. I have just finished a little picture, which is, I believe, the best thing I have yet done; it represents my sister Rose[a] reading to her doll. It is only one metre, if you like I will give it to you; it is the size of the frame of the Valabrègue.[b] I shall send it to the Salon.[c]

Guillemet's lodging consists of a kitchen on the ground floor, a salon looking on to the garden which surrounds the country house. He took two more rooms on the first floor with a closet. He only has the right wing of the house. It is at the beginning of the *route d'Italie* just opposite the little house where you used to live and where there is a pine-tree, you must remember it. It is next to Mère Constalin who kept a music-pub.

But you know all pictures painted inside, in the studio, will never be as good as those done outside. When out-of-door scenes are represented, the contrasts between the figures and the ground is astounding and the landscape

[a] Rose Cézanne, born in 1854, was the younger sister of the painter, 15 years younger than her brother. Marie, the other sister was born in 1841. In 1881 Rose married Maxime Conil by whom she had several children. See Cézanne's letters to his nieces Marthe and Paule Conil (his god-child).

[b] The poet and art historian Antoine Valabrègue (born 1845), boyhood friend of Cézanne and Zola, later became an art critic in Paris. Cézanne painted several portraits of him.

[c] To judge from the catalogue this picture was not accepted. It appears to have been lost.

is magnificent. I see some superb things and I shall have to make up my mind only to do things out-of-doors.

I have already spoken to you about a picture I want to attempt; it will represent Marion and Valabrègue setting out to look for a motif (a landscape motif of course). The sketch, which Guillemet considers good and which I did after nature, makes everything else fall down and appear bad.[a] I feel sure that all the paintings by the old masters representing subjects out-of-doors have only been done with skill [*chic*] because all that does not seem to me to have the true, and above all original, appearances provided by nature. Père Gibert of the museum invited me to visit the Musée Bourguignon. I went there with Baille, Marion, Valabrègue. I thought everything was bad. It is very consoling. I am fairly bored, work alone occupies me a little, I am less despondent when someone is there. I see no one but Valabrègue, Marion and now Guillemet.

Here follows a sketch after the portrait of his sister:

This gives you some slight idea of the morsel I am offering you! My sister Rose is in the centre, seated, holding a little book that she is reading. Her doll is on a chair, she in an armchair. Background black, head light, headdress blue, blue pinafore, frock dark yellow, a bit of still-life to the left: a bowl and children's toys.

Remember me to Gabrielle, also to Solari and Baille who must be in Paris with his *frater*.

I take it that now the trials of the dispute with Ville-

[a] Only the sketch of this picture is known (Venturi no. 96). The full version came to nothing; see Cézanne's letter to Zola of 2nd November, 1866.

messant[a] are over you will feel better, and I hope that your work is not too much for you. I learned with pleasure of your introduction into the great paper.[b] If you see Pissarro give him friendly greetings from me.

But I repeat that I have a little attack of the blues, though for no reason. As you know, I don't know what it comes from, it comes back every evening when the sun sets, and now it is even raining. It makes me feel black.

I think I shall send you a sausage one of these days, but my mother must go and buy it, otherwise I shall be cheated. It would be very . . . annoying.

Just imagine that I hardly read any more. I don't know whether you will be of my opinion, and that would not make me change mine, but I am beginning to see that art for art's sake is a mighty humbug; this *entre nous*.

Sketch of my future picture out-of-doors. (Here a sketch of Marion and Valabrègue on their way to the 'motif').
P.S. For four days I have had this letter in my pocket and I feel the urge to send it to you; Goodbye, my dear,

<div align="right">Paul Cézanne</div>

To Camille Pissarro

<div align="right">*Aix, 23 October, 1866*</div>

My dear friend,

Here I am with my family, with the most disgusting people in the world, those who compose my family stinking more than any. Let's say no more about it.

[a] Villemessant was the director of the paper 'L'Evénement' in which in May 1866 Zola had published a series of articles about the Salon, which he had to break off owing to vehement protests by the public.
[b] This must refer to 'Le Figaro' which Zola joined in 1867.

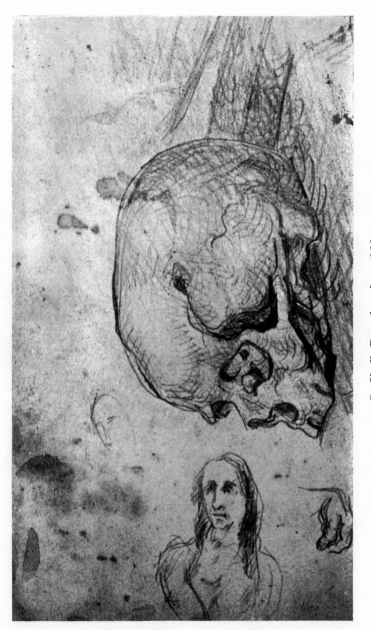

8. Skull, *Drawing about 1866*

I see Guillemet every day and his wife, who have found quite good lodgings, Cours Ste-Anne 43. Guillemet has not yet started on big pictures, as a prelude he has begun with some small paintings which are very good. You are perfectly right to speak of grey, for grey alone reigns in nature, but it is terrifyingly hard to catch. The country here is very beautiful, much individual character, and Guillemet did a study yesterday and today in grey weather, which was most beautiful. His studies seem to me much freer than the ones he brought back from Yport last year. I am delighted with them. Anyway you will be able to judge better when you see them. I add nothing except that he is going to start a big picture as soon as possible, the moment the weather improves. In the next letter which we shall write to you there will probably be some good news about it.

I have just posted a letter to Zola.

I work a little all the time, but paints are scarce here and very expensive, misery, misery! Let us hope, let us hope, that we shall sell. We will sacrifice a golden calf then. You don't send anything to Marseille, well, neither shall I. I do not want to send again, all the more because I have no frames, and because it makes me spend money which it is better to devote to painting. I say this for myself, and damn the jury.

The sun will, I think, still give us some fine days. I am very sorry that Oller, as Guillemet tells me, cannot come back to Paris as he may be very bored at Porto Rico and then too with no colours within reach it must be very difficult to paint. And so he told me that it would be a good thing for him to get work on a merchant ship coming straight to France. If you write to us again some

time please tell me how to write to him, that is to say, the address I must put on the letter and the correct way of stamping it so as to avoid unnecessary expense for him.

I clasp your hand affectionately and after having submitted this letter to be read by sieur Guillemet and acquainting him with yours, I shall take the present one to the post.

Give my kind regards to your family please, to Mme. Pissarro and your brother. I say *bon jour*.

Paul Cézanne

Ps. written by A. Guillemet:

To-day, 23rd October, 1866, year of Grace

Dear old Pissarro,

I was going to write to you when yours arrived. I am feeling quite well at the moment and Alphonsine too. I have made some studies and I shall attempt my big stuff, if autumn helps me. Cézanne has done some very beautiful paintings. He is painting in light tones again and I am sure that you will be pleased with two or three pictures he will bring back. I am not yet quite sure when I shall return, probably when my pictures are finished.

So you are back in Paris and I expect your wife is better there than in Pontoise. The babies are well, I take it, and if you should get too bored, give us your news. We often speak of you and shall be happy to see you again. Always yours. My wife and I send a thousand greetings to you all.

A bientôt

A. Guillemet

To Emile Zola

Letter written by A. Guillemet with a Postscript by Cézanne:

Aix, Friday, 2 November *1866*.

My dear Zola,

. . . In his two letters Paul has written more about me than of himself. I shall do the same thing, that is to say the opposite, and talk to you a lot about the master. His exterior is if anything more beautiful, his hair is long, his face exhales health and his very dress causes a sensation in the Cours.[a] So you can be quite re-assured on that score. His mind, although always on the boil, leaves him moments of clarity and his painting, encouraged by some genuine commissions, promises to reward his efforts, in a word 'the sky of the future seems at times less black'. When he returns to Paris you will see some pictures that you will like very much; among others an '*Ouverture du Tannhauser*'[b] which could be dedicated to Robert, for there is a very successful piano in it; then a portrait of his father in a big arm-chair, which looks very good. The painting is light in colour and the attitude very fine, the father looks like a pope on his throne, were it not for the '*Siècle*'[c] that he is reading. In a word all goes well and in a short time from now we shall see some very beautiful things, you may be sure.

The people of Aix continue to irritate him, they ask to be allowed to come and see his paintings, only to scoff at

[a] The Cours Mirabeau is the main street of Aix.

[b] This picture is in the Hermitage, Leningrad (Venturi no. 90).

[c] Actually he is reading 'L'Evénement', doubtless in honour of Zola, who had just published some daring articles about the Salon in this paper. The picture is now in the Mellon Collection, National Gallery, Washington (Venturi no. 91).

them afterwards, and so he has discovered a good way of dealing with them: "I shit on you," he says to them, and these people devoid of temperament flee in horror. In spite, or perhaps because, of that there is obviously a movement towards him, and I think the time is approaching when he will be offered the directorship of the museum.[a] Which I greatly hope, because either I know him little or else we shall be able to see there some pretty successful landscapes done with the spatula, which have only this chance of getting into any museum whatever ...

With regard to young Marion, whom you know by reputation, he cherishes the hope of being given a professorship in Geology. He excavates hard and tries to demonstrate to us that God never existed and that it is a put-up-affair to believe in him. About which we bother little for it is not painting ...

We got a letter from Pissarro who is well ... We have often been to the Barrage.[b] We shall return to Paris towards the end of December ...

I have added a double sheet because I think Paul will want to write to you on the same occasion; in the same envelope you will have all our greetings. I clasp your hand. Your devoted friend,

A. Guillemet

[a] After the proclamation of the Republic on 4th September, 1870, Baille, Leydet, Vallabrègue and Cézanne's father, then 72 years old, were made City Councillors of Aix and Cézanne himself became a member of the Commission for the Ecole des Arts and the Museum. But as Cézanne, in order to avoid being called up, went into hiding in the nearby L'Estaque, he never took part in the sessions of this commission.

[b] A big retaining sluice near Aix, constructed by Zola's father.

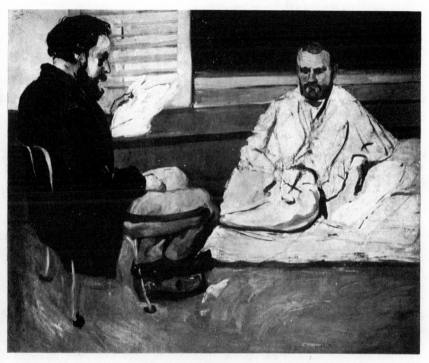

9. Paul Alexis reading aloud to Zola
Oil, about 1869

Postscript by Cézanne:

My dear Emile,

I am taking advantage of Guillemet's writing to you to send you my greetings, but without having anything new to add. I must tell you, however, that as you feared, my big picture of Valabrègue and Marion has not come off and that having attempted a *Soirée de Famille*, that hasn't come off at all. However, I shall persevere and perhaps another shot will be successful. We went for a third walk with Guillemet, it is very beautiful. I clasp your hand and also Gabrielle's

<div style="text-align: right">Paul Cézanne</div>

Greetings to Baille, who sent his to me in his letter addressed to Fortuné Marion, geologist and painter.

In January 1867 Cézanne was back in Paris. In Spring, he was once more refused by the jury of the Salon. In May his mother visited him in Paris and then in June returned with him to Aix, where he remained until Autumn. From October 1867 until the middle of May 1868 he was again in Paris and stayed once more at 22 rue de Beautreillis. It was at that time that he applied for a student's card for the Louvre. The jury of the Salon refused his entries in 1868 also.

To Numa Coste

Monsieur
M. Numa Coste
Sergent, élève d'administration[a]
Place Duplex
in town
Le Vaguemestre.

Paris, Wednesday, 13 May, 1868.

My dear Numa

I have lost the address you gave me. I think that in addressing these lines place Duplex (in spite of the incorrectness of the address) I shall have the happiness of seeing that it reaches you. In consequence I beg of you to come on Thursday the 14th, at 5 o'clock, 2 minutes and a half or thereabouts, at the Pont Royal, I believe at the place where it merges into the place de la Concorde, and from there we shall have the pleasure of dining together, because on Saturday I am leaving for Aix.

If you have a letter or some other commission for your family I shall be your faithful Mercury. Ever your old

Paul Cézanne

If you are unable to come to-morrow, make it Friday, same time, if you like, good-bye.

[a] Numa Coste had followed Baille's advice which Cézanne had passed on to him in his letter of 27th February, 1864 and had enlisted in Paris.

To Heinrich Morstatt

Aix, 24 May, 1868

Postscript to a letter from Antoine Fortuné Marion

My dear Morstatt,

So we shall have the pleasure of seeing you again without having to wait for a better world since, according to your last letter, you have come into your money. I am very happy about this piece of good fortune for you, because all of us together are striving after art, and material difficulties should not disturb the work that is so necessary for the artist. I press with warm sympathy the hand that no longer defiles itself in philistine occupations. I had the good fortune to hear the overtures of 'Tannhauser', 'Lohengrin' and 'The Flying Dutchman'.

Greetings, Always yours

Paul Cézanne

To Numa Coste

Aix, in the first days of July *1868*

My dear Coste,

It is already several days since I had news of you and I shall be hard put to it to tell you anything new about your homeland so far away from you.

Since my arrival I have been in the open, in the country.[a] I have certainly been on the move several times; one evening and then another I ventured to the house of your father whom I did not find in, but one of these days,

[a] Cézanne was at the Jas de Bouffan.

right in the middle of the day, I certainly hope to discover him.

As for Alexis,[a] he was kind enough to come and see me, having learnt from the great Valabrègue of my return from Paris. He has even lent me a little revue by Balzac from the year 1840;[b] he asked me if you were continuing with your painting, etc ... you know all the things one says when talking. He promised to come back and see me; I haven't seen him again for more than a month. For my part, and particularly after receiving your letter, I directed my steps in the evening towards the Cours,[c] which is a little contrary to my solitary habits. It is impossible to meet him. However, pushed by a great desire to fulfil my duty, I shall attempt a descent on his home. But on that day I shall first change my shoes and shirt.

I have had no more news of Rochefort and yet the noise of *La Lanterne*[d] has penetrated even here.

I did see a little of Aufan, but the others seem to hide themselves and a great empty space seems to surround one when one has been absent from the country for some time. I shall not speak to you about him. I don't know whether I am living or simply remembering, but everything makes me think. I wandered alone as far as the Barrage and to Saint-Antonin.[e] I slept in a hay-barn with

[a] Paul Alexis (1847–1901), writer of novels and intimate friend of Zola.

[b] Balzac was the editor of the *Revue de Paris* and had published in it in 1840 an important essay about Stendhal's *Chartreuse de Parme*.

[c] The Cours Mirabeau, the main street of Aix.

[d] The political journalist Henri de Rochefort, a well-known opponent of the Regime, was editor of the opposition paper 'La Lanterne'.

[e] A village at the foot of the thousand-metre high mountain of Ste. Victoire, which suddenly rises out of the undulating plain, about 10 kilometres from Aix.

the Miller family, good wine, good hospitality. I re-membered our attempts at climbing. Shall we not try them again? How bizarre our life, how dispersed and how difficult it would be for us at this hour when I speak, the three of us and the dog, to be where we were before, only a few years ago.

I have no amusements but the family and a few copies of 'Siècle' where I find unimportant news. Being alone I venture with difficulty into the café. But at bottom I am always hoping.

Do you know that Penot is at Marseille? I was not lucky nor was he. Always I was at Saint-Antonin when he came to see me in Aix. I shall try to go to Marseille one day and we shall talk about absent friends and drink their health. In one letter he wrote, "And the beer mugs will fly".

PS. I left this letter unfinished when in the middle of the day Dethès and Alexis dropped in on me. You can imagine that we talked literature, that we refreshed our-selves, for it was very hot that day.

Alexis was kind enough to read to me a piece of poetry that I thought very good indeed, then he recited to me from memory a few verses of another one called 'Symphonie en la mineur'. I thought those few verses were more unusual, more original, and I complimented him on them. I also showed him your letter, he told me he would write to you. In the meantime I send you his love, also from my family to whom I showed your letter, thank you very much for it, it is like dewdrops in the glowing sun. I also saw Combes who came here to the country. I shake you vigorously by the hand, yours from the heart,

Paul Cézanne

To Numa Coste

<p style="text-align:center">Aix, towards the end of November, 1868

It is Monday evening.</p>

My dear Numa,

I cannot tell you exactly the date of my return. But it will probably be during the first days of December, about the 15th. I shall not fail to see your parents before my departure and bring you whatever you want.

Especially as a case of linen has to be sent to me by goods train, I can take several things.

I saw your father quite some time ago, and we went to see Villevieille. Speaking about it to you reminds me to go and see him, and above all not to forget him at the moment of my departure. But I shall write down on a piece of paper all the things I must do and the people I must see and cross them out as I get them done, and so I shall forget nothing. You have given me great pleasure by writing to me for that rouses one from the lethargy into which one finally falls. The lovely expedition we were to have made to Ste-Victoire has fallen into the water this summer because of the excessive heat, and in October because of the rains; you can see from this what softness begins to spread in the will-power of the little comrades. But what can one do, that's how it is, it seems that one is not always fully responsive, in Latin one would say *semper virens*, always vigorous, or better, always strong-willed. As for news from here, I shan't give you any, because except for the creation of 'Galoubet' in Marseille, I don't know anything new. And yet, Gibert *Pater*,[a] bad

[a] Joseph Gibert (1808–84), professor at the Ecole de Dessin and keeper of the museum at Aix.

painter, has refused Lambert permission to photograph some pictures at the Musée Bourguignon, thus cutting off his work. Refusal to Victor Combes to copy, etc. Noré is a dunce. They say he is doing a picture for the Salon.

All this is goitrous. Papa Livé has been sculpting for 58 months a bas-relief of one metre, he is still at the eye of saint XXX. It appears that the Honourable d'Agay, the young fashionable whom you know, one day enters the Musée Bourguignon, and there Mamma Combes says to him, "Give me your cane, papa Gibert will have none of that". "I don't care a fig," says the other. He keeps his cane. Gibert *pater* arrives, he wants to make a scene. "I shit on you," shouts d'Agay. Authentic.

M. Paul Alexis, a boy who is, by the way, far superior and, one can safely say, not stuck-up, lives on poetry and other things. I saw him a few times during the fine weather, only quite recently I met him and told him of your letter. He is burning to go to Paris with paternal consent; he wants to borrow some money, mortgaged on the paternal cranium, and escape to other skies, drawn, by the way, by the great Valab[règue], who gives no sign of life. And Alexis thanks you for thinking of him, he does the same for you. I have scolded him for his laziness, he replied that if only you knew his difficulties (a poet must always be pregnant with some Iliad, or rather with a personal Odyssey) you would forgive him. Why don't you give him a prize for diligence or something similar? But I am in favour of forgiving him, for he read me some verses of poetry which give proof of no mean talent. He already possesses in full the skill of the trade. I clasp your

hand from rather a long distance, whilst waiting to clasp from nearer, ever your old

Paul Cézanne

The word 'employee' seems absurd to me, and yet what am I to call you whilst in the exercise of your new duties?

I cannot post this letter before tomorrow afternoon.

I am still working hard at a landscape of the banks of the Arc, it is always for the next Salon, will it be that of 1869?

To Justin Gabet[a]

Paris, 7 June, 1870

My dear Gabet,

It is quite a long time since I received your letter and I was negligent enough not to answer it—but now I am redressing the wrong done to you. Anyway, my dear fellow, you must have had news of me from Emperaire[b] about a month ago and recently through my uncle who promised me to go and see you, and give you a copy of the caricature done by Stock.[c] Well, I have been turned down as in the past, but I do not feel any the worse for

[a] Justin Gabet, artistic cabinet-maker and joiner at Aix, boyhood friend of Cézanne, with whom he always remained in contact.

[b] Achille Emperaire (1829–92) was a boyhood friend of Cézanne; he was deformed. Cézanne painted several portraits of him.

[c] The caricature of Cézanne had appeared in a Paris weekly published by Stock in Spring, 1870, representing the painter with two pictures, one a lying nude, the other a portrait of Emperaire, both of which had been refused by the jury of the Salon. The accompanying text stated that Cézanne had delivered these paintings on March 20th, the very last day before the opening, creating very great, though

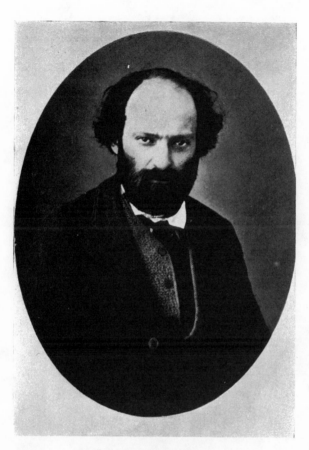

10. Paul Cézanne, about 1871
Photograph

that. It is superfluous to tell you that I am always painting and that for the moment I am well.

There are some very nice things at the exposition I can tell you, and some ugly ones too. There is the picture of M. Honoré which is very effective and is well placed. Solari has also done a very fine statue.

Please give my kind regards to Mme Gabet and a kiss for little Titin. Remember me also to your father and father-in-law. Nor must we forget our friend Gautier, the extinguisher of street lamps, and Antoine Roche.

I embrace you with all my heart, dear fellow, be of good cheer,

Ever your old friend,

Paul Cézanne

Does he walk straight or still to one side, and the great Saint Y . . . ?

ZOLA TO PAUL ALEXIS

Paris, 30 June 1871.

My dear Alexis,

I didn't answer on the spot so as to give you time to settle down. Now, when you must have made a little hole for yourself in the soft life of the provinces, I have decided to write to you and charge you with a task.

spiteful, interest among the artists and critics who happened to be present. Asked about his artistic credo, Cézanne is reported to have said: "Yes, my dear Mr. Stock, I paint how I see and how I feel . . . and my feelings are very strong. The others, Courbet, Manet, Monet etc., feel and see as I do, but they have no courage. They paint pictures for the Salon. I, however, dare, Mr. Stock, I dare. I have the courage of my convictions, and he who laughs last, laughs best."

What you tell me about Cézanne's flight to Lyon is a tall yarn. Our friend simply wanted to put this gentleman Giraud off the scent. He has hidden himself in Marseilles or in some hole of a valley. For me it's important to find him as soon as possible for I am uneasy.

Just think that I had written to him on the day after your departure. My letter, addressed to l'Estaque, must have gone astray, which is not a great loss; but I fear that, by some unforseen circumstances, it could have been sent on to Aix, where it might fall into the hands of the father. And it contains certain details compromising for the son. You understand what I mean, don't you? I want to find Paul so that he can retrieve the letter.

Therefore, I count on you to do the following. Go one of these mornings to the Jas de Bouffan pretending that you have come to hear news of Cézanne. Arrange it so that you can talk to the mother alone for a moment and ask for the correct address of her son for me. If you can't carry through this diplomatic intrigue successfully, go and ask Achille Emperaire, 2, rue Baulezan, telling him that I absolutely must know where Cézanne is staying. The approach to the mother is safer, because it's possible that Emperaire is as ignorant as we are.

That is my commission, and now let me ask for your news. You wrote to me from l'Estaque an enthusiastic letter which has only proved to me that your heart is not dead to the blue sky and the bouillabaisse, but today you should have something else to tell me. Are you working? This is the eternal question I address to you. If you return with empty hands, you will be a very miserable man. And what kind of a life are you leading? How do you manage to forget down there in the solitude

of the Arc, the miseries of the siege and of the Commune?
I fear that you are sleeping a lot. Remember that Vala-
brègue watches you . . .

ZOLA TO CEZANNE

Paris, 4 July, 1871.

My dear Paul,

Your letter has given me great pleasure because I was
just getting worried on your account. For four months
now we haven't had news from each other. Towards the
middle of last month, I wrote to you at l'Estaque, then
learned that you had left and that my letter would not
find you. I was just trying to trace you when you rescued
me from my difficulty.

You ask about my news. Here, in a few words, is my
story. I wrote to you, I believe, shortly before my depar-
ture from Bordeaux, promising you another letter
immediately on my return to Paris. I arrived in Paris on
the 14th March. Four days later, on the 18th, the insur-
rection broke out, the postal services were suspended, I
couldn't think any more of giving you a sign of life. For
two months I lived in the furnace, night and day the
cannons and towards the end the shells whistled over my
head in my garden. Finally, on the 10th May, when I was
in danger of being arrested as a hostage, I took flight
with the help of a Prussian passport, and went to Bon-
nières to get over the worst days. Today, I find myself
living peacefully in Batignolles as if I had awoken from
a bad dream. My country house is the same, my garden

has not moved, not one piece of furniture, not one plant has suffered, and I could believe that these two sieges were nothing but a nasty farce invented to frighten the children ...

They are printing my novel 'La Fortune des Rougon'.[a] You can't imagine the pleasure I experience while correcting the proofs. It is like my first to come out. After all these shocks, I experience the same youthful feelings which made me await feverishly the pages of the 'Contes à Ninon'. I am a bit sad to see that all these fools are not dead, but I console myself with the thought that none of us has disappeared. We can restart the battle ...

Don't wait for months before answering me. Now that you know that I am in Batignolles and that your letters will not go astray, write to me without fear. Give me details. I am nearly as lonely as you and your letters help me to live ...

[a] The first volume of the series Les Rougon-Macquart. A later volume, L'Oeuvre, was the final cause of the breach between the two friends (see p. 223).

IMPRESSIONISM
THE RUPTURE WITH ZOLA

1872–86

The few letters exchanged between Cézanne and Zola during the war of 1870 have been lost. Cézanne stayed at l'Estaque near Aix on the shores of the Mediterranean during this whole period, together with Hortense Fiquet, whom he had just met in Paris and was later to marry, after several conflicts with his father, from whom he tried in vain to conceal his liaison with this woman, eleven years younger than himself, and the child born in Paris in 1872.

After the commune the two friends were reunited in Paris. A few months after the birth of his son, Cézanne, with Hortense and their child, went to live at Pontoise with Camille Pissarro. Then, in the autumn of 1872, he settled down in the neighbouring village of Auvers-sur-Oise, where he stayed until 1874.

Staying in Aix became complicated because Hortense Fiquet and their son were not allowed to accompany him there.

Cézanne's friendship with Zola gradually became less intimate, but in difficult moments of his life Cézanne often approached Zola, who always helped as much as he could.

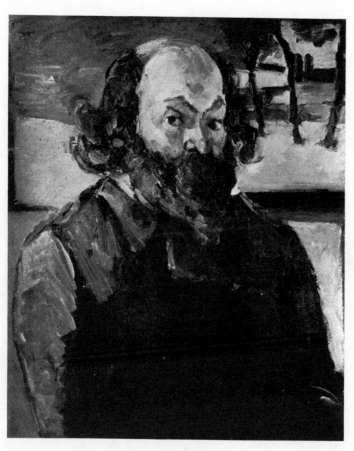

11. Portrait of the Artist
Oil, about 1875

To Achille Emperaire

Paris, January 1872

My dear Achille,

I would like to ask you to transmit the enclosed letter to my mother.[a] Please forgive me for bothering you so frequently.

It would be a great pleasure to me to hear from you. Please address your letter to Monsieur Paul Cézanne, [Paris] 45, rue de Jussieu, or to Cézanne, c/o Monsieur Zola, 14, rue de la Condamine. I enclose a stamp for 25 centimes in order to save you going specially into town for that. You simply put into the letter-box whatever you want to send me.

Always yours

Paul Cézanne

Should you need some tubes of paint I could send them to you.

[a] Cézanne's mother knew about her son's liaison with Hortense Fiquet, but kept it secret from the father. Cézanne could therefore never write directly to his mother about his private affairs. The letter which he sent her through his friend Emperaire may well have contained the news that Hortense Fiquet had borne him a son on 4th January, 1872.

To Achille Emperaire

Paris, 26 January, 1872

My dear Achille,

I have just seen Zola who visited me at no. 45 rue de Jussieu. He still needs four or five days before he can give a definite answer. He has already tried hard to get a pass, but has not yet succeeded in obtaining it.[a] Please be patient for a few more days, then a solution will be found. I need not tell you that I would be very happy to see you. You will be somewhat cramped at my house, but I gladly offer to share my retreat with you.

When you are about to leave Marseille, please be good enough to write to me briefly and tell me the time of your departure and the approximate time of your arrival. I shall then come along with a wheelbarrow and transport your luggage to my house. I live in what used to be rue Saint-Victor, now rue de Jussieu, opposite the wine market, on the second floor.

In any case, I shall write to you as soon as there is any news to report.

Always yours,

Paul Cézanne

If, as I expect, you have a great load of luggage, take only the necessary and send the rest per freight. I must, however, ask you to bring bed linen, as I cannot lend you any.

[a] Emperaire, poor as a churchmouse throughout his life, intended to go to Paris and to earn his living by copying in the Louvre. Apparently he had asked Cézanne to get him a free ticket for the journey.

TO ACHILLE EMPERAIRE

Paris, 5th February, 1872.

My dear Achille,

I have not been able to achieve anything, neither in the Batignolles, nor anywhere else. If I have delayed writing to you for so long, the reason is that up to the last moment I had some hopes. But Zola has now finally told me that he has been unable to obtain what I had asked for.

Should you be able to undertake the journey at your own expense, do so. You can stay with me.

Please believe me that I have at once tried everywhere where there was any hope, but to my distress I have not succeeded.

If, in spite of this failure, you still have the intention of coming here, please send me a few lines, as already mentioned in my last letter. I shall then come to the station to fetch you.

Please believe me that, in spite of this failure, I am your devoted friend, who does not wish for anything better than to be somewhere else but in the mess in which he actually finds himself, and which prevents him from being of any help to you.

Paul Cézanne

I have had some damned trouble about which I'll tell you.

In letters addressed to friends in Aix, Emperaire wrote: (19th Feb., 1872) "Paul was at the station. I went to his house in order to have some rest and then spent the night with a friend who is a sculptor." (17th March, 1872) "Paul is not very well set up; also there is a noise which could awaken the dead. As I couldn't help myself, I accepted [his hospitality], but even if he offered me a kingdom, I would not stay with him."

(27th March, 1872) *"I have left Cézanne—it was unavoidable, other-wise I would not have escaped the fate of the others. I found him here deserted by everybody. He hasn't got a single intelligent or close friend left. Zola, Solari and all the others are no longer mentioned. He is the strangest chap one can imagine. . . ."*

A year later, he expressed himself very disparagingly about Cézanne in a long letter and in June, 1873, shortly before his return to Aix, he wrote: "Apart from all other sorrows, I am more than ever furious not to have at my disposal the big box which you know. I wasn't present when my luggage was delivered to rue de Jussieu and my noble host decided to destroy it. Owing to his happy affair, I am now faced with even more expense."

TO CAMILLE PISSARRO

Pontoise, 11 December, 1872

Monsieur Pissarro,

I take up Lucien's pen at a time when the train should have been taking me to my *Penates*. I am telling you in a round-about way that I have missed my train.—Unnecessary to add that until tomorrow, Wednesday, I am your guest.

Well then, Madame Pissarro asks you to bring back powder[a] for little Georges from Paris. And also the shirts for Lucien which are with his aunt Félicie.

I wish you good evening.

Paul Cézanne

11 December 1872
In the town of Pontoise.

[a] This refers to Nestlé milk powder, recommended by Dr. Gachet, a personal friend of Nestlé. Dr. Gachet, who had met Cézanne's father in Aix during his student days, lived in Auvers-sur-Oise, not far from Pontoise, where Cézanne also stayed at that time, and they met frequently.

To this letter little Lucien Pissarro added the following lines:
"*Mon cher Papa,*

Mamman te fait dire que la porte est cassée que tu viene vite parce que les voleur peuve venir. Je te pris si tu veux bien m'apporté une boite a couleur. Minette te pris que tu lui apporte une baigneuse. Je n'est pas bien écrit parce-que je n'était pas disposée.

Lucien Pissarro, 1872."

Louis-Auguste Cezanne to Dr. Paul Gachet

Aix, 10th August, 1873

To Dr. P. F. Gachet.

I have received your sad letter of the 19th July, telling me about the painful loss of a son of your brother, 19 years old. I am very sad and assure you that I share your grief. You also tell me that, after a grave illness lasting a whole month, your wife has given birth, but that now she is a little better. I hope that her convalescence will make good progress and that she will soon have recovered completely. You write that Paul, from whom I had a letter today, which I am answering, has behaved very well towards you. He has only done his duty.

Please express to your esteemed family my deepest respects and consider me as your devoted

Cézanne[a]

[a] This letter of Cézanne's father has spelling mistakes in nearly every second word. Dr. Gachet corresponded at this time with Cézanne's father, trying successfully to obtain a higher monthly allowance for the painter whom his father thought to be a bachelor, while in fact he had to provide from his meagre allowance for a wife and child.

To a Collector at Pontoise[a]

*Auvers-sur-Oise, beginning
of the year 1874*

Draft

In a few days I shall be leaving Auvers to settle down in Paris. I am therefore taking the liberty of recalling myself to your memory. If you wish me to sign the picture you spoke to me about, please have it sent to M. Pissarro where I shall add my name.

With kindest regards

To the Parents of the Artist

Probably Paris, about 1874[b]

Draft

You ask me in your last letter why I am not yet returning to Aix. I have already told you in that respect that it is more agreeable for me than you can possibly think to be with you, but that once at Aix I am no longer free

[a] Draft of a letter written on a sketch of the farm at 'Jas du Bouffan'; on the back is a landscape of Auvers. This letter is probably addressed to M. Rondés, a grocer in the rue de la Roche at Pontoise, who, on Pissarro's recommendation, had accepted pictures by Cézanne in payment of his debts.

[b] On the back of this draft is a sketch of two peasants. It is impossible to fix the date on which it was written, but it probably refers to Cézanne's stay in Paris, Pontoise and Auvers, where he had spent three years without returning to the South. His request for money was probably due to a desire to make provision for Hortense Fiquet and his son during his absence. It is, therefore, very probable that the letter was written to his parents before he joined them in 1874. In a letter to Zola of 28th March, 1878, Cézanne mentions that his father had promised him 200 francs per month.

and when I want to return to Paris this always means a struggle for me; and although your opposition to my return is not absolute, I am very much troubled by the resistance I can feel on your part. I greatly desire that my liberty of action should not be impeded and I shall then have all the more pleasure in hastening my return.

I ask Papa to give me 200 francs a month; that will permit me to make a long stay in Aix, and I shall be very happy to work in the South where the views offer so many opportunities for my painting. Believe me, I do really beg Papa to grant me this request and then I shall, I think, be able to continue the studies I wish to make.

Here are the last two receipts.

To Camille Pissarro

Aix, 24 June, 1874

My dear Pissarro,

Thank you for having thought of me whilst I am so far away and for not being angry that I did not keep my promise to come and see you at Pontoise before my departure. I painted at once after my arrival, which took place on a Saturday evening at the end of the month of May. And I can well understand all the misfortunes which you have to go through. You really have no luck— always illness at home; however, I hope that when this letter reaches you, little Georges will be well again. By the way, what do you think of the climate of the country in which you are living? Are you not afraid that it will affect the health of your children? I am sorry that fresh circumstances have arisen to keep you from your work

again, for I well know what privation it is for a painter to be unable to paint.—Now that I have seen this country again I really believe that it will satisfy you completely, for it recalls in a most amazing way your study of the railway barrier painted in full sunshine in the middle of summer.[a]

For some weeks I was without news of my little boy and I was very worried, but Valabrègue has just arrived from Paris and yesterday, Tuesday, he brought me a letter from Hortense telling me that he is not doing badly.

From the papers I learned of Guillemet's great success and of the happy event of Groseillez, who has had his picture bought by the administration, after it had been given a medal. Well, this proves that if one follows the path of virtue one is always rewarded by man, but not by art.

I should be happy if you could give me news of Mme. Pissarro after the birth, and if you could let me know whether there are fresh recruits at the Société Coop.[b] But naturally you must not let this interfere in any way with your work.

When the time approaches, I shall let you know about my return and what I have been able to get out of my father, but he will let me return to Paris.—That is already a great deal.—Recently I saw the director of the Musée

[a] This is a painting from Pontoise dated 1873/4; see L. R. Pissarro and L. Venturi: Camille Pissarro, *Son Art, Son Oeuvre*, Paris, 1939, no. 266.

[b] This was the "Société Coopérative Anonyme des Artistes, Peintres, Sculpteurs, Graveurs," whose first exhibition in Paris from 15th April to 15th May, 1874 had just closed. Cézanne had exhibited several pictures there, together with Pissarro, Monet, Renoir, Sisley, Guillaumin, Degas etc. Cézanne had been accepted as a member of the group through the support of Pissarro. About the press campaign against the exhibiting artists, see John Rewald: *Cézanne and Zola*, Ch. X.

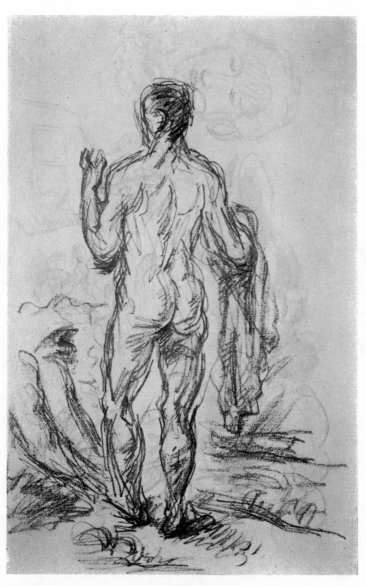

12. Man Bathing
Drawing, about 1876

d'Aix who, driven by a curiosity fed by the Paris papers, which mentioned the Cooperative, wished to see for himself how far the menace to painting went. But at my protestations that, after seeing my productions, he would not have a very good idea of the progress of the evil, and that it would be necessary to see the works of the big criminals of Paris, he replied: "I shall be well able to form an idea of the dangers which painting runs when I see your attentats."—Whereupon he came and when I told him, for instance, that you replaced modelling by the study of tones, and was trying to make him understand this in nature, he closed his eyes and turned his back.— But he said he understood and we parted, each satisfied with the other. But he is a decent fellow who urged me to persevere, because patience is the mother of genius, etc.

I nearly forgot to tell you that mother and father send you their affectionate greetings.

A word to Lucien and Georges, kiss them both for me. My best regards and thanks to Mme. Pissarro for all your goodness to me during our stay at Auvers. A firm handclasp for you, and if wishes were calculated to make things go well, you may be sure that I would not fail to make them. Ever your

<div align="right">Paul Cézanne</div>

To the Artist's Mother

<div align="right">Paris, 26th September, 1874</div>

My dear Mother,

I have first of all to thank you very much for thinking of me. For some days the weather has been beastly and very

cold.—But I don't suffer in any way and I make a good fire.

I shall be very pleased to get the promised box, you can always address it to rue de Vaugirard 120, I shall stay there until the month of January.

Pissarro has not been in Paris for about a month and a half; he is in Brittany,[a] but I know that he has a good opinion of me, who has a very good opinion of myself. I am beginning to consider myself stronger than all those around me, and you know that the good opinion I have of myself has only been reached after serious consideration. I have to work all the time, not to reach that final perfection which earns the admiration of imbeciles.— And this thing which is commonly appreciated so much is merely the effect of craftsmanship and renders all work resulting from it inartistic and common. I must strive after perfection only for the satisfaction of becoming truer and wiser. And believe me, the hour always comes when one breaks through and has admirers far more fervent and convinced than those who are only attracted by an empty surface.[b]

It is a very bad time for selling, all the bourgeois jib at letting go of their sous, but this will end.

My dear Mother, remember me to my sisters.

Kind regards to Monsieur and Madame Girard and my thanks.

Ever your son,

Paul Cézanne

[a] Because of lack of money, Pissarro had been forced temporarily to give up his house in Pontoise and had moved for the winter with his wife and three children to the estate of his friend Piette in Brittany.

[b] This passage probably refers to the Impressionist Exhibition in which Cézanne had shown his works for the first time. The complete failure of this exhibition does not seem to have discouraged him.

To Camille Pissarro

Aix, April, 1876

My dear Pissarro,

Two days ago I received a large number of catalogues and newspapers dealing with your exhibition at Durand-Ruel.[a]—You must have read them.—Among other things I saw a long slating attack by Sieur Wolff.[b] It is Monsieur Chocquet[c] to whom I owe the pleasure of hearing this news.

I have also learned from him that Monet's 'La Japonaise' was sold for two thousand francs. According to the papers it seems that Manet's rejection at the Salon has made a sensation, and that he now exhibits in his own house.

Before leaving Paris I met a man called Authier [?], about whom I have several times spoken to you. He is the fellow who signs the articles on painting with the name Jean-Lubin. I told him what you had shown me about yourself, Monet, etc.—But (as you have no doubt heard

[a] The second exhibition of the Impressionists was held at the gallery of the art dealer Durand-Ruel. Cézanne did not take part.

[b] Albert Wolff was the art critic of *Le Figaro*. He was resolutely hostile to the Impressionist movement and treated the young artists as 'madmen'. His article, and others which appeared on this occasion, are reproduced in G. Geffroy's book: *Claude Monet*, Paris, Crès, 1924.

[c] Victor Chocquet, a customs officer, was a passionate collector. He had begun by buying works by Delacroix, then became interested in Renoir and, in 1875, bought several pictures by him in an auction. Through Renoir, who painted portraits of him and of his wife, he met Cézanne, who became a close friend and also painted several portraits of him. Chocquet became one of the most enthusiastic admirers of Cézanne and formed the first important private collection of his works. Cézanne shared Chocquet's admiration for Delacroix and also introduced Monet to Chocquet. Cf. J. Rewald, Chocquet et Cézanne, *Gazette des Beaux-Arts*, July/August 1969.

since), it was not the word 'imitator' that he had meant to put but 'initiator', which completely changes the meaning of the article. As for the rest, he told me that he considered himself bound, or at any rate thought it right, not to run down the other painters at Durand too much. You understand why.

Blémont's article in *'Rappel'* shows much better judgment in spite of too many reservations, and a long introduction in which he loses himself a bit too much.[a] It seems to me that you are there accused of painting too blue because of your mist effects.

We have just had a very watery fortnight. I am much afraid that this weather has been general. Here with us

[a] This article, published on 9th April, 1876 was one of the few which had treated the new art movement with sympathy and understanding. It began like this: "What is an impressionist painter? We have not been given a satisfactory definition, but it appears to us that the artists who have formed a group or are considered as being associated under this label, are pursuing the same aim, though by different means: to represent the impression which reality creates on them with complete sincerity, without alteration or embellishment and by simple, sweeping means. For them art does not consist of an over-meticulous and restricted imitation of what was once called 'the beauty of nature', they are not concerned to imitate more or less slavishly beings and things . . . They do not imitate; they translate, they interpret, they strive to emphasise the co-relation of manifold lines and colours, which the eye takes in at one single glance. They work by synthesis, not by analysis and it appears to us that they are right. Because, while analysis is the appropriate method for the sciences, synthesis is the proper way of the arts . . . As there exist hardly two people who have exactly the same perception of the same object, the impressionists do not think it necessary to change their personal and direct perceptions according to this or that convention. We can, therefore, entirely agree with them in principle as well as in theory. In practice, however, things are slightly different: One does not always carry out what one would like or ought to do; one does not always reach the aim which appears so clearly in front of one's eyes . . .".

144

the frost has been so severe that all the fruit and vine harvest is lost. But behold the advantage of art, painting remains.

I almost forgot to tell you that a certain letter of rejection[a] has been sent to me. This is neither new nor astonishing.—I wish you fine weather and, if this is possible, a good sale.

Please give my kindest regards to Mme. Pissarro and my love to Lucien and your family.

With a warm handclasp.

Paul Cézanne

Do not forget Guillaumin[b] when you see him, nor Monsieur and Madame Estriel.

To Camille Pissarro

L'Estaque, 2 July, 1876

My dear Pissarro,

I am forced to reply to the charm of your magic crayon with an iron point (that is, with a metal pen). If I dared I should say that your letter bears the marks of sadness. Pictorial business does not go well; I am much afraid that your morale is coloured slightly grey by this, but I am convinced that it is only a passing thing.

How much I should like not always to talk of impossibilities and yet I always make plans which are most

[a] As in the past, Cézanne still continued to send his pictures to the Salon Officiel, where, however, they were always rejected.

[b] Armand Guillaumin (1841–1927) seems to have been the first painter with whom Cézanne became friendly in Paris.

unlikely to come true. I imagine that the country where I am would suit you marvellously.—There are some famous vexations but I think they are purely accidental. This year it rains two days out of seven every week. That's unbelievable in the Midi.—It's unheard of.

I must tell you that your letter surprised me at Estaque on the sea shore. I am no longer at Aix, I left a month ago. I have started two little motifs with the sea, for Monsieur Chocquet, who had spoken to me about them. —It's like a playing-card. Red roofs over the blue sea. If the weather becomes favourable I may perhaps carry them through to the end. Up to now I have done nothing.—But there are motifs which would need three or four months' work, which would be possible, as the vegetation doesn't change here. The olive and pine trees always keep their leaves. The sun here is so tremendous that it seems to me as if the objects were silhouetted not only in black and white, but in blue, red, brown and violet. I may be mistaken, but this seems to me to be the opposite of modelling. How happy our gentle land-scapists of Auvers would be here and that great . . . [*a word of 3 letters*] of a Guillemet. As soon as I can, I shall spend at least a month in these parts, for one must do canvases of two metres at least, like the one by you sold to Faure.[a]

If we were to exhibit with Monet, I should hope that

[a] This refers to an early painting by Pissarro dated c. 1867, which measures 1.50 × 2 metres. (See L. R. Pissarro and L. Venturi, *op. cit.*, no. 59.) Later Pissarro no longer used such big formats.

The Parisian opera singer, J.-B. Faure was an intimate friend and admirer of Manet and had a collection of many of his paintings. He also collected the works of the other Impressionists—though not of Cézanne—and bought, among others, numerous paintings by Pissarro.

the exhibition of our cooperative would be a flop[a]—
you will think me a beast, perhaps, but one's own affairs
first, before everything else.—Meyer, who has not the
elements of success in his hands with the cooperative,
seems to me to become a bloody stick, who tries, by
postponing the date of the impressionist exhibition, to
harm it—he might tire public opinion and bring about
confusion.—In the first place, too many successive ex-
hibitions seem to me bad, on the other hand people who
may think they are going to see the Impressionists will
see nothing but cooperatives.—Cooling off.—But Meyer
must be very eager to damage Monet.—Did Meyer make
a few sous? Another question: As Monet is making
money,[b] why, since this exhibition is a success, should he
fall into the trap of the other one? Once he is successful
he is right. I said: Monet—meaning: Impressionists.

Meanwhile, I much appreciate the 'gentlemanliness' of
Monsieur Guérin, the dandy, who goes about stirring up
bad blood among the rejected cooperatives. ? I give you
these ideas, a bit crudely perhaps, but subtlety is not in
my disposition. Don't be angry with me, and then, when

[a] The first Impressionist Society, the Société Anonyme Coopéra-
tive des Artistes, Peintres, Sculpteurs, Graveurs etc., had been
liquidated on 17th December, 1874 because of lack of funds and a
loss of 3,500 francs. A new association, 'L'Union', was founded on
18th August, 1875; the manager and president was the painter
Alfred Meyer and among the members were Pissarro, Cézanne,
Béliard and Latouche, who had also belonged to the first society.
When Monet and his friends decided, in 1876, to revive the original
group of Impressionists and to arrange a new exhibition, they came
into conflict with Meyer's 'l'Union'. This explains why Cézanne,
who wanted Monet's exhibition to succeed, expressed himself un-
favourably about the artistically much less important group of
Meyer, who was stirring up intrigues against the Impressionists.

[b] Monet had just sold for the then exceptional price of 2,000 francs
'La Japonaise', now in the museum in Boston.

I return to Paris we shall talk about them, and we can be fair to the goat and to the cabbage. So, if the background of the Impressionists be of advantage to me, I shall exhibit the best I have with them and something neutral with the others.[a]

My dear friend, I shall conclude by saying as you that since there is a common aim amongst some of us, let us hope that necessity will force us to act together and that self-interest and success will strengthen the ties that good will, as often as not, was unable to consolidate.— Lastly, I am very pleased that Monsieur Piette[b] is on our side.—Remember me to him, my best regards to Madame Piette and to Madame Pissarro, my love to all the family, a firm handclasp for you and fine weather.

Just imagine I am reading the 'Lanterne de Marseille' and I must subscribe to 'Religion Laïque'. What do you say to that?

I am waiting for Dufaure's downfall, but from now to the partial renewal of the Senate, how much time and how many obstacles.

Ever your,

Paul Cézanne

[a] Cézanne exhibited again, though for the last time, with the Impressionists in the following year 1877, and, in order to avoid a conflict, resigned together with his friends from Meyer's *L'Union*, whose exhibition did in fact take place before that of the Impressionists, as shown by a letter from Guillaumin to Dr. Gachet, dated 24th February, 1877; "You are sure to know that the exhibition of the cooperative L'Union in the Grand Hotel has been opened. Pissarro, Cézanne and myself were supposed to take part, but resigned from the association at the last moment."

[b] Ludovic Piette (1826–77), landscape painter and intimate friend of Pissarro, who had introduced him to Cézanne. He had taken Pissarro into his house in Brittany. He died in the following year at the age of 51.

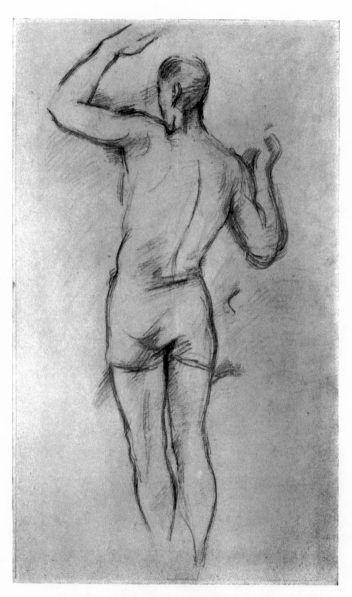

13. Man Bathing
Drawing, about 1885

If the eyes of the people here could flash murder I should have been done for long ago. My head doesn't suit them.

<div align="right">P.C.</div>

I can return to Paris at the end of the month, if you should write sooner, send it: Paul Cézanne, Maison Girard (called Belle), Place de l'Eglise à l'Estaque, Banlieue de Marseille.

To His Parents

Paris, Saturday morning, *10* September, *1876*

My dear Parents,

I am writing to you to give you my news and to receive yours in return. I am well and I hope that you can assure me of the same on your part.

I went to Issy (-les-Moulineux) to see my friend Guillaumin. I found him there and dined with him last Wednesday.—I learned from him that the exhibition organised by the painters of our society last April went very well.—The rent of the premises where the exhibition took place, rue Lepeletier and rue Laffitte (one enters through a door in the rue Lepeletier and leaves by another in the rue Laffitte), amounted to three thousand francs. Fifteen hundred francs only were paid and the landlord[a] had to raise the other fifteen hundred francs from the entrance fees. Not only were all the three thousand francs

[a] This landlord was Durand-Ruel; Cézanne was almost the only one amongst Monet's friends who never had a contract with him.

paid, but also the fifteen hundred francs advanced by the artists in equal shares[a] were repaid to them, plus a dividend of three francs, which, it is true, does not amount to very much. So this a good beginning. And already the artists of the official exhibition, learning about this small success, have turned up to rent the room,[b] but it had been retained for next year by the exhibitors of this year.

According to what Guillaumin had told me, I am one of the three new members who are to take part in it, and I have been very hotly defended by Monet when, at a reunion dinner, which took place after the exhibition, a certain Lepic[c] had spoken against my admission.

I have not yet been able to go and see Pissarro nor the other people I know, as I started painting immediately on the morning after my arrival . . .[d]

[a] As there were twenty participants, this amounted to 75 francs each. If one can believe a report according to which Albert Wolff had the arrogance to ask for repayment of his contribution of 50 centimes, the 3,060 francs taken represent 6,120 paying visitors, while the first exhibition had only attracted 3,500. The entrance fee on that occasion had been 1 franc. However, the total amount received in 1876 might include the money received for the sale of catalogues.

[b] Cézanne—or Guillaumin—must have been wrong. On the 27th January, 1877 Caillebotte wrote to Pissarro: "We are having some trouble about our exhibition. Durand-Ruel's rooms are let for the whole year . . ." (See John Rewald: *History of Impressionism*, New York, 1946, p. 306.)

[c] This is the painter and engraver, Ludovic Napoléon Lepic (1839–89), former pupil of Gleyre in whose studio he had met Monet and his friends. Later he was to associate mainly with Degas, who had more or less imposed him on the group. Caillebotte wrote later to Pissarro that Lepic "had no talent at all". After 1876 it was Lepic who would no longer exhibit together with the Impressionists.

[d] The end of the last page has been torn off, the letter is incomplete.

To Doctor P. F. Gachet

Thursday morning, 5 October, *1876*

My dear Doctor,

I suffer at the moment from a rather heavy headache, which does not allow me to accept your invitation.

Please allow me to excuse myself. Guillaumin, whom you will see tonight, and with whom I was yesterday, Wednesday, in Issy, will be able to tell you about my attack.

I would have cut rather a wretched figure at this pleasant party, although I would have been most happy to take part if only this stupid vexation hadn't prevented me.

I can assure you that I regret this very much indeed.

Always yours,

P. Cézanne

To Emile Zola

Paris, 24 August, 1877

My dear Zola,[a]

My warmest thanks for your kindness to me. May I ask you to tell my mother that I do not need anything, for I am thinking of spending the winter at Marseille. If, when December comes, she will undertake to find me a tiny apartment of two rooms in Marseille, not expensive but

[a] Zola and his wife were staying at l'Estaque. By sending the commissions for his mother to Zola, Cézanne prevented news of his plans from reaching his father, who insisted on his right, as head of the family, to open all letters addressed to any of them.

yet in a district where there are not too many assassinations, she will give me great pleasure. She could have a bed brought there and what is necessary for sleeping, two chairs that she can take from her house in l'Estaque to avoid unnecessary expense.—About the weather here, I must tell you, the temperature is often refreshed by pleasant showers. (Style Gaut d'Aix).

I go every day to the park d'Issy where I do some studies. And I am not too dissatisfied, but it appears that profound desolation reigns in the Impressionist camp. Gold is not exactly flowing into their pockets and the pictures dry out where they are. We are living in very troubled times and I do not know when unhappy painting will regain a little of its lustre.

Was Marguery less desolate on this last excursion to Tholonet? And you didn't see Houchard, Aurélien? With the exception of two or three painters I have seen absolutely nobody.

Will you go to the agape of the Cigale?[a] For a month and a half Daudet's new novel has been appearing in the *Temps*, yellow posters put up even in Issy told me this. I know too that Alexis will be played in the Gymnase theatre.

Are the sea baths beneficial to Madame Zola, and you yourself, do you strike out through the salty waves? I send all of you my respects, and clasp your hand cordially. Au revoir then after your return from the sunny shores.

Grateful for your kindness, I am your painter,

Paul Cézanne

[a] Allusion to the yearly banquet of the 'Cigale', founded in Paris in 1876 by artists and writers from the south of France. The cigale is a cricket found especially in the south of France.

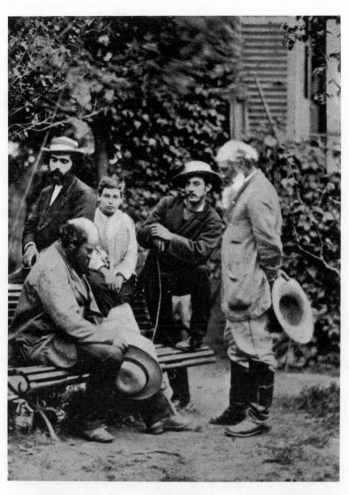

14. Cézanne sitting in Pissarro's garden at Pontoise, 1877.
Standing on the right, Camille Pissarro
Photograph

To Emile Zola

Paris, 28 August, 1877

My dear Emile,

Once again I turn to you asking you to tell my mother not to worry herself. I have changed my plans. This combination seems to be difficult to carry out. I give up.

However, I still intend to go to Aix in December or rather in the first days of January.

Thank you most sincerely. I send greetings to your family. Yesterday when I went to the rue Clauzel to my colour-merchant,[a] I found there dear Emperaire.

Acknowledgment for Julien Tanguy

Paris, 4 March, 1878

The undersigned, Paul Cézanne, painter, resident in Paris, 67, rue de l'Ouest, herewith acknowledges that he owes Mr. and Mrs. Tanguy the sum of two thousand, one hundred and seventyfour francs and eighty centimes, this being the equivalent of painting material received by him.

Paul Cézanne[b]

[a] 'Père' Tanguy was a paint merchant and picture dealer. He was one of the first to take an interest in the Impressionists and often let them have paints in exchange for pictures, although he was by no means well off and their paintings were hard to sell. For a long time, his small shop was the only place where paintings by Cézanne could be seen. Van Gogh, who painted two portraits of him, often mentions him in letters.

[b] Seven years later, Tanguy reminded the artist that this amount was still due to him. See his letter to Cézanne, dated 31st August, 1885.

To Emile Zola

l'Estaque, 23 March, 1878

My dear Emile,

I find myself very near to being forced to obtain for myself the means to live, always provided that I am capable of doing so. The situation between my father and me is becoming very strained and I am threatened with the loss of my whole allowance. A letter that Monsieur Chocquet wrote to me and in which he spoke of Madame Cézanne and of little Paul, has definitely revealed my position to my father, who by the way was already on the watch, full of suspicion and who had nothing more urgent to do than to unseal and be the first to read the letter although it was addressed to: *Mons. Paul Cézanne— artiste peintre*.

I therefore appeal to your goodwill towards me to try in your circle of friends and through your influence to get me in somewhere, if you consider that possible. All is not yet completely broken between my father and myself, but I think that not a fortnight will pass without my situation becoming absolutely clear.

Write to me (addressing your letter to M. Paul Cézanne, poste restante), whatever decision you may take with regard to my request.

Kindest regards to Madame Zola and a firm handclasp for you. I am writing from l'Estaque, but am returning to Aix this evening.

Paul Cézanne

To Emile Zola

Aix, 28 March, *1878*

My dear Emile,

I think as you do that I should not too hastily renounce the paternal allowance. But judging by the traps that are laid for me and which so far I have managed to avoid, I forsee that the great discussion will be the one concerning money and about the uses I must put it to. It is more than probable that I shall not receive more than 100 francs from my father, even though he promised me 200 when I was in Paris. I shall therefore have to have recourse to your kindness, all the more so because my little boy has been ill with an attack of paratyphoid fever for the last fortnight. I am taking all precautions to prevent my father from gaining absolute proof.

Forgive me for the following remark: but the paper of your envelope and notepaper must be heavy: at the post I had to pay 25 *cent.* for insufficient stamping—and your letter contained only one double sheet. When you write to me would you mind only putting in one sheet folded in two?

If therefore, my father does not give me enough, I shall appeal to you in the first week of next month, and I shall give you Hortense's address to whom you will be kind enough to send it.

Remember me to Madame Zola and a handclasp for you.

Paul Cézanne

An exhibition of the Impressionists' will probably take place; if so I shall ask you to send the still-life that you have in your dining-room.[a] I received a summons in this

[a] This exhibition, however, did not take place and in later years Cézanne no longer contributed to the exhibitions of the Impression-

matter for the 25th of this month, rue Lafitte.—I didn't go, naturally.

Has '*Une Page d'Amour*' come out yet?

To Emile Zola

Aix, Wednesday evening, 1878

My dear Emile,

My warmest thanks to you for having sent me your last book[a] and for the dedication. I haven't yet got very far in reading it.—My mother is extremely ill and has been in bed for ten days, her condition is most serious.— I stopped reading at the end of the description of the sun setting over Paris and of the development of the mutual passion between Hélène and Henri.

It is not for me to praise your book, for you could reply, like Courbet, that the conscientious artist addresses to himself praise far more just than that which comes to him from without. So what I am telling you about it, is merely to explain what I have been able to perceive of the work. It seems to me that it is a picture more delicately painted than the preceding one,[a] but the temperament or creative force is always the same. And then—if this is not heresy—the progress of the passion between

ists. The still-life mentioned here is no doubt 'La Pendule Noire', painted in 1870/71 (Venturi no. 69). It is of some interest that the painter intended to exhibit such a comparatively early, though quite important, work instead of one of his later, more impressionistic pictures.

a The novel, *Une Page d'Amour*, from the series, *Rougon-Macquart*.
b *L'Assommoir*.

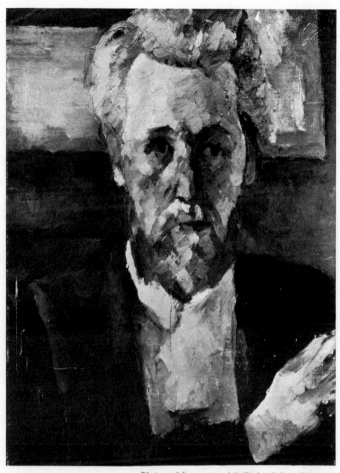

15. Portrait of Victor Choquet
Oil, 1877

the heroes is very finely graded. Another observation which seems to me just, is that the places, through their descriptions, are impregnated with the passion that moves the characters, and through this, form more of a unity with the actors and are less dissociated from the whole. They seem to become animated, to participate as it were in the sufferings of the living beings.—Furthermore, according to the notices in the papers, it will be at least a literary success.

A handclasp for you and please give my regards to Madame Zola.

<div style="text-align: right">Paul Cézanne</div>

You will no doubt notice that my letters are not actually answers to yours, but this is because I often write before having read yours, as I am unable to go to the post regularly.

<div style="text-align: right">P.C.</div>

Last minute reflexion: You observe carefully the rule of Horace for your personages: *"Qualis ab incepto processerit, et sibi constet."*

But you don't care a damn about this, no doubt, and this proves again how things repeat themselves here on earth.

To Emile Zola

<div style="text-align: right">*Aix*, 4 April, 1878</div>

My dear Emile,

I beg of you to send sixty francs to Hortense at the following address: Mme. Cézanne, rue de Rome 183, Marseille. In spite of the sacredness of treaties I was un-

able to obtain more than 100 francs from my father, and I even feared that he would give me nothing at all. He has heard from various people that I have a child, and he is trying to surprise me by all possible means. He wants to rid me of it, he says.—I shall add nothing further.— It would take too long to try and explain the good man to you, but with him appearances are deceptive, you can take my word for it.—If you can write to me, as soon as possible, you will give me pleasure. I am going to try to go to Marseille, I escaped on Tuesday, a week ago, to go and see my little boy; he is better, and I was forced to walk back to Aix seeing that the train given in my railway guide was wrong, and I had to be home for dinner.—I was an hour late.[a]

My respects to Madame Zola and a handclasp for you.

Paul Cézanne

To Emile Zola

Aix, 14 April, 1878

My dear Emile,

I have just returned from Marseille which will explain my long delay in answering you. I couldn't get your letter until last Thursday. Thank you for sending twice. I am writing under the paternal eye.

When I went to Marseille I was in the company of Monsieur Gibert. These people see correctly, but they have the eyes of Professors. Where the train passes close to Alexis's country house, a stunning motif appears on the

[a] The distance between Aix and Marseille is about 30 km.

East side: Ste Victoire and the rocks that dominate Beaurecueil. I said: "What a lovely motif"; he replied: "The lines are too well balanced."—With regard to the '*Assommoir*' about which, by the way, he spoke to me first, he said some very sensible and laudatory things, but always from the point of view of the technique. And then after a long pause: "One should have studied a lot", he continued, "passed out from the Ecole Normale." I had talked to him about Richepin; he said: "that sort of thing has no future".—What a conclusion: he is one who *has* passed out of it.—And yet in a town of 20,000 people he is without doubt the one who devotes himself most and best to art.

I shall be very sensible, I don't know how to be capable. I wish you good health, I present my respects to Madame Zola and I thank you,

<div align="right">Paul Cézanne</div>

The pupils of Villevieille insult me when I pass—I shall have my hair cut, perhaps it is too long. I am working; poor results and too far removed from the general understanding.

TO EMILE ZOLA

<div align="right">*Aix*, May, 1878</div>

My dear Emile,

Since you are kind enough to come to my assistance I shall ask you to send sixty francs to Hortense, at the same address, 183, rue de Rome.

Thank you in advance, I can quite understand that at

this moment you must be fully occupied with your new book, but later when you are able, you would be doing me a great favour if you would tell me about the artistic and literary situation. In this way I shall be still further removed from the provinces and nearer to Paris.

With many thanks, please give my regards to Madame Zola.

<div align="right">Paul Cézanne</div>

To Emile Zola

<div align="right">Aix, 8th May, 1878</div>

My dear Emile,

Thank you for sending again. I can assure you that it is a great service to me and frees me from anxiety.

My mother is now out of danger, she has been getting up for the last two days and that is a great help to her, and she has better nights. She was very tired for a week.— But now I hope that the fine weather and proper care will put her on her feet again.

I did not fetch your letter till yesterday evening, Wednesday, which explains the long delay between your sending it and my reply.

Thank you for the news of my little canvas. I quite understand that it could not be accepted because of my starting-point, which is too far removed from the aim to be attained, that is to say, the rendering of nature.

I have just finished '*Une Page d'Amour*'. You were quite right to tell me that it could not be read in instalments. I had in no way perceived its coherence, it appeared

hashed, whereas on the contrary the composition is extremely clever. It shows a strong dramatic sense.—Nor had I seen that the action took place in a restricted frame, intensified.—it is really regrettable that works of art are not more appreciated and that in order to attract the public an exaggeration is necessary which does not entirely belong, without harming it to be sure.[a]

I read your letter to my mother, she joins me in sending you greetings.

Kind regards to all your family.

<div align="right">Paul Cézanne</div>

To Emile Zola

<div align="right">*Aix*, 1st June, 1878</div>

My dear Emile,

Here is my monthly prayer to you recommencing. I do hope it does not weary you too much and that it does not seem to you too uninhibited. But your offer saves me so much embarrassment that I am having recourse to it again. My good family, otherwise excellent, is, for an unhappy painter who has never been able to achieve anything, perhaps a little bit mean, a slight failing and easily excusable without doubt in the provinces.

Now comes the inevitable result of such an introduction. I am asking you to be kind enough to send sixty francs to Hortense, who, by the way, is feeling no worse.

From Lambert, the democratic bookseller, I bought

[a] The sentence is not very clearly formulated in the original text.

'*L'Assommoir*', illustrated, '*L'Egalité*' of Marseille publishes it as a serial.

I continue to work a little. Politicians occupy a terrifying position. And how is Alexis?

I clasp your hand and send my regards to Mme. Zola.

Paul Cézanne

To Emile Zola

Aix, Tuesday, July, 1878

My dear Emile,

I beg you to send, if you are still willing to do so, sixty francs to Hortense. She has moved and her address at the moment is 12, Vieux Chemin de Rome.

I am thinking of going to l'Estaque in about 10 days.

Girard, known as Belle,[a] has been discharged from the asylum in which he was detained because of his temporary insanity.

It seems that there was a hell of a fight in Marseille. A certain Coste junior, municipal councillor, distinguished himself by playing his baton on clerical backs.

It is beginning to be excessively hot. Are you working at the moment? Was there a distribution of decorations on May 30th?[b] The papers here make no mention of it, but this evening I hope to get Monday's '*Bien Public*'.

I clasp your hand and send my best greetings to Madame Zola.

Paul Cézanne

[a] The landlord of the house in which Cézanne lived at l'Estaque.

[b] The Légion d'Honneur was not given to Zola in 1878 after all; he received it ten years later, in 1888.

To Emile Zola

L'Estaque, 16 July, 1878

My dear Emile,

I have been at l'Estaque for about eight days. Harpooned by Sieur Girard, I learnt from his lips that you will receive a visit from his father-in-law who is going to Paris on Friday of this week. We have been given notice at the house at l'Estaque. At the moment I am quite close to Girard, at Isnard's house. If you think of it, send me a line to let me know how matters stand with regard to your decoration. I haven't seen it announced in the 'Petit Marseillais'.—However, I hope that it is a *fait accompli*.

The great heat has now set in.

Thank you very much for the money you were again kind enough to send to Hortense.

In the meantime I heard of the end of the *'Bien Public'*. Have you a new paper in which you can fight for your theatre? It is annoying that what this paper intended, has not attained its end.

I present my respects to Madame Zola and greetings to you. I saw Guillaumin the gardener, back from Cannes where his boss is going to set up a nursery.

Paul Cézanne

To Emile Zola

L'Estaque, 29 July, 1878

My dear Emile,

Before leaving Paris I left the key of my appartment with a man named Guillaume, a cobbler. This is what

must have happened. The fellow must have taken in people from the provinces because of the exhibition and lodged them in my flat.—My landlord, very annoyed at not having been asked beforehand, sends, with the receipt for last quarter, a pretty strongly worded letter telling me that my flat is occupied by strangers.[a] My father, reading this letter, concluded that I conceal women in Paris. The whole thing is beginning to assume the aspect of a *vaudeville à la Clairville*. Apart from that, everything was going very well; I was trying to settle down at Marseille, to spend the winter working there and go back to Paris next spring, say in March. At that time the atmosphere grows heavy and I don't think that I shall be able to make such good use of my time outside, and another point, I should be in Paris at the time of the Exhibition of painting.

I congratulate you on your purchase,[b] and with your consent I shall take advantage of it to get to know the country better; and if life is not impossible for me there, either at La Roche or at Bennecourt or a little here and a little there, I shall try and spend a year or two there as I did at Auvers.

I beg you to send, as in the past, sixty francs to Hortense, although I am quite seriously considering ridding you of

[a] The owner of the house at 67, rue de l'Ouest, where Cézanne maintained a small apartment during his stay in the south, was a wine merchant with a billiard-room on the premises, who was thus able to observe the comings and goings in the building. The artist's rent was only 230 francs instead of the 270 francs for which the apartment was assessed, which may have prompted the owner to watch for infringements of the lease.

[b] Zola had bought a country place at Médan where he was in future to spend a large part of each year. Cézanne visited him several times and worked there.

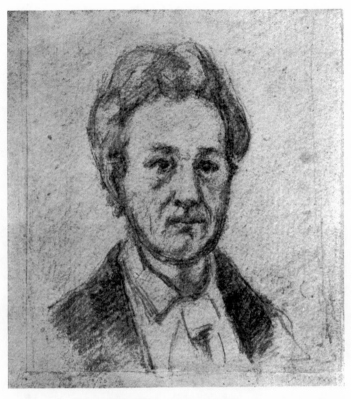

16. Portrait of Victor Choquet
Drawing, about 1877–82

this monthly burden. If I can manage a month's journey to Paris in September or October, I shall do so.

I gave your kind messages to my mother and she was very pleased to get them. I am in fact together with her here.

I clasp your hand, greetings to madame and to your mother, who is no doubt with you. And good trips on the river.

<div align="right">Paul Cézanne</div>

Hortense is still at: Vieux chemin de Rome 12, Marseille.

To Emile Zola

<div align="right">L'Estaque, 27 August, 1878</div>

My dear Emile,

I appeal again this month to your kindness, if you can once more send sixty francs to Hortense who is until the 10th September at the Vieux chemin de Rome 12.

I have not yet been able to find lodgings at Marseille because I don't want them too dear. I count on spending the whole winter there if my father agrees to give me money. This way I could continue some studies I am making at L'Estaque, which I shall not leave until the last possible moment.

Thanking you in advance and with my warmest greetings to you and all your family.

<div align="right">Paul Cézanne</div>

To Emile Zola

L'Estaque, Autumn 1878

My dear Emile,

Hortense recently went to Aix and there saw Achille Emperaire. His family is in great want, three children, winter, no money, etc., you can just imagine what it is like. Therefore I beg you: (1) seeing that Achille's brother is on bad terms with his ex-superiors in the tobacco administration, withdraw the file relating to his petition, if there is nothing for him to obtain within a short time; (2) see if you can find or help him to get, a job of any kind, in the docks, for example; (3) Achille also appeals to you for a job, no matter how small it may be.

So if you can do something for him, please do, you know how much he deserves it, being such a decent man, who has been shouldered aside by everybody and abandoned by all the smart ones. There it is!

Moreover, I wanted to write to you apart from this, for it seems to me that I haven't had news from you for a long time.—I understand that nothing new has happened.—You will give me pleasure if you write a few lines, it will lend a little variety to this long series of days that are so monotonous for me. My position continues the same as ever.

My respects to your wife and mother.

Always yours.

Address your letter M. A. Fiquet, etc . . .

Paul Cézanne

To Emile Zola

L'Estaque, 14 September, 1878

My dear Emile,

It is in a quieter frame of mind that I am writing to you at this moment and if I have been able to weather some slight mishaps without too much suffering, then this is thanks to the good solid plank you held out to me. Here is the latest tile which has fallen on my head.

Hortense's father wrote to his daughter at the rue de L'Ouest (in Paris) under the name of Mme. Cézanne. My landlord hastened to send this letter to the Jas de Bouffan. My father opens and reads it, you can imagine the result. I deny vehemently and, as very fortunately the name Hortense is not mentioned in the letter, I maintain that it is addressed to some woman or other.

I received your book of plays. So far I have only read five acts, three of *'Héritiers Rabourdin'* and two of *'Bouton de Rose'*; it is very interesting, and especially *'Bouton de Rose'*, I find. The *'Héritiers Rabourdin'* have some kinship with Molière, whom I re-read last winter. I have no doubt that you will succeed perfectly in the theatre. Having read nothing of this kind by you, I did not expect such lively and good dialogue.

I met an architect called Huot, who highly praised the whole of the *'Rougon-Macquart'* and told me that the work was greatly appreciated by people who know.

He asked me whether I saw you; I said: "Sometimes"— whether you wrote to me; I said "Recently". Stupefaction, and I rose in his esteem. He gave me his card and an invitation to go and see him. So you see that it is of some use to have friends, and it will not be said of me what the

oak said to the reed: *"Encore si vous naissiez à l'abri du feuillage etc . . ."*

My mother thanks you and is greatly touched by your kind remembrance of her. Pelouze is back from Paris: nothing goes well.

Remember me to Alexis and tell him that commercial firms and artistic reputations are based on hard work.

My respects to Madame Zola and my warmest thanks.

<div style="text-align:right">Paul Cézanne.</div>

Nota-Bene: Father gave me 300 francs this month. Incredible. I think he is making eyes at a charming little maid[a] we have at Aix; I and Mother are at L'Estaque.

What developments.

To Emile Zola

<div style="text-align:right">l'Estaque, 24 September, 1878</div>

My dear Emile,

Your letter arrives at the moment when I am concocting the soup of noodles in oil so much appreciated by Lantier.[b] I shall be at l'Estaque for the whole winter, I am working here. Mother left eight days ago for the wine harvest, for the jam, and for the removal from Aix, they are going to live in town,—behind Marguery, or thereabouts.—I am alone at l'Estaque, I go to Marseille in the evening to sleep and come back the next day in the morning.

[a] Cézanne's father was 80 years old at that time.

[b] An allusion to a passage in Zola's '*L'Assommoir*': "His great treat was a very thick noodle soup cooked in water, into which he then poured half a bottle of oil" (Chap. 8).

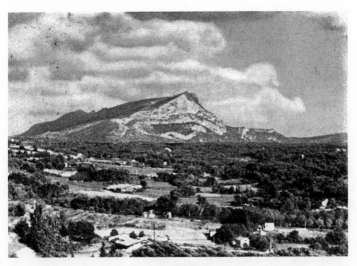

17. Ste Victoire
Photograph

18. Gardanne
Photograph

Marseille is France's oil capital, just as Paris is the butter capital; you have no idea of the presumptuousness of this fierce population, they have but one instinct, that for money; it is said that they earn a lot, but they are very ugly.—Seen from outside their ways of communicating are effacing the most salient features of the types. In a few centuries it will be quite senseless to be alive, everything will be so flattened out. But the little that remains is still very dear to the heart and to the eye.

I saw Mr. Marion from a distance,[a] on his way to the Faculty of Sciences. (Shall I go and see him,—it will take a long time to decide.) He does not appear to be sincere in art, in spite of himself perhaps.

When I said that your Comedy of the 'Héritiers Rabourdin' reminded me of Molière, I had not read the preface. Moreover, it is perhaps Regnard which it calls to mind more.—If I can lay my hand on Dancourt[b] I shall read him.—I have almost finished reading 'Thérèse Raquin'.[c] On the day when you have laid your hands on a very characteristic and personal subject, success will probably come, as in the novel 'L'Assommoir'. In fact, people are hardly fair towards you, because, even if the plays are not appreciated as plays, at least the power and the unity of the characters and the flow of the action could be recognised.

[a] Apparently Cézanne had become completely estranged from the friend of his youth, Marion, just as from Huot. It seems that, apart from Zola and Alexis, Emperaire was the only one of his former friends whom he still saw. Baille especially had completely disappeared from his circle.

[b] Florent Dancourt, one of the most important successors of Molière among French dramatists (1661–1725).

[c] Zola had written a drama based on this early novel of his.

I clasp your hand, and thank you warmly. My respects to Madame Zola, and to Alexis.

<div align="right">Paul Cézanne</div>

Think of Darnagas and the rabbit's tail.

To Emile Zola

<div align="right">L'Estaque, Monday, 4 November 1878</div>

My dear Emile,

I am sending this letter to Paris, assuming that you have already returned to town. My reason for writing this letter is as follows: Hortense is in Paris on urgent business and I beg you to give her 100 francs if you will be kind enough to advance me this sum. I am in a mess, but hope to get out of it.—Let me know if you can do me this new service. If you are prevented, I shall try and find a way out. In either case I thank you; if you write to me, tell me a little about art. I still think of returning to Paris for some months next year, about February or March.

I have just read in the '*Petit Journal*' that '*L'Assommoir*' is to be performed. Who made the adaptation, for I don't think it was you?

This is the address to which you must send the money, if you can: Mr. Antoine Guillaume, rue de Vaugirard 105, he will pass it on to Hortense.

I send you my best greetings, also to Madame Zola and Alexis.

<div align="right">Paul Cézanne</div>

To Gustave Caillebotte[a]

L'Estaque, 13 November, 1878

My dear Colleague,

When you hear that I am very far from Paris, you will forgive me for having failed in the obvious duty imposed on me in view of the fresh blow that has hit you. It is about nine months since I left Paris and your letter reached me at the other end of France after long detours and a long delay.

Allow me to send you in your affliction the expression of my gratitude for the good services you have rendered our cause and the assurance that I share your sorrow even though I did not know Madame your mother, but I well know the aching void caused by the disappearance of people we love. My dear Caillebotte, I press your hand affectionately and beg you to devote your time and energy to painting, this being the surest means of diverting our sadness.

Remember me to Monsieur your father and be of good courage as far as is possible.

Paul Cézanne

[a] Gustave Caillebotte was a painter who exhibited with the Impressionists and was very friendly with most of them. He was very wealthy and often able to help them by buying their pictures, particularly those which were considered unsaleable. In 1893, he bequeathed his entire collection to the State with the stipulation that it had to be accepted as a whole. In spite of this condition only part of the collection was admitted, after long discussions and a violent press campaign. This part of the collection is today in the Louvre, including two of the five paintings by Cézanne which Caillebotte had bequeathed.

TO EMILE ZOLA

L'Estaque, 20 November, *1878*

My dear Emile,

It is now some time since I received news from Paris
telling me that you were kind enough to advance me the
100 francs I asked for. In the meanwhile a week has
passed and I have had no more news from Paris. My little
one is with me at l'Estaque but the weather has been
horrible for some days.

Doubtless you are swamped with work. I am waiting
for a break in the weather to take up again my studies in
painting.

I bought a very curious book, it is a mass of observa-
tions of a subtlety that often escapes me, I feel, but what
anecdotes and true facts! And people *comme il faut* call
the author paradoxical. It is a book by Stendhal: '*Histoire
de la Peinture en Italie*', you have no doubt read it, if not,
allow me to draw your attention to it.—I had read it in
1869, but had read it badly, I am re-reading it for the
third time.—I have just finished buying the illustrated
'*Assommoir*'. But better illustrations would no doubt not
have served the editor better. The next time I can talk to
you face to face I shall ask you whether your opinion on
painting as a means of expressing feeling is the same as
mine.—I ask you to remember me, I am still at l'Estaque.

Do not forget to give my kind regards to Madame
Zola, a handshake for you and Alexis.

Paul Cézanne

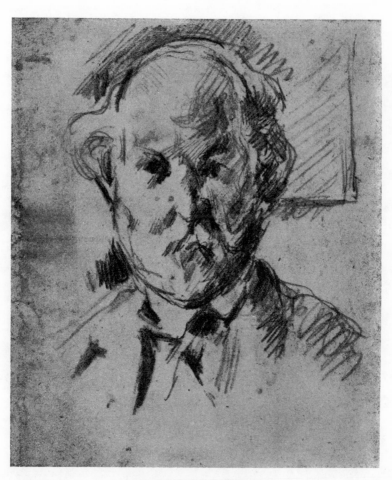

19. Portrait of a Man
Drawing, between 1877–82

To Emile Zola

My dear Emile,

Probably I really did forget to tell you that I had moved last September from the rue du vieux Chemin de Rome. At the moment I am living, or at least Hortense is, in the rue Ferrari 32.—As for me, I am still at l'Estaque, where I received your last letter.

Hortense came back from Paris four days ago, which is a relief to me for my little one was with me and my father might have surprised us. It is almost as if there were a conspiracy to reveal my position to my father, my clot of a landlord is interfering too.—It is more than a month since Hortense received the money that I asked you to send her and I thank you very much for it, she needed it very badly. She had a little adventure in Paris.—I am not going to put it down in writing; I shall tell you when I come back, in any case it is nothing very much.—Finally, I think I shall stay here for a few more months and leave for Paris towards the beginning of March.—I had expected to have a taste of the most complete tranquillity here, but a lack of understanding between myself and the paternal authority makes me on the contrary more disturbed than ever.

The author of my days is obsessed by the idea of liberating me.—There is only one good way of doing that, it is to stick on another two or three thousand francs a year, and not to wait until after my death to make me his heir, for I shall surely end my days before he does.

As you say, there are some very beautiful views here. The difficulty is to reproduce them, this isn't exactly my

line. I began to see nature rather late, though this does not prevent it being full of interest for me.

I wish you all a happy Christmas.—Next Tuesday I shall go to Aix for two days.—You have not mentioned your exploits at hunting, can it be that your fire and that of your arms did not last long? I shake your hand.

<div style="text-align: right">Paul Cézanne</div>

When you write to me please address it still to L'Estaque.

To Marius Roux[a]

<div style="text-align: right">About 1878</div>

Draft

My dear compatriot,

Although our friendly relations have been allowed to relapse in the sense that I have not often sought your hospitality, yet I do not hesitate to turn to you today.— I hope that you will distinguish between my humble personality as an impressionist painter and myself as a person, and that you will only remember the companion. Therefore, it is not to the author of '*L'Ombre et la Proie*' that I appeal but to the Aquasixtain who saw the light of day beneath the same sun as I did, and I am taking the liberty of sending to you my eminent friend and musician Cabaner.[b] I beg you to be kind to him and also recom-

[a] Marius Roux (1838–1905), journalist and author, boyhood friend of Zola. The novel to which Cézanne refers is called *La Proie et l'Ombre*.

[b] The musician and philosopher Cabaner was a friend of Renoir, Cézanne, Manet and others. Manet's pastel portrait of him is today in the Louvre.

mend myself to you in case the day of the Salon should
dawn for me.[a]

In the hope that my request will be favourably received
I send you my thanks and cordial regards.

I shake your hand.

P. Cézanne
Pictor semper virens

Although I have not had [*the honour of meeting her*], may I
send my humble respects to Madame Roux.

To Victor Chocquet[b]

L'Estaque, 28 *January* 1879

My dear Monsieur Chocquet,

May I ask you to be kind enough to get some informa-
tion for me? Here is what it is all about. Always provided,
of course, that you can obtain the information required
without too much bother and inconvenience, otherwise I
could ask the good Tanguy, which I should have done if
I had not had good reason to think that I would get more
satisfactory and complete information from you. But now
to the point: I should like to know how to set about
letting a picture reach the administration of the Beaux-
Arts with the aim of submitting it to the judgment of the
jury, and then if, as I fear, the picture is refused whether
the gentle administration will undertake to return the
above-mentioned work of art to its author, the author
being in the provinces. Unnecessary to add that the artist

[a] Roux was also an art critic.
[b] Victor Chocquet, see footnote c, p. 143.

is not ignorant of the fact that both the sending and the return of his work must be at his own expense.

It is to help one of my compatriots that I am taking the liberty of appealing to you. It is not on my own behalf, for I shall be returning with my little caravan to Paris in the first days of March this year.

The weather is very watery this year, but very mild in our area for the last fortnight.

Please forgive me for troubling you, Monsieur Chocquet, and give my kind regards to Madame; my wife and the little one send you their greetings.

Your humble servant,

Paul Cézanne

To Victor Chocquet

L'Estaque, 7 February, 1879

Monsieur Chocquet,

I am thanking you, although somewhat late, for your kindness in giving me the information about the subject of my last letter.

I think that my friend will have every reason to be satisfied with the peremptory, printed fashion in which the higher administration behaves towards its subordinates.

I am happy to hear of Renoir's success,[a] let us hope

[a] Renoir had received several commissions for portraits; in 1878 he had painted an important picture of Mme. Charpentier, the wife of Zola's publisher, and her children, which was to have a great success in the Salon of 1879.

that some particular and for him not too unpleasant reason has kept him away from you recently.

My wife, on whom rests the burden of attending to our daily food and who well knows the trouble and bother it causes, sympathizes with the worries of Madame Chocquet and sends her, along with your humble servant, her kindest regards. As for our little one, he is terrible all along the line and prepares us for trouble in the future.

I close with a wish for your good health and I am, in gratitude, your devoted

Paul Cézanne

To Emile Zola

L'Estaque, February, 1879

My dear Emile,

I should have written to you some time ago, for I read in 'Figaro' about the great success in the theatre of 'l'Assommoir' and I wanted to congratulate you.—I do not think I shall have to spend more than another fortnight at l'Estaque, after which I shall go to Aix and from there to Paris. If you need anything from this area, I am at your service, or if you have any other commission. Mother joins me in sending you greetings, also to Madame Zola and your mother.

I shake your hand,

Paul Cézanne

To Camille Pissarro

Paris, 1 April, 1879

My dear Pissarro,

I think that, in the middle of the difficulties caused by my sending in to the Salon, it would be more appropriate for me not to take part in the Exhibition of the Impressionists.[a]

Another point, I shall avoid the upset and disturbance caused by the transport of my few canvases. Moreover, I am leaving Paris in a few days.

I send you greetings, waiting for the moment when I can come to shake your hand.

Paul Cézanne

To Emile Zola

Melun, 3 June, 1879

My dear Emile,

The month of June has arrived and am I to come and see you as you more or less suggested last time? I am going to Paris on the 8th of this month and if you write to me before that date I shall take the opportunity to

[a] Monet, Renoir and Sisley, as well as Cézanne, also preferred this year to submit their work to the decision of the jury of the Salon rather than to exhibit with the group of Impressionists. This greatly annoyed Degas, who insisted that, from then onwards, no one should be allowed to exhibit simultaneously with the Salon and the Impressionists. As Cézanne never gave up hope of being accepted by the jury, he could therefore no longer take part in later exhibitions of the group. Both he and Sisley were, however, again refused by the jury in 1879.

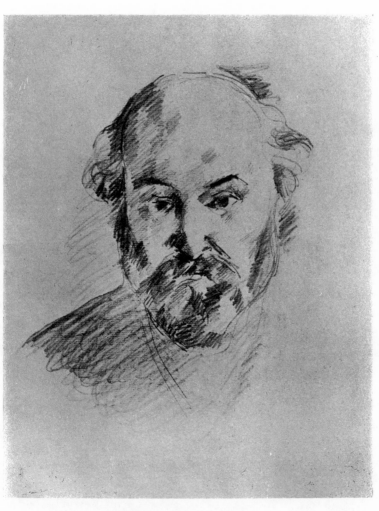

20. Portrait of the Artist
Drawing, about 1880

come and see you in your country house at Médan.— If, on the other hand, you think that I should postpone this little excursion, let me know all the same.

On the 10th of May I went to your house in the rue de Boulogne, but I was told that you had left for the country some days earlier.

Perhaps you knew that I paid an ingratiating little visit to friend Guillemet,[a] who, so I am told, championed me with the jury, but alas without getting any change out of those judges with the hard hearts.

I take this occasion to thank you for having sent me your pamphlet on *'La Républicque et l'Art'*. It happens that Cabaner told me some similar things about the situation, but more gloomy. To conclude, I have sent the pamphlet from here, Melun, to Guillaumin, who wanted to read it.

Shall we have some fine days, the weather hardly seems promising. I felt the water, however, and it didn't seem too cold.

I send my regards to Madame Zola, also to you. I get news of what you do and what you have done through the *'Petit Journal'* and *'La Lanterne'*.

I shake your hand,

Paul Cézanne

[a] The painter Antoine Guillemet who, following Corot's advice, had not sided with the Impressionists, had in the meantime been nominated a member of the Jury of the Salon Officiel. However, as he did not succeed in having a picture by Cézanne accepted, he finally made use of a privilege granted to members of the Jury, which entitled them to accept one work of a pupil without the consent of the Jury. Thus, Cézanne was able to exhibit a picture in the Salon of 1882 under the caption: "P. Cézanne, pupil of A. Guillemet."

To Emile Zola

Melun, Thursday, 5 June, 1879

My dear Emile,

So it is settled for Tuesday between 4 and 4.30.

I shall go to Paris during the day on Monday and I shall look you up in the rue de Boulogne the next day.

I shake your hand,

Paul Cézanne

To Emile Zola

Melun, 23 June, 1879

My dear Emile,

I arrived without any catastrophe at the station at Triel and my arm, waved across the door as I passed in front of your castle, must have revealed to you my presence in in the train—which I didn't miss.[a] Since then I have received, on Friday I believe, the letter which was addressed to me through you, thank you, it was a letter from Hortense. During my absence your book '*Mes Haines*'[b] arrived here and today I have just bought the number of '*Voltaire*' so as to read your article on Vallès.

I have just read it and I find it magnificent. The book by Jacques Vingtras has aroused much sympathy in me for the author.—I hope he will be pleased.

[a] The railway line crossed Zola's garden at Médan.

[b] A collection of Zola's essays of literary and artistic criticism, including his review of the Salon of 1866, with a long dedication to Cézanne.

Please give my respects to Madame Zola your mother, and also to your wife, my sincerest thanks.

I shake your hand.

And good health.

Paul Cézanne

If Alexis is with you—greetings. On some occasion let me know at what depth water was found in the wells.

To Emile Zola

Melun, 24 September, 1879

My dear Emile,

This is what makes me write, for nothing has happened since I left you last June which could give me reason to write a letter, although you did ask me in your last letter to give you news of myself. Tomorrow was so similar to yesterday that I didn't know what to tell you. But this is what I should like: to go and see '*L'Assommoir*'. May I ask you for three seats?—But that is not all, there is still another nuisance, and that is the definite date for which I want this, that is the 6th of the month of October. Please see if my request doesn't cause too much trouble. For, to begin with, you are not in Paris. I am not going there either, and I am afraid it will not be easy to fit in the time of my arrival in Paris with the issuing of the ticket.— And so, if it is too much trouble, tell me and do not be afraid to refuse me for I well understand that you must have been overwhelmed with similar requests. I learnt by way of the '*Petit Journal*' that Alexis was put on with success.

I am still striving to discover my way as a painter. Nature presents me with the greatest difficulties. But I am not too bad, after a renewed attack of the bronchitis I had in '77, which racked me for a month. I wish that you may be spared all similar trials. I hope that this letter will find you and your family in good health. My father lost his partner some time ago, but fortunately they themselves are all well.

I shake your hand and ask you to give my sincerest greetings to Madame Zola, your wife and to your mother.

Your devoted,

Paul Cézanne

To Emile Zola

Melun, 27 September, 1879

My dear Emile,

Heartiest thanks. Send me the tickets to Melun. I am not going to Paris until the morning of the 6th.

I gladly accept your invitation for Médan. Particularly at this time when the country is really astonishing.— There seems to be a greater silence. These are feelings that I cannot express, it is better to feel them.

My greetings to your family and my thanks. I shake your hand.

Your devoted

Paul Cézanne

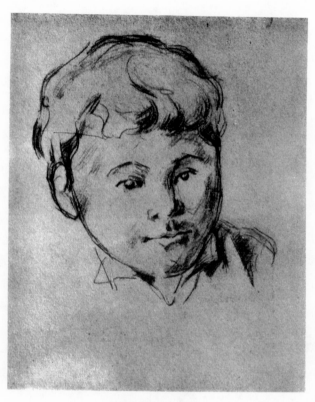

21. The Artist's Son
Drawing, about 1882

To Emile Zola

<p align="right">Melun, 9 October, 1879.</p>

My dear Emile,

I went to see '*l'Assommoir*', and am very pleased I did. I couldn't have had a better seat and I didn't sleep at all, although I am in the habit of going to bed soon after 8 o'clock. The interest does not slacken at all, but I would dare, after seeing this play, to say that the actors seem so remarkable to me, they could bring success to a mass of works which are plays only by name. Literary form does not appear necessary for them. The end of Coupeau is really extraordinary and the actress who plays Gervaise is most appealing. But as a matter of fact they all act very well. What is striking is the necessity to make of the great Virginie a traitress out of a melodrama, that unavoidable concession must have consoled the shades of Bouchardie, who otherwise would not have recognised themselves.

I saw the next appearance of '*Nana*' announced for the 15th, on a large screen which covers the whole curtain of the theatre.

Heartiest thanks, and when my colleagues with the large brushes have finished, please write to me.

Please give my respects to Madame Zola, to your mother and yourself.

I shake your hand,

<p align="right">Paul Cézanne</p>

To Emile Zola

<div align="right">Melun, 18 December, 1879</div>

My dear Emile,

I received your last two letters, the one telling me of the increase in snow, the other of the complete absence of any thaw. I can well believe it. With regard to the cold I have nothing to envy you.—On Wednesday we had as much as 25 degrees of frost here. And what is still less amusing, is that I am unable to obtain fuel!

Probably by Saturday I shall have no more coal and shall be forced to take refuge in Paris. It is an astounding winter. I have some difficulty in thinking back to the month of July, the cold reminds one too strongly of reality.

It is settled for the month of January then, if I really do not disturb you. If I go to Paris I shall give you my address.

I shake your hand and please give my respects to Madame Zola and your mother.

<div align="right">Paul Cézanne</div>

To Emile Zola

<div align="right">*Melun, February, 1880*</div>

My dear Emile,

I am a little late in thanking you for the last volume you sent me. But the attraction of novelty made me hurl myself upon it and yesterday I finished reading '*Nana*'.—It is a magnificent book but I am afraid that by mutual

agreement the papers have not mentioned it. In fact I have seen neither an article nor an advertisement in any of the three little newspapers I take. Well, this discovery annoyed me a bit, because it would be the indication of too great an indifference towards works of art or the sign of a prudish and deliberate reticence which is not felt for certain other subjects.[a]

Now it may be that the stir which should have been caused by the publication of the book '*Nana*' did not reach me here, and then it would be the fault of our beastly papers, in which case I should be consoled.

I present my respects to Madame Zola and my thanks to you. I shall come and see you in March.

<div align="right">Paul Cézanne</div>

To Emile Zola

<div align="right">Melun, 25 February, 1880</div>

My dear Emile,

This morning I received the book that Alexis has just published. I should like to thank him and as I do not know his address I must ask you to be kind enough to let him know how touched I am at this sign of friendship that he is good enough to show me. This volume will be added to the literary collection which you have made for me, and I have for quite some time enough to distract me and to occupy my winter evenings. Moreover, I hope that

[a] This sentence is not entirely clear in the original French text. In spite of the hostile silence of the press, *Nana* was an even greater success than *l'Assommoir*.

I shall see Alexis when I am back in Paris, and that I shall be able to thank him myself.

Our friend Antony Valabrègue has published a charming volume '*Petits poèmes parisiens*' with the publisher Lemerre. You must have had a copy. My paper speaks well of it.

But it appears that Mademoiselle Deraismes,[a] from Pontoise or somewhere around there, maltreated you grossly. Pons, the one out of Sainte-Beuve, would say that she would do well to knit stockings.

An affectionate handshake for you and please give my respectful greetings to Madame Zola,

Your devoted friend,

Paul Cézanne

To Emile Zola

Paris, 1 April, 1880

My dear Emile,

Having received your letter this morning 1st April, enclosing the one from Guillemet, I descend on Paris, I learn from Guillaumin that the 'Impressionists' are open. —I rush there. Alexis falls into my arms, Doctor Gachet invites us to dine, I prevent Alexis from paying his respects to you. May I take the liberty of inviting us to dinner on Saturday evening? Should the opposite be the case, please be good enough to let me know. I am staying at the rue de L'Ouest 32, Plaisance.

[a] Maria Deraismes (1828–94), French feminist.

186

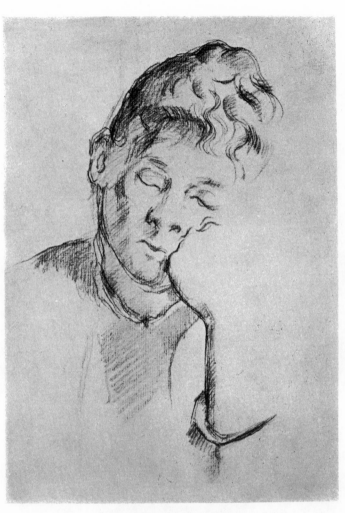

22. The Artist's Wife
Drawing, about 1880–82

I remain in gratitude your ancient college comrade of 1854. I ask you to give my respects to Madame Zola.

<div align="right">Paul Cézanne</div>

To Emile Zola

<div align="right">*Paris*, 10 May, 1880</div>

My dear Emile,

I am enclosing a copy of a letter that Renoir and Monet are going to send to the Ministre des Beaux-Arts to protest against the bad hanging of their pictures and to demand an exhibition next year for the group of the pure Impressionists. Now here is what I have been requested to ask you to do:

That is, to publish this letter in '*Voltaire*', preceded or followed by a few words on the previous activities of the group. These few words should aim at showing up the importance of the Impressionists and the real interest they have aroused.[a]

I shall not add that whatever solution you consider proper to give to this request must have no influence on your friendly feelings for me nor on the good relations

[a] In answer to this request, Zola published from the 18th–22nd June, a series of articles in 'Voltaire' about 'Naturalism in the Salon'. His point of view, however, did not really agree with that of the Impressionists and could hardly be said to represent the intervention which they had expected from him. Having become very successful himself, Zola could understand the constant difficulties of the Impressionists only by persuading himself that none of the painters had achieved real mastery. About Cézanne, Zola said only briefly: "M. Paul Cézanne has the temperament of a great painter, still engaged in the effort to express himself; he is close to Courbet and Delacroix."

that you have very kindly wanted to exist between us. For I am liable more than once to have to make requests of you that may be disagreeable for you. I fulfil the function of an intermediary and nothing more.

I heard yesterday the very sad news of Flaubert's death.—Also, I fear that this letter will fall upon you at a time of much worry and excitement.

My sincerest respects to Madame Zola and your mother. I shake your hand cordially.

<div align="right">Paul Cézanne</div>

Monsieur le Ministre,

Two artists known by the name of 'Impressionists', appeal to you to grant them permission to have their works exhibited next year under suitable conditions at the Palais des Champs-Elysées.

Please accept, monsieur le Ministre, the expression of our deepest respect.

To Emile Zola

<div align="right">*Paris*, Saturday, 19 June, 1880</div>

My dear Emile,

I ought to have thanked you for the last letter but one that you wrote to me on the subject of what I had asked you to do for Renoir and Monet. Partly owing to negligence and because the month of June is progressing so rapidly, I did not reply.—Finally and lastly, your latest letter did not reach me until today. This was because the address was not quite right. You should put 32, rue de

l'Ouest and not 12. My heartiest thanks. I was able to obtain the number dated the 19th.[a] I shall go to the '*Voltaire*' to get the number for the 18th of the current month.—Monet has at the moment a very fine exhibition at Mons. Charpentier's at the '*Vie Moderne*'.[b]

I am not quite sure whether the really hot weather is coming, but as soon as I shall not be in your way please write to me and I shall come to Médan with pleasure. And if you are not alarmed at the length of time that I risk taking, I shall allow myself to bring a small canvas with me and paint a motif, always providing that you see in this nothing disturbing.

I am very grateful to Madame Zola for the large pile of rags she sent me, which are very useful.—I go into the country every day to do a little painting.

I saw that very excellent man Solari. Tomorrow I am going to visit him, he came three times to the house and I was always out. Tomorrow, Sunday, I shall go and shake his hand. Nothing goes well for him. He cannot get luck on his side. With less effort, how many lucky rascals make good. But man remains, and for my part I thank God I have an eternal father.

Please remember me to Madame Zola, also to Madame Zola your mother.

I shake your hand.

<div align="right">Paul Cézanne</div>

[a] This number contained the short and lukewarm remark about Cézanne, who, however, seems to have preferred not to react to it; he avoided altogether commenting on Zola's reticent views.

[b] It was in fact the publisher's wife who had favoured the publication of the new periodical 'La Vie Moderne'; the editor was Renoir's brother. Exhibitions were arranged in a special room at the publisher's office, mostly of minor followers of Impressionism.

To Emile Zola

<div align="right">Paris, 4 July, 1880</div>

My dear Emile,

On the 19th June last I sent my reply to your letter of
the 16th. I asked you whether I could come to you to
paint, it is true,—but please understand that I didn't
want to cause embarrassment. Since than I have had no
news from you, and as nearly a fortnight has now passed
I am taking the liberty of asking you to send me a few
lines to explain the position. If you would like me to
come and say how do you do, I shall come, or if you tell
me the contrary, I shall not come yet.[a]—I have read,
beginning with no. 11, the articles that you are publishing
in '*Voltaire*'. And I thank you in my own name and in the
name of my other colleagues.—Monet, so I have heard,
has sold some of the pictures he exhibited at Monsieur
Charpentier's and Renoir is said to have received some
good commissions for portraits.

I send my best wishes for your health—and please
give my sincere respects to Madame Zola and to your
mother.

I remain your grateful and devoted

<div align="right">Paul Cézanne</div>

My address is: 32, rue de l'Ouest and not 12, as you
wrote by mistake.

[a] Cézanne did in fact visit Médan in August; on the 22nd Zola
wrote from there to Guillemet: "Paul is still here with me, he works
a lot." During his long stay in Médan, Cézanne met many of Zola's
friends, among them Huysmans, Céard, Rod, and probably also
Théodore Duret.

To Emile Zola

Saturday, *1880*

My dear Emile,

I have just received the copy which you sent me.[a] I shall regale myself with it when the peaceful hours of evening arrive. May I ask you to be the interpreter of the feelings of artistic sympathy which bind together all sensitive people—in spite of the difference in their means of expression—to your colleagues, when you see them, and thank them for joining with you to offer me this volume which I sense to be full of emanations both substantial and nourishing.

Yours from the heart, the Provençal in whom maturity has not preceded old age.—I must not forget to send my respects to Madame and to beg her to consider me her very humble servant.

Paul Cézanne

To Emile Zola

Paris, 28 October, 1880

My dear Emile,

This morning Solari brought me the letter that you sent me. I had learnt from the '*Journal*' that you had lost your mother and also that you were going to Aix,[b] which is why I did not come to Médan. I was going to

[a] The 'Soirées de Médan'. The volume contains short stories by Zola, Maupassant, Alexis, Huysmans, etc.
[b] Zola's mother was buried at Aix-en-Provence.

write and ask you if you intended coming to Paris next month, but since you tell me of your arrival in a little while I shall wait until then, unless you would like me to come and see you, I am at your service for whatever I can do.

I well understand the sadness of your position and I only hope that it will affect your health as little as possible, also your wife's.

Please accept my sincerest greetings and I shake your hand warmly.

<div align="right">Paul Cézanne</div>

32, rue de l'Ouest.

To Emile Zola

<div align="right">12 April, 1881</div>

My dear Emile,

In a few days the sale for the benefit of Cabaner will take place. And this is what I want to ask you: that you undertake to write a little notice about it as you did for the sale of Duranty.[a] For there is no doubt that the weight of your name alone will have a great appeal for the public to attract amateur collectors and advertise the sale.

Here is a list of some names of artists who have offered their works:

Manet, Degas, Frank Lamy, Pissarro, Béraud, Gervex,

[a] Edmond Duranty (1833–1880), author and art critic, a friend of the Impressionists and author of a pamphlet on 'La Nouvelle Peinture'. Zola had written the preface to the catalogue of the sale for his wife.

Guillemet, Pils, Cordey, etc., and your humble servant.

As one of your oldest friends, I have been charged to ask this favour of you.

I shake your hand cordially and ask you to give my respects to Madame Zola.

Yours ever,

Paul Cézanne

To Theodore Duret[a]

April 1881

Here is the very friendly letter that Zola was kind enough to send me.

For your part be good enough, if you please, to send him the necessary details.

Believe me your very humble servant,

Paul Cézanne

This note is written on the back of the following letter from Zola to Cézanne:

Médan, 16 April '81

My dear Paul,

I shall be pleased to write the little notice you ask for; but it is absolutely necessary for me to have some details.

I have to speak of Cabaner, but in what terms? Am I

[a] It is not certain that this letter was really addressed to Théodore Duret (1838–1927); it was found among the papers of this famous writer on the Impressionists. Duret had been a friend of Zola since 1868, when they worked together at *La Tribune,* and became enthusiastic admirers of Manet's work. Cézanne was probably the only member of the group who did not have a close relationship with Duret.

to say that he is ill, that he is in the South, that the sale is being held to help him? In a word, am I to mention his distress? I know very little of him and should not like to hurt him. Answer me quickly what you think about it and whether we can move the public to pity for his lot while speaking of his artistic struggles and of his talent. This I think would be the right note. But I want the organizers of the sale to authorize me to say this.

I await your letter before writing the notice.

Sincerely yours,

Emile Zola[a]

To Emile Zola

Pontoise, 7 May, 1881

My dear Emile,

I have been at Pontoise for two days. Since you so kindly wrote that you would undertake to write the notice about Cabaner, I have not seen Frank Lamy, one of the organizers, I believe, of the sale for the benefit of the unfortunate musician.

So I should be much obliged if you would tell me whether you have received the details on which you were to work and whether you have concocted the little notice for which I had been charged to ask you. Huysmans and Céard, as well as you, have all sent me your most recent publications, and I was delighted with them.—I think

[a] The details for which Zola asked were in the end provided by Frank Lamy. Zola's note was printed in the Catalogue of the sale, which had only limited success. A few months later, on 3rd August, 1881 Cabaner died from tuberculosis.

Photograph by permission of Alex. Reid & Lefevre, London

23. Flowers in a Green Vase
Oil, 1883–87

that Céard will be very popular, because it seems to me very amusing, not to mention the great qualities of insight and observation contained in his book.

Thank you very much for having introduced me to these very remarkable people, and please give my respects to Madame Zola and also to yourself.

With my best greetings,

Paul Cézanne

At the moment I am living
 Quai du Pothuis, 31
 at Pontoise (Seine-et-Oise)

At the last moment I hear that Madame Béliard is very ill, it is always painful to hear that fate weighs heavily on people whom one likes.

TO VICTOR CHOCQUET

Pontoise, 16 May, *1881 or 1880*

Monsieur Chocquet,

Having heard that the 40 canvas [*c. 70 × 100 cm.*] which Monsieur Tanguy must have given you did not have a frame, I should be much obliged if you would be good enough to have the frame of the picture in question brought to you. Thank you in advance and please accept my apologies for the new inconvenience I am causing you.

Monsieur Chocquet, we are all in good health, and since our arrival we are enjoying all the atmospheric variations that the sky is pleased to bestow upon us. Monsieur Pissarro, whom we saw yesterday, gave us

news of you, and we are happy to know that you are in good health.

My wife and Paul junior ask me to send you their most affectionate greetings; permit me to offer you the homage of my most sincere greetings and to convey them, too, to Madame Chocquet, not forgetting, on behalf of my family, Mademoiselle Lisbeth.

I salute you and shake your hand affectionately,

Paul Cézanne

To Emile Zola

Pontoise, 20 May, 1881

My dear Emile,

Since you were kind enough to answer me, the sale for the benefit of Cabaner has taken place. As you tell me, I did in fact think that Frank Lamy must have got in touch with you, and I thank you very much for the preface that you wrote about the metaphysician, who really should have written some substantial work, for he has some really quaint and paradoxical theoretical conceptions which do not lack a certain flavour.

A slight torment outlines itself before me. My sister and brother-in-law are coming to Paris, accompanied, I believe, by their sister Marie Conil. You can see me piloting them through the Louvre and other places with pictures.

Most certainly, as you say, my stay at Pontoise will not prevent me from coming to see you; on the contrary I am planning to come to Médan by road and at the expense

of my legs. I do not think that I am beyond this task.

I see Pissarro fairly often, I lent him Huysmans' book, which he gobbles up.

I have started several studies in dull weather and in sunshine.—I hope you will soon recover your usual state of mind in work, for it is, I think, in spite of all the alternatives, the only refuge where one finds true contentment in oneself.

Please present my respects to Madame Zola, and I shake your hand cordially.

Ever your

Paul Cézanne

Please remember me to your compatriot Alexis whom I have not seen for a long time and whom you will necessarily see before I do.

TO EMILE ZOLA

Pontoise, Tuesday, June, 1881

My dear Emile,

I wanted to thank you for sending me your last volume, but by constantly postponing it I might have let a long time pass, had it not been that this morning I found myself up before 4 o'clock.—I have started reading but have not finished it yet, although I think I have read a fair amount as, because it is in sections, I read now one essay and now another. It seems to me that the one on Stendhal is very beautiful.

Having gone to Paris I found at my house the book

that Rod[a] had been kind enough to send me, which is easy reading. I have read it all through. I didn't know his address and was unable to thank him for the copy he sent me.—If you should happen to write me a few lines give me his address so that I can do my duty to him.

My sister and brother-in-law came to spend some days in Paris. On Sunday morning, my sister being ill, I was forced to pack them off to Aix. The first Sunday of the month I went with them to Versailles, the city of the great King, to see the great fountains.

I wish you good health for it is the most precious thing, particularly when, in addition, one is in good material circumstances.

I take the liberty of sending my respects to Madame Zola, and I shake your hand.

<div style="text-align: right">Paul Cézanne</div>

I am working a little but with much indolence.

To Emile Zola

<div style="text-align: right">Pontoise, Monday July, 1881</div>

My dear Emile,

I heard when I went to Auvers that Alexis had been wounded in a duel, where, as always, the right was the loser. If it is not too much trouble for you, you would be doing me a favour by giving me news of our gallant countryman.

[a] Edouard Rod (1857–1910), Swiss author attached to the Médan circle.

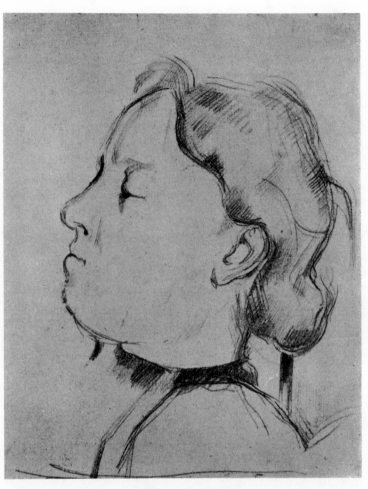

24. The Artist's Wife
Drawing, about 1885

I cannot go to Paris until the first days of August, when I shall inquire about his health.

It was also by chance that I learnt earlier of the discussion raised by Wolff on the subject of the article you wrote about Maupassant and Alexis.

I ask you to give my greetings to Madame Zola and, in the middle of all this commotion, I hope that you will remain in good health; and if Alexis should by chance be with you, for I still hope that his wound is not serious, please assure him of my brotherly sympathy.

I am your old comrade,

Paul Cézanne

To Emile Zola

Pontoise, 5 August, 1881

My dear Emile,

Whilst I was with Alexis on Tuesday morning, your letter came to Pontoise. So I learnt from both sides that the affair Alexis had ended in a manner not too annoying for him. I found my compatriot completely restored and he showed me the articles which preceded and followed his duel.

At my house in Paris was a letter that had come from Caserta and was signed by a man called Etorre-Lacquanitin or something similar, asking me to help him to obtain a pile of articles and reviews about your works, both recent and those written before the '*Rougon-Macquart*'. You probably know this author, who wants to make a critical study of your work.

Alexis, to whom I showed the letter, told me that he had received a similar one and that he would answer for both of us.

Some minor troubles have not facilitated my visit to Médan, but I shall come for certain at the end of October. I must at that time leave Pontoise and I may perhaps spend some time at Aix. Before undertaking this journey I shall, if you write to me at that time, come and stay with you for several days.

I shake your hand affectionately and send my respects to Madame Zola, and good bathing.

Ever your

Paul Cézanne

To Emile Zola

Pontoise, 15 October, 1881

My dear Emile,

The time is approaching when I must leave for Aix. Before going I should like to come and say *bonjour* to you. As the bad weather has come I am writing to you at Médan, guessing that you must now be back from Grandcamp.[a] So if you do not see any difficulty, I shall come and visit you about the 24th or 25th of this month. If you can write me a line about this, you will give me pleasure.

Please give my greetings to Madame Zola, hoping

[a] A small port on the Channel coast, where Seurat often painted in 1885. After Zola's return from Grandcamp, Cézanne did in fact visit him for a week in Médan and then went to the South.

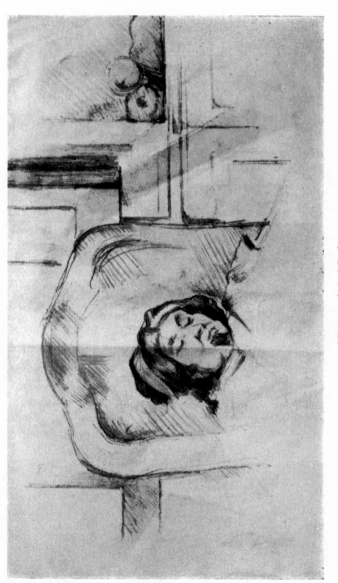

25. The Artist's Mother
Drawing, about 1885

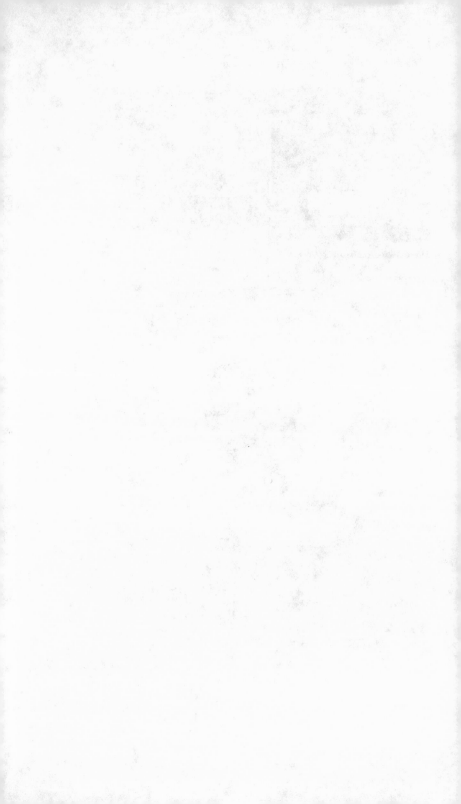

that you have both returned in good health, and a warm handshake for you.

Your devoted,

Paul Cézanne

To Paul Alexis

L'Estaque, 15 February, 1882

My dear Paul,

I am afraid that I am very late in thanking you for sending me your biographical volume,[a] because I am at l'Estaque, the home of the Sea-urchins. The copy that you were kind enough to send me landed at Aix and fell into the hands of my impure relatives. They took good care not to mention this to me. They stripped it of its envelope, cut it, went through it in every sense and I was waiting under the harmonious pine tree.—But at last I found out.—I demanded it, and now here I am in possession and reading.

I thank you warmly for the pleasant emotions you wake in me through reminders of things past. What more can I say. I shall be telling you nothing new if I say what wonderful stuff there is in the beautiful verses of him who likes to continue to be our friend.[b] But you know how much it means to me. Don't tell him. He would say that I am a bit touched.—This between us and under our breath.

[a] Alexis had just published *Emile Zola, notes d'un Ami*, in which a great part is devoted to the youth of Zola and Cézanne.

[b] In the Appendix, Alexis published a number of Zola's early poems, one of them dedicated to Cézanne.

Therefore my dear Alexis, I send you my greetings as your compatriot and friend.

Vale,
Paul Cézanne

To Emile Zola

L'Estaque, 28 February, 1882

My dear Emile,

I received the day before yesterday the volume of literary criticism that you were kind enough to send me. So I am writing to thank you and at the same time to tell you that, after having stayed in the South for four months, I am going to return to Paris in a week's time. And as I believe that you are at Médan, I shall come and say *bonjour* to you in your abode. But first of all I shall call at the rue de Boulogne to find out whether you are perhaps there.

I send greetings to Madame Zola and shake your hand cordially.

I am your grateful

Paul Cézanne

To Emile Zola

Paris, 2 September, 1882

My dear Emile,

As you told me in April, I take it that you are at your country house. So I am addressing this scrap of a letter

there. As I have only another month to spend in Paris, may I come and find you at Médan? If, as you did two years ago, you come to Paris about the 10th or the 12th, will you let me know and I shall come and shake hands with you. And I shall know when I see you whether I can set out for your home in the country.

Well, I hope that my letter will find you in good health.

I close by sending my respects to Madame Zola and ask you to accept my warmest greetings.

<div align="right">Paul Cézanne</div>

To Emile Zola

<div align="right">

Aix, Jas de Bouffan,
Tuesday, 14 November, 1882
</div>

My dear Emile,

Yesterday I received the book you sent me and I should like to thank you for it. Since I arrived, I haven't budged from the country and I have only met Gibert, the director of the Museum, whom I must go and see.

I have also met big Dauphin, with whom we went to school and also little Baille,—both of them attorneys, the latter seems to be a nice little legal rascal.—But here there is nothing new, not the least little suicide.[a]

Should you need anything from here, write to me. I shall be happy to be at your service. I continue to work a little though I do nothing else.

[a] No doubt an allusion to the death of their boyhood friend Marguery, who had committed suicide in August 1881.

My respects to Madame Zola and greetings from mamma who wishes to be remembered to you both. I send you my greetings and a firm handshake.

I am ever your

Paul Cézanne

I have not seen the good Alexis; as you have the opportunity to see him, please tell him that I wish him *bonjour*.

To Emile Zola

Aix, Jas de Bouffan,
27 November, *1882*

My dear Emile,

I have decided to make my will, because it seems that I can do so as the title-deeds of the stocks that fall to me are made out in my name.[a] So I am asking your advice. Could you tell me how I should word this document? In the event of my death, I should like to leave half my income to my mother and the other half to my little boy.—If you know anything about it, please let me know. For if I were to die in the near future, my sisters would inherit from me, and I think my mother would be cut out, and my little boy (whom I acknowledged when I registered him at the *mairie*) would, I believe, have a right to half my estate, but perhaps not uncontested.

[a] Cézanne's father, in order to save his children payment of death duties, had transferred his fortune into their names a few years after retiring from his bank in 1871. However, he of course continued to administer the money himself and by no means allowed his children to dispose of it.

If I can make out a will in my own hand, I should like to ask you, if it is no trouble to you, to keep in custody a duplicate of the same.—Provided this does not inconvenience you, because the paper in question might be purloined from here.

This is what I wanted to explain to you. I salute you and wish you *bonjour*, not forgetting to send my respects to Madame Zola.

Ever your

Paul Cézanne

TO NUMA COSTE

Aix, 6 January, 1883

My dear Coste,

I think it is to you that I am indebted for sending me the paper '*L'Art Libre*'.[a] I read it with the most lively interest, and with good reason. So I wish to thank you and to tell you how much I appreciate the generous impulse with which you take up the defence of a cause to which I myself am far from remaining indifferent.

I am with gratitude your compatriot and, I might say, your colleague.

Paul Cézanne

[a] Numa Coste, who, together with Zola, Alexis and others, had founded the periodical *L'Art Libre*, continued to paint in his leisure time and exhibited fairly regularly at the official Salon.

To Emile Zola

My dear Emile,

I am rather late in thanking you for sending me your last novel. But here is the attenuating circumstance for this delay. I have just come from l'Estaque, where I had been for a few days. Renoir, who is to have an exhibition of painting following Monet's, which is now taking place, asked me to send him two landscapes which he had left with me last year. I sent them to him on Wednesday; and so here I am at Aix, where snow fell all day on Friday. This morning the countryside presented the very beautiful sight of a study in snow. But it melts.

We are still in the country. My sister Rose and her husband have been at Aix since October and she gave birth to a little girl there. All this is anything but amusing. I think the result of my protestations will be that they won't return to the country this summer.—This is a joy to my mother.—I shall not be able to return to Paris for a long time; I think I shall spend another five or six months here. So I remind you of my existence and ask you to remember me to Alexis.

Please give my respectful greetings to Madame Zola, also from my mother.

Thanking you warmly, I am always your,

Paul Cézanne

To Emile Zola

<p style="text-align:right">L'Estaque, 19 May, 1883</p>

My dear Emile,

I asked you in December 1882, I believe, whether I could send you *testamentum meum*. You answered "yes". I now wish to ask you if you are at Médan, as is very likely, in which case I shall send it to you there, registered. This is what I ought to do, I think. This, after no little equivocation, is what has happened. My mother and I went to a notary at Marseille, who advised me to draw up a testament with my own hand, and, if I wished, to make my mother universal legatee. And so I did. When I return to Paris I should be glad if you could accompany me to a notary, I shall get fresh advice and remake my will, and then I shall explain to you personally what is urging me to do this.

Now that I have put down for you nicely all the serious things I wanted to tell you, I shall end this letter by asking you to give my respects to Madame Zola and I shake your hand, and, if wishes are any use, that you are in fine health, for things happen which are not funny. These last words are inspired by Manet's catastrophe,[a] otherwise I am well. Now I have finished and thank you for this new service.

<p style="text-align:right">Paul Cézanne</p>

Here is my address which I nearly forgot: Cézanne, Quartier du Château, above the station at l'Estaque (Marseille)

[a] Manet had just died after having had a leg amputated.

ZOLA TO CEZANNE

Médan, 20 May, 1883

My dear Paul,

I thought of you just this morning and promised myself to write to you and to ask for your news, when I received your letter.

Yes, I have been in Médan for a month and you can send me your last will: it will be in safe hands. As soon as you return, we shall go to the best notary for the discussion which you wish to have and you can do all that's necessary to put your mind at rest. But, it is necessary that you should be there in order to explain your case well.

You don't mention your return. In your earlier letter you told me that you would remain down there for the whole of the summer. I count on seeing you in September, you can then still pass several days here and we can talk at ease.

Do you work? Are you satisfied? I have started a new novel. That is my life. Otherwise, nothing new: we are still settling down and are very well.

In your next letter give me the likely date of your return. Keep up your courage. Very friendly greetings to your mother and you all.

Very affectionately,

P.S. The idea of making your mother sole legatee appears to me a good one, provided you have confidence in her.

26. The Artist's Son
Oil, 1885

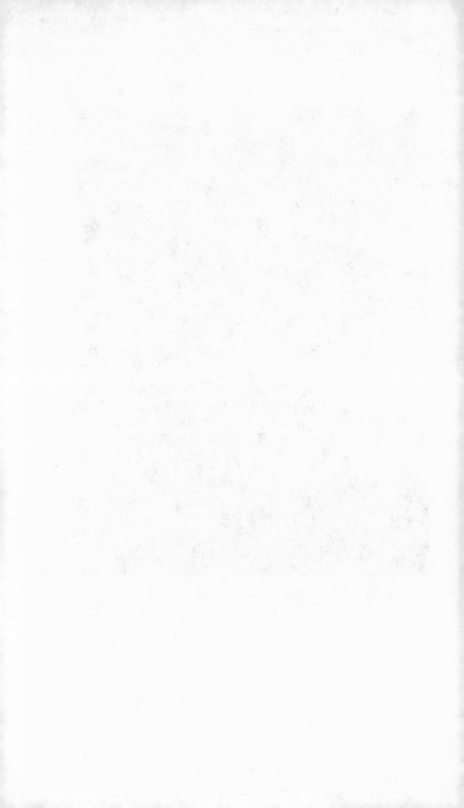

To Emile Zola

L'Estaque, 24 May, 1883

My dear Emile,

Now that I am quite certain you are at Médan, I am sending you the paper in question, of which my mother has a duplicate. But I am afraid that all this will not be of much use for these wills are very easily disputed and annulled. A formal statement in front of the civil authorities would be better, should the case arise.

I shall not return to Paris before next year; I have rented a little house and garden at l'Estaque just above the station and at the foot of the hill, where behind me rise the rocks and the pines.

I am still busy painting.—I have here some beautiful views but they do not quite make *motifs*.—Nevertheless, climbing the hills as the sun goes down one has a glorious view of Marseille in the background and the islands, all enveloped towards evening to very decorative effect.

I do not speak to you about yourself seeing that I don't know anything about anything except that when I buy '*Figaro*' I sometimes hit upon a few facts relating to men I know, thus lately I read a weighty article about the valiant Desboutins.[a]—I did learn, however, that Gaut values your last novel very highly (but no doubt you know this). As for me, I liked it very much, but my appreciation is not of much literary value.—Thank you very much, very much indeed, and do not forget to give my greetings to Madame Zola, and also remember me to

[a] Marcellin Desboutins, painter, etcher and dramatic writer (1823–1902), was a special friend of Manet and frequented the Café Guerbois and the Café de la Nouvelle Athènes, where the Impressionists used to meet in the evenings.

Alexis and the living ones. I press your hand warmly. Ever your

<div align="right">Paul Cézanne</div>

The document is pre-dated, seeing that the stamped paper was bought last year.

TO PHILIPPE SOLARI

<div align="right">L'Estaque, 10 July, 1883</div>

My dear Solari,

I received the letter you sent me on the occasion of the marriage of your daughter to Monsieur Mourain. Under these circumstances may I ask you to be the interpreter to the young couple of my warm feelings and give them our best wishes for their happiness and prosperity in the future.

I send my congratulations to you and also to Madame Solari, and my love to baby Emile,[a] who must be very happy.

A warm handshake for you, from your old fellow excursionist

<div align="right">Paul Cézanne</div>

P.S. My wife joins me in my good wishes and also my terrible youngster.

[a] Emile Solari (son of the sculptor Philippe Solari), writer and godchild of Zola, to whom Cézanne later addressed several letters.

To Emile Zola

L'Estaque, 26 November, 1883

My dear Emile,

I received the book you were kind enough to send me. But here is the reason for the new delay which makes me thank you such a long time after, it's that since the beginning of November I have been back at l'Estaque where I intend to remain until January. Mama has been here for some days; and last week Rose, who is married to Maxime Conil, lost her child, which was born in September or October, I think. The fact is, the poor little thing didn't last long. Otherwise everything is as usual.

If the good Alexis is not far from you, remember me to him. Apart from that, I send you very good wishes and greetings to Madame Zola.

I have the honour to salute you and to renew my thanks for your kind thoughts of me.

Ever your

Paul Cézanne

To Emile Zola

Aix, 23 February, 1884

My dear Emile,

I received the book that you were kind enough to send me recently, the '*Joie de Vivre*' which appeared in '*Gil Blas*', because I saw some extracts in the above paper. Therefore, thank you very much for sending it, and for not forgetting me in the seclusion of my retreat. I should

have nothing to tell you were it not that, happening to be at l'Estaque a few days ago, I received there a letter written in his own hand from good old Valabrègue, Antony, telling me of his presence at Aix, where I at once ran to yesterday, and where I had the pleasure of clasping his hand this morning—Saturday. We made a tour of the town together—recalling some of those we had known—but how far apart we are in our feelings! I had my head full of the character of this country, which seems to me quite extraordinary.—On the other hand, I saw Monet and Renoir who went for a holiday to Genoa in Italy towards the end of December.

Don't forget to remember me to my compatriot Alexis, although I have not heard from him for ages.

My best thanks to you and my respects to Madame Zola, hoping you are both in good health.

I salute you sincerely,

<div align="right">Paul Cézanne.</div>

On the 29th March, 1884, A. Guillemet wrote to Zola: "I have received a line from Cézanne recommending to me a portrait head that he had sent to the Salon. Alas, this head was refused."

To Emile Zola

<div align="right">*Aix*, 27 November, 1884</div>

My dear Emile,

I have just received two new books that you were kind enough to send me. I thank you, and I must tell you that I have not much news to give you about the good old

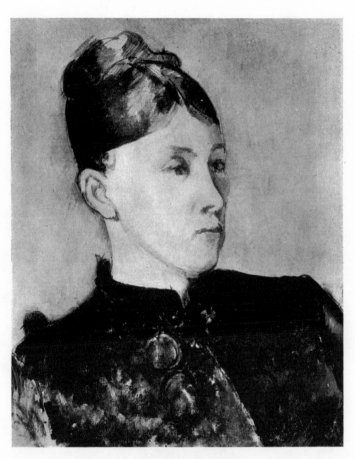

27. The Artist's Wife
Oil, about 1885

town where I saw the light of day. Only (but this doubt-less will not affect you much), art is changing terribly in its outer appearance, putting on too much of a small, very mean form, while at the same time the ignorance of harmony reveals itself more and more through the dis-cord of the colours and, what is even worse, the aphony of the tones.

After groaning, let us cry long live the sun, which gives us such a beautiful light.

I can only repeat, I am yours from my heart, not for-getting to send my respects to Madame Zola,

Paul Cézanne

TO EMILE ZOLA

L'Estaque, 11 March, 1885

My dear Emile,

I received the book you were kind enough to send me about ten days ago. Rather severe neuralgic pains, which left me only moments of lucidity, made me forget to thank you. But my head has eased and I go for walks on the hills where I view many a beautiful panorama. I wish you good health; thinking that you do not lack the rest.

I shake your hand cordially,

Paul Cézanne

To an Unknown Lady[a]

Spring 1885

Rough draft.

I saw you and you allowed me to kiss you; from that moment a profound emotion has not stopped exciting me. You will excuse the liberty that a friend, tortured by anxiety, takes in writing to you. I do not know how to explain to you this liberty that you may find so great, but could I have remained under this burden which oppresses me? Is it not better to give expression to a sentiment rather than to conceal it?

Why, I said to myself, suppress the cause of your agony? Is it not a relief granted to suffering, to be allowed to express itself? And if physical pain seems to find relief in the cries of the afflicted, is it not natural, Madame, that moral sadness seeks some consolation in the confession made to an adored being?

I know well that this letter, the hasty and premature sending of which may appear indiscreet, has nothing to recommend me to you but the goodness of....

To Emile Zola

Aix, Jas de Bouffan, 14 May, 1885.

My dear Emile,

I am writing to ask you to be kind enough to answer me. I should be much obliged if you would do me a

[a] This fragment is on the back of a drawing by Cézanne belonging to the Albertina in Vienna. It breaks off abruptly at the end of the page.

favour which is, I think, very small for you but vast for me. It would be to receive a few letters for me and to send them on by post to the address that I shall send you later. Either I am mad or I am very sensible. *Trahit sua quemque voluptas!*[a]

I appeal to you and implore you for your absolution; happy are the wise!

Do not refuse me this service, I don't know where to turn.

My dear friend, I clasp your hand warmly.

Ever your,

Paul Cézanne

PS. I am very small and can do you no service; as I shall leave this world before you, I shall put in a good word with the Almighty to get you a good place.

To Emile Zola

La Roche-*Guyon*,[b] 15 June, 1885

My dear Emile,

I arrived this morning at La Roche. I am therefore asking you to readdress any letters that may come for me: poste restante at La Roche-Guyon, par Bonnières
(Seine-et-Oise).

[a] Quotation from Virgil, 'Everyone is swept away by his passion'.
[b] La Roche-Guyon, where Pissarro had painted 20 years earlier, is a picturesque place near Bonnièrres, opposite Bennecourt, where Cézanne and Zola had stayed in 1866. Cézanne seems to have gone there after a short visit to Zola, probably invited by Renoir, who spent the summer in La Roche-Guyon and apparently wanted to repay Cézanne for his hospitality in Estaque.

Last night I stuffed myself rather too full of good things, please accept my thanks and greetings.

<div align="right">Paul Cézanne</div>

Also to Madame Zola, and good recovery.

To Emile Zola

<div align="right">La Roche-Guyon, 27 June, 1885.</div>

My dear Emile,

The end of June is approaching. When the time comes for your departure to Médan and you are installed there, will you please let me know? The need for change irritates me a little.

Happy are the faithful hearts!

My respects to Madame Zola, and I thank you in anticipation, also for taking care of my letters from Aix.

I am with the usual formulas.

<div align="right">Paul Cézanne</div>

To Emile Zola

<div align="right">La Roche-Guyon, 3 July 1885.</div>

My dear Emile,

Life here, owing to fortuitous circumstances, is getting rather difficult for me. Will you tell me if you can have me at your house?

If you are not yet settled at Médan, be good enough to send me a word.

A warm handshake and heartiest thanks,

<div align="right">Paul Cézanne</div>

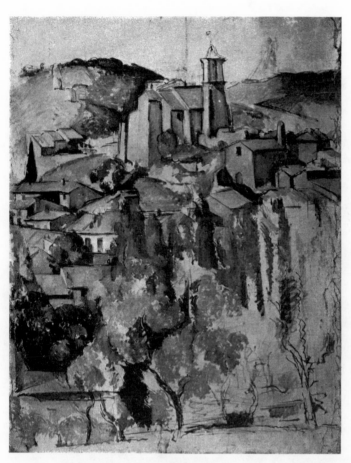

28. Gardanne
Water Colour, 1885–86

Emile Zola to Paul Cezanne

Médan, 4 July *1885*.

My dear Paul,

Your letter perturbs me even more, whatever is going on? Can't you be patient for a few more days? In any case, keep me au courant and let me know should you have to leave La Roche, because I would like to know where I can write to you as soon as the house becomes finally available. Be philosophical, nothing works as one wants it and I myself have at the moment a lot of trouble.

A bientot? Agreed? As soon as I can, I shall write to you.[a]

Affectionately,

Emile Zola

To Emile Zola

La Roche-*Guyon*, 6th July, 1885.

My dear Emile,

I must ask you to forgive me—I am a great fool. Just imagine, I forgot to fetch your letters from the poste restante. Which explains my second, so insistent [*letter*]. Thank you a thousand times.

Please give my respects to Madame Zola.

As soon as you can, send me a word: Grande Rue, Cézanne chez Renoir at La Roche.

Ever your

Paul Cézanne

[a] This seems to be the last extant letter written by Zola to Cézanne before the final breach in April, 1886 (see p. 223).

Should, however, a letter come to you from Aix, be good enough to address it poste restante and send me a brief word to my home to let me know, making a cross in a little corner of your letter.

To Emile Zola

La Roche-Guyon, 11 July, 1885.

My dear Emile,

I am leaving today for Villennes.[a] I am going to the inn. I shall come and see you for a moment as soon as I arrive; I want to ask if you could lend me 'Nana' to paint; I shall return it to its moorings after work.[b]

Doing nothing, I am bored even more.

Ever your

Paul Cézanne

See nothing bad in my decision. I am simply obliged to move. And then, when you are free, I shall have no more than a step to your house.

To Emile Zola

Vernon, 13 July, 1885.

My dear Friend,

It is impossible during this week of festivities to find a room at Villennes. Neither at 'Sophora' nor at 'Berceau'

[a] Villennes, a village on the Seine, next to Médan.

[b] 'Nana' was the name of Zola's boat, which Cézanne used to go to the island opposite the author's house, from where he painted a view of the Château de Médan (Venturi no. 325, acquired by Gauguin).

nor at the 'Hôtel du Nord'. I shake your hand, I am at Vernon, 'Hôtel de Paris'. If my canvases are sent addressed to you, please have them collected for me and keep them.

Thanking you in advance

Paul Cézanne
'Hôtel de Paris', Vernon (Eure)

TO EMILE ZOLA

Vernon, 15 July, 1885.

My dear Emile,

As I informed you in a line dated the 13th inst., I am at Vernon. I cannot find here what I need under the conditions in which I find myself. I have decided to leave for Aix as soon as possible. I shall pass through Médan so as to shake hands with you. I confided some papers to your care which I should like to have; if they are in Paris, one day when your servant goes to the rue de Boulogne, could you get him to fetch them?[a]

Good-bye and thank you in advance. You will excuse me once more for having to call on you under the present circumstances, but to wait another seven or eight days seems very long to me.

Allow me to shake your hand cordially,

Paul Cézanne

[a] This probably refers to the duplicate of Cézanne's will.

To Emile Zola

Vernon, 19 July, 1885.

My dear Emile,

As you tell me, I shall come to Médan on Wednesday. I shall try to start in the morning. I should have liked to be able to go on with my painting, but I was in the greatest perplexity, for, as I have to go down South, I decided that the sooner I went the better. On the other hand it would perhaps be better if I waited a little. I am in a state of indecision. Perhaps I shall get out of it.

I send you my cordial greetings,

Paul Cézanne

To Emile Zola

Aix, Jas de Bouffan, 20 August, 1885.

My dear Emile,

I received the news you sent me about your address last Saturday. I should have answered at once, but the pebbles under my feet, which are like mountains to me, have distracted me.

I know you will forgive me. I am at Aix and I go to Gardanne[a] every day.

Please give my respects to Madame Zola, and remember me well.

Ever your

Paul Cézanne

[a] Gardanne is a little village about 10 km. from Aix; leaning against a hill crowned by a church with a high clock-tower, it presents a very picturesque view. Cézanne often painted the town and the surrounding landscape.

To Emile Zola

Aix, Jas de Bouffan, 25 August, 1885.

My dear Emile,

This is the beginning of the comedy. I wrote to La Roche-Guyon the very day that I sent you a line to thank you for having thought of me. Since then I haven't received any news; besides, for me, there is complete isolation. The brothel in town, or something like that, but nothing more. I pay, the word is dirty, but I need rest, and at that price I ought to get it.

I beg you therefore not to reply, my letter must have arrived at the proper time.

I thank you and ask you to excuse me.

I am beginning to paint, but [*only*] because I am very nearly without trouble. I go to Gardanne every day and in the evening I come back to the country at Aix.

If only I had an indifferent family, everything could have been for the best.

I shake your hand cordially.

Paul Cézanne

Julien Tanguy to Paul Cezanne

Paris, 31 August, 1885

My dear Monsieur Sézanne (sic)

I begin by saying *bonjour* to you, and at the same time informing you of my distress.

Imagine that my idiotic landlord has sent me a demand note with right of seizure for six months advance on the

rent which I owe him, according to our agreement. As it is impossible for me to satisfy him, I turn to you, dear Monsieur Sézanne, asking you to do all you can in order to pay me a small amount on account of your bill. In this connection I am enclosing the statement for which you had asked me, which, after deduction of your payment of 1,442.50 francs (in accordance with the enclosed note) comes to 4,015.40 francs.

I have an I.O.U. for two thousand one hundred and seventy four francs and eighty centimes (2,174.80 francs) which you signed on March 4th 1878 in order to adjust it to the sum of 4,014.40 which you owe me, you would therefore have to give me an I.O.U. for 1,840.60. Should you prefer the whole sum to appear on our paper, please sign a new I.O.U. as soon as you receive the old one; I shall return to you the one you signed in 1878.

I should be most grateful if in this critical moment you could help me.

Hoping that you will have the goodness to answer my request, I thank you in advance, and remain.

<div align="right">
Your humble servant

Julien Tanguy
</div>

To the Prefect of Paris

<div align="right">

Probably Spring, 1886.
</div>

Draft[a]

The undersigned has the honour to ask you to kindly confirm the signature of his Honour, the Mayor, of the 4th arrondissement; this signature is affixed to the

[a] This draft is written on the margin of a watercolour.

testimonial of moral respectability, which is enclose.
with this application

Accept, Monsieur le Prefet, the humble greetings of
the undersigned,

Paul Cézanne[a]

To Emile Zola

Gardanne, 4 April, 1886.

My dear Emile,

I have just received 'L'Oeuvre' which you were kind
enough to send to me. I thank the author of the 'Rougon-
Macquart' for this kind token of remembrance and ask
him to allow me to press his hand in memory of old
times.

Ever yours under the impulse of years gone by.

Paul Cézanne

At Gardanne, arrondissement d'Aix.

*This letter, the last found amongst Zola's papers, seems in fact to
have been the last Cézanne ever wrote to him. There is a noticeable
difference in tone from Cézanne's earlier letters. The rupture was pre-
sumably caused by the publication of 'L'Oeuvre', the only one of the
series of the 'Rougon-Macquart' to have a certain autobiographical
character. In this book we recognize many friends of Zola, e.g. Baille,*

[a] This letter was probably written in connection with the pre-
paration for Cézanne's marriage. When his mother and sister had
finally succeeded in overcoming the resistance of his father, who by
now was 88 years old, Cézanne was married on 28th April, 1886 at
Aix in the presence of his parents, to Hortense Fiquet, the mother of
his son, who had been born in 1872. The old banker died on 28th
October, 1886, leaving the artist a considerable fortune.

Valabrègue, Alexis, Solari, Zola himself, and finally many characteris-
tics of Cézanne in the principal character, the painter, Claude Lantier.
Lantier is a brilliant but imperfect artist, who, in the end, is charac-
terized as a madman and a failure and finally takes his own life. This
must have shown Cézanne how little Zola really understood his aims.
The publication of the book therefore meant for him deep and painful
disillusionment, and after more than thirty years of affectionate friend-
ship he preferred a complete breach to a superficial continuation of their
friendship. See John Rewald: 'Cézanne et Zola,' Paris, 1936.

There is no record to show whether or not Cézanne repaid the money
which he owed to Zola although, after the death of his father in 1885,
he would have been in a position to do so. While preserving a certain
interest and affection for each other, neither Zola nor Cézanne later
made any attempt to heal the breach.

To Victor Chocquet

Gardanne, 11 May, 1886

Monsieur Chocquet,

Touched by your last letter, I intended to answer fairly
quickly, but always, although little occupied, on account
of failing health and a spell of intemperate weather, one
puts it off till tomorrow!

Now, I do not want to weigh too heavily on you, I
mean morally, but seeing that Delacroix acted as inter-
mediary between you and me, I will allow myself to say
this: that I should have wished to possess the intellectual
equilibrium that characterizes you and allows you to
achieve with certainty the desired end. Your good letter,
which was enclosed with the one from Madame Chocquet,
bears witness to a great equilibrium of vital faculties.
And so, as I am struck by this serenity, I am discussing it

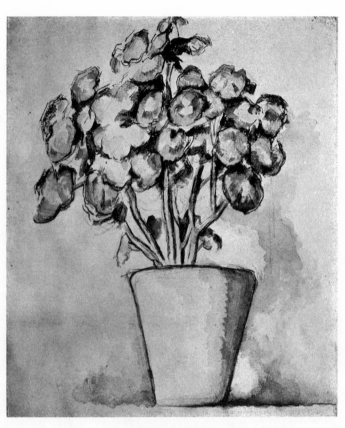

29. Pot of Flowers
Water Colour, about 1885

with you. Fate has not endowed me with an equal stability, that is the only regret I have about the things of this earth. As for the rest, I have nothing to complain about. Always the sky, the boundless things of nature, attract me and give me the chance to look with pleasure.

As for the realization of wishes about the most simple things, which, for instance, really ought to run along by themselves, malevolent fate is apparently determined to harm success; for I had a few vineyards, but unexpected frosts came and cut the thread of hope. And my wish would have been, on the contrary, to see them grow well; and so I can only wish you success for your plantations and a good development of your vegetation: green being one of the gayest colours which does the most good to the eyes. To conclude, I must tell you that I am still occupied with my painting and that there are treasures to be taken away from this country, which has not yet found an interpreter equal to the abundance of riches which it displays.

Monsieur Chocquet, I should wish that this letter may find favour in your eyes and that it will not tire you; and I take the liberty of addressing to you our humble greetings, which include also Mme. Chocquet, and to express our hopes that you will continue to preserve your good health.

As in the past, I am your grateful

<div align="right">Paul Cézanne</div>

My little boy is at school and his mother is well.

OLD AGE

LETTERS TO YOUNG FRIENDS
LETTERS ON PAINTING

1889–1906

As he had not exhibited in Paris for more than ten years, Cézanne was entirely unknown there. Only a small group of the initiated used to go to the little shop of père Tanguy to admire the pictures by the recluse at Aix. Gradually this circle grew; Huysmans, who had met Cézanne at Zola's house, published a first article about him in 1888, critics such as Roger Marx and Gustave Geffroy began to take an interest in Cézanne's work and Octave Maus, secretary of the Art-Association of the 'Vingts' invited him to exhibit with them at Brussels. In 1895 Ambroise Vollard, following the urgent advice of Camille Pissarro and his friends, organized the first great exhibition of Cézanne's pictures in his newly opened gallery in the rue Laffitte. This was soon followed by other exhibitions in the same gallery, which led to heated discussions between fanatical opponents and a small minority of sincere and passionate admirers among the younger generation of painters, who soon began to seek the friendship and advice of the master at Aix.

It is to these young painters and writers—among them especially the son of Gasquet, the friend of his youth—that Cézanne, between 1889 and 1906, addressed letters which contain his ideas and artistic theories.

From the years 1887 and 1888 no letters have been preserved. No longer disturbed by family disputes after the death of his father, Cézanne spent the year 1887 in Aix, where he was in future to stay often and for long periods, living with his old mother in the Jas de Bouffan. He returned in 1888 to Paris and until 1890 retained an apartment at 15 Quai d'Anjou, close to Guillaumin's studio. In the summer of 1889 he paid a short visit to Chocquet at Hattenville in Normandy, and

later returned to Aix where Renoir joined him, renting for some time the estate of Cézanne's brother-in-law, Maxime Conil. To judge from a letter of Pissarro's, Cézanne seems this time to have fallen out with Renoir (see footnote to letter dated 5th July, 1895).

30. Landscape with Ste Victoire
Oil, 1885–87

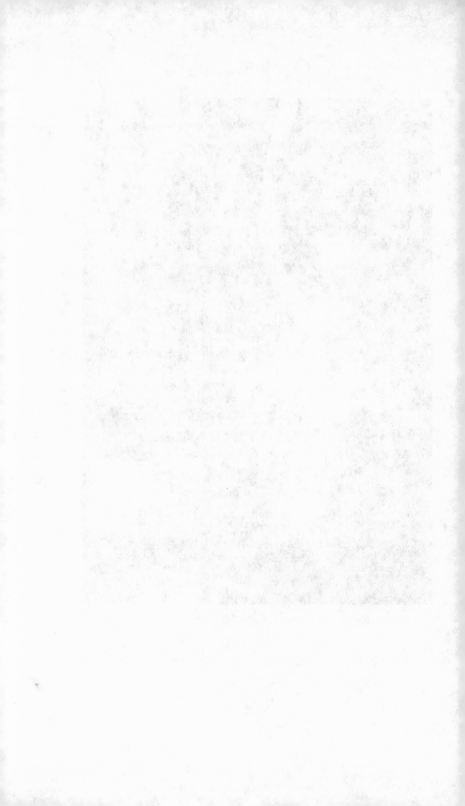

To Count Armand Doria

Paris, 20 June, 1889.

Monsieur le Comte,

You were so kind as to promise M. Chocquet that the *Maison du Pendu* [*The House of the hanged Man*], could be exhibited; this is the title which has been given to a landscape I painted in Auvers.[a] Just now I learn that Monsieur Antonin Proust[b] has admitted the painting for exhibition. Please be good enough to send the little picture to the Palais des Beaux-Arts for the World Exhibition.[c]

Thanking you sincerely, I remain,

Yours respectfully,

Paul Cézanne

[a] This famous painting, now in the Louvre, had been shown at the first group exhibition of the Impressionists in 1874 and had been bought by Count Doria for 300 francs (see Venturi no. 133). In the catalogue, Cézanne himself gave the picture the title 'Hut in Auvers-sur-Oise'.

[b] A friend of Manet and a former minister.

[c] Cézanne's picture was shown at the World Exhibition by a ruse, without the knowledge of the artist. Chocquet had refused to lend some of his valuable furniture unless a painting by Cézanne was included in the Exhibition and had for this purpose chosen 'The House of the Hanged Man'. He had obtained the consent of the Inspecteur des Beaux-Arts, Roger Marx, and of the former minister Antonin Proust. After the Exhibition, Chocquet persuaded Count Doria to let him have the painting in exchange for another one. It was bought at the Chocquet sale by Isaac de Camondo and passed to the Louvre, as part of his collection.

To Roger Marx[a]

Paris, 7 July, 1889.

Monsieur,

I wrote to you to thank you for your kindness in taking an interest in me. I am sorry that the letter did not reach you. I repeat my thanks most sincerely and will you please express my deep gratitude to Monsieur Antonin Proust.

Accept, Monsieur, the assurance of my warmest sentiments.

Paul Cézanne

To Octave Maus[b]

Paris, 27 November, 1889.

Monsieur,

Having learnt the contents of your flattering letter, I should like to thank you in the first place and to accept with pleasure your kind invitation.

[a] Roger Marx (1859–1913), writer and art critic, was one of the first to champion Cézanne, about whom he wrote numerous articles. At the Centenary Exhibition of 1900, he gave Cézanne's works a place of honour, to the great indignation of the official artists.

[b] Octave Maus was the leading spirit and secretary of the Belgian avant-garde group of artists 'Les Vingts' in Brussels. Cézanne sent three pictures to their exhibition in 1890, which were displayed together with paintings by Renoir, Sisley, Signac, Toulouse-Lautrec, Van Gogh and others. At first, Cézanne seems to have refused Maus' invitation, but when he received yet another urgent letter, in which the other invited artists were mentioned, he finally agreed.

May I, however, be permitted to refute the accusation of disdain which you attribute to me with reference to my refusal to take part in the exhibitions of painting?

I must tell you with regard to this matter, that as the many studies to which I have dedicated myself have given me only negative results, and as I am afraid of only too justified criticism, I had resolved to work in silence until the day when I should feel myself able to defend theoretically the result of my attempts.

However, in view of the pleasure in finding myself in such good company, I do not hesitate to modify my resolve and I beg you, Monsieur, to accept my thanks and friendly greetings.

<div align="right">Paul Cézanne</div>

To Victor Chocquet

<div align="right">Paris, 18 December, 1889.</div>

Monsieur Chocquet,

I am going to ask a favour of you, always provided that the idea which I have had seems acceptable to you. Asked by the '*Association des Vingts*' of Brussels to take part in their exhibition, and finding myself caught unprepared, I am venturing to ask you for the '*Maison du Pendu*' to be sent to them. I allow myself to enclose with these lines the first letter received from Brussels, which will make clear to you my position with regard to this association, when I add that I have consented to their friendly request.

Please accept, Monsieur Chocquet, my warmest greetings, and give Madame Chocquet my respects.

The mother and the little one join me in this.

Your grateful

Paul Cézanne

To Octave Maus

Paris, 21 December, 1889

Dear Sir,

I have written to Tanguy to find out which of my studies it was that he had sold to M. de Bonnières. He was unable to give me any details. I am therefore asking you to catalogue this picture as: *'Etude de Paysage'*. Further, taken unawares, I turned to M. Chocquet who is at the moment out of Paris, and he immediately placed at my disposal: *'Une Chaumière à Auvers-sur-Oise'*. But this picture is without a frame, as the one ordered by M. Chocquet (carved wood) is not yet ready. If you have in your possession some old frame to put on it, you would be doing me a great favour. It is a canvas of usual measurements, size 15.[a] Finally, I am sending you a picture: *'Esquisse de Baigneuse'* the frame of which I have sent to M. Petit.

Please accept, Monsieur, my warmest greetings.

P. Cézanne

[a] 55 × 66 cm.

31. The 'Jas de Bouffan' in Springtime
Oil, 1885–87

To Octave Maus

Paris, 15 February, 1890.

Dear Sir,

I should like to thank you for sending me the catalogue of the exhibition of the '*Vingts*'; I do so all the more warmly because I had made up my mind to ask you to be kind enough to send me a copy.

Permit me to express my heartiest congratulations for the *aspect pittoresque* [sic] and most successfully planned design that you gave this charming little booklet.

Please accept, Monsieur, my sincerest thanks and my most cordial greetings.

Paul Cézanne

There is yet another gap in Cézanne's correspondence, from 1890 to the spring of 1894. During the summer of 1890 he spent five months with his wife and son in Switzerland, staying in Berne, Fribourg, Vevey, Lausanne, Geneva and, the longest time, in Neuenburg. At the beginning of 1891 he was at Aix, where he was frequently together with Alexis and Coste; later he moved to Paris and installed himself in a new apartment at 2, rue des Lions-Saint-Paul. He often painted in the Forest of Fontainebleau, where he returned again the following year. In 1892, 1893 and 1894 he spent part of the year in Paris, part in Aix.

In 1894, Caillebotte died, and part of his collection, containing several paintings by Cézanne, was accepted by the Luxembourg. Père Tanguy also died in 1894. At the auction sale of his estate, Cézanne's works went for prices between 45 and 215 francs, while at that time Monet already obtained thousands for his paintings.

At this time, Cézanne began to suffer from diabetes, which often made him extremely irritable. At the same time, influenced by his older sister Marie, he turned towards the Catholic Church and regularly attended the services.

Zola had obviously asked all mutual friends to keep him up to date about Cézanne's health. There exist two letters, one by Paul Alexis,

the other by Numa Coste, with detailed information about the painter. In February, 1891 Alexis wrote from Aix to Zola:

"This town is dead, without comfort and paralysing. Coste, the only one with whom I have any contact, is not digestible every day . . . Fortunately, Cézanne, whom I rediscovered some time ago, brings a breath of fresh air into my social life. He at least vibrates, is expansive and lively. He is furious about the 'Ball' (Hortense Fiquet), who, after a stay of one year in Paris, last summer imposed on him five months in Switzerland at the Table d'hôte . . . where he found no understanding except with one Prussian. After Switzerland, the 'Ball' departed with Monsieur le fils to Paris. But by the reduction of her income to half, she has been forced to return to Aix. Yesterday, Thursday, evening at seven o'clock, Cézanne left us in order to fetch her from the station . . . and the furniture also is about to arrive, transported here from Paris at a cost of 400 francs. Paul intends to put all this into a place which he has rented in the rue de la Monnaie, where she will have her rooms. Yet he himself does not intend to leave his mother and older sister, with whom he has installed himself in the suburbs (in the Jas de Bouffan); he likes it there and prefers them decidedly to his wife. If, as he hopes, the 'Ball' and the shrimp settle down here, nothing will stop him going to Paris for half a year from time to time. "Long live the beautiful sun and freedom!", he exclaims. . . .

"By the way, no money troubles. Thanks to his father, whom today he holds in great esteem, and who used to say to him: "Look before you leap," and "Don't be too hasty, take your time and save your strength," he has enough to live on. He has divided his income first of all into twelve monthly shares, and then sub-divided each of these into three parts: for the 'Ball', for the little 'Ball' and for himself! But the 'Ball', who it appears is not easily satisfied, constantly tends to over-spend her share. Supported by his mother and sister . . . he now feels strong enough to resist.

"During the day he paints in the Jas de Bouffan, where a workman serves him as a model and where I want to visit him one of these days in order to see what he is doing.—Finally, in order to complete the psychological picture, he is converted, he is a believer and goes to mass."

This report was enlarged by a letter from Numa Coste, written at the same time: "How are we to explain that a grasping and hard-

headed banker could produce a human being like our poor friend
Cézanne, whom I have seen recently? He is in good health and physically
everything is all right, but he is timid, primitive and younger than ever.
He lives in the Jas de Bouffan with his mother, who by the way, has
fallen out with the 'Ball', who on her part is not on good terms with her
sisters-in-law, nor are they among themselves. That is how it has come
about that Paul lives here and his wife there. And it is one of the most
touching things I have ever experienced, to see how this brave boy has
preserved his child-like naïveté, forgetting his disappointments in the
struggle for life—in resignation and suffering—stubbornly pursuing the
work which he does not succeed in bringing off."

To Gustave Geffroy[a]

Alfort, 26 March, 1894.

Monsieur,

I read yesterday the long study that you devoted to
throwing light on the efforts I have made in painting. I
wish to express my gratitude for the understanding that I
find in you.[b]

Paul Cézanne

[a] Cézanne had been introduced to the writer Gustave Geffroy
(1855–1926) by Claude Monet at Giverny. See Geffroy: *Claude Monet*,
Paris, 1924, II, p. 65.

[b] Geffroy had written an article about the auction of Théodore
Duret's collection, in which three paintings by Cézanne fetched
between 600 and 800 francs. The article appeared in the *'Journal'* on
March 25th, 'Geffroy, La vie artistique', Paris, 1894, II, pp. 6, 66.

To a Merchant of Colours and Artists' Materials at Melun

Draft, in one of Cézanne's sketchbooks.

21 September, 1894.

Yesterday, the 20th inst., I bought four canvases from you of which three are size 20 and one size 25.—The first three cost 2 fr. 50, the one of 25 costs 2 fr. 80. The total therefore should be 10 fr. 30, and not 11 fr. 50 which I paid by mistake.

I take it you will refund me this on my next journey to Melun.

When Cézanne, in the autumn of the same year, visited Monet in Giverny, near to La Roche-Guyon, Monet wrote on 25th November to his friend Geffroy: "... next Wednesday then. I hope Cézanne will still be here and will join us, but he is so strange and so shy of new faces, that I fear he will let us down in spite of his desire to meet you. What a tragedy that this man has not had more support in life. He is a true artist, but has far too many doubts about himself. He needs encouragement and he greatly appreciated your article."

In fact Cézanne remained in Giverny for the planned meeting, to which Monet had invited not only Geffroy, but also Clemenceau, Rodin and Zola's friend, the writer Octave Mirbeau. According to Geffroy's Memoirs, *Cézanne seemed "a strange person, timid, violent, and highly excitable. Did he not, among other things, give us an idea of his naiveté, or his confusion, when he took Mirbeau and myself aside and declared, with tears in his eyes: 'Monsieur Rodin is not proud at all, he has shaken me by the hand! He, a man who has been decorated with the Légion d'Honneur!' Did he not after lunch in the middle of an avenue go down on his knees in front of Rodin to thank him once more for shaking hands with him? In view of all this, one can only feel sympathy with the primitive soul of Cézanne, who at that moment was as sociable as he could be and, through his laughter and his jokes, showed that he felt at home in the present company." Clemenceau had a special gift for making him feel at ease by telling jokes which amused*

Cézanne. But later Cézanne confessed to Geffroy that he did not trust Clemenceau. "He then gave me the surprising explanation: 'The reason is that I am too weak! . . . And Clemenceau could not protect me! . . . Only the Church could protect me." (Monet, Clemenceau and Geffroy were free-thinkers, which worried Cézanne.)

During this stay in Giverny Cézanne also met the American painter, Mary Cassat, who was a pupil of Degas and stayed at the same inn. In her letter to a friend, she gave the following description:

"The circle has been increased by a celebrity in the person of the first impressionist, Monsieur Cézanne—the inventor of impressionism, as Madame D. calls him. . . . Monsieur Cézanne is from Provence and is like the man from the Midi whom Daudet describes; when I first saw him I thought he looked like a cut-throat with large red eyeballs standing out from his head in a most ferocious manner, a rather fierce-looking pointed beard, quite gray, and an excited way of talking that positively made the dishes rattle. I found later on that I had misjudged his appearance, for far from being fierce or a cut-throat, he has the gentlest nature possible, 'comme un enfant' as he would say. His manners at first rather startled me—he scrapes his soup plate, then lifts it and pours the remaining drops in the spoon; he even takes his chop in his fingers and pulls the meat from the bone. He eats with his knife and accompanies every gesture, every movement of his hand, with that implement, which he grasps firmly when he commences his meal and never puts down until he leaves the table. Yet in spite of the total disregard of the dictionary of manners, he shows a politeness towards us which no other man here would have shown. He will not allow Louise to serve him before us in the usual order of succession at the table; he is even deferential to that stupid maid, and he pulls off the old tam-o'-shanter, which he wears to protect his bald head, when he enters the room. I am gradually learning that appearances are not to be relied upon over here. . . .

"The conversation at lunch and at dinner is principally on art and cooking. Cézanne is one of the most liberal artists I have ever seen. He prefaces every remark with: 'Pour moi' it is so and so, but he grants that everyone may be just as honest and as faithful to nature from their own convictions; he doesn't believe that everyone should see alike." [a]

[a] Letter to Mrs. Stillman, cf. A. D. Bellskin, *The Graphic Work of Mary Cassatt,* New York, 1948, p. 33.

To Octave Mirbeau[a]

Draft

End of December
1894

Make see—I would ask you to put me in touch with an art dealer. Make see . . . if you are intelligent—you see. Make the reader see what you see.—Write for the average intelligence. I don't believe that you are a Huysman. Never feel like one of his readers.—

I was waiting for the New Year to recall myself to your esteemed attention, but in view of the recent mark of sympathy which you have given me in the '*Journal*' I can no longer delay thanking you.

I count on having the honour of seeing you again, and to be able to show in a manner less ephemeral than by simple words, the gratitude which [*illegible word*] and is called for.

Please give my respectful greetings to Madame Mirbeau and believe me very cordially yours,

P. Cézanne

[a] Undated draft in one of Cézanne's sketchbooks belonging to Adrien Chappuis and published by him in facsimile as: '*Album de Paul Cézanne,* Paris 1966'. Chappuis suggests as the date December 1894, because Tanguy's recent death would explain Cézanne's request to be put in touch with a *marchand de tableaux*. Mirbeau had written about Tanguy in February 1894 and on 25th December, 1894 an article by him about '*Le Legs Caillebotte et l'Etat*' appeared in the *Journal*, probably the one to which Cézanne is referring.

Cézanne had met the writer, Mirbeau, at Monet's house in Giverny (see p. 236). Mirbeau used to write passionate reviews defending modern art, but it is not known to which of his articles Cézanne's letter refers. Later Mirbeau tried in vain to obtain for Cézanne the Légion d'honneur.

TO GUSTAVE GEFFROY

Paris, 31 January, 1895.

Monsieur,

I have continued to read the essays which make up your book '*Le Coeur et l'Esprit*' in which you were kind enough to write a dedication with so much sympathy towards me. Now in continuing my reading, I have learnt to understand the honour that you have shown me.[a] I am asking you to preserve for me in the future this sympathy which is precious to me.

Paul Cézanne

TO GUSTAVE GEFFROY

Paris, 4 April, 1895.

Dear Monsieur Geffroy,

The days are lengthening, the temperature is growing milder. I am unoccupied every morning until the hour

[a] Cézanne's appreciation of Geffroy's book apparently grew the more he read in it, and this sentence may be just a somewhat awkwardly expressed compliment. It is not impossible, however, that the sentence refers to a part of the book where an old man expresses views similar to those expressed by Cézanne himself in Giverny and later repeated in some of his letters: ". . . I have asked myself whether the short time given us to establish contact with the things of the world would be better used in an attempt to understand the whole of the universe or to assimilate what is within our reach. A brain that thinks too much is too heavy a weight for the body . . . within myself, my youth feels regret for my life which now fades . . . it wants to enjoy the last rays of the sun and everything which one day it will have to leave behind: the green foliage, water, wind, morning and evening. It wants still to look and still to love before it has to depart." Geffroy, *Le Coeur et l'Esprit*, Paris, 1894, p. 222.

when civilized man sits down to lunch. I intend coming up to Belleville to shake your hand and to submit to you a plan which I have now embraced, now abandoned and to which I sometimes return . . .[a]

Very cordially yours

Paul Cézanne, painter from inclination.

To Gustave Geffroy

Paris, 12 June, 1895.

Dear Monsieur Geffroy,

I finish [*these words have been crossed out*]. As I am about to depart and cannot bring to a satisfactory conclusion the work which surpasses my strength and which I was wrong to undertake, I would like to ask you to excuse me and to hand over to the messenger whom I shall send to you, the things which I have left in your library.

Please accept the expression of my regret and of my esteem.[b]

P. Cézanne[c]

[a] The plan, later carried out, was to paint a portrait of Geffroy, although Cézanne never quite finished the painting (Venturi no. 692).

[b] Later, Geffroy recollected that he had succeeded in persuading the painter to work on his portrait for another week. Before he left, Cézanne promised to finish the portrait after his return, but never fulfilled this promise and later on did in fact send a messenger to collect the artists' materials which had remained with Geffroy. About Cézanne's relations with Geffroy, see J. Rewald: *Cézanne, Geffroy et Gasquet*, Paris, 1959. See also letter to Monet, 6th July, 1895.

[c] Letter communicated by Adrien Chappuis.

To Francisco Oller

Aix, Jas de Bouffan, 5 July, 1895.

Monsieur,

The high-handed manner you have adopted towards me recently and the rather brusque tone you permitted yourself to use at the moment of your departure, are not calculated to please me.

I am determined not to receive you in my father's house.

The lessons that you take the liberty of giving me will thus have borne their fruit. Good-bye.

P. Cézanne

Cézanne had met Oller (1831–1917) in about 1864 through Pissarro at 'Suisse'. Oller had now returned from Puerto Rico in order to exhibit at the Salon. The incident between the friends is described in a letter dated 20th January, 1896 from Camille Pissarro to his son Lucien: "Oller told me of some extraordinary things that had happened to him with Cézanne, which indicate that the latter is really a bit touched . . . After numerous tokens of affection with this very southern expansiveness, Oller was confident that he could follow his friend Cézanne to Aix-en-Provence; a rendezvous was made for the next day for the P.L.M. train—'3rd class', says friend Cézanne. So the next day Oller, on the platform, strains his eyes, looking in all directions; no Cézanne. The trains pass, no one!!! Finally, Oller says to himself: 'He has gone' . . . makes up his mind and leaves. Arriving in Lyon he has 500 francs stolen from his purse at the hotel. Not knowing how to get back, he wires to Cézanne just in case; the latter was at home, had travelled first class!! . . . Oller receives one of those letters which you would have to read to form an idea. He forbade him the house, asking if he took him for an imbecile, etc. In a word, an atrocious letter. My word, it is a variation of what happened to Renoir. It seems he is furious with all of us. Pissarro is an old fool, Monet too clever by half; they are no good [ils n'ont rien dans la ventre], only I have temperament, only I understand how to paint a Red."

A few more details which have come to light show that Oller had

sent his telegram from Lyon, not to Cézanne himself, but to Cézanne's son in Paris, who then informed Oller that his father was already in Aix. Having arrived there Oller let Cézanne know that he was in the town, and received a note from Cézanne reading: "If that is so, come at once. I am expecting you. P. Cézanne."

To Claude Monet

Aix, 6 July, 1895.

My dear Monet...

I had to leave Paris, as the date fixed for my journey to Aix had arrived. I am with my mother, who is far on in years and I find her frail and alone.

I was forced to abandon for the time being the study that I had started at the house of Geffroy, who had placed himself so generously at my disposal, and I am a little upset at the meagre result I obtained, especially after so many sittings and successive bursts of enthusiasm and despair. So here I am then, landed again in the South, from which I should, perhaps, never have separated in order to fling myself into the chimerical pursuit of art.

To end, may I tell you how happy I was about the moral support received from you, which served as a stimulus for my painting. So long then, until my return to Paris, where I must go to continue my task, as I promised to Geffroy.

Greatly regretting that I had to leave without seeing you again, I remain, cordially yours,

Paul Cézanne

To Francisco Oller

Aix, Jas de Bouffan, 17 July, 1895.

Monsieur,

Your somewhat laughable letter does not surprise me at all—But first as to any accounts which have to be settled with you—you should not have forgotten certain accounts that I had to settle with M. Tanguy. Let us pass over in silence the unsuccessful attempt at Mme. Ch's.[a] Finally, I do not understand in what way I can be held responsible for the loss of money which you say you have suffered during your stay at Lyon.

You can have your canvas fetched from the studio in the rue Bonaparte between now and the 15th January next.

I shall release you from repaying the money I advanced you and everything else.

I hope that, thanks to your change of attitude, you can prolong your stay with Doctor Aguiar.[b]

Good-bye.

P. Cézanne

[a] Mme. Chocquet?

[b] Doctor Aguiar, a Cuban, was a friend of Pissarro, Oller and Doctor Gachet. Through them Cézanne made the acquaintance of the doctor who was an amateur painter. When Oller told him about the events in Aix, Aguiar assured him that he himself had witnessed similar scenes and that, as a doctor, he considered Cézanne to be ill and not entirely responsible for his actions. This made Pissarro exclaim: "Is it not sad and pitiful that a man of such great temperament should have so little equilibrium!" See Pissarro's letter to his son, p. 241.

To Joachim Gasquet[a]

Aix, 15 April, 1896

Dear Sir,

Tomorrow I go to Paris.[b] Please accept the expression of my warmest sentiments and my most sincere greetings.

P. Cézanne

To Joachim Gasquet

Aix, 30 April, 1896

Dear Monsieur Gasquet,

I met you this evening at the bottom of the *cours*, you were accompanied by Madame Gasquet. If I am not mistaken, you appeared to be very angry with me.

[a] The poet Joachim Gasquet (1873–1921), son of a school friend of Cézanne, had recently become very friendly with the painter. His somewhat colourful memories of Cézanne were published shortly before the author's death. See also J. Rewald: *Cézanne, Geffroy et Gasquet*, Paris, 1959.

Gasquet had met Cézanne a few months after Cézanne's first exhibition at Vollard's in November–December 1895. At the same time Numa Coste wrote from Aix to Zola: "Cézanne is very depressed and often attacked by fits of melancholia. His self-confidence, however, receives some satisfaction and at auctions his works have a certain success to which he is not accustomed . . ."

Under these circumstances, Gasquet's youthful enthusiasm seems to have touched Cézanne and when the poet was deeply impressed by a view of Ste. Victoire which he had admired at an exhibition at Aix, the painter made him a present of the picture (Venturi no. 454). After their first meeting many long walks followed and endless discussions; presumably it was mainly Gasquet who talked.

[b] Cézanne had no intention of returning to Paris, as the next letter shows. It seems that he used this somewhat evasive excuse in order to put off the young Gasquet and to withdraw into his customary solitude.

Could you see inside me, the man within, you would be so no longer. You don't see then to what a sad state I am reduced. Not master of myself, a man who does not exist—and it is you, who claim to be a philosopher, who would cause my final downfall? But I curse the Geffroys[a] and the few characters who, for the sake of writing an article for fifty francs, have drawn the attention of the public to me. All my life I have worked to be able to earn my living, but I thought that one could do good painting without attracting attention to one's private life. Certainly, an artist wishes to raise himself intellectually as much as possible, but the man must remain obscure. The pleasure must be found in the work. If it had been given me to realise my aim, I should have remained in my corner with the few studio companions, with whom we used to go out for a drink. I still have a good friend[b] from that time, well, he has not been successful, which does not prevent him from being a bloody sight better painter than all the daubers, with their medals and decorations which bring one out in a sweat, and you want me at my age to believe in anything? Anyway, I am as good as dead. You are young, and I can understand that you wish to succeed. But for me, what is there left for me to do in my situation; only to sing small; and were it not that I am deeply in love with the landscape of my country, I should not be here.

But I have bored you enough as it is, and now that I have explained my position to you, I hope you will no

[a] When he published this letter Gasquet suppressed the name of Geffroy, who was then still alive.

[b] Probably Achille Emperaire, whom Cézanne seems to have seen frequently at that time.

longer look at me as if I had made an attempt upon your personal security.

Please accept, dear sir, also in consideration of my great age, the expression of my warmest feelings and best wishes.[a]

<div align="right">Paul Cézanne</div>

TO JOACHIM GASQUET

<div align="right">Aix, 21 May 1896.</div>

Dear Monsieur Gasquet,

As I am obliged to go into town rather early this evening, I shall not be able to be at the 'Jas'. Please excuse this hitch.

Yesterday afternoon at 5 o'clock I had received neither Geffroy's '*Le Coeur et l'Esprit*' nor the article from '*Figaro*'. I have sent a telegram to Paris about it.[b]

[a] Later Gasquet said that when he received this letter he rushed immediately to the Jas de Bouffan where Cézanne is supposed to have received him with open arms, and to have said "Don't let's talk about it any more. I am an old ass. Sit down there. I'll paint your portrait." It is a fact that after this incident, the friendship between them was revived. But Gasquet sat only five or six times for this portrait, which remained in a less advanced state than those of Geffroy or of his father, Henri Gasquet, which Cézanne had started in April of the same year.

[b] This refers to a book by Geffroy, published towards the end of 1894, a dedication copy of which the author had sent to Cézanne (see letter dated 31st January, 1895). The *Figaro* article was Zola's review of the Salon, published on the 2nd May, 1896. In this review, Zola seemed to say goodbye to the beliefs and convictions which in his youth had made him defend so passionately the new art of Manet and his companions. Zola wrote, for instance: "I had grown up almost in the same cradle as my friend, my brother, Paul Cézanne,

'Till tomorrow, Friday, then, if this suits you, at the usual time.[a]

Most cordially,

P. Cézanne

To Joachim Gasquet

Vichy, 13 June, 1896

My dear Gasquet,

You want to launch a review.[b] I count out my own self. Call for help on the persons who—in response to your initiative—have each written a letter to Mr. d'Arbaud. Their contribution, I would say their firm support, is necessary—is the solid base of your review. They have lived; through this alone they have gained experience. One does not lower oneself by acknowledging facts. You are young, you have vitality, you will give your publication the impetus which only you and your friends who have the future before you, can give. It seems to me that this is a role important enough to be proud of, and that

whose genius is only now being recognised as that of a great painter who has failed."

It is not clear why Cézanne was so keen to obtain for Gasquet this rather unfavourable article especially as he had been estranged from Zola since the publication of *L'Oeuvre* in 1896, or why he wanted to have Geffroy's book, which he had several times strongly criticised in front of Gasquet.

[a] Cézanne was obviously referring to the time at which Gasquet came regularly to the Jas de Bouffan to sit for his portrait. When Cézanne went to Vichy during the next month, the sittings were interrupted and apparently never resumed (Venturi no. 694).

[b] Gasquet had sent Cézanne the first number of his newly-founded periodical 'Les Mois Dorés'.

you are very interested in it. Call upon all the initiative which has already proved itself. It isn't possible that a man who is aware that he is alive and who has, consciously or not, reached the summit of his existence should impede the progress of those who begin their life. The way which they have travelled is an indication of the path to follow and not a barrier to your steps.

My son has read your review with the greatest interest. He is young, he cannot but associate himself with your hopes.

I have landed here in Vichy about eight days ago. The weather, rainy and dull on our arrival, has cleared up, the sun shines and hope smiles in the heart.—I shall soon go to work.

If you see my friend Solari, say 'hello' to him on my behalf. Be of good courage, I don't doubt that you will. Believe me that I am with you with all my heart and accept my best wishes.

<div style="text-align: right">Paul Cézanne</div>

Vichy, Hotel Molière (Allier)

EXTRACT

<div style="text-align: right">July 1896</div>

From an article by Joachim Gasquet in his periodical 'Les Mois Dorés'.[a]

[a] An allusion to the 'Vers Dorés' by Pythagoras. This first article of Gasquet's about Cézanne has remained unknown for a long time. It shows clearly the poet's purely literary attitude towards the art of painting and is an example of his exaggerated verbosity when expressing his enthusiasm. Even Cézanne's reply to Gasquet's letter seems somehow to be affected by Gasquet's style.

"... Under the foliage of the Jas de Bouffan, near the well, Cézanne dedicates himself to painstaking studies and it is overwhelming to see how suddenly the soul of the landscape transforms the coloured lines so as in future to participate in the calm activity of our spirit. The painter has just finished a canvas which is a pure masterpiece.[a] *In a blue dress, deeply depressed, at the end of her suffering, her face consumed by all too many days, an old woman, a servant, holds with fervour and resignation the beads of a rosary in her old hands. A ray of light falls on her humble face. She is completely immersed in memories. I don't know what emotion overcame me in front of this latest painting by Cézanne. I intend later on ... to report on the whole life of the noble master of Aix and to talk about the deep meaning which rises from the thousand canvases stored in his studio. Only in these paintings, as in the landscape of Mount Ste. Victoire*[b] *... have I found the life of our light realised and represented, only there is the simple, rough and tender beauty of Provence to be rediscovered ...*

The studies which Cézanne has brought back from l'Estaque, for instance, express all the brilliant harmony of the river-banks and I often evoke in front of my eyes the little town as it appears in these pictures, huddled under its church-tower, which stands out in shimmering clarity and whose entire existence is nourished by unforgettable caresses of the light and the sea ... The master has also represented the naive and august figures of the farmers who work this earth, which is glorified by all the divine bounty of our light ..."

[a] This is the painting 'The Old Woman with the Rosary', which the painter later gave to Gasquet as a present, now in the National Gallery, London (Venturi no. 702).

[b] Cézanne seems to have given this painting to Gasquet after their first meeting. Gasquet sold it only two years after the painter's death. It is today in the Courtauld Institute in London (Venturi no. 454).

To Joachim Gasquet

Talloires,[a] 21st July, 1896.

My dear Gasquet,

Here I am, away from our Provence for some time. After quite a lot of toing-and-froing, my family, in whose hands I find myself at the moment, has made up my mind for me to settle down for the time being where I am. It's a temperate zone. The height of the surrounding mountains is quite considerable, the lake which is here narrowed by two tongues of land seems to lend itself to the linear exercises of the young English miss. It is still nature, of course, but a little bit as we have learned to see it in the travel sketchbooks of young ladies.

Always energetic, you, with your magnificent mental capacity, work incessantly and without too much fatigue. I am too remote from you, through my age and the knowledge which you acquire every day; nevertheless, I commend myself to you and your kind remembrance so that the links which bind me to this old native soil, so vibrant, so austere, reflecting the light so as to make one screw up one's eyes and filling with magic the receptacle of our sensations, do not snap and detach me, so to speak, from the earth whence I have imbibed so much even without knowing it. It would therefore be a real act of kindness and a comfort to me if you would be good enough to continue to send me your *Revue*, which would remind me of my distant land and of your lovable youth, in which I was allowed to take part. When I was last in

[a] Cézanne had returned from Vichy to Aix and from there gone to Talloires at Lake Annecy. He painted the lake; the picture is now in the Courtauld Institute in London (Venturi no. 762).

Aix, I was sorry not to see you. But I have learnt with pleasure that Mme. Gasquet and you yourself have presided over a number of regional and meridional festivities.[a]

How many friendly thanks do I not have to render for the good wishes to my wife which you have had the kindness to express in your letter. And I also have to thank you for sending me the second number of your *Revue*, so rich and so full.[b] I dare to hope, therefore, that I shall read you again, you and your ardent collaborators.

In finishing, I shall ask you to give my respects to the Queen of Provence, to remember me to your father and the other members of your family and to permit me to remain cordially yours

Paul Cézanne

Address: Hotel de l'Abbaye,
 Talloires par Annecy (Haute-Savoie).
It would require the pen of Château[*briand*], to give you an idea of the old monastery where I am staying.

TO PHILIPPE SOLARI

Talloires, 23 July, 1896.

My dear Solari,

When I was at Aix it seemed to me that I should be better elsewhere, now that I am here, I think with regret

[a] During the year 1896 the Association of Provençal poets, the Félibres, arranged a number of festivities. One of them took place on 23rd January, when Gasquet married Marie Girard, 'Queen of the Félibrige'; another one took place at Stes.-Maries-de-la-Mer.

[b] For unknown reasons Cézanne seems to avoid mentioning Gasquet's article about himself.

of Aix. Life for me is beginning to be of a sepulchral monotony.—I went to Aix three weeks ago, I saw Père Gasquet there, his son was at Nîmes. In June I spent a month at Vichy, one eats well there. Here, one doesn't eat badly either.—I am staying at the Hotel de l'Abbaye.— What a superb remnant of ancient times:—an open staircase five metres wide, a magnificent door, an interior courtyard with columns forming a gallery all round; a wide staircase leading up, the rooms look out on to an immense corridor, and the whole thing is monastic.— Your son will no doubt soon be in Aix. Tell him about my memories, of what we recall of our walks to Peirières, to Ste-Victoire and if you see Gasquet, who must be revelling in the joys of regained fatherhood, give him my love.

Remember me to your father and give him my respects.

To relieve my boredom, I paint; it is not much fun, but the lake is very good with the big hills all round,[a] two thousand metres so they say, not as good as our home country, although without exaggeration it really is fine.— But when one was born down there, it's all lost— nothing else means a thing. One should have a good stomach and get roaring drunk; "the vine is the mother of the wine" thus Pierre, do you remember? And to think that I'm going to Paris at the end of August. When shall I see you again? If your son should pass Annecy on his way back let me know.

A good strong handshake.

Your old

Paul Cézanne

[a] Cézanne painted a landscape of the Lac d'Annecy (Venturi no. 762), now in the National Gallery, London.

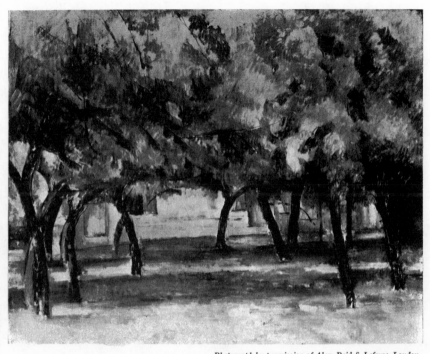

32. Norman Farm
Oil, 1888

Jo[a] sent me no. 2 of the Revue while I was still at Vichy, towards the end of June. My dear fellow, it does one good to get news from down there. My address here is: Hôtel de l'Abbaye, Talloires-par-Annecy (Haute Savoie).

Gasquet told me that you have done some very good things—so much the better.

TO JOACHIM GASQUET

Paris, 29 September, 1896

My dear Gasquet,

Here I am, rather late, confirming receipt of the friendly missive in which you have had the kindness to send me the last two numbers of the '*Mois Dorés*'. But on returning to Paris from Talloires, I have sacrificed quite some days in order to find a studio in which to spend the winter. Circumstances, I greatly fear, will keep me for some time in Montmartre, where my place of work is situated. I am a gun-shot away from Sacré-Coeur, whose campaniles and clock-towers rise into the sky.[b]

At the moment I am re-reading Flaubert, interrupting him while I leaf through the *Revue*. I am in danger of repeating myself frequently; it is fragrant with Provence. Reading you, I see you again and when my head becomes calmer I think of the brotherly sympathy which you have shown me. I could not say that I envy you your youth, that is impossible, but your vigour, your inexhaustible vitality.

[a] Joachim Gasquet.
[b] The building of Sacré-Coeur began in 1875 but was not finished until 1914.

I thank you warmly, therefore, that you do not forget me now that I am far away.

Please remember me to your father, my old school-mate, and give my respects to the Queen who presides so magnificently over the renewal of Art which awakens in Provence.

For yourself, accept the expression of my warmest sentiments and good wishes for your continued success.

<div style="text-align:center">Always yours,</div>

<div style="text-align:right">Paul Cézanne</div>

P.S. Unfortunately I have to tell you that Vollard has been unsuccessful in placing the drawings of Mr. Heiriès.[a] He maintains that he has made several fruitless attempts because of the difficulty of finding an outlet, so small is the demand for book illustrations. I shall ask for the drawings to be returned to me and forward them to you with great regret.

<div style="text-align:right">Paul Cézanne.</div>

To Emile Solari

<div style="text-align:right">Paris, 30 November, 1896</div>

My dear Solari,

I did regret very much that I was not at the rue des Dames when you came. There is only one way to make up for this, and that is to fix a rendezvous, say for to-morrow.—A clearly defined place, an exact time that I leave for you to choose. I am free from 4 o'clock in the

[a] Gustave Heiriès, one of Gasquet's friends in Aix; otherwise nothing is known about him.

afternoon onwards.—A word then if you please, and
believe me yours very cordially

<div align="right">Paul Cézanne</div>

To a Young Artist
(*friend of Joachim Gasquet*)

Fragment *Date unknown*

... I have perhaps come too early. I was the painter of
your generation more than of my own.... You are
young, you have vitality; you will impart to your art an
impetus which only those who have emotion can give.
I, I feel I am getting old. I shall not have the time to
express myself ... Let's work! ...

Perception of the model and its realization are some-
times very long in coming ...

To Antoine Guillemet

<div align="right">Paris, 13 January, 1897</div>

My dear Guillemet,

Confined to my room for a fortnight by a persistent
attack of influenza, I didn't receive until the day before
yesterday the letter in which you gave me a rendezvous
and the card which confirmed your good visit. So I want
to tell you how very sorry I am that I was unable to be
in my studio when you came to see me, and to say how
very annoyed I am at the bad luck which prevented me

from letting you know the condition I was in and that I should be unable to go to the studio.

Please accept my apologies for this, and believe me most cordially yours,

Paul Cézanne.

TO PHILIPPE SOLARI

Paris, 30 January, 1897.

My dear Solari,

I have just received your kind letter. No need to tell you that I did not receive the one which you say you wrote to me at the end of December. I have not seen Émile again since the end of last month, and with good reason. Since the 31st last I have been confined to barracks because of influenza, Paul arranged my removal from Montmartre. And I have not yet been out, although I am getting better. As soon as I can, I'll write a line to Émile to fix a meeting.

Now, let's come to Gasquet. His request touches me deeply, and tell him about my wish that Monsieur Dumesnil[a] should agree to accept the two pictures in question. For this purpose, I ask you to accompany Gasquet to my sister, 8 rue de la Monnaie, and ask her to take you to the "Jas" where the pictures in question are. I am going to write to my sister about the matter.

Except for a certain depression natural under the cir-

[a] Georges Dumesnil was Gasquet's teacher at Aix, and through him knew Cézanne. The two paintings have not been identified. Venturi does not mention Dumesnil in his catalogue.

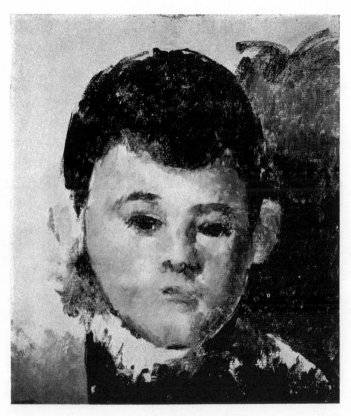

33. The Artist's Son
Oil, about 1880

cumstances, it's not going too badly, but if I had known how to arrange my life to live down there, it would have suited me better. But a family demands quite a lot of concessions.

I embrace you with all my heart and please give my greetings to all the friends around you.

Very cordially yours,

Paul Cézanne

P.S. You will find my sister at home either at about 10 in the morning, her breakfast time, or at about 6 in the evening, time for dinner.

To Joachim Gasquet

Paris, 30 January, 1897

My dear Gasquet,

Just now Solari has told me about your project. May I ask you to use all possible roundabout ways demanded by the circumstances to make Mr. Dumesnil accept the two pictures in question. I would be very happy if the Professor for Philosophy at the faculty of Aix would deign to accept my hommage. I can rightly use the argument that in my country I am rather a friend of the arts than a fabricater of pictures and that, on the other hand, it would be an honour for me to know that two of my studies have been accepted in such a respected place, etc. etc. Please develop this argument further using your discretion: I know that you will do it magnificently.

So, that's agreed. And I thank you for the honour which comes to me through your mediation.

Please give all my respects to Mme. Gasquet—the Queen, I mean—my best greetings to your father and, believe me, yours gratefully

Paul Cézanne

P.S. Thank you for the big last number of the '*Revue*'. And long live Provence.

To Emile Solari

Mennecy, 24 May, 1897

My dear Solari,

I shall soon be leaving for Aix. This departure will in all probability take place during the night of Monday, 31st May to June 1st, if God wills.—Saturday, the 29th inst. I shall go to Paris; if you are free and if you want us to see each other again before my departure, please be at 73 rue St. Lazarre at the time agreed.

Very cordially yours,

Paul Cézanne

Hotel de la Belle Etoile, Mennecy près Corbeil (Seine-et-Oise)

To Joachim Gasquet

Tholonet, 18 July 1897.

My dear Gasquet,

As a result of great effort, such exhaustion has overcome me that I cannot accept your kind invitation. I realise that I am at the end of my strength and ask you to excuse me

and make my excuses to your whole family. I ought to have more sense and to realise that at my age illusions are no longer permitted and that they will always be my ruin.

Please give my respects and all my regrets to Madame Gasquet, to Madame and Monsieur Girard and believe me cordially yours

Paul Cézanne

To Philippe Solari

Tholonet, end of August 1897

My dear Solari,

On Sunday, if you are free and if it gives you pleasure, come for lunch, to Tholonet, restaurant Berne. If you come in the morning you will find me at about 8 o'clock at the quarry[a] where you made a study when you came here the time before last,

Most cordially,

Paul Cézanne

To Emile Solari

Tholonet, 2 September, 1897

My dear Solari,

I received your letter of the 28th August last. I didn't answer at once. You did in fact announce that you were

[a] The quarry Bibémus is above the village of Le Tholonet and the François Zola dam. For some time Cézanne rented a little house there in order to work and painted several landscapes with yellow-red cubes of rock and pine trees.

sending me a review which promised the enticing prospect of some of your poems. I waited several days, but no review.

I have just re-read your letter and see that I didn't understand it properly, and that what you had promised me was a report on the festivities at Orange.

You call the Revue in which you wrote '*Revue inconnue*'. Is that really its name, must I claim it under that title at the post office, as it hasn't reached me?

On the other hand it is really very kind of you to remember, in the midst of your Parisian occupations and preoccupations, the all-too-short hours that you spent in Provence; it is true that the great magician, I mean the sun, was of the party. But your youth, your hopes must have contributed not a little to making you see our country in a favourable light.—Last Sunday your father came to spend the day with me—unfortunate man, I saturated him with theories about painting. He must have a good temperament to have withstood it.— But I see that I am going on a bit too long so I send you a cordial handshake, wishing you good luck and *au revoir*.

<div align="right">Paul Cézanne</div>

To Emile Solari

<div align="right">Tholonet, 8 September, 1897</div>

My dear Solari,

I have just received '*L'Avenir Artistique et Litteraire*' which you were kind enough to send me. Thank you very much.

Your father is coming to eat a duck with me next

Sunday. To be done with olives, (the duck I mean).—
What a pity that you can't be one of us! Remember me
kindly in future ages and allow me to call myself yours
very cordially,

<div align="right">P. Cézanne</div>

To Joachim Gasquet

<div align="right">Tholonet, 26 September, 1897</div>

My dear Gasquet,

To my great regret I cannot avail myself of your
excellent invitation. But as I left Aix this morning at
5 o'clock, I could not return before the end of the day.
I have had supper with my mother and the state of lassi-
tude in which I find myself at the end of the day does not
allow me to present myself in suitable shape before other
people. Therefore, please excuse me.

Art is a harmony which runs parallel with nature—
what is one to think of those imbeciles who say that the
artist is always inferior to nature?

Most cordially yours, and I promise you to come soon
and shake your hand.[a]

<div align="right">P. Cézanne</div>

[a] A month after the date of this letter, on the 25th October, 1897,
Cézanne lost his mother, at the age of 82. Her death affected him
deeply. Her estate had to be divided between the painter and his two
sisters, who insisted that the Jas de Bouffan should be sold. Cézanne
therefore had to give up this place which was to him home and to
which he was deeply attached. Later on, he often painted in the
grounds of the Château Noir, on the way from Aix to the small
village of Le Tholonet, from where one has a particularly fine view
of the nearby mountain of Ste. Victoire.

To Emile Solari

Aix, Jas de Bouffan, 2 November, 1897

My dear Solari,

I received the letter in which you announce your forthcoming marriage. I do not doubt that you will find in your future companion the support indispensable for every man when he embarks on a long and often arduous career. I am sending my best wishes for the realization of your legitimate hopes.

You also tell me of the difficulties you are experiencing in finding an opening to produce your plays on the stage. Reflecting on this, I can tell you that I am fully aware of the difficulties that you are having. What can I add except that whilst sympathizing with your troubles, I exhort you to have a lot of courage, for one needs it to reach one's goal.

When these lines reach you, you will already have heard of the death of my poor mother.

Renewing once more my exhortations to you to have courage and to work, I remain yours very cordially

Paul Cézanne

It is some days since I had the pleasure of seeing your father, who has promised me to come to the "Jas".

34. Cézanne in his Studio in Paris
Photograph, 1894

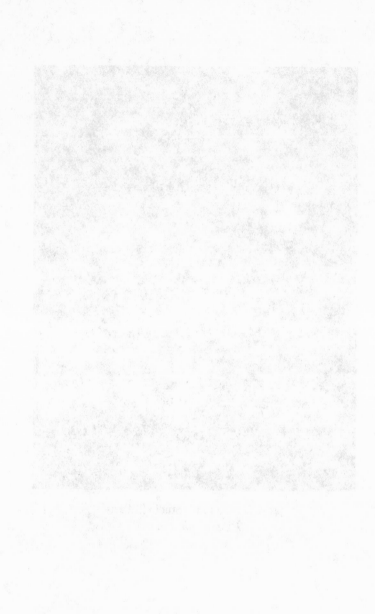

To Louis le Bail[a]

Montgeroult, Monday evening, *1898*

Dear Sir,

I have just woken up and I remember that in a situation similar to the one that happened to me during the last few days[b], I have repaid the visit that someone had been kind enough to pay me. I am extremely annoyed at the false position in which I have placed myself. Although I have not had the honour of knowing you very long, I am taking the liberty of asking your help in making good my blunder. What should I do, tell me, I shall be most grateful.

Please accept the assurance of my good wishes.

P. Cézanne

To Louis le Bail

Marines, *1898*

Monsieur,

The manner, a little too cavalier, in which you take the liberty of entering my room is not to my liking. In

[a] Louis Le Bail was a young painter living at the time at Marines near Pontoise. He had heard from Pissarro that Cézanne worked in the vicinity, visited him on several occasions, and Cézanne had become friendly with this young colleague.

[b] Baron Denys Cochin, an art collector and great admirer of Cézanne, had approached the painter, whom he found at work at Montgeroult, during one of his riding excursions. Cézanne, not realising that the Baron was a great admirer of his art, had not received him very amiably. Later Le Bail explained to Cézanne who the rider was and that he had several pictures by Cézanne in his collection.

future, you would be better to have yourself announced.[a]

Would you hand over the glass and the canvas which were left in your studio to the person who will come for them.

Accept Monsieur, my respectful greetings.

<div align="right">Paul Cézanne</div>

EXTRACT

From a book review by Joachim Gasquet of Charles de Ribbe's work 'La Société provençale à la fin du Moyen-âge', published in Gasquet's journal 'Les Mois Dorés' in March/April, 1898:

The soul, the idea of Provence slumbers under the olive trees, the strong lines of the landscape embrace it, the pine trees give it their perfume, the sun exalts it . . . and this idea, which is concealed in a thousand places, scattered and blurred, in the red earth, the rocks, the radiant pine trees, the planes and hills—one day, when I looked at Cézanne's landscapes, I suddenly saw it spring up in its strong synthesis, in its unique splendour, both rural and mystical; it dominates in magnificent reality the whole work of this master, who is in love with clarity. The soul of Provence, which de Ribbe, the indefatigable historian, has evoked for us, far from our mute cities, the faith, which he has given us through patriotic examples, has also been brought near to us by Paul Cézanne, who has revealed it to us through the luminous saintliness, which impregnates his landscapes. The tormented or pensive attitude of his rocks, the red blood, which runs tumultuously

a What had happened was that Cézanne had asked Louis Le Bail to call on him every day at 3 o'clock after his nap; Le Bail, taking Cézanne at his word and finding him asleep, entered his room, after having knocked several times, to wake him.

*under the red earth, the severity of his horizons, the flames of the
sea, the dreams of the water, the sweetness, the chastity of the
lines, which in his paintings intertwine with austere tenderness,
the harvest burnt by the sun, the river from which the children
are emerging, and then the air, the air which remembers, which
thinks, which knows* ... [*several lines more in this vein!*] *all
these noble forms which he evokes, fill us with a sense of religion,
indicate that, as in biblical times, trees and stones will speak,
that all are awaiting a saviour, that the world wants a master,
that the soul of Provence will descend in the shape of some
human being* ... *etc. etc. etc.*

To Joachim Gasquet

Paris, 22 June, 1898

My dear Gasquet,

Having read the superb lines in which you exalt the
Provençal blood, I cannot get myself to keep silence, as
though I found myself in the presence of an unfortunate,
a vulgar Geffroy.[a]

There is only one thing to say, which is that the achieve-
ment does not measure up to the eulogy which you have

[a] Having received the copy for March and April of the *Revue*
which contained Gasquet's article *Le Sang Provencal*, Cézanne seems
to have waited for several weeks before writing this letter of
thanks.

It is not clear why Cézanne here once again speaks so slightingly
about Geffroy, whose article shows so much more understanding
than Gasquet's effusion. Perhaps the fact that Geffroy was an active
liberal made him suspect to the royalist Gasquet and to Cézanne
who had rejoined the Catholic Church.

written about it. But you are accustomed to that, and you see things so colourfully, as if through a prism, that in thanking you every word becomes pale.

Would you be good enough to tell Paul [*Cézanne's son*], on which day I could see you again?[a]

Sending you my warmest thanks, I ask you to give my respects to Madame Gasquet.

<div align="right">Paul Cézanne</div>

To Henri Gasquet

<div align="right">Paris, 23 December, 1898</div>

My dear Henri,

I have just received the friendly greetings which you have been good enough to address to me. I can only thank you with great warmth. For me, this is the evocation of more than forty years of our past. May I say that it was an act of providence that allowed me to meet you? If I were younger, I would say that, for me, this is a support and a comfort. Someone stable in his principles and his opinions, that's splendid. I ask you to thank also

[a] Gasquet must also have been in Paris at this time. It does not seem unlikely, then, that the two men met again after this letter and together made visits to the Louvre, which Gasquet later mentioned, with a considerable amount of poetic licence, in his 'Imaginary conversations' with Cézanne. Gasquet also seems to have tried to persuade Cézanne to accompany him on a visit to Zola, who, since the publication of his famous article '*J'accuse*' in January 1898, had been in the centre of the Dreyfus controversy. Cézanne, however, vigorously resisted this attempt to bring about a reconciliation with his friend.

your son, whom heaven has allowed me to encounter and whose friendship is very precious to me.

I hope to see him again soon, either that I go down to the Midi or that his studies and his literary interests bring him here again. He, Madame Gasquet and his friends have the future on their side. I associate myself with all my heart with the movement in the arts which they represent and to which they give its character. You have no idea how enlivening it is to find oneself surrounded by a young generation which consents not to bury one immediately; so I can only express the most sincere wishes for their triumph.

I don't want to dwell on this any longer here; it is much better to talk directly—one always explains and understands one another better.

To finish, please remember me to your mother who, in your house, is the mother of the wisdom which you represent. I know that she well remembers the Rue Saffren, which was our cradle. It is impossible not to be deeply moved when we think of this beautiful time gone by, of this atmosphere which we breathed without being aware of it, and which is no doubt the cause of the present spiritual state in which we find ourselves.

My dear Henri, asking you to convey the expression of my warmest sentiments to your family, allow me to embrace you with all my heart,

<div style="text-align:center">Your old comrade,</div>

<div style="text-align:right">Paul Cézanne</div>

To Emile Solari

Paris, 25 February, *1899?*

My dear Émile,

Two sittings a day bring me easily to the limit of my strength. And this state of things has been going on for several weeks.[a] To-morrow, Sunday, rest.

Would you mind coming to see me at the studio during the afternoon? I shall be there between 2 and 4.

Very cordially yours,

Paul Cézanne

To Mademoiselle Marthe Conil
(*the artist's niece*)

Paris, 16 May, 1899

My dear Niece,

I received yesterday the letter in which you invite us to attend your first communion. Aunt Hortense, your cousin Paul and I are greatly touched by your kind invitation. But the great distance separating us from Marseille prevents us, to our great regret, from coming to you to be present at this beautiful ceremony.

At the moment I find myself tied to Paris by a rather lengthy piece of work,[b] but I hope to come down south during the course of next month.

[a] Probably this refers to a portrait of Ambroise Vollard which Cézanne painted in 1899 and for which more than 100 sittings were required. (See Venturi no. 696.) Vollard mentions this portrait in his Cézanne biography.

[b] Probably the portrait of Ambroise Vollard.

So I shall soon have the pleasure of embracing you. I ask you to pray for me, for once old age has caught up with us we find support and consolation in religion alone.

Thanking you for your kind thought, with love from aunt Hortense and your cousin Paul and a warm kiss from your old uncle

<div align="right">Paul Cézanne</div>

Give our love also to your sisters Paulette and Cécile.

LETTER FROM EGISTO PAOLO FABBRI[a]

<div align="right">Paris, 28 May, 1899.</div>

Monsieur,

I have the happiness to possess sixteen of your paintings. I understand their aristocratic and austere beauty—for me they represent what is most noble in modern art. And often when looking at them I have felt the urge to tell you in person what emotions they arouse in me.

I know, however, that you are pestered by many people and, if I ask permission to come and see you, I may appear to you very importunate.—Nevertheless I like to think that one day I shall have the pleasure and the honour of making your acquaintance; and, however that may be, please accept Monsieur this expression of my profound admiration.

<div align="right">Egisto Fabbri</div>

[a] E. P. Fabbri (1866–1933), Italian painter-collector, had by 1899 brought together an important collection of Cézanne's works, no doubt bought from Vollard.

To Egisto Paolo Fabbri

Paris, 31 May, 1899

Monsieur,

The number of my studies to which you have given hospitality assures me of the great artistic sympathy which you have the kindness to show me.

I find myself unable to resist your flattering desire to make my acquaintance. The fear of appearing inferior to what is expected of a person presumed to be at the height of every situation is no doubt the excuse for the necessity to live in seclusion.

Please accept, Monsieur, the expression of my highest esteem.

Paul Cézanne
15, rue Hégésippe Moreau,
Villa des Arts

To Henri Gasquet

Paris, 3 June, 1899

My dear Henri,

Last month I received a number of the '*Memorial d'Aix*' which published at the head of its columns a splendid article of Joachim's about the age-old titles to fame of our country.[a] I was touched by his thoughtful-

[a] Joachim Gasquet had just passionately defended his home town in the widely read Aix weekly against the accusation that Aix was dead. To prove its liveliness, he quoted the names of some of its most important sons, like Malherbe, Vauvenargues, Mirabeau, Mignet, Thiers and Frédéric Mistral; all of them, however, except Mistral, belonged to the past. The two most important living citizens of Aix, Cézanne and Zola, were not mentioned by Gasquet: the

ness and I ask you to interpret to him the sentiments which he has re-awakened in me, your old school-fellow at the Pensionat St. Joseph; for within us they have not gone to sleep for ever, the vibrating sensations reflected by this good soil of Provence, the old memories of our youth, of these horizons, of these landscapes, of these unbelievable lines which leave in us so many deep impressions.

As soon as I get down to Aix, I shall come and embrace you. For the time being I continue to seek the expression of the confused sensations which we bring with us when we are born. When I die everything will be finished, but never mind.

Whether I shall be the first to come down to the South, or whether you will come to Paris before me, I commend myself to your good thoughts; let me know and we shall meet again.

Please give my respects and best wishes to Mme. Gasquet, your mother and convey the expression of my sincerest wishes to your son, your wife; and for you, my warmest greetings, in the hope of meeting you again soon, from your old comrade

Paul Cézanne

In Autumn 1899, after a long absence, Cézanne returned to Aix, where he stayed until 1904. He had to agree to the sale of the Jas de Bouffan and tried unsuccessfully to acquire the Château Noir, situated between Aix and Le Tholonet. During this time he apparently burned a great number of his canvases. He then rented an apartment at 23 rue Boulegon in Aix and built himself a small studio in the attic. During the alterations, Cézanne accepted the hospitality offered by

painter probably because he was not taken seriously by most of his fellow-citizens and the writer because of his attitude in the Dreyfus affair, which was at its height at the time, and in which Gasquet took the side of the militarists.

*Joachim Gasquet. During his stay, their relationship apparently be-
came somewhat strained. According to some, Gasquet lacked tact in
dealing with the old man, who believed he was being 'exploited'.
Gasquet already possessed 'La Montagne Sainte-Victoire' and perhaps
other works by Cézanne, such as 'La Vieille au Chapelet'. To
Cézanne it appeared that Gasquet wanted to 'get his hands on' Cézanne's
canvases. On the other hand, it is certainly true that towards the end of
his life, Cézanne easily suspected his friends of such intentions. In any
case, the breach was not complete; Cézanne and Gasquet continued to
maintain friendly relations, but from that time on, the painter talked
about Gasquet with some disillusionment.*

*Cézanne returned to work at the Château Noir and Le Tholonet.
During the summer he addressed only two notes to Gasquet, the first
referring to an article about Gasquet's poetry. As his wife and his son
preferred to remain most of the time in Paris, he asked an older
woman, Madame Brémond, to keep house for him, while his sister Marie
looked after his financial affairs.*

*At two auctions in 1899 works by Cézanne for the first time fetched
better prices. When Victor Chocquet's collection was auctioned after the
death of his widow, a total of 54,555 francs was paid for 35 paintings
by Cézanne, among them 'La Maison du Pendu'; while Monet, at the
sale of Count Doria's collection, acquired a snowscape of Fontainebleau
for the then astonishingly high price of 6,750 francs.*

*In 1899, Cézanne had also for the first time sent three paintings to
the Open Exhibition 'Salon des Independants'; in the next year, Roger
Marx gave two landscapes and a still-life by Cézanne place of honour in
the Paris Centenary Exhibition. The following letter gives the required
information for the Catalogue.*

TO ROGER MARX

Aix, 10 July, 1900

Monsieur,

I have the honour to send you the information you
were kind enough to ask for:

Born at Aix-en-Provence in 1839.

Please accept, Monsieur, the expression of my respectful sentiments.

<div align="right">Paul Cézanne</div>

To Joachim Gasquet

<div align="right">Aix, Sunday, August 1900</div>

My dear Gasquet,

I am returning the article which you lent me and which I have read with great pleasure. It illuminates admirably the verses which you have dedicated to the picture of rural life which you have represented in your beautiful poems. And now, as you are "master of the expression of your sentiments", I too believe that with a work of this quality, you will achieve public recognition of your talent.

Please allow me the expression of my warmest feelings and my best wishes for your future success.

<div align="right">Paul Cézanne</div>

To Joachim Gasquet

<div align="right">Aix, 11th August, 1900</div>

My dear Gasquet,

I am ill and cannot come to thank you, as I would wish to do. I shall come as soon as possible to shake your hand.

All my heartfelt greetings.

<div align="right">P. Cézanne</div>

Edmond Jaloux, who met Cézanne at Gasquet's, described the scene in his Memoirs: "Suddenly the door opens. Someone enters with an air of almost exaggerated caution and discretion. He had the appearance of a petit bourgeois or a well-to-do farmer, shrewd yet formal. His back was slightly bent, his complexion weather-beaten with brick-red patches, the forehead bare, white hair falling down in long strands, piercing and inquisitive little eyes, a Bourbon nose, slightly red, a short moustache with drooping ends and a short beard, military fashion. That's how I saw Paul Cézanne . . . I still hear his manner of speaking, nasal, slow, meticulous, somehow careful and tender. I still hear him discourse about art or nature, with subtlety, dignity and deep understanding."

Perhaps Cézanne's "almost exaggerated caution" indicated a certain embarrassment. Louis Aurenche, who also met him there, went so far as to say that he appeared "distinctly unhappy".[a] Was he no longer at ease at Gasquet's house? He confided to Camoin, one of his young friends: "What am I supposed to do in their salon? I say all the time—Nom de dieu!" Cézanne's next letter to Gasquet seems to indicate that they no longer saw each other very often.

To Joachim Gasquet

Aix, 4 January, 1901

My dear Gasquet,

I would like to thank you for the friendly letter you have written to me. It proves to me that you don't desert me. If isolation fortifies the strong, it is a stumbling-block for the uncertain. I'll confess to you that it is always sad to renounce life while we are on earth. Feeling myself morally united with you, I shall resist to the end.[b]

P. Cézanne

[a] J. Rewald: *Cézanne*, Paris, 1939, p. 390.
[b] Published in facsimile in 1914, this letter is not among the Gasquet mss. entrusted by Mme. Joachim Gasquet to the Bibliothèque Méjanes in Aix-en-Provence.

To Maurice Denis[a]

Aix, 5 June, 1901

Monsieur,

I learned through the press of the manifestation of your artistic sympathy for me exhibited at the *Salon de la Société Nationale des Beaux-Arts*.

Please accept my warmest gratitude and be good enough to pass it on to the artists who have joined with you on this occasion.

Paul Cézanne

Maurice Denis to Paul Cezanne

Paris, 13 June 1901

Monsieur,

I am deeply moved by the letter which you have been good enough to send me. Nothing could have given me greater joy than to hear that the stir caused by 'Hommage à Cézanne' has penetrated even your solitude. Perhaps this will give you some idea of the position as a painter which you occupy in our time, of the admiration which you evoke and of the enlightened enthusiasm of a group of young people to which I belong and who can rightly call themselves your pupils, as they owe to you everything

[a] The young painter Maurice Denis (1870–1943) had exhibited a picture called 'Hommage à Cézanne', now in the Musée d'Art Moderne, Paris. It shows, gathered round a still life by Cézanne, the following: Odilon Redon, Vuillard, K. X. Roussell, Ambroise Vollard, Denis himself, Sérusier, Mellerio, Ranson, Bonnard and Madame Denis. When Denis painted this picture, he had not yet met Cézanne. The painting was at that time acquired by André Gide.

which they know about painting. We shall never succeed in acknowledging this sufficiently.

Believe me, Monsieur, etc.

<div align="right">Maurice Denis</div>

To Joachim Gasquet

<div align="right">Aix, 17th June, 1901</div>

My dear Gasquet,

I have received '*L'Ombre et Les Vents*' which you sent me. How kind you are to have remembered him to whom you addressed it. I shall read it leisurely, but already in leafing through it, an exquisite and heady perfume has risen from it.

I don't doubt that you will have the great success with it to which you are entitled.

Yesterday, Sunday, I saw your father and his mother, who ask you not to forget them.

Please give my respects to Mme. Gasquet, and I wish that your success may be accompanied by many others.

Very cordially yours,

<div align="right">Paul Cézanne</div>

To Louis Aurenche[a]

<div align="right">*Probably Aix, October 1901*
On paper headed Café Clément, Aix</div>

Dear Monsieur Aurenche,

Were I not under the powerful sway of the poet Larguier, I would deliver myself of some deeply felt

[a] The young writer Louis Aurenche had in the autumn of 1900

phrases, but I am only a poor painter and without doubt it is rather the brush which heaven has put into my hands as a means of expression. So, it's not my affair to have ideas and to develop them. I shall be brief,—I wish that you may soon arrive at the end of your trials and your liberation will allow us to shake your hand vigorously and in friendship.

He, who precedes you on the road of life and wishes you the best of luck.

<div align="right">Paul Cézanne</div>

TO LOUIS AURENCHE

<div align="right">Aix, 20 November, 1901</div>

Dear Monsieur Aurenche,

My pen is clogged up—please excuse my calligraphy which, I think, might still allow the pleasure to shine through, which I experienced when reading your letter.

Last night, the 19th of this month, Léo Larguier[a] and the signatory of this letter dined together. We talked a bit

come to Aix, where, through Gasquet, he met Cézanne and was received into the small circle of young friends who surrounded Cézanne during his last years in Aix, among them, apart from Gasquet, Léo Larguier and Charles Camoin. Aurenche left Aix in the autumn of 1901 to accept employment in Pierrelatte. His memoirs of Cézanne were published in 1960 as an appendix to John Rewald's book, *Cézanne, Geffroy et Gasquet.*

[a] The young poet, Léo Larguier, did his military service in Aix and met the painter through Gasquet. When off duty he visited Cézanne regularly every Sunday and was then often invited by him for supper in the Rue Boulegon. His memoirs of the artist were published under the title: *Les Dimanches avec Paul Cézanne*, Paris, 1925.

about everything; as you can imagine, you were not forgotten in our conversation, quite the contrary. As your deeply human feelings are well known to us, we could not but sympathise with you. *Homo sum: nihil humani a me* etc.

I have had the pleasure of making the acquaintance of M. Léris,[a] who has all the amiability of his age and the excellent qualities with which kind nature has endowed him.

You remind me in your letter of Mr. de Taxis.[b] He is, I believe, an excellent man, whose acquaintance should be cultivated, because Reason, this clarity which permits us to penetrate the problems submitted to us, seems to me to guide his life and his social studies. As you say, we shall not be far apart and neither you nor we shall forget each other.

Last night I received news from my rascal of a son, who lets life run sweetly, while waiting to become a settled person.[c] He will depart [*from Paris*] on Friday night, i.e. the 29th, in order to arrive in Aix on the 30th of this month. If you can let me know the day of your arrival, we shall arrange it so that we can all dine together in my house at Aix.

I hope that this letter will find you in good spirits; take courage and we shall try to spend some more good evenings together and talk philosophy endlessly. The Jo's[d] seem (nescio cur)[e] to have dimmed their haughtiness a little, in any case hardly dangerous.

[a] Pierre Léris, a young friend of Aurenche, from Aix.
[b] A gentleman of Aix.
[c] Cézanne's son was at that time nearly 30.
[d] Joachim and Marie Gasquet.
[e] 'I don't know why.' This remark seems to show that Cézanne's feelings towards Gasquet had become very much cooler.

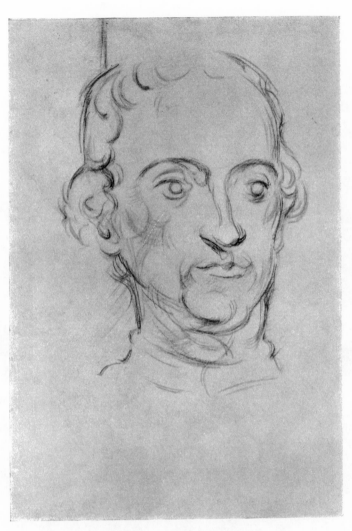

35. Drawing after a Bust, about 1890–95

Yours very cordially. One who has gone ahead of you in life and who—cahin, caha—will probably more or less pull through. Your old

<div align="right">Paul Cézanne</div>

To Ambroise Vollard[a]

<div align="right">Aix, 23 January 1902</div>

Dear Monsieur Vollard,

It is now some days since we received the case of wine that you were kind enough to send us. In the meantime your last letter has reached me. I am still working at the bouquet of flowers which will doubtless take me until about the 15th or 20th February.[b] I shall have it very carefully packed and shall send it to the rue Lafitte. When it arrives please have it framed and may I ask you to have it entered?[c]

The weather is very unsettled; sometimes beautiful sunshine is followed unexpectedly by dull, grey, leaden weather, which prevents the painting of landscape.

Paul and my wife join me in thanking you and I send

[a] The famous art dealer, Ambroise Vollard (1865–1939), established in Paris since 1895, was after the death of Père Tanguy the first to become interested in Cézanne, whose work was brought to his attention by Pissarro and Degas. Later he published his recollections in a biography of Cézanne.

[b] Cézanne often used artificial flowers as models, which enabled him to work for several weeks on a still-life.

[c] Cézanne intended to send this flower still-life to the Salon and charged Vollard with the formalities. He was, however, unable to finish the painting in time (see letter to Vollard, 2nd April 1902) and notified the dealer in January 1903, after a year's work, that he had finally abandoned it.

you my warmest thanks for the magnificent present you
made me of the work of the great Master.[a]

Please accept my warmest greetings.

Paul Cézanne

TO CHARLES CAMOIN[b]

Aix, 28 January, 1902

Dear Monsieur Camoin,

Several days have now passed since I had the pleasure
of reading your letter. I have little to tell you; indeed one
says more and perhaps better things about painting when
facing the motif than when discussing purely speculative
theories—in which as often as not one loses oneself. I
have more than once, in my long hours of solitude,
thought of you. Monsieur Aurenche has been appointed
tax collector at Pierrelatte in La Dauphinée. Mr. Larguier,
whom I see fairly often, especially on Sundays, gave me

[a] This was a watercolour by Delacroix, 'Bouquet de Fleurs', which
Vollard had bought on behalf of Cézanne at the auction of the
Collection Chocquet and of which Cézanne later made a copy
(Venturi no. 754).

[b] Charles Camoin (born 1879), a painter, was doing his military
service at Aix and Vollard gave him an introduction to Cézanne.
A friendship sprang up between them and Cézanne seems to have
been considerably drawn to his young colleague. Unfortunately, the
most important letter Cézanne wrote to Camoin has been lost; the
young, penniless artist had sent it to a well-to-do aunt in Venice,
hoping to impress her with Cézanne's high opinion of him. Never
having heard of Cézanne, however, the old lady attached little
importance to the letter and threw it away.
After he had left Aix, Camoin continued to correspond with
Cézanne.

your letter. He is pining for the moment of his release, which will take place in six or seven months. My son, who is here, has made his acquaintance and they often go out and spend the evening together; they talk a little about literature, about the future of art. When his military training is over Mr. Larguier will probably go back to Paris to continue his studies (moral philosophy and politics) at the rue Saint-Guillaume [*Ecole des Sciences Politiques*] where among others Mr. Hanoteaux is teaching, without, however, giving up poetry. My son will go back too, so he will have the pleasure of making your acquaintance when you return to the capital. Vollard passed through Aix about a fortnight ago. I had news of Monet, and Louis Leydet, son of the senator for the district of Aix, left his card. The latter is a painter, he is in Paris at the moment and has the same ideas as you and I. You see that an era of a new art is opening, you feel it coming; continue to study without weakening, God will do the rest. I conclude by wishing you good courage and good work and the success which cannot fail to crown your efforts.

Believe me to be very sincerely your friend and long live our country, our common mother, the land of hope, and please accept my warmest thanks for your kind thoughts.

Your devoted,

Paul Cézanne

To Charles Camoin

Dear Monsieur Camoin,

I received your last letter only on Saturday, I have addressed my reply to Avignon. Today, the 3rd, I found your letter of the 2nd in my box, coming from Paris. Larguier was ill last week and kept in hospital, which explains the delay in sending me your letter.

Since you are now in Paris and the masters of the Louvre attract you, if it appeals to you, make some studies after the great decorative masters Veronese and Rubens, but as you would do from nature—a thing I myself was only able to do inadequately.—But you do well above all to study from nature. From what I have been able to see of you, you will advance rapidly. I am happy to hear that you appreciate Vollard, who is a sincere man and serious at the same time. I congratulate you on being with Madame, your mother, who in moments of sadness and discouragement will for you be the surest point of moral support and the most vital source from which you can draw fresh courage to work at your art; for this is what you must strive to do, not spineless and soft, but with quiet persistence, which will not fail to lead you into a state of clear insight, very useful to guide you firmly in life.—Thank you for the very brotherly way in which you regard my efforts to express myself lucidly in painting.[a]

[a] Camoin had written to Cézanne that in the poem '*Les Phares*', in which Baudelaire praises the splendours of works by Rubens, Leonardo, Rembrandt, Michelangelo, Puget, Watteau, Goya and Delacroix, one verse would in future be felt to be missing, a verse about Cézanne.

Hoping that one day I shall have the pleasure of seeing you again, I clasp your hand cordially and affectionately.

Your old colleague

Paul Cézanne

To Louis Aurenche

Aix, 3 February, 1902

Dear Monsieur Aurenche,

I received several days ago your kind letter and I am happy with it. All the pleasant memories which you evoke come back into my head. I have vividly regretted your departure but life is only a constant voyage and I liked being with you; that was egoistic, because I found myself with new friends in the steppes of the good town of Aix. I have not managed to become intimate with anyone here.[a] Today, when the sky is overhung with grey clouds, I see things even more in black.

I see Léris only very seldom; my son, who goes out frequently, meets him more often. Larguier, with his perfect equilibrium, gives me the pleasure of dining here in my house on Sunday evenings with my wife and Paul. We miss you.

Larguier has been promoted Corporal. I have received a long letter from Camoin and have answered him in a paternal manner, as befits my age.[b]

My painting goes *cahin-caha*. Sometimes I have fabulous

[a] It is noticeable that Cézanne apparently no longer counted Gasquet as one of his intimate friends.

[b] See previous letter of the same date to Camoin.

283

bursts of enthusiasm, and still more often painful disappointments. Such is life.

I am happy about your news of the presence of Madier de Montjau[a] in Pierrelatte. I don't doubt that he is a deeply serious artist, not only in his talent but also in his heart.—When very young (we were then in the sixth form of Père Brémond, nickname Pupille), there was also Edgard de Julienne d'Arc, who was killed at Gravelotte. He was already a virtuoso.—Please express to him my gratitude that he has preserved the memory of our years together at the Collège Bourbon.

Paul, my son, who regretted your departure, and my wife, join me in sending you greetings. I shall be very happy if next April you come to Aix.—Léo [Larguier] will still be here and I invite you, if you are free, to stay with me at 23 rue Boulegon.

My best wishes and a firm handshake. In moments of sadness, think of your old friends and do not entirely give up art; it is the most intimate manifestation of ourselves.

Thank you for remembering me and very cordially yours.

Paul Cézanne

To Louis Aurenche

Aix, 10 March, 1902

Dear Monsieur Aurenche,

I am very late in answering your last letter. The cause of it are the mental troubles from which I suffer and

[a] Former conductor of the Paris Opera.

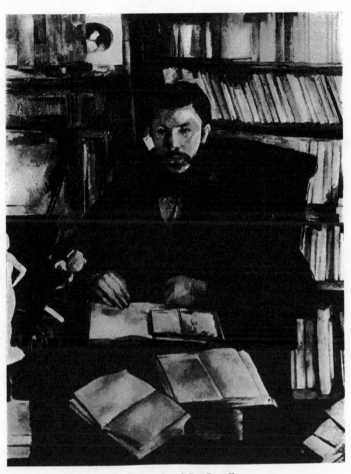

36. Portrait of G. Geoffroy
Oil, 1895

which allow me only to be guided by the model in my painting.

Here then is what I want to explain. Could you delay your arrival in Aix until May, because otherwise I could not offer you hospitality at my house, as my son occupies his room until that time. In May he departs to Paris with his mother, who is not too well.

Larguier has been in hospital for a fortnight because of eye trouble, called conjunctivitis. The Gasquets, of one and the other sex, have not appeared before my eyes. They have bought a Château at Eguilles, a hamlet ten kilometres from Aix. The life of the Château will beat at its fullest; the Abbé Tardif is going to buy a car, a big model, in order to get there. He is, it is said, a distinguished preacher.

As for me, I painfully continue my painting studies. If I had been young, some dough would have come out of it. But old age is a great enemy of man.

I've had the honour while going for a walk on the main road to Marseille, to be met by Mme. de Taxis. I've had the honour to salute her and the rest according to usual formalities.

Believe me very cordially yours.

<div align="right">P. Cézanne</div>

obliged to admit that he is not one of the most miserable on earth.—A little bit of confidence in yourself and work. Don't ever forget your art, *sic itur ad astra*.[a]

[a] 'Thus one reaches the stars.'

To Charles Camoin

Aix, 11 March, 1902

Dear Monsieur Camoin,

With regard to your first question I must tell you that I know Mr. Louis Leydet, son of the senator, only as a painter. He is a pleasant person and I think you can approach him, giving my name as a reference. I am sorry he did not come to Aix, I think we could have tightened still further the bonds of artistic friendship already existing between us. He lives at 85, Boulevard Saint-Michel, with his father, the senator.

Since your departure, the Bernheims and another dealer have been to see me; my son did a little business with them. But I remain true to Vollard and am only sorry that my son has now given them the impression that I would ever give my pictures to anyone else.

I am having a studio built on a piece of land that I bought for this purpose.[a] Vollard, I have no doubt, will continue to be my intermediary with the public. He is a man with a great flair, of good bearing and knowing how to behave.

Your devoted

P. Cézanne

[a] As the 'Jas de Bouffan' had been sold after his mother's death, Cézanne was living in the town, in the rue Boulegon, where he had only a very small studio at his disposal. For that reason he had a large studio built on a hill above the town, Chemin des Lauves. There he painted, among others, the big compositions of bathers. The studio is now open to the public.

TO MAURICE DENIS

Aix, 17 March, 1902

Monsieur and dear colleague,

In answer to your letter of the 15th, which touched me very deeply, I am writing immediately to Vollard asking him to place at your disposal the pictures which you consider suitable for exhibition at the *"Independants"*.

Believe me yours most sincerely,

P. Cézanne

TO AMBROISE VOLLARD

Aix, 17 March, 1902

Dear Monsieur Vollard,

I have received from Maurice Denis a letter which describes as a desertion my not taking part in the exhibition of the "Independants". I am replying to Monsieur Denis telling him that I am asking you to place at his disposal the pictures that you are able to lend him and to choose what will do least harm.

Believe me very sincerely yours,

Paul Cézanne

It seems to me that it is difficult for me to dissociate myself from the young people who have shown themselves to be so much in sympathy with me, and I do not think that I shall in any way harm the course of my studies by exhibiting.

P. Cézanne

If this causes you any inconvenience please let me know.

To Louis Aurenche

Aix, March 1902

Dear Monsieur Aurenche,

I have a lot to do; that's what happens to everybody who is somebody. I shall therefore not be able to get away this year. I recommend you strongly to work intellectually; that's the only serious relief which we have on earth to get away from the annoyances which dog us.

Very cordially yours,

Paul Cézanne

To Ambroise Vollard

Aix, 2 April, 1902

Dear Monsieur Vollard,

I find myself obliged to postpone to a later date sending you the picture of your roses. Although I should greatly have liked to send something to the Salon of 1902, I am again this year putting off the execution of this plan. I am not satisfied with the result I have obtained. On the other hand I am not giving up work on my 'study' which, I like to believe, has obliged me to make efforts that will not be sterile. I have had a studio built on a small plot of land that I bought for that purpose. As you see, I am going on with my search and shall inform you of the results achieved as soon as I have obtained some satisfaction from my efforts.

Believe me very sincerely yours,

Paul Cézanne

To Ambroise Vollard

Aix, 10 May, 1902

Draft[a]

Dear Monsieur Vollard,

De Montigny, distinguished member of the Society of Friends of the Arts in Aix, chevalier of the Légion d'honneur, has just invited me to exhibit something with his group.

I would, therefore, like to ask you to send me something which wouldn't look too bad, to have it framed at whatever cost, at my expense obviously, and to send it post haste to the Society of Friends of the Arts, Aix-en-Provence, Bouche-du-Rhône, 2, avenue Victor-Hugo.

To Joachim Gasquet

Aix, 12 May, 1902

My dear Gasquet,

Asked by the intermediary Mr. de Montigny to exhibit at the Society of the Friends of the Arts, I find myself without anything ready. The above-mentioned distinguished colleague finally comes *iterum* to me and asks that you should kindly lend them the head of the old woman, ex-maid of [Jean] Marie Demolins, collaborator, not without some importance, of the Revue which you edit.

Allow me the expression of my deep co-citizenship,

P. Cézanne

23, rue Boulegon, Aix-en-Provence

Should it not have a frame, please let me know and I shall do the necessary.

[a] In the collection of M. V. Nicollas, Aix-en-Provence.

*The painting to which this letter refers is 'La Vieille au Chapelet',
which Gasquet had mentioned in his first article written in 1896 and
which Cézanne had then given to him as a present. By referring to the
model as "the ex-maid of Marie Demolins", Cézanne seems clearly
to contradict the story which Gasquet related twenty years later, when
he wrote that the old woman had been a former nun whom Cézanne had
sheltered and employed as a maid and eventually used as a model. She
then began to steal, maintained Gasquet, and ended up by trying to sell
to him his own towels and sheets, which she had torn up, as cleaning
rags for his brushes, murmuring litanies all the time; but Cézanne kept
her in his employment, closing his eyes out of charity; Gasquet,*
Cézanne, Paris, 1921, p. 67.

*For unknown reasons, Gasquet seems to have persuaded Cézanne not
to exhibit 'La Vieille au Chapelet' after all (see following letter). He
was represented in the Exhibition by 'Le Pré, au Jas de Bouffan
(environ d'Aix)', and 'Nature Morte' (nos. 16 and 16 bis in the
Catalogue), which Vollard must have sent from Paris.*

To Joachim Gasquet

Aix, 17 May 1902

My dear Gasquet,

I thank you for the excellent advice which you have
had the kindness to give me. I shall make use of it.

I believe that it was a wise decision to isolate yourself
in the country. I am sure you will work there excellently.

As soon as I have recovered from these recent excitements, I shall come and shake your hand.[a]

Thanks and very cordially yours

Paul Cézanne

[a] It seems that Cézanne was in no great hurry to visit Gasquet,
who finally sent him an emissary. Cézanne answered in the following
letter.

To Joachim Gasquet

Aix, 8 July, 1902

My dear Gasquet,

Yesterday Solari came to my house. I was out. According to the report of my housekeeper, I believe that you do not understand why I don't keep my word with regard to my intention to come to Font Laure.[a]

I try to succeed by work. I despise all living painters, except Monet and Renoir, and I want to succeed by work.

As soon as I have a favourable moment, I shall come to shake your hand.

One must have something in the belly, then there is nothing but work.

Most cordially yours.

Paul Cézanne

I had a study, started two years ago; I thought I had better get on with it. The weather has at last become beautiful.

To Louis Aurenche

Aix, 16 July, 1902

Dear Monsieur Aurenche,

I have received your good news. I shall certainly be in Aix on the 24th, 25th and 26th July. I shall, therefore, have the pleasure of seeing you again and, hoping that the Gods who protect work and intelligence may be favourable towards you.

[a] The name of Gasquet's property in Eguilles.

I ask you to accept the expression of my warmest feelings.

Please give Mme. Aurenche my most respectful greetings.

<div align="right">Paul Cézanne</div>

To Mademoiselle Paule Conil

<div align="right">Aix, 1 September, 1902</div>

My dear Godchild,

I received your nice letter on Thursday, 28th August. Thank you very much for having thought of your old uncle; this thought touches me and reminds me at the same time that I am still of this world, which might not have been the case.

I remember perfectly well the Establon and the once so picturesque banks of l'Estaque. Unfortunately what we call progress is nothing but the invasion of bipeds who do not rest until they have transformed everything into hideous *quais* with gas lamps—and, what is still worse—with electric illumination. What times we live in!

The sky, which has clouded over stormily, has refreshed the air a little and I am afraid that the sea is no longer warm enough to permit you to bathe with pleasure, if it permits you this hygienic diversion at all.

On Thursday I went to see Aunt Marie[a] where I stayed to dinner in the evening. I met there Thérèse Valentin, to whom I showed your letter, as also to my sister.

Here everything is as usual. Little Marie cleaned my

[a] The older of Cézanne's two sisters, who had not married.

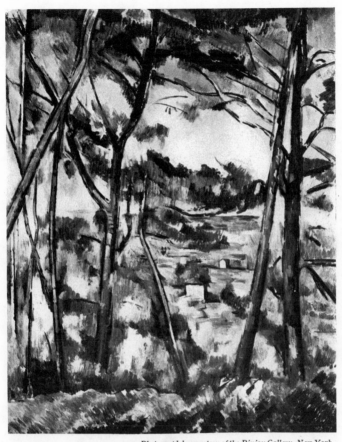

37. Village in the Provence
Oil, 1890–93

studio which is now ready and where I slowly settle in. I think with pleasure of your honouring me with a visit when you return.

Give my love to your sisters and also to little Louis. I kiss you warmly,

Your uncle,

Paul Cézanne

In the autumn of this year Cézanne briefly visited Larguier and his family in the Cevennes. On the 23rd September Zola died in Paris. When Cézanne learned of the death of his friend, he broke into tears and for the rest of the day locked himself in his study.

During 1902 Octave Mirbeau is supposed to have applied on behalf of Cézanne for the artist to be decorated with the Légion d'honneur, but his application was refused by the Director of the Beaux-Arts, Monsieur Roujon.

TO AMBROISE VOLLARD

Aix, 9 January, 1903

Dear Monsieur Vollard,

I am working doggedly, for I see the promised land before me. Shall I be like the great Hebrew leader or shall I be able to enter?

If I am ready by the end of February I shall send you my picture for framing and dispatch to some hospitable port.

I had to give up your flowers with which I am not very happy. I have a large studio in the country. I work there, I am better off than in town.

I have made some progress. Why so late and with such difficulty? Is art really a priesthood that demands the

pure in heart who must belong to it entirely? I am sorry about the distance which separates us, for more than once I should have turned to you to give me a little moral support. I live alone, the . . ., the . . .[a] are unspeakable, it is the clan of the intellectuals and good God, of what a brand! If I am still alive we will talk about all this again. Thank you for thinking of me.

<div align="right">Paul Cézanne</div>

To Charles Camoin

<div align="right">Aix, 22nd February, 1903</div>

Dear Monsieur Camoin,

Very tired, 64 years of age, I must beg you to excuse me for my very long delay in answering your letter. I shall only write a few words.

My son, at the moment in Paris, is a great philosopher. I do not mean to say that he is either the equal or the rival of Diderot, Voltaire or Rousseau. Will you honour him with a visit at 21, rue Ballu near the place Clichy, where the statue of General Moncey stands!—When I write to him I shall say a word about you; he is rather shy and unemotional but a good fellow. His help will smooth out for me the difficulty I have in coping with life.

Warmest thanks for your last letter. But I must work.— Everything, especially in art, is theory developed and applied in contact with nature.

[a] It is not impossible that Cézanne here referred to Gasquet, whose name, however, was omitted by Vollard when he published the letter during Cézanne's lifetime.

Let us talk more about this when I have the pleasure of seeing you again.

This is the most honest letter I have yet written to you. *Credo*.

Very sincerely yours,

<div align="right">Paul Cézanne</div>

When I see you again I shall talk to you more honestly about painting than anyone else.—I have nothing to hide in art.

Nothing but primary force, *id est* temperament, can bring a person to the end he should attain.

<div align="right">P. Cézanne</div>

To His Son

<div align="right">*Aix, March 1903*</div>

Fragment

. . . unnecessary to send it to me,[a] I find them under the door every day, not to mention the copies of '*l'Intransigeant*' which I get sent by post . . .

[a] An article by Henri Rochefort, published in '*L'Intransigeant*', on 9th March, 1903, on the occasion of the sale of Zola's collection. In this collection were ten pictures by Cézanne which led the author to attack viciously both Zola and Cézanne, suggesting without any justification that Zola's political and philosophical views were identical with those of Cézanne. The article, entitled '*L'Amour du Laid*' did not have any effect. Cézanne's paintings fetched better prices (from 600–4,200 francs) than the paintings by Pissarro and Monet auctioned at the same time.

To Joachim Gasquet

Aix, 25 June, 1903

My dear Gasquet,

I didn't have your address, which explains the delay in thanking you for your most friendly missive. Your father has given it to me. So far I have only been able to leaf through your poem. You have acquired the title of a young master; by young, I want to say "burdened with few years and ready for the good fight, which is about to break out."

The artistic movement which Louis Bertrand characterises so well in his fine preface, which precedes the '*Chants Séculaires*' is full of determination. March on and you will continue to open for the arts a new road leading to the Capitol.

Your devoted compatriot and admirer,

Paul Cézanne

To Joachim Gasquet

Aix, 5 September, 1903

My dear Gasquet,

I have just heard that you have honoured me with a visit at the Rue Boulegon. I shall explain my situation to you; I must still work for six months at the canvas which I have begun; it will then in the *Salon des Artistes français* seek the fate for which it is destined.[a]—Before then I shall

[a] Cézanne was not represented in the Exhibition, so the jury seems, as before, to have rejected his painting.

find a day when I can come to shake your hand. If I delay visiting you, the reason is the inextricable situation from which I burn to escape. It's ten thousand or nothing which I need, or, like Bourdelet [?] and the idiots with whom he associates, I shall have to inspect the streets, to find out who is the unhappy girl who has had a child before going to the Registry Office and you can imagine what a charming intellectual level that would be.[a]

My respects to Madame Gasquet and for you a cordial handclasp.

P. Cézanne
bête noire of Roujon[b]

To Charles Camoin

Aix, 13 September, 1903.

Dear Monsieur Camoin,

I was delighted to get your news and congratulate you on being free to devote yourself entirely to your studies.

I thought I had mentioned to you that Monet lived at Giverny; I wish that the artistic influence which this master cannot fail to have on his more or less immediate circle, may make itself felt to the strictly necessary degree, which it can and ought to have on a young artist willing to work. Couture used to say to his pupils: "Keep good company, that is: go to the Louvre. But after having seen

[a] The meaning of this phrase is not clear.
[b] Roujon, then director of *Les Beaux-Arts*, had refused to support Octave Mirbeau's proposal that Cézanne should be decorated with the *Légion d'Honneur*.

the great masters who repose there, we must hasten out and by contact with nature revive within ourselves the instincts, the artistic sensations which live in us." I am sorry not to be able to be with you. Age would be no obstacle were it not for the other considerations which prevent me from leaving Aix. Nevertheless I hope that I shall have the pleasure of seeing you again. Larguier is in Paris. My son is at Fontainebleau with his mother.

What shall I wish you: good studies made after nature, that is the best thing.

If you meet the master[a] whom we both admire, remember me to him. He does not, I believe, much like being bothered, but in view of the sincerity he may relax a little.

Believe me very sincerely yours,

Paul Cézanne

To Louis Aurenche

Aix, 25 September, 1903.

Dear Monsieur Aurenche,

I am very happy to hear of the birth of your son, you will see what a difference he will make to your life.

Paul, who is in Fontainebleau, will undertake to deliver my congratulations in person, I can't tell you when; but I am working doggedly and should the Austerlitz sun of painting shine for me, we shall come in chorus to shake hands with you.

[a] Claude Monet.

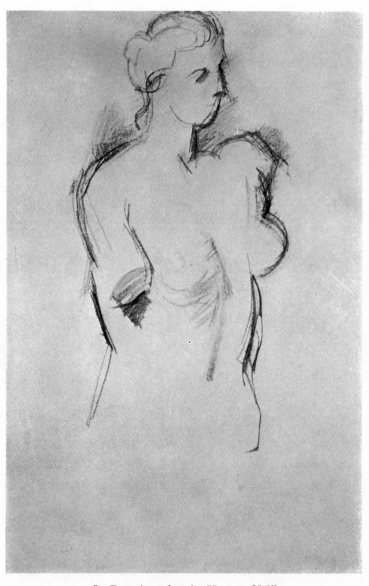

38. Drawing after the Venus of Milo
About 1890–95

May I offer my congratulations and respectful greetings to Madame Aurenche.

<div align="right">P. Cézanne</div>

To Louis Aurenche

<div align="right">Aix, 25 January, 1904.</div>

My dear Monsieur Aurenche,

Thank you very much for the good wishes you and your family sent me for the New Year.

Please accept mine in turn for you and all at home.

In your letter you speak of my realization in art. I believe that I attain it more every day, although a bit laboriously. Because, if the strong feeling for nature—and certainly I have that vividly—is the necessary basis for all artistic conception on which rests the grandeur and beauty of all future work, the knowledge of the means of expressing our emotion is no less essential, and is only to be acquired through very long experience.

The approbation of others is a stimulus of which one must sometimes be wary. The feeling of one's own strength makes one modest.

I am happy at the success of our friend Larguier. Gasquet, who lives completely in the country, I have not seen for a long time.

I send you, dear Monsieur Aurenche, my very warmest greetings.

<div align="right">Paul Cézanne</div>

To Louis Aurenche

Aix, 29 January, 1904.

Dear Monsieur Aurenche,

Your solicitude touches me deeply. At the moment I am feeling quite well. If I have not replied earlier to your first letter the explanation is simple. After a whole day working to overcome the difficulties of realizing nature, I feel, when evening comes, the need to take some rest, and my mind has not then the freedom of spirit necessary for writing.

I don't know when I shall have occasion to go up to Paris. If the opportunity comes I shall not forget that I have friends waiting for me at Pierrelatte.

If you were to come to Marseille I should, I think, be more sure of the pleasure of seeing you.

Accept, dear Monsieur Aurenche, my very sincerest greetings.

P. Cézanne

To Emile Bernard[a]

Aix-en-Provence, 15 April, 1904.

Dear Monsieur Bernard,

When you get this letter you will very probably already have received a letter, from Belgium I believe, and

[a] The young painter Emile Bernard (1868–1941), formerly a friend of Van Gogh and Gauguin, was a fervent admirer of Cézanne, about whom he had written his first article in 1892, long before they had met. In 1904, returning from a long stay in Italy and Egypt, he visited Cézanne in Aix with his wife and two children and stayed for a month. Always deeply involved in philosophical and religious thought, Bernard seems to have had long theoretical discussions

addressed to you at the rue Boulegon. I am happy with the expression of warm artistic sympathy which you kindly address to me in your letter.

May I repeat what I told you here: treat nature by means of the cylinder, the sphere, the cone, everything brought into proper perspective so that each side of an object or a plane is directed towards a central point. Lines parallel to the horizon give breadth, whether it is a section of nature or, if you prefer, of the show which the *Pater Omnipotens Aeterne Deus* spreads out before our eyes. Lines perpendicular to this horizon give depth. But nature for us men is more depth than surface, whence the need to introduce into our light vibrations, represented by the reds and yellows, a sufficient amount of blueness to give the feel of air.

I must tell you that I had another look at the study you made from the lower floor of the studio, it is good.[a] You only have to continue in this way, I think. You have the understanding of what must be done and you will soon turn your back on the Gauguins and [*Van*] Goghs!

Please thank Madame Bernard for the kind thoughts that she has reserved for the undersigned, a kiss from *père Goriot* for the children, all my best regards to your dear family.

<div align="right">P. Cézanne</div>

with Cézanne, which he attempted to continue in his letters. Although Cézanne had little taste for such speculations and discreetly made this apparent in his answers, Bernard's questions did in fact make him express his own views about painting. Bernard published his '*Souvenirs sur Paul Cézanne*', but did not realise how critical Cézanne was about his young admirer's work (see Cézanne's letters to his son, especially that dated 13th September, 1906).

[a] Cézanne had built up a still-life for Bernard in a small room below his studio; apparently Bernard also painted a landscape from there.

To Emile Bernard

Aix, 12 May, 1904

My dear Bernard,

My absorption in work and my advanced age will sufficiently explain the delay in answering your letter.

You entertain me, moreover, in your last letter with such a variety of topics, though all are connected with art, that I cannot follow it in all its developments.

I have already told you that I like Redon's[a] talent enormously, and from my heart I agree with his feeling for and admiration of Delacroix. I do not know if my indifferent health will allow me ever to realize my dream of painting his apotheosis.[b]

I progress very slowly, for nature reveals herself to me in very complex ways; and the progress needed is endless. One must look at the model and feel very exactly; and also express oneself distinctly and with force.

Taste is the best judge. It is rare. Art addresses itself only to an excessively limited number of individuals.

The artist must scorn all judgment that is not based on an intelligent observation of character.

He must beware of the literary spirit which so often causes the painter to deviate from his true path—the concrete study of nature—to lose himself too long in intangible speculation.

The Louvre is a good book to consult but it must be

[a] Bernard was a great admirer of Redon whom he had known since about 1889 and with whom he had kept up a correspondence.

[b] Cézanne had always admired Eugène Delacroix and had copied several of his works. He made a number of sketches for an apotheosis of Delacroix, one of which appears in the photograph of Cézanne in his studio taken in 1894.

only an intermediary. The real and immense study to be undertaken is the manifold picture of nature.

Thank you for sending me your book; I am waiting until I can read it with a clear head.

You can send Vollard what he has asked you for,[a] if you think it right.

Please give to Madame Bernard my kind regards, and to Antoine and Irène a kiss from *père Goriot*

Sincerely yours,

P. Cézanne

To Emile Bernard

Aix, 26th May, 1904.

My dear Bernard,

On the whole I approve of the ideas you are going to expound in your next article for *'Occident'*.[b] But I must always come back to this: painters must devote themselves entirely to the study of nature and try to produce pictures which will be an education. Talking about art is almost useless. The work which brings about some progress in one's own craft is sufficient compensation for not being understood by the imbeciles.

The man of letters expresses himself in abstractions whereas a painter, by means of drawing and colour, gives concrete form to his sensations and perceptions. One is neither too scrupulous nor too sincere nor too submissive to nature; but one is more or less master of one's model, and above all, of the means of expression. Get to the

[a] A photograph of Cézanne in his studio taken by Bernard at Aix.
[b] Bernard was preparing an article on Cézanne.

heart of what is before you and continue to express your-self as logically as possible.

Please give my kindest regards to Madame Bernard, a good squeeze of the hand for you, love to the children.

<div align="right">Pictor P. Cézanne</div>

To Emile Bernard

<div align="right">Aix, 27th June, 1904</div>

My dear Bernard,

I have received your esteemed letter of ... which I have left in the country. If I have delayed answering it, this was because I find myself in the grip of cerebral disturbances which hinder me from developing my thoughts freely. I remain in the grip of sense-perceptions and, in spite of my age, riveted to painting.

The weather is fine and I am taking advantage of it to work, I ought to make ten good studies and sell them at a high price, as amateur collectors are speculating on them.

Yesterday a letter came here addressed to my son which Madame Brémond[a] guessed was from you; I had it addressed to him at 16 Rue Duperré, Paris IXth arrondissement.

It seems that Vollard, a few days ago, gave a soirée dansante where there was much feasting.—All the young school was there it appears, Maurice Denis, Vuillard, etc. Paul and Joachim Gasquet met again there. I think the best thing to do is to work hard. You are young, produce and sell.

[a] Madame Brémond was Cézanne's housekeeper.

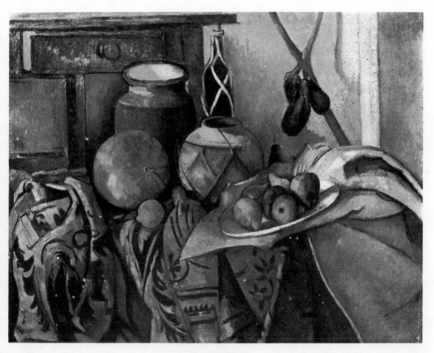

39. Still Life
Oil. 1890–95

You remember the fine pastel by Chardin, equipped with a pair of spectacles and a visor providing a shade. He's an artful fellow, this painter. Haven't you noticed that by letting a light plate ride across the bridge of the nose the tone values present themselves better to the eye?[a] Verify this fact and tell me if I am wrong.

Very sincerely yours and with kind regards to Madame Bernard and love to Antoine and Irène.

<div align="right">P. Cézanne</div>

It seems to me that Paul wrote to me that they had rented something at Fontainebleau to spend a couple of months there.

I must tell you that in view of the great heat I have my lunch brought out into the country.

To Emile Bernard

<div align="right">Aix, 25 July, 1904</div>

My dear Bernard,

I have received the 'Revue Occidentale'.[b] I can only thank you for what you wrote about me.

I am sorry that we cannot be side by side, for I don't want to be right in theory, but in front of nature. Ingres in spite of his "estyle" (Aixian pronunciation) and his admirers, is only a very small painter. The greatest, you know them better than I; the Venetians and the Spaniards.

[a] This sentence is not clear, the French text reads: N'avez-vous pas remarqué qu'en faisant chevaucher sur son nex un léger plan transversal d'arête, les valeurs s'établissent mieux à la vue?

[b] Bernard's article on Paul Cézanne had just been published in the July number of the 'Revue Occidentale'.

In order to make progress, there is only nature, and the eye is trained through contact with her. It becomes concentric through looking and working. I mean to say that in an orange, an apple, a ball, a head, there is a culminating point; and this point is always—in spite of the tremendous effect; light and shade, colour sensations[a]— the closest to our eye; the edges of the objects flee towards a centre on our horizon. With a small temperament one can be very much of a painter. One can do good things without being very much of a harmonist or a colourist. It is sufficient to have a sense of art—and this is without doubt the horror of the bourgeois, this sense. Therefore institutions, pensions, honours can only be made for cretins, humbugs and rascals. Don't be an art critic, but paint, there lies salvation.

A warm handclasp from your old comrade

P. Cézanne

My kind regards to Madame Bernard and love to the children.

To Joachim Gasquet

Aix, 27 July, 1904

My dear Gasquet,

I cannot tell you how touched I am that you remember me so well. Trying to shake off my torpor, I emerge from my shell and shall make every effort to follow up your invitation.

I went to the musical [*society?*] in order to obtain, through my friend, your father, particulars of the journey

[a] The words between dashes were added by Cézanne on the margin of his letter.

to be undertaken. Please tell him he should give me indications about the departure times of the trains and the place of rendezvous where we could meet.

Very cordially yours and all my respects to your family.

Paul Cézanne

I have read the article which '*La Provence Nouvelle*' has published about your beautiful work.

This is the last letter which Cézanne ever wrote to Gasquet and everything seems to point to the fact that the differences which already existed between the two men must have emerged even more strongly during the visit which Cézanne paid to Gasquet in the summer of 1904, two years before his death. Although it is well known that the two men finally parted company, Gasquet carefully avoided mentioning their dissensions and separation in the book about Cézanne which he later published. Cézanne's letters also give no indication which could clarify the problem, so that the deeper reasons for their estrangement will probably never be known.

To Philippe Solari

Aix, Friday, 24 September, 1904.

My dear Solari,

I should like to have a sitting on Sunday morning.[a] Will you come and have lunch at Madame Berne's at eleven o'clock? From there we shall go up to your house —see if this arrangement suits you, if not I shall make inquiries and try to come to you.

Ever your

P. Cézanne

[a] Philippe Solari was modelling in plaster a life-size bust of Cézanne.

To Gaston Bernheim-Jeune[a]

Aix, 11 October, 1904.

Dear Monsieur,

My reply is belated, the precarious state of my health is doubtless an excuse which will seem sufficient to you.

I am very touched at the token of esteem and the terms of praise in your letter.

I ask nothing better than to reply favourably to your request if all I have to do is simply to describe to you my theories and to explain the constant aim which I have been striving to attain all my life.

Accept, dear Monsieur, the expression of my sympathy as an artist.

P. Cézanne

Charles Camoin

Aix, 9 December, 1904

My dear Camoin,

I received your kind letter dated from Martigues. Come whenever you like, you will always find me at work; you can accompany me to the motif if you like. Tell me the date of your arrival for if you come to the studio on the Lauves I can have lunch brought up for us both. I have lunch at 11 o'clock, and after that I set off for the motif unless it rains. I have a baggage depot 20 minutes away from my house.

[a] Gaston Bernheim-Jeune (see footnote to letter of 11th March, 1902) seems this time to have approached Cézanne for artistic reasons alone, as Cézanne was obviously determined not to co-operate with any art dealers other than Vollard.

308

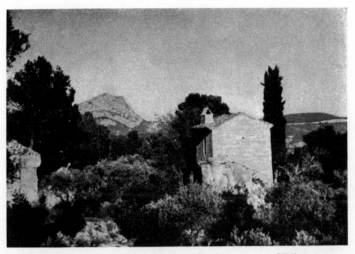

40. Cottage rented by Cézanne in the quarry of Bibémus
Photograph

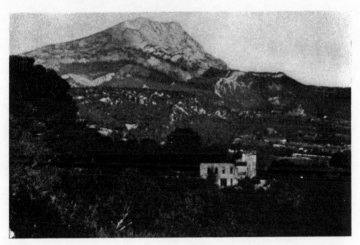

41. Château Noir, in front of the mountain Ste Victoire
Photograph

The understanding of the model and its realisation, is sometimes very slow in coming for the artist. Whoever the master may be whom you prefer, this must be only guidance for you. Otherwise you will never be anything but a pasticheur. With any feeling for nature and some fortunate talents—and you have some—you should be able to dissociate yourself; advice, someone else's methods must not make you change your own way of feeling. Should you momentarily be under the influence of someone older than you, believe me, as soon as you begin to feel vividly, your own emotion will always emerge and win its place in the sun,—gain the upper hand, confidence,—what you must strive to achieve is a good method of construction. Drawing is merely the outline of what you see.

Michelangelo is a constructor, and Raphael an artist who, great as he may be, is always tied to the model.—When he tries to become a thinker he sinks below his great rival.

Very sincerely yours,

P. Cézanne

To Emile Bernard

Aix, 23 December, 1904

My dear Bernard,

I received your kind letter dated from Naples. I shall not enter with you into aesthetic considerations. Yes, I approve of your admiration for the strongest of the Venetians; we praise Tintoretto. Your need to find a moral, an intellectual point of support in works, which

assuredly will never be surpassed, keeps you constantly on the qui vive, incessantly on the search for the means, only dimly perceived, which will surely lead you, in front of nature, to sense your own means of expression; and on the day you find them, be convinced you will rediscover without effort, in front of nature, the means employed by the four or five great ones of Venice.

This is true, without any possible doubt—I am quite positive:—an optical sensation is produced in our visual organs which allows us to classify the planes represented by colour sensations as light, half tone or quarter tone. Light, therefore, does not exist for the painter. As long as we are forced to proceed from black to white, with the first of these abstractions providing something like a point of support for the eye as much as for the brain, we flounder, we do not succeed in becoming masters of ourselves, in being in possession of ourselves. During this period (I am necessarily repeating myself a little) we turn towards the admirable works that have been handed down to us through the ages, where we find comfort, support, such as a plank provides for the bather.—Everything you tell me in your letter is very true.

I am happy to hear that Madame Bernard and the children are well. My wife and son are in Paris at the moment. We shall be together again soon I hope.

I have the wish to reply as far as possible to the principal points in your kind letter, and I ask you to give my warmest regards to Madame Bernard, a big kiss for Antoine and Irène, and you my friend, after wishing you a happy New Year, I send you a warm handclasp.

P. Cézanne

TO JEAN ROYERE[a]

Aix, 1904

Fragment

[*Cézanne thanks the poet for having sent him his 'Poèmes Eurythmiques'.*]

. . . I wanted immediately to penetrate the keenness of vision which gives them the quality of drawings. Unfortunately, the advanced age that I have reached makes the approach to new art forms difficult for me . . . So I was not ready to taste, at first approach, the full flavour of your colourful rhythms. This, in two words, is the explanation for the delay in answering . . .

TO GUSTAVE GEFFROY

1904

[*Letter of subscription to Rodin's 'Thinker'. Cézanne often said that he had subscribed because Geffroy and Rodin had openly complained that there were only Dreyfusians among the subscribers.*]

TO CHARLES CAMOIN

Aix, 5 January, 1905

My dear Camoin,

On receipt of your last letter I reply that, after inquiries, Madame Brémond says that there are rooms to be let at the Crémerie d'Orléans, rue Matheron 16. There are some

[a] A poet introduced to Cézanne by Joachim Gasquet.

311

on the first, some on the second and some on the third floor; the food is quite decent.

Very sincerely yours,

P. Cézanne

To Louis Aurenche

Aix, 10 January, 1905

I am sorry not to have the pleasure of seeing you this year either. So I too send you my best wishes.

I work all the time and that without paying any attention to criticism and the critics, as a real artist should. My work must prove that I am right.

I have no news of Gasquet who is, I believe, in Paris at the moment.

And now, dear Monsieur Aurenche, I send you our very best wishes and my kind regards for Madame Aurenche.

Paul Cézanne

To Louis Leydet[a]

Aix, 17 January, 1905

My dear colleague,

I received your kind greeting and thank you very much. If I am able to travel to Paris in the spring I shall come and see you.

[a] The young painter Louis Leydet had got to know Cézanne in 1892 through his father, the senator Victor Leydet, who was a boyhood friend of the artist. In 1895 the senator had tried in vain to obtain the cross of the Légion d'honneur for Cézanne, and it was he who in 1906 gave the funeral oration for the painter.

To succeed in formulating sufficiently the impression which we experience in contact with this beautiful nature—man, woman, still-life—and that circumstances should be favourable to you, that is my wish to all who are in sympathy with art.

Your old

Paul Cézanne

To Roger Marx

Aix, 23rd January, 1905

Monsieur le Rédacteur,

I read with interest the lines that you were kind enough to dedicate to me in your two articles in the '*Gazette des Beaux-Arts*'.[a] Thank you for the favourable opinion that you express about me.

My age and health will never allow me to realize my dream of art that I have been pursuing all my life. But I shall always be grateful to the public of intelligent amateurs who—in spite of my hesitations—have intuitively understood what I wanted to try in order to renew my art. To my mind one does not put oneself in place of the past, one only adds a new link. With a painter's temperament and an artistic ideal, that is to say a conception of nature, sufficient powers of expression

a These were two articles about the new '*Salon d'Automne*' founded by Redon, Marx and Huysmans; in one of them a landscape by Cézanne was reproduced. Cézanne had not only been asked to participate in the Exhibition, but during the first Exhibition in 1904 had been allocated a room of his own. He had gone to Paris on the occasion of the Exhibition and worked for several weeks in Fontainebleau.

would have been necessary to be intelligible to the general public and to occupy a fitting position in the history of art.

Please accept, Monsieur le Redacteur, the expression of my warmest sympathy as an artist.

P. Cézanne

To a Colour Merchant

Aix, 23rd March, 1905

[*Cézanne is slightly indisposed and cannot attend to the returning of the cinnabar green which had been sent to him. He requests at the same time the despatch of 5 Prussian blues plus a bottle of Harlem fixative which he urgently needs.*]

To a Colour Merchant

Fontainebleau,[a] 6 July, 1905.

Yesterday I had the pleasure to receive the canvases and colours that I had ordered from you, but I am waiting impatiently for my box which I had asked you to have mended for me and to add a palette with a hole large enough to put my thumb through. . . .

Cézanne goes on to ask for some burnt lake, cobalt and chrome yellow.

[a] This was Cézanne's last stay in Paris. Although he was represented by ten paintings in the 'Salon d'Automne' of 1905, he does not seem to have been present at the opening. On the occasion of the Exhibition, Geffroy published an article about Cézanne in which he stated: "I believe that his art will outlive our time."

42. Drawing after a plaster cast of the 'Écorché',
attributed to Michelangelo
About 1895

To Emile Bernard

My dear Bernard,

I am replying briefly to some of the paragraphs in your last letter. As you say, I believe I have in fact made some more progress, rather slow, in the last studies which you have seen at my house. It is, however, very painful to have to state that the improvement produced in the comprehension of nature from the point of view of the picture and the development of the means of expression is accompanied by old age and a weakening of the body.

If the official Salons remain so inferior, the reason is that they encourage only more or less widely accepted methods. It would be better to bring in more personal emotion, observation and character.

The Louvre is the book in which we learn to read. We must not, however, be satisfied with retaining the beautiful formulas of our illustrious predecessors. Let us go forth to study beautiful nature, let us try to free our minds from them, let us strive to express ourselves according to our personal temperament. Time and reflection, moreover, modify little by little our vision, and at last comprehension comes to us.

It is impossible in this rainy weather to practise out of doors these theories which, however, are so right. But perseverance leads us to understand interiors like everything else. Only the old dregs clog our intelligence, which needs to be whipped on.

Very sincerely yours and my regards to Madame Bernard and love to the children.

<div style="text-align: right">P. Cézanne</div>

You will understand me better when we see each other again; study modifies our vision to such a degree that the humble and colossal Pissarro finds himself justified in his anarchistic theories.

Draw; but it is the reflection which envelops; light, through the general reflection, is the envelope.

P.C.

To Emile Bernard

Aix, 23 October, 1905.

My dear Bernard,

Your letters are precious to me for a double reason: The first being purely egoistic, because their arrival lifts me out of the monotony caused by the incessant pursuit of the sole and unique aim, which leads in moments of physical fatigue to a kind of intellectual exhaustion; and the second, allows me to reassess for you, undoubtedly rather too much, the obstinacy with which I pursue the realization of that part of nature, which, coming into our line of vision, gives us the picture. Now the theme to develop is that—whatever our temperament or form of strength face to face with nature may be—we must render the image of what we see, forgetting everything that existed before us. Which, I believe, must permit the artist to give his entire personality, whether great or small.

Now, being old, nearly 70 years, the sensations of colour, which give the light, are for me the reason for the abstractions which do not allow me to cover my canvas entirely nor to pursue the delimitation of the objects where their points of contact are fine and delicate; from

43. View of l'Estaque
Photograph

which it results that my image or picture is incomplete. On the other hand the planes fall one on top of the other, from whence neo-impressionism emerged, which circumscribes the contours with a black line, a fault which must be fought at all costs.[a] But nature, if consulted, gives us the means of attaining this end.

I remembered quite well that you were at Tonnerre but the difficulties of settling down in my house make me place myself entirely at the disposal of my family, who make use of this to seek their own comfort and neglect me a little. That's life; at my age I should have more experience and use it for the general good. I owe you the truth about painting and shall tell it to you.

Please give my kind regards to Madame Bernard; the children I must love, seeing that St. Vincent de Paul is the one to whom I must recommend myself most.

Your old

Paul Cézanne

A strong handshake and good courage.

Optics, which are developed in us by study, teach us to see.

To His Son

Aix, Friday, *18* July, 1906.

My dear Paul,

This morning, as my head feels fairly clear, I am answering your two letters, which always give me the

[a] In fact the delineation of contours had nothing to do with Seurat's neo-impressionism but had first been used by Bernard himself when, together with Anquetin, he invented the 'Cloisonnisme'. Later, Gauguin took over this particular element of style.

greatest pleasure. Four-thirty in the morning—by 8 o'clock the temperature will be unbearable—I am continuing my studies. One ought to be young and do many of them. The atmosphere is sometimes full of dust and the colours are deplorable—it is only beautiful at certain times.

Thank you for the news you give me, I pursue my good old way.

My love to mamma and to all the people who still remember me. Give my regards to Madame Pissarro,[a]—how distant everything already is and yet how close.

Your father who embraces you both.

Paul Cézanne

I have not yet seen your aunt. I sent her your first letter.

Do you know where the little sketch of the Bathers is?

To His Son

Aix, 24 July, 1906

Yesterday the filthy Abbé Gustave Roux took a carriage and came to hunt me up at the house of Jourdan —he is poisonous.—I promised to go and see him at the Catholic College. I shan't go, you have time to send me a reply giving me your advice.

I embrace you, you and mamma. It is very hot.

Your old father,

Paul Cézanne

[a] Pissarro died at the end of 1903.

To His Son

Aix, 25 July, 1906

My dear Paul,

Yesterday, I received your good letter giving me your news; I can only feel sorry about the state in which mother finds herself, give her the greatest possible care, look for well-being, coolness and diversions appropriate to the circumstances.

Yesterday, Thursday, I should have gone to see the blackfrock Roux. I didn't go, and that's how it will be till the end, that's still the best thing to do. He is poisonous. Apropos of Marthe, I went to see your Aunt Marie. —That is another nuisance, at my age one should live an isolated life and paint.

Vallier[a] massages me, my ribs are a little better, Madame Brémond says that my foot is better.—I follow Boissy's treatment, it is horrible. It is very hot.—From eight o'clock on the weather is unbearable.—The two pictures of which you sent photographs are not by me.

I embrace you both with all my heart.

Your old father

Paul Cézanne

Remember me to Monsieur and Madame Legoupil, their kind thoughts touched me deeply and they are so good to your poor mother.

P. Céz.

[a] Vallier, Cézanne's gardener, posed for several pictures.

Aix, 3 August, 1906

My dear Paul,

I received your affectionate letters of various dates all fairly close together. If I have not answered at once, the oppressive heat which reigns is the reason. It depresses my brain considerably and prevents me from thinking. I get up in the early morning, and live my ordinary life only between 5 and 8 o'clock. By that time the heat becomes stupefying and exerts such a strong cerebral depression that I can't even think of painting. I was forced to call in Doctor Guillaumont for I had an attack of bronchitis, and I gave up homœopathy in favour of mixed syrups of the old school.—I didn't half cough, mother Brémond applied some cotton-wool soaked in iodine, and it did me a lot of good. I regret my advanced age, because of my colour sensations.—I am glad that you see Monsieur and Madame Legoupil who have their feet on the ground and must ease your existence considerably. I am happy to hear of the good relations you have with the intermediaries between art and the public, whom I wish to see continue in their favourable attitudes towards me.

It is unfortunate that I cannot make many proofs of my ideas and sensations, long live the Goncourts, Pissarro and all those who have the impulse towards colour, representing light and air.—I can quite understand that owing to the terrible heat which reigns, mamma and you are tired; it is therefore lucky for you that you were able to go up to Paris in time to find yourselves in a less burning climate. As to my foot, it is not

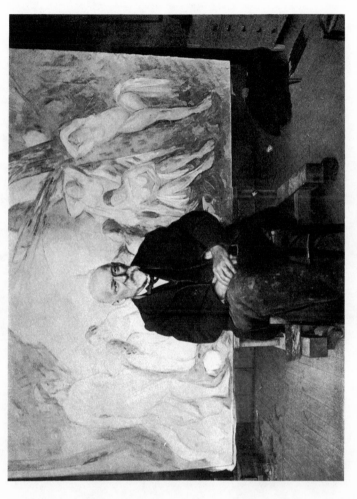

44. Cézanne in his studio at Aix
Photograph taken in 1904 by Emile Bernard

too bad at present.—I am greatly touched by the kind thoughts of Forain and Léon Dierx, our acquaintance goes back a long time. With Forain to 1875 at the Louvre, and with Léon Dierx to 1877 at Nina de Villard's[a] house in the rue des Moines.

I must have told you that when I dined at the rue des Moines, Paul Alexis, Frank Lami, Marast, Ernest d'Hervilly, L'Isle Adam and many lovers of good food, also the much regretted Cabaner, were present around the table. Alas, what memories have been engulfed in the abyss of the years.—I think that I have answered about all your questions.—Now I must ask you not to forget my slippers, those which I have are about to abandon me entirely.

I embrace you and mamma with all my heart.

Your old father

Paul Cézanne

To His Son

Aix, 12 August, 1906.

My dear Paul,

The days have been terribly hot; to-day, particularly this morning, it was pleasant from five o'clock in the morning, the time at which I got up, until about eight o'clock. The sensations of pain exasperate me to the point

[a] Nina de Villard or Nina de Callias, whose portrait was painted by Manet, was a friend of Verlaine and Malharmé and assembled many artists around her. Cézanne may have been introduced to her by Paul Alexis or the musician, Jean de Cabannes, called Cabaner. Cézanne's son had certainly met Forain and Dierx at the house of Vollard. Cf. Tabarant, Manet et ses oeuvres, p. 227–8.

where I can no longer overcome them and force me to live a retired life, that is what is best for me. At St. Sauveur,[a] the old choirmaster Poncet has been succeeded by an idiot of an abbé, who works the organ and plays wrong. In such a manner that I can no longer go to mass, his way of playing music makes me positively ill.

I think that to be a catholic one must be devoid of all sense of justice, but have a good eye for one's interests.

Two days ago the sieur Rolland came to see me, he made me talk about painting. He offered to pose for me as a bather on the shores of the Arc.[b]—That would please me, but I am afraid that the gentleman simply wants to lay hands on my sketch; in spite of that I almost feel inclined to try something with him. I demolished for him Gasquet and his Mardrus, he told me that he would read the 'Thousand and one Nights' in Galland's[c] translation. He seems to understand that personal influence can help to ingratiate us but that in the long run the public notices that it is being tricked. I hope that this heat will pass as quickly as possible and above all that you and your mother are not suffering too much from it.—You must have received the letter from your aunt Marie.

When you have the opportunity, please give my greetings to all our friends down there. I have had no further news from Emile Bernard, I am afraid that commissions are not showered on him.

[a] The Cathedral of Aix-en-Provence.

[b] It had always been Cézanne's wish to paint nudes in water, and especially scenes of bathers in the open air.

[c] A new translation of 'The Thousand and One Nights' by Dr. Mardrus, published in 1900 had caused some stir. It is interesting that Renoir also preferred the old translation by Galland, published in 1704.

A poor tramp from Lyon came to borrow a few sous from me, he seemed to me to be in a frightful mess.[a]

I embrace you and mamma with all my heart.

Your old father,

Paul Cézanne

The heat is becoming oppressive again.

I remind you of the slippers.

To His Son

Aix, 14 August, 1906.

My dear Paul,

It is two o'clock in the afternoon. I am in my room, the heat has started again, it is appalling.—I am waiting for 4 o'clock, the carriage will come and fetch me and will take me to the river by the bridge of the Trois Sautets.[b] It is a little fresher there; I felt very well there yesterday, I started a water-colour in the style of those I did at Fontainebleau, it seems more harmonious to me, it is all a question of putting in as much inter-relation as possible.

In the evening I went to wish a happy birthday to your aunt Marie. I found Marthe there; you know better than I do what I should think of the position, so it is up to you to direct our affairs.—My right foot is improving. But

[a] Perhaps the poet and tramp Germain Nouveau (**Humilis**), who used to beg at the gate of the Cathedral of St. Sauveur in Aix and to whom Cézanne often gave considerable alms.

[b] A small bridge across the Arc near Palette where Cézanne used to paint during the last months of his life, especially some water-colours of a mill, since burnt down (Venturi nos. 978, 979, 1076).

how great the heat is, the smell of the atmosphere is almost nauseating.

I received the slippers. I have tried them on, they fit me well, that's a success.

By the river a poor little child, very lively, came up to me, in rags, asked me if I was rich; another, older, told him that one didn't ask that. When I got back into my carriage to return to town he followed me; at the bridge I threw him two sous, if you could have seen how he thanked me.

My dear Paul, I have nothing to do but paint. I embrace you with all my heart, you and mamma, your old father,

Paul Cézanne

To His Son

Aix, Sunday, 26 August, 1906

My dear Paul,

If I forget to write to you it is because I loose a little the awareness of time. It has been terribly hot and on the other hand my nervous system must be very much enfeebled. I live a little as if in a void. Painting is what means most to me. I am very irritated about the cheek of my compatriots who try to put themselves on an equal footing with me as an artist and to lay their hands on my work.—You should see the dirty tricks they play. I go every day to the river by carriage. It is quite nice there, but my weakened state is very bad for me. Yesterday I met the priest Roux, he repels me.

I am going up to the studio, I got up late this morning,

after 5 o'clock. I am still working with much pleasure, but sometimes the light is so horrible that nature seems ugly to me. Some selection is therefore necessary. My pen hardly works. I embrace you both with all my heart and remember me to all the friends who still think of me, across time and space. A kiss for you and mamma. Greetings to Monsieur and Madame Legoupil, your old father,

<div align="right">Paul Cézanne</div>

To His Son

<div align="right">Aix, 2nd September, 1906</div>

My dear Paul,

It is nearly 4 o'clock, there is no air at all. The weather is still stifling. I am waiting for the moment when the carriage will take me to the river. I spend some pleasant hours there. There are some large trees, they form a vault over the water. I am going to a spot known as the *Gour de Martelles,* on the little *chemin des Milles* which leads to Montbriant.[a] Towards evening come the cows being brought to pasture. There is plenty of material to study and make masses of pictures. Sheep have also come to drink, but they disappear rather quickly. Some working-painters approached me and told me that they would willingly paint in the same way, but that at the drawing

[a] Montbriant was the estate belonging to M. Maxime Conil, Cézanne's brother-in-law. Cézanne often went there to paint the Arc Valley with the railway bridge and Mt. Ste. Victoire (Venturi nos. 452/7).

school they are not taught that, I told them that Pontier[a] was a dirty brute, they seemed to approve. You see that there is really not much news. It is still hot, it doesn't rain, and it doesn't seem as if it would rain for a long time.—I don't really know what to tell you except that four or five days ago I met Demolins[b] and that he seemed to me to be jolly artificial. Our judgment must be much influenced by our mental state.

I embrace you and mamma with all my heart.

Your father,

Paul Cézanne

To His Son

Aix, 8 September, 1906

My dear Paul,

To-day (it is nearly eleven o'clock) a startling return of the heat. The air is overheated, not a breath of air. This temperature can be good for nothing but the expansion of metals, it must help the sale of drinks and bring joy to the beer merchants, an industry which seems to be assuming a fair size in Aix, and it expands the pretentions of the intellectuals in my country, a pack of ignoramuses, cretins and rascals.

The exceptions, there may be some, do not make them-

[a] The sculptor Auguste-Henri Pontier was keeper of the Museum at Aix from 1892–1925. He was very hostile towards Cézanne and is supposed to have sworn that during his lifetime no painting by Cézanne would be accepted by the Museum at Aix. He died in 1925, having kept his promise.

[b] Marie Demolins, a notary in Aix.

selves known. Modesty is always unaware of itself.—
Finally I must tell you that as a painter I am becoming
more clear-sighted before nature, but that with me the
realization of my sensations is always painful. I cannot
attain the intensity that is unfolded before my senses. I
have not the magnificent richness of colouring that
animates nature. Here on the bank of the river the motifs
multiply, the same subject seen from a different angle
offers subject for study of the most powerful interest and
so varied that I think I could occupy myself for months
without changing place, by turning now more to the
right, now more to the left.

My dear Paul, in conclusion I must tell you that I have
the greatest faith in your feelings, which impress on your
mind the necessary measures to guard our interests, that
is to say that I have the greatest faith in your direction of
our affairs.

It is with a most patriotic satisfaction that I learn of the
impending visit with which the statesman who presides
over the political destinies of France[a] is about to honour
our country, it will make our southern population
quiver with joy. Jo,[b] where will you be? Is it the artificial
and conventional things that succeed best in this world
and in our lives or do a series of lucky coincidences
crown our efforts with success?

Your father, who sends a kiss for you and Mamma,

Paul Cézanne

[a] The newly-elected president, Armand Fallières.
[b] Joachim Gasquet.

To His Son

My dear Paul,

I am sending you a letter that I have just received from Emilio Bernardinos, one of the most distinguished aesthetes. I am sorry not to have him under my thumb so as to instil into him the idea so sane, so comforting and the only correct one, of a development of art through contact with nature. I can scarcely read his letter, but I think he is right, though the good man absolutely turns his back on what he expounds in his writings; in his drawings he produces nothing but old-fashioned rubbish which smacks of his artistic dreams, based not on the emotional experience of nature but on what he has been able to see in the museums, and more still on a philosophic attitude of mind which comes from his excessive knowledge of the masters he admires. You must tell me if I am mistaken.—On the other hand I cannot help regretting the annoying accident which happened to him.—You will understand that I cannot go to Paris this year.—I wrote to you that I go every day in the carriage to the river bank.

Because of fatigue and constipation, I have had to give up going up to the studio. This morning I went for a little walk, I came back at about 10 or 11 o'clock, had lunch, and at half-past three left, as I told you above, for the banks of the Arc.

My studies interest me greatly. Perhaps I could have made a convinced follower of Bernard. Obviously one must succeed in having feelings of one's own and in expressing oneself adequately. I know I harp always on

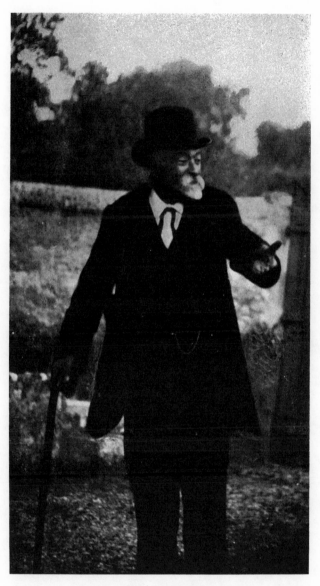

45. Cézanne at Aix
Photograph taken in 1904 by J. Bernheim

the same thing, but my life arranged in this way allows me to isolate myself from the lower sphere.

I embrace you, you and your mother, with all my heart,
Your old father,

Paul Cézanne

One of the strong is Baudelaire, his '*Art Romantique*' is astounding, and he doesn't go wrong in the artists he admires.

If you want to send an answer to his letter, let me have it and I will copy it.[a]—Do not mislay the aforementioned letter.

To Emile Bernard

Aix, 21 September, 1906

My dear Bernard,

I am in such a state of mental disturbance, I fear at moments that my frail reason may give way. After the terrible heatwave that we have just had, a milder temperature has brought some calm to our minds, and it was not too soon; now it seems to me that I see better and that I think more correctly about the direction of my studies. Will I ever attain the end for which I have striven so much and so long? I hope so, but as long as it is not attained a vague state of uneasiness persists which will not disappear until I have reached port, that is until I have realized something which develops better than

[a] From later letters to his son, it appears that Cézanne forgot to include Bernard's letter. The answer to Bernard dated 21st September, 1906 is undoubtedly by Cézanne himself.

in the past, and thereby can prove the theories—which in themselves are always easy; it is only giving proof of what one thinks that raises serious obstacles. So I continue to study.

But I have just re-read your letter and I see that I always answer off the mark. Be good enough to forgive me; it is, as I told you, this constant preoccupation with the aim I want to reach, which is the cause of it.

I am always studying after nature and it seems to me that I make slow progress. I should have liked you near me, for solitude always weighs me down a bit. But I am old, ill, and I have sworn to myself to die painting, rather than go under in the debasing paralysis which threatens old men who allow themselves to be dominated by passions which coarsen their senses.

If I have the pleasure of being with you one day, we shall be better able to discuss all this in person. You must forgive me for continually coming back to the same thing; but I believe in the logical development of everything we see and feel through the study of nature and turn my attention to technical questions later; for technical questions are for us only the simple means of making the public feel what we feel ourselves and of making ourselves understood. The great masters whom we admire must have done just that.

A warm greeting from the obstinate macrobite who sends you a cordial handshake.

<div align="right">Paul Cézanne</div>

To His Son

Aix, 22 September, 1906

My dear Paul,

I sent a long letter to Émile Bernard, a letter which reflects my preoccupations, I described them to him, but as I see a little further than he does and as the manner in which I told him of my reflections cannot offend him in any way, even though I have not the same temperament nor his way of feeling, at last and finally I have come to believe that one cannot help others at all. With Bernard it is true one can develop theories indefinitely because he has a rational temperament. I go into the country every day, the motifs are beautiful and in this way I spend my days more agreeably than anywhere else.

I embrace you and mamma with all my heart, your devoted father,

Paul Cézanne

My dear Paul, I have already told you that I am oppressed by cerebral disturbances, my letter reflects them. Moreover, I see the dark side of things and so feel myself more and more compelled to rely on you and to look to you for guidance.

To His Son

Aix, 26 September, 1906

My dear Paul,

I received a notification from the *Salon d'Automme*, signed by Lapigie, who is doubtless one of the big

organizers and . . . of the exhibition; from it I see that eight of my pictures[a] are on view. Yesterday I saw that valiant Marseillean Carlos Camoin, who came to show me a pile of paintings and to seek my approval; what he does is good, if anything he seems to be making progress, he is coming to spend a few days at Aix and is going to work on the *petit chemin du Tholonet*.[b] He showed me a photograph of a figure by the unfortunate Émile Bernard; we are agreed on this point, that he is an intellectual constipated by recollections of museums, but who does not look enough at nature, and that is the great thing, to make himself free from the school and indeed from all schools.—So that Pissarro was not mistaken, though he went a little too far, when he said that all the necropoles of art should be burned down.

Certainly one could make a strange menagerie with all the professionals of art and their kindred spirits.—The Secretary-General is himself an artist. In this case, in view of his position, he would be the equal, in the Salon d'Automne of course, of a member of the Institute. It is, therefore, a structure which rises proudly if not victoriously opposite the barracks of the Quai Conti, the library of which was founded by the man Sainte-Beuve described as an 'artful Italian'.[c]—I still go into the country, to the banks of the Arc, and I leave my baggage with a man named Bossy who offered me hospitality for it.

I embrace you and Mamma with all my heart, your father,

Paul Cézanne

[a] In fact there were ten.
[b] The road leading to the Château Noir, where a few years before Cézanne had painted several landscapes.
[c] This is an allusion to Cardinal Mazarin.

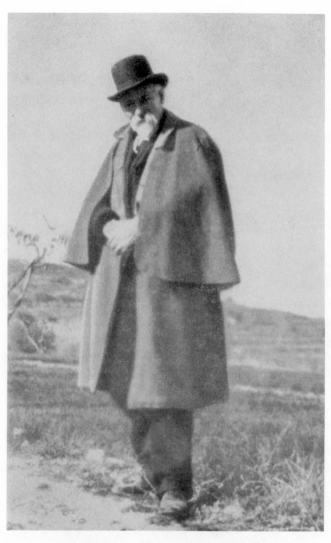

46. Cézanne going for a walk near Aix
Photograph taken in 1905 by Emile Bernard

To His Son

Aix, 28 September, 1906

My dear Paul,

I am writing to ask you to send me the reconstituent pills no. 4, I have only two or three rows left in my last box. I have already told you that I had to send back to Vignol three tubes out of five of fine lake, the other two got lost when I took them from the studio in the rue Boulegon or into the country. I do not think that the good man is capable of running his shop. The weather is magnificent, the countryside superb. Carlos Camoin is here, he comes to see me from time to time—I am reading the appreciation that Baudelaire has written about the work of Delacroix. As for me, I must remain alone, the meanness of people is such that I should never be able to get away from it, it is theft, complacency, infatuation, violation, laying hand on one's work, and yet, nature is very beautiful. I still see Vallier,[a] but I am so slow in expressing myself that it makes me very sad. You alone can console me in my sad state.—So I commend myself to you. I embrace you, you and mamma, with all my heart.

Your old father,

Paul Cézanne

[a] See letter by Cézanne's sister, p. 337.

To His Son

<div align="right">Aix, 8 October, 1906</div>

My dear Paul,

I am sending you the card you asked for.[a] I am very sorry about the state of nervousness in which I find myself and which prevents me from writing you longer letters; the weather is fine, in the afternoon I go to my motif. Emery raised the price of the carriage to three francs return, when I used to go to the Château Noir[b] for five francs. I chucked him. I made the acquaintance of Monsieur Roublard who has married a pretty dowry in the person of Mlle. Fabry.—You will see when you are here what there is to do. He is a young man well looked upon in town, he arranges spiritual and very artistic concerts.

I shall not say anything more to-day. Yesterday I spent the time before dinner from about four to seven o'clock at the Café des Deux Garçons with Capdeville, Niolon,[c] Fernand Bouteille, etc.

Your father who embraces you and your mother very tenderly,

<div align="right">P. Cézanne</div>

[a] Probably the artist's admission ticket to the Salon d'Automne.

[b] A large wooded property about three miles from Aix. Cézanne worked there from 1899, the date on which the 'Jas de Bouffan' was sold, until 1902 when he had the studio des Lauves built.

[c] Niolon was a painter of Aix, who often went with Cézanne and Mme. Louise Germain to paint at the Château Noir. Cézanne used to take them in his carriage.

Aix, 13 October, 1906

My dear Paul,

To-day, after a terrific thunderstorm in the night and as it was still raining this morning, I remained at home. It is true, as you remind me, that I forgot to mention the wine. Madame Brémond tells me that we must have some sent. When, on the same occasion, you see Bergot, you should order some white wine for yourself and your mother. It has rained a lot and I think that this time the heat is over. As the banks of the river are now a bit cool I have left them and climb up to the quartier de Beauregard where the path is steep, very picturesque but rather exposed to the mistral. At the moment I go up on foot with only my bag of water colours, postponing oil painting until I have found a place to put my baggage; in former times one could get that for 30 francs a year. I can feel exploitation everywhere.—I am waiting for you to make a decision. The weather is stormy and changeable. My nervous system is very weak, only oil painting can keep me up. I must carry on. I simply must produce after nature.—Sketches, pictures, if I were to do any, would be merely constructions after nature, based on method, sensations, and developments suggested by the model, but I always say the same thing.—Could you get me marzipan in a small quantity?

I embrace you and mamma with all my heart, your father,

Paul Cézanne

My dear Paul, I have just found the letter from Emile

Bernard.—I hope he will be able to win through, but I fear the contrary.

Ever your

Paul Cézanne

To His Son

Aix, 15th October, 1906

My dear Paul,

It rained on Saturday and Sunday and there was a thunderstorm, the weather is much cooler—in fact it is not hot at all. You are quite right in saying that here we are deep in the provinces. I continue to work with difficulty, but in the end there is something. That is the important thing, I believe. As sensations form the basis of everything for me, I am, I believe, impervious. I shall, by the way, let the poor devil, you know who, imitate me as much as he likes, it is scarcely dangerous.

Give my regards, when you have the opportunity, to Monsieur and Madame Legoupil, who are kind enough to remember me. Do not forget Louis and his family either and my good father Guillaume.—Everything passes with frightening speed, I am not too bad. I take care of myself, I eat well.

I should like to ask you to order me two dozen marten-hair brushes, like the ones we ordered last year.

My dear Paul, in order to give you news as satisfactory as you would like, I would need to be 20 years younger.— I repeat, I eat well, and a little moral satisfaction—but work alone can give me that—would do me a lot of good. —All my compatriots are arseholes beside me.

I should have told you that I received the cocoa.

I embrace you and mamma, your old father,

Paul Cézanne

I think the young painters are much more intelligent than the others, the old ones see in me only a disastrous rival. Ever your father

P. Cézanne

I must say it again, Emile Bernard seems to me worthy of deep compassion for he has to look after his family.

To a Colour Merchant

Aix, 17 October, 1906

Monsieur,

It is now eight days since I asked you to send me ten burnt lakes no. 7 and I have had no reply. What ever is the matter?

An answer and quick, please.

Accept, Monsieur, my distinguished greetings,

Paul Cézanne

Three days later, on the 20th October, the painter's sister Marie Cézanne wrote to his son: "Your father has been ill since Monday. . . . He remained outside in the rain for several hours, he was brought back in a laundry cart; and two men had to carry him up to his bed. The next day, early in the morning, he went into the garden to work under the lime-tree, on a portrait of Vallier, he came back dying."

Paul Cézanne died at Aix on the 22nd October, 1906.

POEMS IN FRENCH

1.

Enfin je prends la plume
Et selon ma coutume[a]
Je dirai tout d'abord
Pour nouvelle locale
Qu'une forte rafale
Par son ardent effort
Fait tomber sur la ville
Une eau qui rend fertile
De l'Arc[b] le riant bord.
Ainsi que la montagne
Notre verte campagne
Se ressent du printemps,
Le platane bourgeonne,
De feuilles se couronne
L'aubépin vert aux bouquets blancs.

2.

Le temps est brumeux
Sombre et pluvieux,
Et le soleil pâle
Ne fait plus aux cieux
Briller à nos yeux
Ses feux de rubis et d'opale

3.

Adieu, mon cher Émile:
Non, sur le flot mobile
Aussi gaiement je file
Que jadis autrefois,
Quand nos bras agiles
Comme des reptiles

[a] Cette phrase parait indiquer que la lettre du 9 avril n'est pas la première que Cézanne adressa à Zola. On ne connaît cependant pas de lettres d'une date antérieure.

[b] L'Arc est une petite rivière qui coule dans une large vallée près d'Aix et où les trois amis aimaient à se baigner. Cézanne a peint souvent la vue de cette vallée traversée d'un viaduc de chemin de fer et dominée par Sainte-Victoire.

Sur les flots dociles
Nageaient à la fois.
Adieu, belles journées
Du vin assaisonnées!
Pêches fortunées
De poissons monstrueux!
Lorsque dans ma pêche,
A la rivière fraîche
Ma ligne revêche
N'attrapait rien d'affreux.

4.

Phébus en parcourant sa brillante carrière
Inonde Aix tout entier des flots de sa lumière.

5.

POÈME INÉDIT

C'était au fond d'un bois
Quand j'entendis sa voix brillante
Chanter et répéter trois fois
Une chansonnette charmante
Sur l'air du mirliton, etc.

J'aperçus une pucelle
Ayant un beau mirliton
En la contemplant si belle
Je sentis un doux frisson
Pour un mirliton, etc.

Ses grâces sont merveilleuses
Et son port majestueux,
Sur ses lèvres amoureuses
Erre un sourire gracieux
Gentil mirliton, etc.

Je résous de l'entreprendre,
J'avance résolument:
Et je tiens ce discours tendre
A cet objet charmant:
Gentil mirliton, etc.

Ne serais-tu pas venue,
Inexprimable beauté,
Des régions de la nue,
Faire ma félicité?
Joli mirliton, etc.

Cette taille de déesse,
Ces yeux, ce front, tout enfin
De tes attraits la finesse
En toi tout semble divin.
Joli mirliton, etc.

Ta démarche aussi légère
Que le vol du papillon
Devance aisément, ma chère,
Le souffle de l'aquilon,
Joli mirliton, etc.

L'impériale couronne
N'irait pas mal à ton front.
Ton mollet, je le soupçonne
Doit être d'un tour bien rond.
Joli mirliton, etc.

Grâce à cette flatterie,
Elle tombe en pâmoison,
Tandis qu'elle est engourdie,
J'explore son mirliton.
O doux mirliton, etc.

Puis revenant à la vie
Sous mes vigoureux efforts,
Elle se trouve ébahie
De me sentir sur son corps.
O doux mirliton, etc.

Elle rougit et soupire
Lève des yeux langoureux
Qui semblaient vouloir me dire
"Je me complais à ces jeux."
Gentil mirliton, etc.

Au bout de la jouissance
Loin de dire: "C'est assez."
Sentant que je recommence
Elle me dit: "Enfoncez."
Gentil mirliton, etc.

Je retirai ma sapière,
Après dix ou douze coups—
Mais trémoussant du derrière:
"Pourquoi vous arrêtez-vous?"
Dit ce mirliton, etc.

6.

Cher ami que Paris retient bien loin de moi
D'un ténébreux rébus devine le mystère.
Est-il bon? Je ne sais; mais je sais, par ma foi,
Que je l'ai composé dans le but de le faire
Bon, mais non pas mauvais. Si tu peux deviner
Le sens de ce rébus que je te fais donner
Par la poste, morbleu! je saurai bien prétendre
Qu'il est bon et fort bon, et je ne veux entendre
Là-dessus point du tout de contradiction.
Comme j'en suis l'auteur, c'est toute la raison.

7

Adieu nos belles nages
Sur les riantes plages
Du fleuve impétueux
Qui roulait sur la grève
Une onde, dont mon rêve
Ne souhaita rien mieux.
Une eau rouge et bourbeuse
Sur la fange terreuse
Entraîne maintenant
Plantes déracinées,
Branches abandonnées
Au gré de son courant.
Elle tombe, la grêle!
Puis elle se dégèle
Bientôt elle se mêle

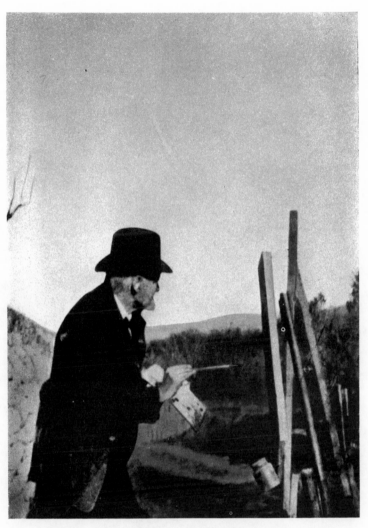

47. Cézanne 'Sur le Motif'
Photograph taken in 1906 by K. X. Roussel

A ces noirâtres eaux.
De grand torrents de pluie
Que la terre essuie
Forment de grands ruisseaux.
Ce sont des rimes sans raison.

Mon cher, tu sais, ou bien tu ne sais pas,
Que d'un amour subit j'ai ressenti la flamme
Tu sais de qui je chéris les appas,
C'est d'une gentille femme.
Brun est son teint, gracieux est son port,
Bien mignon est son pied, la peau de sa main fine
Blanche est sans doute,[a] enfin, dans mon transport
J'augure, en inspectant cette taille divine,
Que de ses beaux têtons l'albâtre est élastique,
Bien tournés par l'amour. Le vent en soulevant
Sa robe d'une gaze en couleurs magnifiques
Laisse d'un rond mollet deviner le charmant
Contour. . . .

8.

Que ta santé soit parfaite,
En amour sois toujours heureux,
Rien n'est si beau qu'être amoureux,
C'est tout ce que je te souhaite.

9.

L'éclair a sillonné la nue
Et la foudrrre en grrrondant rrroule dans l'étendue.

10.

Cicéron
foudroyant Catilina,
après avoir découvert la conspiration
de ce citoyen perdu d'honneur.
Admire, cher ami, la force du langage
Dont Cicéron frappa ce méchant personnage,
Admire Cicéron dont les yeux enflammés
Lancent de ces regards de haine envenimés,

[a] Car elle avait des gants (*Note de Paul Cézanne*).

345

Qui renversent Statius cet ourdisseur de trames
Et frappent de stupeur ses complices infâmes.
Contemple, cher ami, vois bien Catilina
Qui tombe sur le sol, en s'écriant "Ah! Ah!"
Vois le sanglant poignard dont cet incendiaire
Portait à son côté la lame sanguinaire.
Vois tous les spectateurs, émus, terrifiés
D'avoir été bien près d'être sacrifiés?
Vois-tu cet étendard, dont la pourpre romaine
Autrefois écrasa Carthage l'Africaine?
Quoique je sois l'auteur de ce fameux tableau
Je frissonne en voyant un spectacle si beau.
A chaque mot qui sort (j'ai horreur, je frissonne)
De Cicéron parlant tout mon sang en bouillonne,
Et je prévois déjà, je [*suis*] bien convaincu
Qu'à cet aspect frappant, tu seras tout ému.
Impossible autrement! Non jamais, autre chose
Dans l'Empire romain ne fut plus grandiose.
Vois-tu des cuirassiers les panaches flottants
Ballottés dans les airs par le souffle des vents?
Vois aussi, vois aussi, cet appareil de piques
Qu'a fait poster par là l'auteur des Philippiques.
C'est te donner, je crois, un spectacle nouveau
Que t'exposer aussi l'aspect de l'écriteau:
"*Senatius, Curia*". Ingénieuse idée
Pour la première fois par Cézanne abordée!
 O sublime spectacle aux yeux très surprenant
Et qui plonge dans un profond étonnement.

II.

En plongeur intrépide
Sillonner le liquide
de l'Arc
Et dans cet eau limpide
Attraper les poissons que m'offre le hasard.
Amen! amen! ces vers sont stupides.
Ils ne sont pas pleins de goût
Mais ils sont stupides
Et ne valent rien du tout.
Adieu, Zola, adieu.

Te chanter quelque nymphe de bois
Je ne me trouve pas une assez belle voix
Et les beautés des campagnes agrestes
Sifflent de mes chansons les tours trop peu modestes.

Tel on voit vers les cieux un tas d'absurdités
S'élever avec les stupidités.
C'est assez.

PETITS VERS
Je vois Leydet[a]

Sur un bidet
Poignant son âne
Et triomphant
Il va chantant
Sous un platane.

L'âne affamé
Tout enflammé
Tend vers la feuille
Joyeux et fol
Un très long col
Qui bien la cueille.

Boyer chasseur
Plein de valeur
Met dans sa poche
Un noir cul-blanc
Qui plein de sang
Verra la broche.

[a] Victor Leydet (1845-1908) was a boyhood friend of Cézanne and Zola.
Later he became senator of Bouche-du-Rhône. His son, a painter, knew Cézanne
during his last years.

Zola nageur
Fend sans frayeur
L'onde limpide.
Son bras nerveux
S'étend joyeux
Sur le doux fluide.

15.

De la dive bouteille
Célébrons la douceur,
Sa bonté sans pareille
Fait du bien à mon cœur.

16.

Que ton front tout baigné d'une chaude sueur
Était environné de la docte vapeur,
Qu'exhale jusqu' à moi l'horrible géométrie!
(Ne prends pas au sérieux cette dure infamie)
Si je qualifie
Ainsi la Géométrie!
C'est qu'en l'étudiant je me sens tout le corps
Se fondre en eau, sous mes trop impuissants efforts.

17.

Car dans les bouts rimés je te trouve adorable,
Et dans les autres vers vraiment incomparable,

18.

Notre âme encore candide,
Marchant d'un pas timide,
N'a pas encore heurté
Au bord du précipice
Où si souvent l'on glisse,
En cette époque corruptrice.
Je n'ai pas encore porté
A mes lèvres innocentes,
Le bol de la volupté
Où les âmes aimantes
Boivent à satiété.

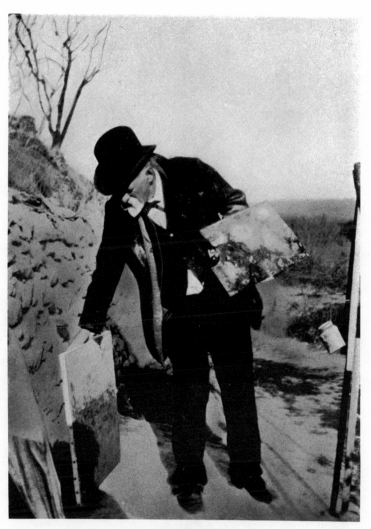

48. Cézanne 'Sur le Motif'
Photograph taken in 1906 by K. X. Roussel

CHANSON EN TON HONNEUR!

(Je chante ici comme si nous étions ensemble adonnés
à toutes les joies de la vie humaine,
c'est pour ainsi dire une élégie,
c'est vaporeux, tu vas voir.)

Le soir, assis au flanc de la montagne,
Mes yeux au loin erraient sur la campagne:
Je me disais, quand donc une compagne,
De tant de mal qui m'accable aujourd'hui
Viendra, grands Dieux, soulager ma misère?
Oui, avec elle, elle me paraîtrait légère,
Si gentillette ainsi qu'une bergère,
Aux doux appas, au menton rond et frais
Aux bras rebondis, aux mollets très bien faits,
A la pimpante crinoline,
A la forme divine,
A la bouche purpurine,
digue, dinguedi, dindigue, dindon,
O, ô le joli menton.

Hélas! Muses, pleurez, car votre nourrisson
Ne peut pas même faire une courte chanson.
O du bachot, examen très terrible!
Des examinateurs, ô faces trop horribles!
Si je passais, ô plaisir indicible.

Je frémis, quand je vois toute la géographie.
L'histoire, et le latin, le grec, la géométrie
Conspirer contre moi: je les vois menaçants
Ces examinateurs dont les regards perçants
Jusqu'au fond de mon cœur portent un profond trouble.
Ma crainte, à chaque instant, terriblement redouble!
Et je me dis: Seigneur, de tous ces ennemis,

Pour ma perte certaine impudemment unis,
Dispersez, confondez la troupe épouvantable.—
La prière, il est vrai, n'est pas trop charitable.—
Exaucez-moi pourtant, de grâce, mon Seigneur,
Je suis de vos autels un pieux serviteur. . .

D'un encens quotidien j'honore vos images
Ah! terrassez, Seigneur, ces méchants personnages.
Les voyez-vous déjà prompts à se rassembler,
Ils se frottent les mains, prêts à nous tous couler?
Les voyez-vous, Seigneur, dans leur cruelle joie
Compter déjà des yeux quelle sera leur proie?
Voyez, voyez, Seigneur, comment sur leurs bureaux
Ils groupent avec soin les fatals numéros!
Non, non, ne souffrez pas que victime innocente
Je tombe sous les coups de leur rage croissante.
Envoyez votre Esprit-Saint sanctificateur!
Qu'il répande bientôt sur votre serviteur
De son profond savoir l'éclatante lumière.
Et si vous m'exaucez, à mon heure dernière
Vous m'entendrez encore beugler des oremus
Dont vous, Saintes et Saints, serez toùs morfondus.
De grâce, veuillez bien, veuillez, Seigneur, m'entendre
Daignez aussi, Seigneur, ne pas vous faire attendre
(Dans l'envoi de vos grâces, sous-entendu)
Puissent mes vœux monter jusqu'au céleste Eden:
 In saecula saeculorum, amen!

22.

Sacré nom, sacré nom de 600.000 bombes!
Je ne peux pas rimer.—Je tombe et tu succombes
Aux 600.000 éclats des 600.000 bombes.

C'est trop d'esprit en un seul coup, oui.

Je le sens (bis) je dois jeune en mourir,
Car comment tant d'esprit en moi pourrait tenir?
Je ne suis pas assez vaste, et ne puis suffire
A contenir l'esprit, aussi, jeune j'expire.

Oui, mon cher, oui mon cher, une très vaste joie,
A ce titre nouveau, dans mon cœur se déploie,
Du latin et du grec je ne suis plus la proie!
O très fortuné jour, ô jour très fortuné,
Où ce titre pompeux put m'être décerné;
Oui, je suis bachelier, c'est une grande chose,
Oui, dans l'individu fait bachelier, suppose
Du grec et du latin une fameuse dose!

24.

SONGE D'ANNIBAL

ANNIBALIS SOMNIUM

Au sortir d'un festin, le héros de Carthage,
Dans lequel on avait fait trop fréquent usage
Du rhum et du cognac, trébuchait, chancelait.
Oui, déjà le fameux vainqueur de Cannes allait
S'endormir sous la table: ô étonnant miracle!
Des débris du repas effrayante débâcle!
Car d'un grand coup de poing qu'appliqua le héros
Sur la nappe, le vin s'épandit à grands flots.
Les assiettes, les plats et les saladiers vides
Roulèrent tristement dans les ruisseaux limpides
De punch encore tout chaud, regrettable dégât!
Se pouvait-il, messieurs, qu'Annibal gaspillât!
Infandum, Infandum, le rhum de sa patrie!
Du vieux troupier français, ô liqueur si chérie!
Se pouvait-il, Zola, commettre telle horreur,
Sans que Jupin vengeât cette affreuse noirceur?
Se put-il qu'Annibal perdit si bien la tête
Pour qu'il pût t'oublier d'une façon complète,
O rhum?—Éloignons-nous d'un si triste tableau!
O punch tu méritais un tout autre tombeau!
Que ne t'a-t-il donné, ce vainqueur si farouche,
Un passe-port réglé pour entrer dans sa bouche,
Et descendre tout droit au fond de l'estomac?
Il te laissa gisant sur le sol, ô Cognac!

—Mais par quatre laquais, irrévocable honte,
Est bientôt enlevé le vainqueur de Sagonthe
Et posé sur un lit; Morphée et ses pavots
Sur ses yeux alourdis font tomber le repos,
Il bâille, étend les bras, s'endort du côté gauche;
Notre héros pionçait après cette débauche,
Quand des songes légers le formidable essaim
S'abattit tout à coup auprès du traversin.
Annibal dormait donc. — Le plus vieux de la
 troupe
S'habille en Amilcar, il en avait la coupe. —
Les cheveux hérissés, le nez proéminent,
Une moustache épaisse extraordinairement;
Ajoutez à sa joue une balafre énorme
Donnant à son visage une binette informe,
Et vous aurez, messieurs, le portrait d'Amilcar.
Quatre grands chevaux blancs attelés à son char
Le traînaient: il arrive et saisit Annibal par
 l'oreille
Et bien fort le secoue: Annibal se réveille,
Et déjà le courroux. . . Mais il se radoucit
En voyant Amilcar qu'affreusement blêmit
La colère contrainte: "Indigne fils, indigne!
Vois-tu dans quel état le jus pur de la vigne
T'a jeté, toi, mon fils — Rougis, corbleu, rougis,
Jusqu'au blanc de l'œil. Tu traînes sans souci,
Au lieu de guerroyer, une honteuse vie.
Au lieu de protéger les murs de ta patrie,
Au lieu de repousser l'implacable romain,
Au lieu de préparer, toi vainqueur au Tésin,
A Trasimène, à Cannes, un combat où la Ville
Qui fut des Amilcars toujours le plus hostile
Et le plus acharné de tous les ennemis,
Vit tous ses citoyens par Carthage soumis,
O fils dégénéré, tu fais ici la noce!
Hélas! ton pourpoint neuf est tout taché de sauce,
Du bon vin de Madère et du rhum! C'est
 affreux!
Va, suis plutôt, mon fils, l'exemple des aïeux.
Loin de toi, ce cognac et ces femmes lascives
Qui tiennent sous le joug nos âmes trop captives!

49. Cézanne's rucksack and paint-box in the Studio des Lauves
Photograph

50. Studio in Chemin des Lauves
*To the left of the large studio window there is in the wall a hatch
through which Cézanne transported the big pictures of the bathers*
Photograph

Abjure les liqueurs. C'est très pernicieux
Et ne bois que de l'eau, tu t'en trouveras mieux."
A ces mots Annibal appuyant sur son lit
Sa tête, de nouveau profondément dormit.

As-tu trouvé jamais style plus admirable?
Si tu n'es pas content, tu n'es pas raisonnable.

25.

Hélas, j'ai pris du Droit la route tortueuse.
—J'ai pris, n'est pas le mot, de prendre on m'a forcé!
Le Droit, l'horrible Droit d'ambages enlacé
Rendra pendant trois ans mon existence affreuse!

Muses de l'Hélicon, du Pinde, du Parnasse
Venez, je vous en prie, adoucir ma disgrâce.
Ayez pitié de moi, d'un malheureux mortel
Arraché malgré lui d'auprès de votre autel.
Du Mathématicien les arides problèmes,
Son front pâli, ridé, ses lèvres aussi blêmes
Que le blême linceul d'un revenant terreux,
Je le sais, ô neuf sœurs, vous paraissent affreux!
Mais celui qui du Droit embrasse la carrière
De vous et d'Apollon perd la confiance entière.
Sur moi ne jetez pas un œil trop dédaigneux
Car je fus moins coupable, hélas, que malheureux
Accourez à ma voix, secourez ma disgrâce
Et dans l'éternité, je vous en rendrai grâces.

26.

O Droit, qui t'enfanta, quelle cervelle informe
Créa, pour mon malheur, le Digeste difforme?
Et ce code incongru, que n'est-il-demeuré
Durant un siècle encore dans la France ignoré?
Quelle étrange fureur, quelle bêtise et quelle
Folie avait troublé ta tremblante cervelle,
O piètre Justinien des Pandectes fauteur,
Et du *Corpus juris* impudent rédacteur?
N'était-ce pas assez qu'Horace et que Virgile,

Que Tacite et Lucain, d'un texte difficile
Vinssent, durant huit ans, nous présenter l'horreur,
Sans t'ajouter à eux, causes de mon malheur!
S'il existe un enfer, et qu'une place y reste
Dieu du ciel, plongez-y, le Gérant du Digeste!

27.

Tu sais que de Boileau l'omoplate cassé,
Fut trouvé l'an dernier dans un profond fossé,
Et que creusant plus bas des maçons y trouvèrent
Tous ses os racornis, qu'à Paris ils portèrent.
Là, dans un muséum, ce roi des animaux
Fut classé dans le rang des vieux rhinocéros.
Puis on grava ces mots, au pied de sa carcasse:
"Ci-repose Boileau, le recteur du Parnasse."

Ce récit que voilà, tout plein de vérité
Te fait bien voir le sort qu'il avait mérité,
Pour avoir trop loué dans sa verve indiscrète
Le quatorzième Louis, de nos rois le plus bête.
Puis cent francs l'on donna pour les récompenser,
Aux ardents travailleurs, qui, pour cette trouvaille,
Portent, avec ces mots, une belle médaille:
"Ils ont trouvé Boileau dans un profond fossé."

Hercule, un certain jour, dormait profondément
Dans un bois, car le frais était bon, car vraiment
S'il ne s'était tenu sous un charmant bocage
Et s'il avait été exposé à la rage
Du soleil, qui dardait des rayons chaleureux,
Peut-être aurait-il pris un mal de tête affreux;
Donc il dormait très fort. Une jeune dryade
Passant tout près de lui. . . .

28
POÈME

Ma gracieuse Marie
Je vous aime et je vous prie
De garder les mots d'écrit
Que vous envoient vos amis.

Sur vos belles lèvres roses
Ce bonbon glissera bien,
Il passe sur bien des choses
Sans en gâter le carmin.

Ce joli bonbon rose
Si gentiment tourné
Dans une bouche rose
Serait heureux d'entrer.

29.

Le Dante: Dis-moi, mon cher, que grignotent-ils là?
Virgile: C'est un crâne, parbleu.
Le Dante: Mon Dieu, c'est effroyable.
 Mais pourquoi rongent-ils ce cerveau détestable!
Virgile: Ecoute, et tu sauras cela.

Le père: Mangez à belles dents ce mortel inhumain
 Qui nous a si longtemps fait souffrir de faim.
L'aîné: Mangeons!
Le cadet: Moi, j'ai bien faim, donne cette oreille!
Le troisième: A moi le nez!
Le petit-fils: A moi cet œil!
L'aîné: A moi les dents!
Le père: Hé-hé, si vous mangez d'une façon pareille
 Que nous restera-t-il pour demain, mes enfants!

J'ai résolu, mon cher, d'épouvanter ton cœur
D'y jeter une énorme, une atroce frayeur
Par l'aspect monstrueux de cet horrible drame
Bien fait pour émouvoir la plus dure des âmes.
J'ai pensé que ton cœur sensible à ces maux-là
S'écrierait: quel tableau merveilleux que voilà!
J'ai pensé, qu'un grand cri d'horreur, de ta poitrine
Sortirait, en voyant ce que seul imagine
L'enfer, où le pêcheur, mort dans l'impunité,
Souffre terriblement durant l'éternité.

355

Mais j'observe, mon cher, que depuis quinze jours
Notre correspondance a relâché son cours;
Serait-ce par hasard l'ennui qui te consume,
Ou bien ton cerveau pris par quelque fâcheux rhume
Te retient, malgré toi, dans ton lit, et la toux
Te chagrinerait-elle? Hélas, ce n'est pas doux
Mais pourtant mieux vaut ça que d'autres maux encore.
Peut-être est-ce l'amour qui lentement dévore
Ton cœur? Oui? Non? Ma foi, je n'en sais rien
Mais si c'était l'amour, je dirais, ça va bien.
Car l'amour, je crois fort qu'il n'a tué personne;
Peut-être que parfois tout de même il nous donne
Quelque peu de tourment, quelque peu de chagrin,
Mais vient-il aujourd'hui, il disparaît demain.
Si, par malheur, malheur serait, il faut le dire,
Si quelque maladie horrible te déchire;
Pourtant je ne crois pas que les Dieux malveillants
T'aient donné, sacrebleu, quelque affreux mal de dents,
Ou bien quelque autre chose horriblement bien bête
A souffrir, par exemple, un vaste mal de tête
Qui du chef jusqu'aux pieds promenant son tourment
Te fasse envers le ciel jurer atrocement.
Cela serait stupide; être malade est chose,
Quelque mal que ce soit, extrêmement morose;
Car l'on perd l'appétit, et l'on ne mange pas;
En vain devant nos yeux passeraient mille plats
Très doux, très attrayants; notre estomac repousse
Le plus doux, le meilleur des fricots, la plus douce
Des sauces: le bon vin — car je l'aime — il est vrai
Que chez Baille il nous a sur le coco frappé,
Mais je l'excuse: adonc le vin est bonne chose
Des maux les plus divers il peut guérir la cause
Bois-en donc, cher ami, bois-en, car il est bon
Et de ton mal bientôt viendra la guérison
Car le vin est bien bon: *bis, ter*.
Aurais-tu, par hasard, mangé trop de bonbons
Le jour de l'an? Pourquoi non? car trop forte dose
T'aurait pu condamner à rester bouche close,

En te donnant, hélas, une indigestion,
Mais c'est assez, ma foi, se livrer sans vergogne
A la bêtise: car le temps sans cesse rogne
Notre vie, et nos jours déclinent. Le tombeau,
Ce vorace et terrible abîme insatiable
Est là toujours béant — Dépucelé, puceau
Quand viendra notre jour, vertueux ou coupable
Nous paîrons le tribut au sort inévitable.

31.

Tu me diras peut-être: Ah! mon pauvre Cézanne,
Quel démon féminin a démonté ton crâne?
Toi que j'ai vu jadis marcher d'un pas égal,
Ne faisant rien de bien, ne disant rien de mal?
Dans quel cahos confus de rêves si bizarres,
Comme en un Océan aujourd'hui tu t'égares?
Aurais-tu vu danser par hasard la Polka
Par quelque jeune nymphe, artiste à l'Opéra?
N'aurais-tu pas écrit, endormi sous la nappe
Après t'être enivré comme un diacre du pape,
Ou bien, mon cher, rempli d'un amour rococo
Le vermouth t'aurait-il frappé sur le coco?

— Ni l'amour, ni le vin n'ont touché ma sorbonne
Et je n'ai jamais cru que l'eau seule fut bonne;
Ce seul raisonnement doit te prouver, mon cher,
Que, bien qu'un peu rêveur, je vois pourtant très clair.

N'aurais-tu jamais vu dans des heures rêveuses
Comme dans un brouillard des formes gracieuses,
Indécises beautés dont les ardents appas,
Rêvés durant la nuit, le jour ne se voient pas?
Comme on voit le matin la vaporeuse brume,
Quand le soleil levant de mille feux allume
Les verdoyants coteaux où bruissent les forêts,
Les flots étincellants des plus riches reflets
De l'azur; puis survient une brise légère
Qui chasse en tournoyant la brume passagère,
C'est ainsi qu'à mes yeux se présentent parfois
Des êtres ravissants, aux angéliques voix,

Durant la nuit. Mon cher, on dirait que l'aurore
D'un éclae frais et pur à l'envi les colore,
Ils semblent me sourire et je leur tends la main.
Mais j'ai beau m'approcher, ils s'envolent soudain,
Ils montent dans le ciel, portés par le zéphyre
Jetant un regard tendre et qui semble me dire
Adieu! près d'eux encor je tente d'approcher,
Mais c'est en vain, en vain que je veux les toucher,
Ils ne sont plus — déjà la gaze transparente
Ne peint plus de leurs corps la forme ravissante.

Mon rêve évanoui, vient la réalité
Qui me trouve gisant, le cœur tout attristé,
Et je vois devant moi se dresser un fantôme
Horrible, monstrueux, c'est le DROIT qu'on le nomme.

32.

O crasse lycéenne! ignoblissimes croûtes![a]
O vous qui barbotez dedans les vieilles routes
Que dédaignent tous ceux dont la moindre chaleur
Fait naître quelque élan sublime dans leur cœur;
Quelle insane manie à critiquer vous pousse
Celui-là qui se rit de si faible secousse
Myrmidons lycéens! admirateurs forcés
De ces tristes vers plats que Virgile a laissés:
Vrai troupeau de pourceaux qui marchez sous l'égide
D'un pédant tout pourri qui bêtement vous guide,
Vous forçant d'admirer sans trop savoir pourquoi
Des vers que vous trouvez beaux sur sa seule foi;
Quand au milieu de vous surgit comme une lave
Un poète sans frein, qui brise toute entrave,
Comme autour de l'aiglon l'on entend criailler
Mille chétifs oiseaux; bons rien qu'à fouailler,
O mesquins détracteurs, prêtres de la chicane
Vous vomissez sur lui votre bave profane.
Je vous entends déjà, vrais concerts de crapauds,
Vous égosiller tous chantant sur un ton faux,
Non, on n'a jamais vu dans le monde grenouilles

[a] Ces épithètes s'adressent aux camarades de collège de Zola, qui ne paraissaient pas goûter les poésies de ce dernier.

Qui comme vous, messieurs, plus sottement bredouilles.
Mais remplissez les airs de vos sottes clameurs,
Les vers de mon ami demeureront vainqueurs!
Ils résisteront tous à votre vilenie,
Car ils sont tous marqués au vrai coin du génie.

33.

Baille ne t'écrit pas, il craint qu'à son esprit
Tu restes, cher Zola, sur le coup interdit.
De peur conséquemment que tu ne le comprennes
Aujourd'hui pour t'écrire il me livre les rênes,
Donc je suis dans sa chambre et c'est sur son bureau
Que je t'écris ces vers, enfants de mon cerveau.
Je ne crois pas, mon cher, qu'aucun les revendique
Car ils sont vraiment plats d'une façon unique.
Cependant ci-dessous je m'en vais t'exposer
Des vers que nous avons eu soin de composer
A ton honneur: "Le suif" est le titre de l'ode
Qui de l'art poétique a méprisé le code.

34.
ODE

O suif dont le bienfait vraiment incomparable
Mérite qu'on lui rende un honneur remarquable
O toi qui de la nuit éclaircis la noirceur
 Honneur.
Non, non, rien n'est plus beau qu'une belle chandelle
Et rien n'éclaire mieux qu'une chandelle belle,
Qu'on te chante en tout temps et dans tout l'univers
 En vers.
C'est pourquoi j'entreprends d'une ardeur pleine de zèle
De célébrer ici la chandelle immortelle.
Pour t'immortaliser je ne vois pas de mots.
 Trop beaux.
Ta gloire est très brillante, et brillants les services
Que tu rends à ceux-là qui se graissent les cuisses.
Oui, ta gloire inspira ces sublimes versets
 Bien faits.
 Mais ce serait surtout à l'armée autrichienne
 De prendre la parole et de chanter la tienne.

35.
I

Mon cher,
 si je suis tardif
A te donner en rime en if
Le résultat définitif
Sur l'examen rébarbatif
Dont le souci m'était très vif. [a]

36.

Chose facile à croire
 Avec deux rouges et une noire.
Aussitôt j'ai voulu rassurer tes esprits
Dans le doute flottant sur mon sort indécis.

37.
II

"LA PROVENCE" bientôt verra dans ses colonnes
Du flasque Marguery l'insipide roman:
A ce nouveau malheur, Provence, tu frissonnes,
Et le froid de la mort a glacé tout ton sang.

38.
III

PERSONNAGES:
Esprits inspirateurs de Gaut; Gaut lui-même rédigeant le
sublime "MEMORIAL"[b]
UN ESPRIT:
Grand Maître, avez-vous lu le roman feuilleton
Que la "PROVENCE" vient de mettre en livraison?[c]
GAUT:
C'est du dernier mauvais.

[a] Il s'agit d'un examen de droit.
[b] Gaut, Jean-Baptiste (1819–91), poète provençal et publiciste, rédacteur
du journal hebdomadaire le "MEMORIAL D'AIX", conservateur de la Biblio-
thèque Méjanes.
[c] Sans doute allusion à une publication de Louis Marguery "*Ludovico*".

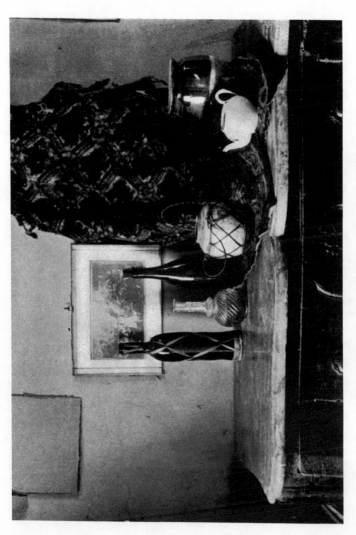

51. Sideboard in Cézanne's Studio with a Still Life arranged

Photograph

UN SECOND ESPRIT:
> J'en dis de même, Maître,
"LA PROVENCE" jamais au jour n'a fait paraître
Rien de plus saugrenu.

GAUT:
> Quel est le polisson
Assez présomptueux pour braver mon renom
Et venir après moi, moi flambeau de la Presse,
D'un roman si mesquin étaler la détresse?

UN ESPRIT:
Son nom jusqu'à ce jour plongé dans le brouillard
Veut se produire enfin...

UN ESPRIT AUTRE
> Juste ciel, quel écart!

GAUT:
Et que pense-t-il faire, aurait-il donc l'audace
De vouloir ici-bas marcher sur notre trace,
Oserait-il prétendre atteindre la hauteur
Au-dessus du vulgaire où je règne en vainqueur?

UN ESPRIT:
Non, Maître, non jamais, car sa plume débile
Ne connaît nullement comme un roman se file
Comment, par une intrigue embrouillée, aux lecteurs
Qui vous lisent, on fait arriver les vapeurs.

UN AUTRE ESPRIT:
Il ignore surtout cet art si difficile,
Cet art, où plus que vous aucun autre est habile,
Cet art si précieux et pénible d'autant,
Cet art ambitionné, dont Dieu vous fit présent,
Cet art, enfin cet art, que tout le monde admire,
Et que pour l'exprimer nul mot n'y peut suffire.

GAUT:
C'est bien, je te comprends, c'est la V e r b o l o g i e,
Du gréco-latin sort son étymologie
En effet sous l'azur des cieux aux mille feux,
Quel est le g u n o g è n e assez audacieux
Pour proclamer avoir inventé quelque chose
De plus beau que les noms employés dans ma prose.

Mes c a r m i n e s français sont très supérieurs
A tout ce qu'ont produit un tas de rimailleurs
Et mes romans surtout, ce champ où je domine,
Et comme le soleil, se levant, illumine
Les e x c e l s e s hauteurs des v i r i d e s forêts
Comme un prisme brillant au monde j'apparais.

UN ESPRIT:
D o m i n e souverain, Esprit incomparable
Louange soit rendue à votre estimable
Vertu.

UN CHŒUR D'ESPRITS:
Toi seul, toi seul, Grand Gaut innovateur
Sublime dans les cieux plans avec grandeur
Les plus brillants s i d è r e s
Au feu de tes paupières
Courbant leur front confus,
Ébloui de ta gloire,
Sans tenter la victoire
Croisant les bras moulus
Et remuant la tête
Ludovico s'arrête
Et dit: "je n'écris plus!"
Gloire à toi, gloire à toi, Gaut p h i l o n o v o s t y l e,
Pour t'égaler, grand Gaut, ce sera difficile.

39.

Mon cher ami, quand des vers l'on veut faire
La rime au bout du vers est chose nécessaire;
Dans cette lettre donc, s'il vient mal à propos
Pour compléter mon vers se glisser quelques mots,
Ne va pas t'offusquer d'une rime stérile
Qui ne se cogne là que pour se rendre utile;
Te voilà prévenu: je commence et je dis
Aujourd'hui 29 décembre, je t'écris.
Mais mon cher, aujourd'hui fortement je m'admire
Car je dis aisément tout ce que je veux dire;
Pourtant il ne faut pas se réjouir trop tôt,
La rime, malgré moi, peut me faire défaut.
De Baille, notre ami, j'ai reçu la visite
Et pour t'en informer je te l'écris bien vite.

Mais le ton que je prends me semble être trop bas;
Sur les hauteurs du Pinde il faut porter mes pas:
Car je ressens du ciel l'influence secrète;
Je vais donc déployer mes ailes de poète
Et m'élevant bientôt d'un vol impétueux,
Je m'en irai toucher à la voûte des cieux.
Mais de peur que l'éclat da ma voix t'éblouisse,
Je mettrai dans ma bouche un morceau de réglisse,
Lequel interceptant le canal de la voix
N'étourdira plus par des cris trop chinois.

40
UNE TERRIBLE HISTOIRE

C'était durant la nuit. — Notez bien que la nuit
Est noire, quand au ciel aucun astre ne luit.
Il faisait donc très nuit, et nuit même très noire,
Lorsque dut se passer cette lugubre histoire.
C'est un drame inconnu, monstrueux, inouï,
Et tel qu'aucun gens n'en a jamais ouï.

Satan, bien entendu, doit y jouer un rôle,
La chose est incroyable, et pourtant ma parole
Que l'on a toujours crue, est là pour constater
La vérité du fait que je vais te conter.
Écoute bien: C'était minuit, heure à laquelle
Tout couple dans son lit travaille sans chandelle,
Mais non pas sans chaleur. Il faisait chaud. C'était
Par une nuit d'été; dans le ciel s'étendait
Du nord jusqu'au midi, présageant un orage,
Et comme un blanc suaire, un immense nuage.
La lune par instants, déchirant ce linceul,
Éclairait le chemin, où, perdu, j'errais seul —
Quelques gouttes tombant à de courts intervalles
Tachaient le sol. Des terribles rafales
Précurseur ordinaire, un vent impétueux
Soufflant du sud au nord s'éleva furieux;
Le simoun qu'en Afrique on voit épouvantable
Enterrer les cités sous des vagues de sable,
Des arbres qui poussaient leurs rameaux vers les cieux
Courba spontanément le front audacieux.

Au calme succéda la voix de la tempête.
Le sifflement des vents que la forêt répète
Terrifiait mon cœur. L'éclair, avec grand bruit
Terrible, sillonnait les voiles de la nuit:
Vivement éclairés par sa lueur blafarde
Je voyais les lutins, les gnomes, Dieu m'en garde,
Qui volaient, ricanant, sur les arbres bruissants.
Satan les commandait; je le vis, tous mes sens
Se glacèrent d'effroi: son ardente prunelle
Brillait d'un rouge vif; parfois une étincelle
S'en détachait, jetant un effrayant reflet;
La ronde des démons près de lui circulait.

Je tombai; tout mon corps, glacé, presque sans vie,
Trembla sous le contact d'une main ennemie.
Une froide sueur inondait tout mon corps,
Pour me lever et fuir faisant de vains efforts
Je voyais de Satan la bande diabolique
Qui s'approchait, dansant sa danse fantastique,
Les lutins redoutés, les vampires hideux,
Pour s'approcher de moi se culbutaient entre eux,
Ils lançaient vers le ciel leurs yeux pleins de menaces
Rivalisant entre eux à faire des grimaces.

"Terre, ensevelis-moi! Rochers, broyez mon corps!"
Je voulus m'écrier: "O demeure des morts,
Recevez-moi vivant!" Mais la troupe infernale
Resserrait de plus près son affreuse spirale:
Les goules, les démons, grinçaient déjà des dents,
A leur festin horrible, ils préludaient. — Contents,
Ils jettent des regards brillants de convoitise.
C'en était fait de moi. . . quand, ô douce surprise!
Tout à coup au lointain retentit le galop
Des chevaux hennissants qui volaient au grand trot.
Faible d'abord, le bruit de leur course rapide
Se rapproche de moi; le cocher intrépide
Fouettait son attelage, excitant de sa voix
Le quadrige fougueux qui traversait les bois.
A ce bruit, des démons les troupes morfondues
Se dissipent, ainsi qu'au zéphyr les nues.

364

52. Cézanne's last Letter
17th October, 1906

Moi, je me réjouis, puis, plutôt mort que vif
Je hèle le cocher: l'équipage attentif
S'arrêta sur-le-champ. Aussitôt du calèche
Sortit en minaudant une voix douce et fraîche:
"Montez" elle me dit, "Montez." Je fais un bond:
La portière se ferme, et je me trouve front
A front d'une femme... Oh, je jure sur mon âme
Que je n'avais jamais vu de si belle femme..
Cheveux blonds, yeux brillants d'un feu fascinateur,
Qui, dans moins d'un instant, subjuguèrent mon cœur.
Je me jette à ses pieds; pied mignon, admirable,
Jambe rondé; enhardi, d'une lèvre coupable,
Je dépose un baiser sur son sein palpitant;
Mais le froid de la mort me saisit à l'instant,
La femme dans mes bras, la femme au teint de rose
Disparaît tout à coup et se métamorphose
En un pâle cadavre aux contours anguleux:
Ses os s'entrechoquaient, ses yeux éteints sont creux...
Il m'étreignait, horreur!... Un choc épouvantable
Me réveille, et je vois que le convoi s'entable...
...le convoi déraillant, je vais, je ne sais où,
Mais très probablement je me romprai le cou.

41.
CHARADE

Mon premier fin matois à la mine trompeuse
Destructeur redouté de la classe rongeuse,
Plein de ruse, a toujours sur les meilleurs fricots
Avec force impudeur, prélevé des impôts.
Mon second au collège avec de la saucisse
De nos ventres à jeun faisait tout le délice.
Mon troisième est donné dans l'indigestion
Et pour bien digérer. L'anglaise nation
Après un bon souper, chaque soir s'en régale;
Mon entier est nommé vertu théologale.[a]

[a] Solution: chat-riz-thé — charité.

42.

J'ai vu d'Yvon la bataille éclatante;
Pils dont le chic crayon d'une scène émouvante
Trace le souvenir dans son tableau vivant,
Et les portraits de ceux qui nous mènent en laisse;
Grands, petits, moyens, courts, beaux ou de pire espèce.
Ici c'est un ruisseau; là, le soleil brûlant,
Le lever de Phébus, le coucher de la lune;
Un jour étincelant, une profonde brune,
Le climat de Russie ou le ciel africain;
Ici, d'un Turc brutal la figure abrutie,
Là, par contre, je vois un sourire enfantin:
Sur des coussins de pourpre une fille jolie
Etale de ses seins l'éclat et la fraîcheur.
De frais petits amours voltigent dans l'espace;
Coquette au frais minois se mire dans la glace.
Gérôme avec Hamon, Glaise avec Cabanel,
Müller, Courbet, Gubin, se disputent l'honneur
De la victoire...

43.

Ce temps où nous allions sur les prés de la Torse
Faire un bon déjeuner, et la palette en main,
Retracer sur la toile un paysage rupin:
Ces lieux où tu faillis te donner une entorse
Dans le dos, quand ton pied glissant sur le terrain
Tu roulais jusqu'au fond de l'humide ravin,
Et "Black",[a] t'en souviens-tu! Mais les feuilles jaunies
Au souffle de l'hiver ont perdu leur fraîcheur.
Sur le bord du ruisseau les plantes sont flétries
Et l'arbre, secoué par les vents en fureur,
Agite dans les airs comme un cadavre immense
Ses rameaux dépouillés que le mistral balance.

a "Black" était un chien. Cézanne le mentionne également dans une autre lettre à Numa Coste.

INDEX

367

373

ILLUSTRATIONS